PEWTER

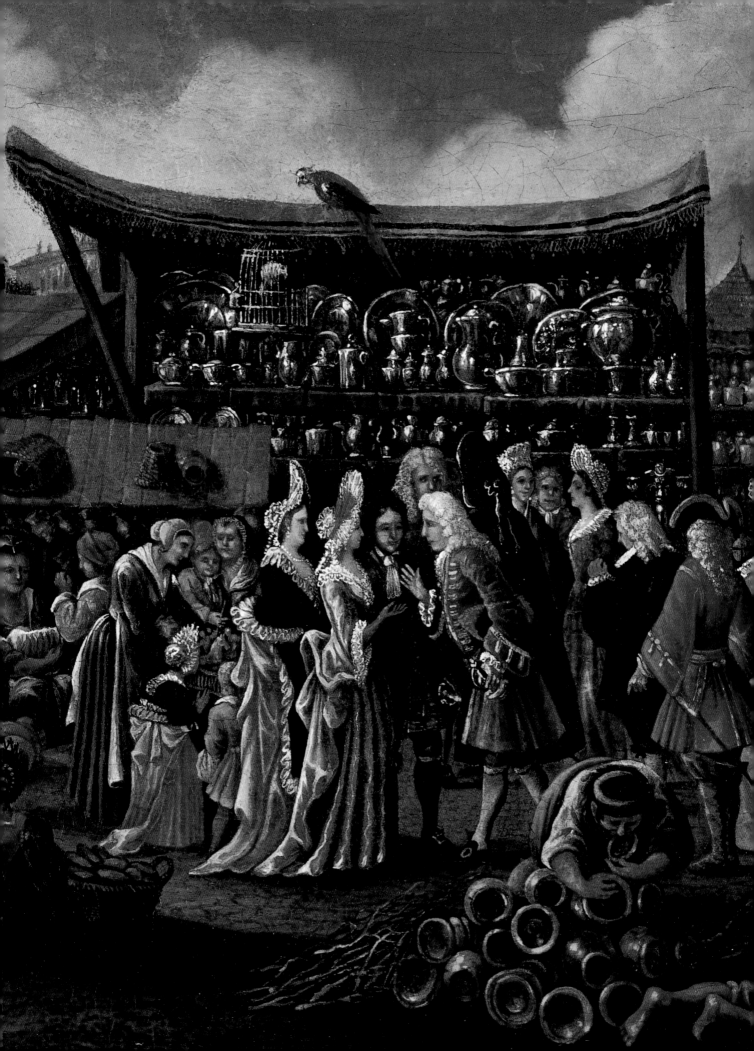

PEWTER

AT THE VICTORIA AND ALBERT MUSEUM

ANTHONY NORTH

AND ANDREW SPIRA

First published by V&A Publications, 1999

V&A Publications
160 Brompton Road
London SW3 1HW

Designed by Jason Ellams
Photography by Dominic Naish; V&A Photographic Studio

ISBN 185177 2235

A catalogue record for this book is available from the
British Library.

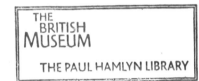

Printed in Hong Kong

Every effort has been made to seek permission to reproduce
those images whose copyright does not reside with the
V&A, and we are grateful to the individuals and institutions
that have assisted in this task. Any omissions are entirely
unintentional and details should be addressed to the
publishers.

Jacket illustrations:
FRONT: 116. *Porringer*, English, late 17th century
BACK: 13. *Tankard of a Butchers' Guild*, German (Zittau),
about 1560
FRONTISPIECE: *A Stall of Pewter Wares at a Market in a Town in
Alsace*, about 1700, by an unknown master. *Dr Karl Ruhmann
Foundation, Wildon, Austria.*

Contents

Preface

The enduring appeal of pewter lies in its softened forms, its quiet glow and its association with the triple pleasures of the table, drink and tobacco. Revived a century ago as an art form, having fallen out of favour towards the end of the eighteenth century, pewter is once again benefitting from exploration by designer-silversmiths such as Toby Russell and Keith Tyssen. In this celebration of British and continental pewter, drawn from the V&A's comprehensive collection of some 1200 objects dating from 1300 to 1998, Anthony North has brought a new lustre to the subject. His wide-ranging introduction describes the history of the design and decoration of pewter, highlighting technical and economic aspects of the craft, and explains the rise and fall of this unassuming but perennially fascinating alloy. Some 300 pieces are illustrated and described within their social and regional context, the fruit of his many years study in the Metalwork, Silver and Jewellery Department of the V&A Museum.

Although pewter is sometimes perceived as a humble material, it was without rival in the 16th and 17th centuries before delft and creamware supplanted it on the table. Since it was recyclable, the alloy retained its value and like silver was priced by weight, although silver was 12 times as costly. It has declined from the days when a garnish of pewter was the proud index of prosperity for an English yeoman and fit to be hired for a Lord Mayor's dinner or Coronation feast. Munich, Nuremberg and Zurich kept their admiration for pewter long after it was supplanted in Britain. The early 19th century saw commercial competition from the less durable but shinier Britannia metal, its upstart rival. The bright glare of acetylene lamps and electric filaments was unkind to pewter's soft gleam.

Anthony North has been cataloguing the V&A's collection for the last five years. In later stages of selecting objects, writing and editing the text and collecting illustrations, he has been partnered by Andrew Spira. Other specialist contributors are Eric Turner, also from the V&A's Department of Metalwork, and Ming Wilson in the Far Eastern Department.

We are grateful to Mr P.K. Yong of Royal Selangor, a licensing partner of V&A Enterprises Ltd, for his assistance with this publication. His Company has done much to revive interest in pewter, celebrating the curvaceous reassuring forms of this underrated metal. The tea service illustrated on page 185 was kindly donated to the Museum by Royal Selangor.

We hope that Anthony North's enthusiasm for these objects and their history will be shared by the readers of this book.

Philippa Glanville
Curator, Metalwork, Silver and Jewellery Collection

Acknowlegements

The idea of this book in its present form was first suggested to me by my colleague Philippa Glanville from whom I have received every support. Special thanks are due to Andrew Spira who not only contributed the section on ecclesiastical pewter but also did much of the background research. I also owe a debt to my colleague Eric Turner for his chapter on twentieth-century pewter which brings the book up to date. I should like to thank Robin Hildyard who explained the complexities of the various mounted wares and also helped to select appropriate examples; also Ming Wilson who wrote the section on Chinese pewter. Christine Darby and Madeleine Tilley succeeded in turning a barbaric handwritten text into a neatly typed English version, and Norbert Jopek helped with difficult German inscriptions. Various members of the V&A's Metalwork Department have provided assistance, especially Louise Hofmann, Angus Patterson, Ann Eatwell, Pippa Shirley, Bet McLeod and Clare Phillips. Sincere thanks are due to Dominic Naish for his skill in photographing very difficult subjects, to David Ford for his XRL analyses and the staff of the Picture Library for their co-operation. I am extremely grateful to Mary Butler, Miranda Harrison, Tim Ayres and Jason Ellams of V&A Publications for seeing the book through publication.

I owe a considerable debt to the Society of Pewter Collectors of Great Britain, especially for their Journal which has proved a most valuable source not only for the details of the pewter trade but also for the personalities associated with the craft. I have derived many benefits from the conversations and correspondence I have had with Dr Ron Homer and with James Johnson who generously shared his knowledge of Scottish pewter. Tim Homfray drew my attention to the connection between pewter and music printing. I would like to thank Dr Robert Keeley for his assistance with some of the metallurgical problems posed by pewter and to his colleague Vicky Sully for her work on the capacities of pewter measures. Many collectors and specialists, including Claude Blair, Tim Wilson, Tony Pilson, Helen Clifford, Rosemary Weinstein, Geoff Egan and Elizabeth Wells have also been invaluable. Finally, I would like to thank Royal Selangor for their contribution.

A.R.E. North
November 1998

Introduction

THE METAL

Pewter is an alloy, that is to say, a mixture of different metals. Its principal component is tin, to which, at various times, different proportions of copper, lead, bismuth, antimony and other metals have been added. The earliest pewter vessel at present recorded is the Abydos flask, now in the Ashmolean Museum, Oxford. In the form of a plain flask with a flattened globular body and waisted neck, it is fitted with two handles and has a hinged lid. It was found in a grave at Abydos in Upper Egypt datable to the XVIII Dynasty (1580–1350 BC). Analysis using x-ray fluorescence shows that the alloy from which it was made consists of 86.6% tin, 6% lead, 1.7% copper, 0.4% iron and 2.5% silicon. Pewter was known, therefore, long before the Roman period, and curiously the Abydos flask is made from a far better quality alloy than was used by the later Roman pewterers.

As described by Pliny in his *Historia Naturalis*, pewter consisted of tin and lead, either in equal proportions or 67% tin to 33% lead (two-thirds to a third). Analysis of a series of pewter vessels from Roman Britain has shown that Pliny's recipes are accurate, although the more decorative wares often have a much higher proportion of tin. Most of the pewter found in Roman Britain comes from the south-west and eastern part of England and dates from after 250 AD. If pewter wares were produced in Britain during the Dark Ages, no examples have survived. It is more likely that the secret of its manufacture was lost until the reintroduction of pewter into Britain, probably from France in the ninth century.

Pewter has never been made to a single standard throughout the history of its manufacture. In France, for example, a top-quality alloy contained at least 90% tin, whereas the lowest quality sometimes contained as much as 26% of lead. In 1348 the mayor and aldermen of London ratified ordinances governing the pewter trade. Standards were established for the different alloys. The best alloy, known as 'fine metal', was to contain 26 lbs. of copper to 112 lbs. of tin – that is to say, approximately 18.8% copper. The best alloy was to be used for 'sadware' or flatware objects, such as plates, dishes and chargers. 'Lay metal', an alloy containing lead, was generally used for humbler wares, such as measures, chamber pots and spoons.

Over the centuries, various attempts were made to harden pewter. Antimony, for example, was added in fifteenth-century Italy. Pewter containing antimony was introduced into England by a French Huguenot refugee called Jacques Taudin, who came to London in the 1650s. His wares were of higher quality than those of English contemporaries, and disputes with the Pewterers' Company are well documented. Taudin

marked his wares and analysis of one of the five plates by him in the collection of the Pewterers' Company shows that the alloy contains 2.3% antimony, 0.6% copper and 0.2% bismuth.

The most important mineral used in the manufacture of pewter is tin, which is produced from cassiterite, a tin oxide. Northern Spain had produced most of the tin for the Roman Empire, until these mines failed. Then the Romans turned to Cornwall, which had almost certainly been exploited in the pre-Roman period as well; Roman metallurgists developed already existing mineral workings throughout their Empire. Cornwall remained the richest source of tin in Europe from the Middle Ages onwards, although the mines of Ergebirge on the borders of Bohemia and Saxony were also worked; hence the well established pewterers' guilds in those areas from the fifteenth century. The Dutch East India Company imported tin from Thailand towards the end of the seventeenth century, but in small quantities compared to the Cornish production. The twentieth century has seen the large-scale development of the tin deposits in Bolivia, Malaysia, Indonesia and the Congo.

Tin occurs in seams and is usually found as a dark blue-black ore containing quartz, tourmaline and cassiterite (SnO_2). As with other minerals, it has to be excavated from the seam and brought to the surface for refining. It is then separated from the ore by roasting. Many of the Cornish mines, such as Wheal Jane and South Crofty, have been exploited for hundreds of years. South Crofty, the last working tin mine in Europe, closed down on 6 March 1998. Some of the draining channels known as 'adits' had been in constant use since the early eighteenth century. The mining of tin is a typically traditional business, employing the same families for generation after generation, with the passing on of specialist skills from father to son.

Once the mined ore has been washed and crushed, it is smelted. In Cornwall this was done in early times in a shaft furnace fed with alternate layers of ore and charcoal, and raised to extreme temperatures by blowing blasts of air into it. The melted tin was then cast into ingots (fig. 1). Around 1700 the reverberatory furnace process was introduced into Cornwall. In this, purified ore is mixed with coal or anthracite, moistened to prevent it from being blown away by the blasts of air. The mixture was then put into the furnace for about five or six hours, before the melted tin was cast into bars. At this stage, the metal is relatively impure and has to be further purified. By tradition, the process

1. Salmon's *Art du Potier*, Paris, 18th century, depicts a wide variety of processes involved in the working of pewter. In this illustration, ingots of tin and the recycling of old wares can be seen.

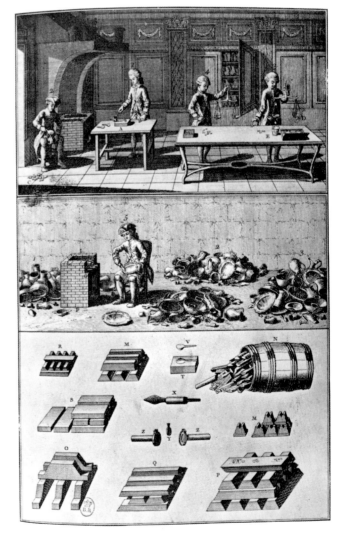

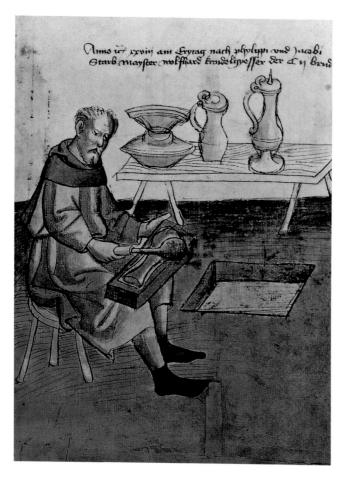

known as 'poling' requires the stirring of the molten metal with the branch of an apple tree. This brings any oxides to the surface. The pure tin can then be cast into ingots.

Cornwall and tin-mining have produced several distinguished engineers, the most famous being Richard Trevithic (1771–1833), whose father managed the Dolcoath mine. His early inventions, such as the improved plunger pole-pump of 1797, were designed to allow for the exploitation of deeper tin deposits by pumping off water, the miners' great enemy. Consistent with the common Cornish practice of sending specialist mining engineers abroad, Trevithic worked both in Peru and Costa Rica. As a result of the exodus, the football team of Mexico City in 1903 consisted entirely of Cornishmen.

Because so little pewter survives from before 1600, it is difficult to assess how much Cornish tin was actually worked in earlier times. However, the chance survival of three leaves from a pewterers' working record book dating from May 1551 gives some remarkable statistics. Between 25 May and 5 June 1551, 1,400 lbs. of pewter were cast into over six hundred items of flatware, and between 5 and 15 June over four hundred different wares were cast. The variety of wares was considerable, ranging from 'great French platters' to '8 dozen of jelly dishes'. There are also references to the recycling of old wares, described as 'old metal' and the refashioning of vessels. For example, a small French platter was taken 'to make the bottom of a small still' and a 'great French platter' was converted into 'a deep basin', weighing 3 lbs.

Constant recycling is the main reason why so little early pewter survives. There is some evidence to suggest that in the past pewter was sent considerable distances by cart or pack-horse, as well as by ship and barge. Damaged wares for use as scrap would be regularly collected in this way for recycling and replacement (fig. 1).

One phenomenon that contributed towards the decline of pewter was the development of Britannia metal, an alloy that is similar in appearance, but with no (or very little) lead and a considerably higher proportion of antimony. Britannia metal consists of 90% tin, 8% to 10% antimony, with small quantities of copper and bismuth. By tradition, the recipe was acquired by James Vickers, a metalworker of Sheffield, in 1769 for 5 shillings from 'a person taken very ill'. If the alloy was known before this date, Vickers was certainly the first to introduce it to Sheffield and to see its potential for cheap mass-produced wares. Because the alloy is hard,

I. A pewterer filling a mould for a flagon with molten pewter, from the *Housebook of the Mendel Brotherhood*, 15th century. The separate sections of a vessel would be joined together and then turned. *Mendelschen Stiftung, Nuremberg.*

objects made from it can be thinner, using less metal. This made the various wares much cheaper. Unlike pewter objects, which are formed by casting, Britannia metal wares were produced by stamping from sheets of metal and then turning. Decorative features such as cast mouldings, feet and handles were soldered to the body later. The earliest objects made from the alloy were spoons, but a variety of household vessels, such as mustard pots, salts, tobacco boxes and tea sets, soon followed (nos. 153–55). The alloy appeared at a time when Sheffield and Birmingham were developing the use of machine tools, such as stamping presses and lathes. The development of the electroplating process, by which Britannia metal wares could be given a surface coating of silver, ensured the continuing popularity of the alloy after the mid-nineteenth century, much to the detriment of the pewter industry.

II. The basic technique of casting pewter and then turning it to erase surface imperfections has changed little since the 15th century.

METHODS OF MANUFACTURE

All the various combinations of metals that can be called pewter have a low melting point, so that casting has always been the preferred method of forming wares (plates I and II). Stone moulds for casting oval dishes, together with pewter fragments and coal, have been found at Camerton, a third to fourth-century AD Roman site near Bath. Early pewter wares were almost certainly produced in stone or clay moulds. The well known treatise on metalworking by the German monk

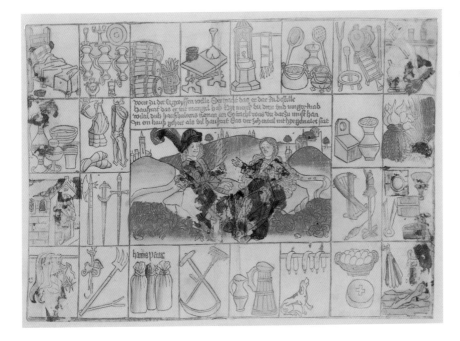

III. In the second image from the left in the top row of this visual guide to *The Household Utensils Necessary in Married Life* (Hans Paur, Nuremberg, about 1480), three pewter flagons can be seen hanging upside down from their bases. The narrowest parts of the bases have been inserted into recesses cut into the edge of a high shelf; the lids can be seen hanging open. On the floor is a pewter flask. *Staatliche Graphische Sammlung, Munich.*

Theophilus, *De Diversis Artibus*, written in the twelfth century, gives a detailed description of how to make a cruet from pewter using the lost-wax process and finishing on a lathe. By the early fifteenth century, bronze moulds for making salts, beakers and smaller items such as hinges appear in the inventories of pewterers' workshops. The making of a mould was an expensive and time-consuming process, but once complete, near-perfect vessels requiring little finishing could be produced in substantial quantities (plate II; see no. 143). Surviving inventories show that these bronze moulds were the most valuable items in the workshop. It is clear that once an investment had been made in such moulds, there was no incentive to change a design. A candlestick base, for instance, could also serve as the base for a salt, as the pewterer made the most of his existing moulds. This is why pewter shapes became so traditional, continuing in production over many years.

An illustrated guide to heraldic devices – Randle Holmes' *Academie of Armorie*, published in 1688 – has proved helpful in identifying vessels and tools used in a variety of trades, including that of the pewterer, but this is a rare insight into craft practices. The eighteenth century, particularly after 1750, presents less of a problem in this respect, owing to the expansion of knowledge and the production of well illustrated encyclopaedias, such as that by Diderot, published between 1751 and 1765 (fig. 2), or Salmon's *Art du Potier* (fig. 1). These give very precise accounts of the various trades and are well illustrated with engravings that show every aspect of the pewterer's trade, from casting in moulds to polishing and finishing. Moulds were usually made in two halves which fitted together. Bronze and gunmetal moulds were the most common, although some eighteenth-century cast iron spoon moulds have survived (no. 143). A set of early eighteenth-century pewterers' tools has also survived and is now in the collection of the Worshipful Company of Pewterers of London. These include heavy planishing hammers and a series of scrapers and formers, for use with a lathe. Hammers were used to raise hollow shapes from flat sheet and to correct the shapes of flatwares such as plates and dishes. They compacted the metal and hardened it, and the craftsmen made a special practice of hammering the 'booge' on a plate (the curved section between the rim and the base).

Hollow vessels such as tankards and measures were cast in several parts, which were then soldered together. The upper section and the base would be

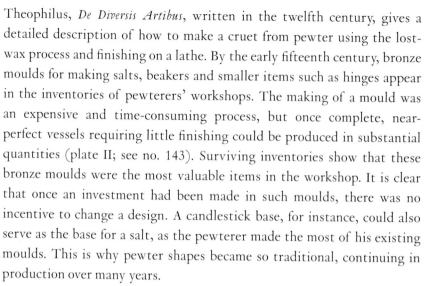

2. A pewter workshop showing a craftsman pouring molten metal into a clamped plate mould (far left) and another turning a cylindrical form on a manually operated wheel (far right). In the foreground, a craftsman adds the finishing touches to a handle. The bottom half of the image shows the component parts of a mould for casting a measure. Diderot's *Encyclopaedia*, 1751–65. *Victoria and Albert Museum.*

soldered first, then the handle cast on to the body. Lathe turning for finishing and shaping pewter vessels is described by Theophilus and was used both for flatware and hollow ware. The soldered joints are usually clearly visible on the inside of such vessels as measures and tankards, but invisible on the outside. Because pewter has a low melting point, soldering has to be carefully judged. A cool, damp cloth was held against the inside walls of porringers and measures when the handles were attached to prevent the body from melting; the matted impression of the cloth can sometimes be seen on the inside wall, opposite the junctions with the handle, where the body has begun to soften. After casting and turning, the vessel would be burnished using a burnisher of steel, bloodstone or agate, as used by silversmiths; it was then given a final polish with rag or leather, lubricated by oil or rottenstone.

Some wares such as boxes and certain forms of square container were made from sheets of metal. The appropriate shapes were cut out with large shears and then soldered together. An ingenious piece of recent research into the manufacture of organ pipes, by tradition made from sheets of tin/lead alloy, has unearthed an illustrated manual dating from the mid-eighteenth century which shows how the sheet alloy was made. Using very simple equipment, a large even sheet of pewter could be produced. The original text is French – *L'Art du facteur d'orgues* – and dates from 1766, published by the French Académie des Sciences. The process involved a large straight-sided frame which had one loose end panel that was slightly raised off the base level; while the frame was being filled with molten pewter or lead, this loose end was slid evenly and rapidly towards the centre of the frame, allowing a consistent thickness of pewter to escape below it before solidifying into a sheet. The illustrations show that the sheet pewter was supplied in large rolls.

STYLE AND DECORATION

Pewter was often engraved. With the exception of heraldic engraving, however, the quality of design and execution is rarely as good as that on silver. It has been suggested that pewterers were prevented by their guild regulations from employing trained engravers and that the decoration had to be done by the person who actually made the object. This may explain the simplicity of much engraved decoration.

Wriggle-work is a decorative technique commonly used on pewter, in which a burin with a narrow flat blade is 'walked' from point to point over the surface of an object to produce an incised zig-zag design. It is first used in England in about 1630–40, but the majority of wares decorated with wriggle-work date from 1660–1730. This form of decoration was used principally on dishes, plates, tankards and beakers. The designs are sometimes so bold and fluent that they seem likely to have been executed free-hand by craftsmen with no special training in engraving techniques. Some of the floral ornament may owe a debt to the designs of contemporary

raised embroidery work or to Staffordshire slipware. It is also conceivable that pewterers were stimulated to enliven their large plain wares by the bold and colourful designs on contemporary delftware.

Many of the designs of the 1660s are commemorative, associated with the Restoration, coronation and marriage of Charles II (1660–62). The chargers that are decorated with such patriotic sentiments appear to have been given as presents, sometimes for weddings, and they are often stamped or incised with the owners' names. Commemorative wares in other metals, such as silver and brass, also become increasingly common, especially after 1660. The motifs include royal heraldry, flowers, especially roses and tulips, birds such as peacocks and swans, lions and deer. Traditional designs, such as the pot with a lily, are also found on brassware and even on sword-hilts.

The number of known makers producing wriggle-work ornament is comparatively small. A recent survey notes Hickman, Jackson, Jackman, Gregory, Lovell and Timothy Fly. A series of fine flat-topped tankards, bearing charmingly naive portraits of William and Mary with their monogram underneath, is known to have been the work of a few London pewterers, John and Richard Donne, Peter Duffield, William Eddon and the maker RS (either Robert Seare or Rowland Steward). These portraits were very roughly based on contemporary medals or coins. At present, however, the identity of the engravers and wriggle-workers remains something of a mystery. A curious parallel exists with the miniature brass and steel products of the German metalworker Michel Mann, who worked in Nuremberg in the 1630s. Mann's small cannon, boxes and firearms are masterpieces of precise steel and brass work, but the engraving is usually very poor. It may be simply that the bold and naive animals and flowers of English wriggle-work were preferred to the meticulously engraved scenes and ornament that are so often found on silver.

One function of engraving on pewter was to indicate ownership. A small number of wares dating from the late medieval period bear owners' names, merchants' marks and tongue-twisters. These are very lightly incised into the surface and extremely difficult to decipher. More common are the engraved crests or coats of arms of an institution or family. Any heraldry appearing on a dish or other vessel is likely to have been put on after the object had been bought. It would be taken by the owner to a trained engraver to have his personal arms or crest put on it. On the other hand, it is not unreasonable to surmise that any London pewterer with a large commission from an armigerous family would offer to have the owner's arms engraved as part of the service. Heraldic engraving was a specialized trade. These skilled artists are usually anonymous, as they rarely, if ever, signed their work. A very rare survival of a late eighteenth-century London engraver's work-book consists of various designs, 'pulls' from his own work and rubbings of useful sources. The craftsman, William Palmer, worked principally for the London gun trade, but the

work includes crests and coats of arms for spoons and a variety of plates and dishes, some of which may well have been of pewter.

As tankards and mugs were frequently borrowed from taverns, the establishment of ownership was important. Some have the name of the landlord and the tavern engraved on the body. Many, especially in the first half of the nineteenth century, have the name and address on the underside of the base. 'Engraved' is too sophisticated a term for most of these inscriptions, which are generally very roughly incised in a tortured, angular and often indecipherable script.

Wriggle-work was also used on continental pewter, often combined with other finely engraved ornament. A series of Dutch beakers dating from the seventeenth century is engraved with biblical scenes and inscriptions. In general, the standard of engraved work on continental pewter is higher than on English wares. For example, the scrollwork and flowers on some seventeenth-century German tankards are as good as those on silver. For the more precise engraving found on continental pieces and some late eighteenth-century English pewter, a pattern must have been laid on the surface and the required design traced through it. In England, as the grip of the Pewterers' Company slackened in the latter part of the eighteenth century, pewterers went to trained engravers to enhance their wares. Engraved scenes of smoking and drinking parties, set within oval cartouches, on such objects as tea-caddies, are very similar both in quality and design to those on contemporary silver.

An engraving technique associated more commonly with eighteenth-century silver than with pewter is known as 'bright-cutting'. This involves cutting the sides of the engraved groove at an angle so that light is amply reflected. It is occasionally found on cutlery and smaller wares such as snuff and tobacco boxes. Some pewter of the 1780s and 1790s is decorated with bright-cutting, especially tea-caddies.

Given the softness of the alloy, it is surprising that acid etching was not used more commonly. The cities of southern Germany, such as Augsburg and Nuremberg, had a well established tradition of etching iron and steel. This was usually combined with blueing and gilding to heighten the design, techniques that do not work on pewter. Examples of etched decoration on pewter do exist, but in such cases it is the moulds rather than the metal that was etched (nos. 23, 24).

As with other base metals, such as copper and brass, stamping was occasionally used to decorate pewter, especially in the sixteenth and seventeenth centuries. It was usually confined to the rims of dishes and the designs clearly owe a debt to contemporary brass work. By using several stamps or punches, some variation in design could be produced. As for brass and copper wares, lathes were sometimes used to cut narrow lines around the bodies of plates and hollow wares. These break up a plain surface on a dish or plate and produce a pleasing decorative effect.

Enamelling is occasionally found. It is usually in the form of a boss set

in the centre of a dish, or less often as a medallion on the handle or body of a ewer. An oval dish in the Museum's collection, decorated with raised oval lobes, has a raised circular boss of brass enamelled with the Stuart royal arms in blue and white (no. 42). It appears that this type of enamelling, which is found on a range of objects from stirrups to sword-hilts, was done in one workshop in London in the period around 1650–60. Pewterers who wished to decorate a dish with enamel simply bought the boss and set it in the centre. One of the last pewter dishes to have been made by François Briot, dating from the 1550s, has an enamelled boss in the centre (no. 26).

There is evidence to suggest that some of the later medieval pilgrim and retainer badges were originally coloured. A Tudor rose badge found on the Thames foreshore, dating from about 1500, examined by the author, had clear traces of red pigment on the surface. Painting seems especially to have been reserved for those pewter wares which could be used to furnish a room. The Dutch coffee urns with bulbous bodies and tripod feet, designed to stand on a sideboard, are typical of this trend; most of these date from the eighteenth century (nos. 145–47). The painted designs, usually done in bright colours, echo the 'chinoiserie' decoration to be found on contemporary metal trays and lacquered furniture. Neoclassical pewter wares were also sometimes painted. A pair of English chestnut urns, decorated with japanning (a European means of imitating oriental lacquer) and modelled after the typical Neoclassical vase form fashionable in the early nineteenth century, provide good examples (nos. 146, 147, 171). A particularly rare example of japanned pewter in the Museum's collection is a Dutch cruet set containing glass bottles (no. 171). Designed to form part of the decoration of a table or side-board, the pewter frame is painted with typical Neoclassical motifs in delicate white and blue.

Some early pewter wares show traces of plating. There are references to pewter being gilded in England in the mid-sixteenth century, although the practice was firmly discouraged by the London Pewterers' Company. Because pewter has a low melting point, mercury gilding cannot be used. The references to gilding are specific and the Pewterers' Company was clearly concerned that pewter should not be palmed off as silver-gilt or gold. It has been suggested that the gold might have been applied as gold leaf. Part of the body of a French sixteenth-century ewer in the Museum's collection throws some light on the problem. It is covered with the remains of gold leaf and, when new, would certainly have had a gilded surface good enough to deceive the unwary. It is perhaps significant that one of the pewterers who brought the wrath of the Pewterers' Company on his head for selling gilded pewter was French.

Under certain conditions pewter wares can develop a gold patination, known to collectors as 'nature's gilding'. The Museum has a seventeenth-century wine taster with just such an effect (no. 132). This is a natural

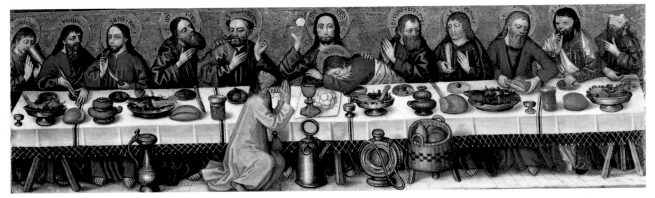

patination formed when pewter is buried, and not an artificially produced surface coating. The gilding is caused by corrosion products, principally iron and copper, and may be associated with burial in an especially iron-rich soil. The gold surface is usually about one thousandth of an inch thick and has a flat rather brassy appearance.

Pewter was often used in conjunction with other materials. Ceramics, glass and hardstone wares were often mounted in pewter, tankards being by far the most commonly found vessels. The mounts usually consist of a lid, thumb-piece and handle, as well as bands around the body. Germany nourished a particular taste for such wares, which remain popular even today. The earliest to be found with pewter mounts are the highly decorated salt-glaze stoneware vessels of the sixteenth century, in blue, grey and brown. By contrast, the mounts are often very plain. The linear descendants of these are the classic *Bierhumpen* in porcelain and glass, beloved by the German *Corpsstudenten* or duelling corps, and used for their formal toasts. The bodies of these bear the university arms, and the lids and mounts of cast pewter are elaborately decorated with corps badges, with thumb-pieces in the form of eagles.

Many of the early photographs of pewter collections show the various wares arranged in serried ranks on Welsh dressers and buffets. By the 1920s it had become fashionable for 'old oak' furniture to be garnished with pewter and many of the dealers who specialized in English period furniture also dealt in pewter. The Museum, at this time, was actually acquiring plates and dishes specially to 'dress' furniture. They were bought by the dozen, many of them being old wares redecorated at a later date and of little historical interest. After the Second World War, when the Museum galleries were redesigned, most of these were consigned to store. A number of these plates have found a new life, arranged in piles in the recently dressed Tudor kitchens at Hampton Court.

Some of the finest examples of the pewterer's art are the cast dishes, ewers and tankards decorated with low-relief cast work known in German as *Edelzinn*. Dating from the second half of the sixteenth century, they were almost certainly intended as contemporary parade plate and are pewter versions of the ornate French goldsmiths' work of the period. They first appear in France and are associated with the workshop of

IV. *The Last Supper*, by Hans Mu̇rer d. Ä (d.1486–87), includes three characteristic types of pouring vessel: a measure, wine can and flask. The spouted wine can in the centre is Swiss and the form remained unchanged over a long period. The Museum has examples dating from the 17th and 18th centuries (see no. 96). *Historisches Museum des Kantons Thurgau, Schloss Frauenfeld.*

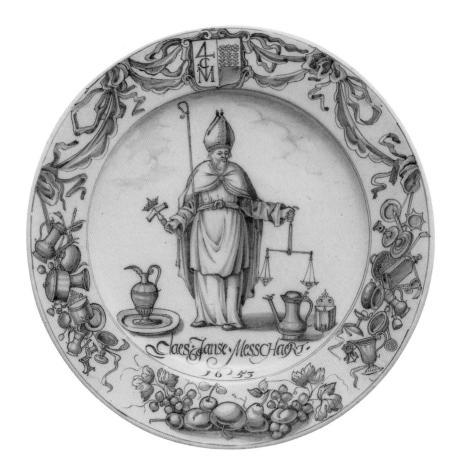

V. This delftware plate, made by Claes Jansz Messchaert in 1653, represents St Eligius, patron saint of metalworkers, holding a pewterer's hammer in his right hand. Many of the vessels shown on the plate, such as the spouted flagon beneath the scales and the measures on the border, are only found in pewter. *Private collection.*

François Briot (1550–1616). Briot was born a Protestant in Lorraine, but later emigrated to Montbéliard to avoid persecution during the Wars of Religion. In 1580 he joined a craft guild – the Corporation of St Eligius, patron saint of metalworkers (plate V). Briot was not a pewterer but a model carver and a pattern-maker – in German, *Bildschnitzer* or *Formschneider*. He was one of a small group of craftsmen who made the models and cut the dies for ornament. These could be assembled in a

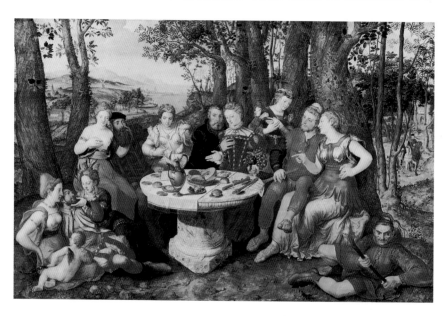

VI. *An Allegory of True Love*, by Pieter Pourbus (1532–1584), depicts the highly refined and symbolical world in which the designs of François Briot would have been appreciated. On the table can be seen pewter trenchers. *Reproduced by permission of the Trustees of the Wallace Collection, London.*

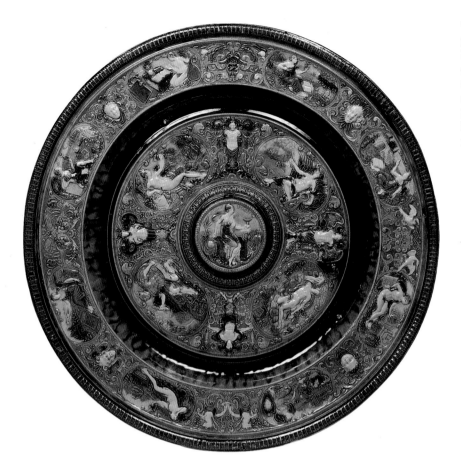

mould to produce a cast vessel, usually in a precious metal such as gold or silver. Patterns were made in various materials – wax, boxwood and copper being the most popular – because they were easy to work.

Briot's name appears on a number of works, but he is best known for the so-called Temperantia ewer and dish (nos. 25, 28). These are decorated with a series of classical figures within oval niches, set between masks. The ornament is in low relief on a hatched ground and shows great originality and skill. The figures are allegorical, representing the Arts, such as Music and Grammar, the central print being labelled 'Temperantia' – hence the name. The figures are very skilfully executed in a highly advanced Mannerist style (plate VI). Each element of the design is unique and even the masks separating the main elements are individually treated. The exact source for Briot's ornament has not been identified, although the reclining female figures have much in common with the engravings of Etienne Delaune (1518/19–1583) and Aegidius Sadeler (1570–1629). Strapwork appears to have been first created by the Mannerist painter and designer Rosso Fiorentino for the stucco frieze he designed for the gallery of François I at Fontainebleau between 1533 and 1535. Designs developed from Rosso's frieze were rapidly disseminated throughout northern Europe by graphic artists such as Cornelis and Jakob Floris, Cornelis Bos and René Boyvin.

Other craftsmen almost certainly hired or bought Briot's patterns,

and his designs therefore became very influential, especially in Germany. One of the Nuremberg masters of *Edelzinn*, Caspar Enderlein (1586–1633) copied the design of the Temperantia basin and put his own name to it (no. 27). Copies were not limited to pewter. It was also reproduced in earthenware, possibly by Bernard Palissy (d.1590) but more probably by one of his followers (plate VII), and in silver. The trophy for the Women's Singles Champion Challenge at Wimbledon was also modelled on the Temperantia basin. It was made by Elkington and Co. of Birmingham in 1864 and is still used today (fig. 3).

In the early seventeenth century, Nuremberg became a centre for the production of *Edelzinn*. A speciality of the Nuremberg pewterers was a small circular plate designed for display, usually incorporating medallions, one in the centre and others grouped around the rim. The subject matter might include topical characters, for instance Gustavus Adolphus, King of Sweden (1594–1632) or German rulers such as Kaiser Ferdinand (1608–1657), or figures of saints. These small plates were very popular, and were produced in the late nineteenth century in other materials, like brass and cast iron. They were also made in Switzerland and one showing the arms of the Swiss cantons is often found (no. 36). From the large number that survive and the immaculate condition of many examples, it is likely that some of these plates are after-casts.

A unique technique is associated with the Nuremberg pewterers Albrecht Preissensin (d.1598) and his colleague Nicholaus Horchaimer (1561–1583). The moulds from which the objects were cast, either copper or brass, were etched rather than engraved. As a result, the decoration appears on two distinct and flat levels – either on the surface or as the background – with no graded depth or modelling between. Not surprisingly, the decorated areas resemble the wood blocks used for printing plates, from which Horchaimer may have derived the technique. Rarer are the dishes and plates decorated with geometric strapwork in the 'moresque' style. They are based on the so-called Veneto-Saracenic brass wares which were fashionable in Italy and Germany in the first half of the sixteenth century, so it is not surprising that pewter versions should be found. Nuremberg makers such as Horchaimer were able to make large dishes that capture much of the intricate quality of the engraved and silver-inlaid originals. As with all these highly decorated cast pewter wares, they were designed to be displayed on buffets, where the quality of the workmanship could best be admired.

Another sixteenth-century master whose designs

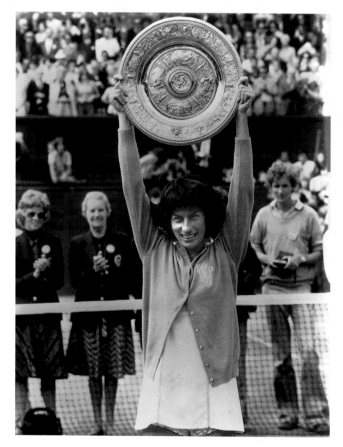

3. Virginia Wade, winner of the Women's Singles at Wimbledon in 1977, raises the trophy, copied from Briot's 'Temperantia' dish, by Elkington and Co. of Birmingham in 1864. *Wimbledon Lawn Tennis Museum.*

appear on pewter was Peter Flötner. He came to Nuremberg in 1522 and specialized in the production of plaquettes, which were used to decorate a variety of goldsmiths' work. His patterns were usually carved in boxwood and honestone, lead casts were then made from these and, as a result, his designs could be very widely distributed. The large guild tankard by Paulus Weise (no. 13) is decorated with plaques by Peter Flötner from his series representing the Virtues and Muses.

Pewter decorated with cast low-relief ornament was also made to a limited extent in England and the Museum has a small number of these interesting wares. The decorative technique is the same as that found in French and German pewter, and is clearly derived from it. The style seems to have been fashionable in the early years of the seventeenth century and lasted only a relatively short time. The ornament is highly characteristic and much cruder in execution than the fine *Edelzinn* of German and French pewterers. The ground of the design is usually hatched and the ornament, in very low relief, consists of strapwork, flowers, heraldic devices and inscriptions. Some pieces are commemorative and bear royal coats of arms and the Prince of Wales' feathers. Few English wares decorated in this manner survive and the impression is formed of a very limited production, perhaps in one London workshop (fig. 4).

A more limited use of cast ornament on pewter is to be seen on a well known group of late seventeenth-century English spoons, decorated with pewter busts of William and Mary taken from coins and medals (no. 138d). Royal portraits also appear on English porringers in the early part of the eighteenth century, often with a monogram.

The use of cast medallions to decorate pewter can be traced back to the sixteenth century. Usually based on contemporary coins and medals, they occupy the centre of a dish. One of the most attractive forms of cast work is to be found on some French eighteenth-century porringers (nos. 125, 126). These copy French silver forms fairly closely, and the cast rococo scrolls and Neoclassical ornament on the lids and 'ears' of these vessels are particularly pleasing, contrasting with the plain body.

Pewter vessels are very occasionally inlaid with other metals, such as copper or brass. These not only provided an attractive colour contrast, but were also useful areas for engraved inscriptions and heraldry. Brass-inlaid pewter is almost entirely limited to German drinking vessels of the eighteenth century. There are also instances of pewter spoons of the fifteenth and sixteenth centuries being fitted with brass knops, imitating the colour contrast of parcel-gilt silver, but they are extremely rare. Brass

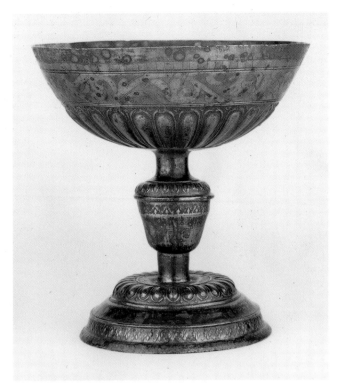

4. The gadrooning and the engraved and hatched foliage running around the bowl of this tazza can be compared with that of English cups of the late sixteenth century. Vase-shaped knops with horizontal mouldings appear on German cups from the same period. The cast decoration on the knop is very similar to that on the stem of the Granger candlestick (no. 187) which is dated 1616. Possibly English, about 1600. *Ashmolean Museum, Oxford.*

mouldings sometimes occur as reinforcing bands on the edges of candlestick bases or on lids, where they provided a hard surface in areas which were likely to be knocked or dented.

A fine German seventeenth-century tankard provides a good example of brass used for strengthening (no. 69). It was used for the drinking of toasts and so would have had a hard working life. The body is decorated with a series of facets engraved with figures of classical gods and heroes. The edge of the lid, top of the drum and edge of the base are mounted with stout convex brass mouldings. These were to preserve the edges and prevent some of the damage that revellers might accidentally cause, but they have not prevented the base from being crushed, presumably when the tankard was repeatedly thumped on the festive board.

Brass was also used in the form of sheet, as applied decoration. A German guild cup dated 1717 has brass decoration in this technique (no. 20). The surface has been cut away to leave a shallow depression. The brass sheet was cut and engraved in a design of scrolling foliage with winged cherubs and then attached to the surface using solder. The work has been rather roughly done and was perhaps an afterthought, to glamorize the cup. It bears the date 1717 and a device consisting of a coffee urn. Presumably the name indicates the donor of the cup, rather than the craftsman who carried out the inlaid work. The device suggests that he made brass or copper coffee urns and could not resist a little subtle advertising.

Brass and pewter are also occasionally inlaid together in fine furniture of the seventeenth and eighteenth centuries, in a technique known as *contre-partie*. J. A. Roubo writes in *Le Menuisier Ebéniste* of 1772:

> Cabinet-makers make little use of pewter these days, although it is very good for marquetry. Pewterers produce it in sheet form, planishing and polishing it before selling it to music engravers. These sheets were of great use to cabinet-makers. In the absence of planished sheets, the pewter could be flattened in a rolling-mill; but planished sheets received engraving better and were therefore better suited to marquetry work.

Roubo's mention of 'music engravers' refers to the use of pewter in the production of printing plates for sheet music. Copper plates had been used for hand engraving from the fifteenth century, but were too hard for the quicker process of punching and, towards the end of the seventeenth century, they were replaced by pewter, which was both softer and cheaper. In England, one of the earliest music publishers to work with pewter (or sometimes lead) plates was the elder John Walsh, who began publishing in 1696 and became the principal publisher of Handel's work. The printing quality of pewter plates depended on the alloy from which they were made, becoming brittle in proportion to the amount of antimony present; but a fine one could produce as many as 4,000 copies. The tendency towards brittleness, together with general wear (for instance, the

compacting of the metal in the areas adjacent to the punched marks), may explain why cracks can be seen in music printed direct from plates, particularly in the nineteenth century. At this period, it became more common to make a proof of the plate and to transfer it to lithographic stone for printing.

Music also took advantage of the unique technical properties of pewter in the production of wood flutes in the first half of the nineteenth century. A boxwood example in the collection of the Royal College of Music, London, made by Johannes Ziegler of Vienna in about 1840, is mounted with brass fittings, but the plugs (the terminal points which actually contact and close the holes) are made of pewter. The 'soft hardness' of pewter enabled it to become perfectly shaped to the holes, rendering unnecessary the leather pads which were otherwise used. The technique was patented by Potter in 1785.

Extensive use of pewter can also be seen in an unusual collection of around sixty bagpipes made in the Berry district of central France at the end of the eighteenth and beginning of the nineteenth centuries. The instrument, known as a *cornemuse*, consists of a blowpipe, chanter and two drones; in many cases each pipe is entirely clad in a tight bodice of inlaid pewter latticework (fig. 5). The instrument formed an integral part of the local folk culture. George Sand, who lived in the region and devoted so much of her writing to recording the quality of life around her, captured its aesthetic and aural impact, as well as its ingenuity, in her novel *Les Maîtres Sonneurs* (1853):

> The pipes had a double drone, one of which when completely assembled, measured five feet in length; and all the wood used in the instrument, which was black cherry, dazzled your eyes with its lead [*sic*] embellishments which gleamed as if they were made of fine silver and were encrusted over all the joins. The wind bag was made of fine leather, clad with a cover of blue and white striped calico. And all the work that had gone into it had been done in so craftsmanlike a fashion that all you had to do was to puff lightly to fill the whole instrument and create a sound like a clap of thunder.

MARKS AND INSCRIPTIONS

Makers' marks were first struck on English pewter towards the end of the fifteenth century, probably in imitation of hallmarks and date-letters on silver, which were fully introduced in 1478. An ordinance of Henry VII laid down that pewterers were to mark their wares with a touch, so that individual makers could be identified. Some early porringers dating from the period are stamped with initials or with initials and a simple device. The earliest maker's mark on a pewter object in the Museum's collection is on a spoon with an acorn knop, dating from about 1500, which is marked with three pellets within a circle (no. 10). The earliest mark incorporating a date is as late as 1594. The early marks are usually quite

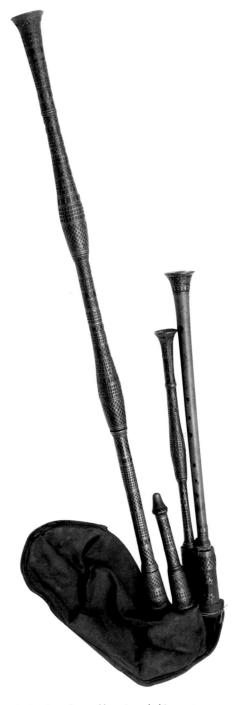

5. A unique form of bagpipe, clad in pewter, was developed in central France at the beginning of the 19th century. *Royal College of Music, London.*

small and set within a beaded circle. It was customary for a pewterer to strike his mark or 'touch' on a plate which was kept in the Hall of the Pewterers' Company (fig. 6). A written record was usually made in addition, so that individual makers could be identified. As a result of the introduction of full names and devices at some time in the first half of the seventeenth century, makers' marks began to increase in size. Some of the devices were puns on the makers' names, such as the fly used by Timothy Fly or the quill pen by Humphrey Penn.

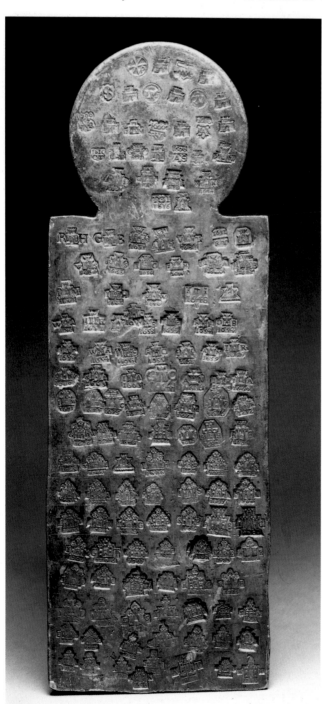

6. The touch plate of the pewterers in Edinburgh includes marks from around 1575 to 1760. *National Museums of Scotland.*

A feature of many English seventeenth-century pewter wares is the appearance of a series of small marks closely resembling hallmarks on silver. The Goldsmiths' Company of London was very aware of this plagiarism and in 1635 the city authorities were asked to settle a 'long-standing' grievance between the Goldsmiths and the Pewterers. It is clear from this that the practice of using pseudo-hallmarks goes back to the early seventeenth century, if not before. They resemble the hallmarks found on silver wares quite closely, both in layout and in form. There seems also to have been an attempt to imitate the date-letters found on silver. It should be remembered that when pewter is new, it can resemble silver both in colour and design. An English tankard in the V&A has good examples of these pseudo-hallmarks (no. 66).

Most pewter is marked and this was done for various reasons. One of the marks found on early wares consists of a pewterer's hammer, usually within a circle. This was used not only in England but also on the continent, being quickly adopted as an indication that the metal was of good quality. A crowned hammer above the word *fin* appears as a mark used in Mons dating from 1468. Another well known mark is a feather below a crown. This is found stamped on the rim of a series of English dishes dating from the last quarter of the fifteenth century. The feather probably represents the ostrich feather device used as a badge by the Prince of Wales and it closely resembles an English retainer's badge of the same period (no. 11g). It has been suggested that all the dishes bearing this mark belong to one service supplied to the household of Arthur, Prince of Wales, who died in 1502.

From the late Middle Ages, English pewter had a particular reputation for quality and English marks were widely imitated. The 'crowned rose' mark was

associated with English pewter early in the sixteenth century and was recognized as an indicator of quality. As such, it was quickly imitated on the continent, especially in the Low Countries. It was still being used as a sign of quality in the eighteenth century. Pewterers in German-speaking lands often stamped their wares with the word *Englischzinn* – English pewter – to emphasize the quality of the metal. Naturally pewterers wanted to underline the superiority of their wares over those of rivals. The term *Superfine Hard Metal* was stamped on English pewter, especially in the eighteenth century.

Inscriptions are found very rarely on early wares. The cruet from Ashby de la Zouch, Leicestershire, dating from the fourteenth century, has a medieval tongue-twister on one of the panels forming the body, just visible in the reproduction (no. 40): the word *HONORIFICABILIUT* (an abbreviation of HONORIFICABILITUDINATIBUS!), no doubt the work of some monk in an idle hour. The inscription has all the character of the frivolous doodles sometimes found in the margins of medieval manuscripts.

As a valuable commodity, it was customary for owners to incise their names or devices on their pewter. Many Roman wares are marked in this way. In the medieval period, there are sometimes merchants' marks. The fourteenth-century dish found near Coventry is a good example of this practice (no. 5). It bears on the base a merchant's mark consisting of a cross-staff with pennant set above a W and the name *WYN CHEST*. In addition, a cross, indicating possession by a religious institution, is inscribed on the rim. Such engraving has been done very lightly with a fine graver and can easily be missed, especially if a medieval dish is heavily patinated.

Heraldry was first used as a means of identification on pewter in the fifteenth century, but became more common in the second half of the sixteenth century. It consists usually either of a coat of arms or a crest, sometimes with initials. The quality of the engraving is often high. In a small number of cases it may be possible to identify an individual owner, especially if the arms also show those of a wife, and initials are supplied. For those not entitled to arms, stamped or engraved initials had to suffice. These are usually arranged so that a single letter is above the rest. The surname is the last letter on the base, and the letters usually indicate a husband and wife with the husband's Christian name at the top. Sometimes an owner simply had his surname engraved on the back, as on a late seventeenth-century dish engraved with the name *DERING*, a well known Kent family.

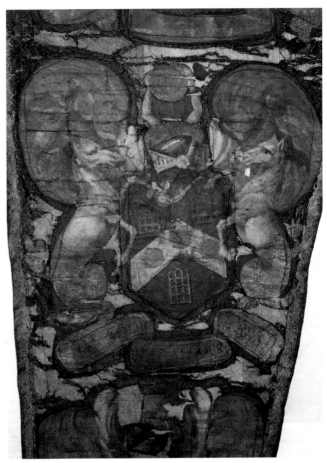

VIII. This is a detail of one of two silk streamers made for the Ludlow Society of Hammermen in 1734. The streamers are embroidered with the arms of sixteen crafts, including those of the London Pewterers' Company, shown here. The pewterers' arms incorporate two raised arms holding a large pewter dish. *Shropshire County Museum Service.*

Measures sometimes bear what are known as house marks, the mark used by a tavern keeper to indicate ownership. These often incorporate the owner's initials. A baluster measure found at Three Cranes Wharf in the City of London is stamped on the lid three times with a mark incorporating three birds for Three Cranes Wharf. Others have a girl's head and initials, presumably for a tavern called the Maiden's Head. House marks are almost invariably struck a number of times, presumably to emphasize the concept of ownership and to make identification easy. Tavern keepers often had their pots engraved with their name and address, sometimes with the stern warning 'STOP THIEF' or 'IF FOUND STOLE'.

Many hollow wares, particularly measures and tankards, are stamped with marks indicating their capacity, to prevent fraudulent short measure. The capacity of a measure would be checked against a standard measure by an inspector and the vessel then marked, indicating that it held the requisite amount of liquid. Later verification marks used not only civic coats of arms, but also the names of towns and cities, as well as initials for particular districts. Whereas the date of verification can be assessed reasonably easily, the place is often very difficult to establish.

Continental pewter usually bears town and guild marks. These were often based on the coat of arms of the place where the piece was made. German pewter, for example, is generally stamped with a number of separate marks. A plate in the Museum's collection demonstrates the usual system of marking to be found on German wares (no. 41).

THE SOCIAL STANDING OF PEWTER

> The third thing they tell of is the exchange of vessel, as of treen platters into pewter, and wooden spoons into pewter or tin. For so common were all sorts of treen stuff in old time that a man should hardly find four pieces of pewter (of which one was peradventure a salt) in a good farmer's house ...; whereas in my time, although peradventure four pounds of old rent be improved to forty, fifty or a hundred pounds, yet will the farmer, as another palm or date tree, think his gains very small toward the end of his term if he have not six or seven years of rent lying by him, therewith to purchase a new lease, beside a fair garnish of pewter on his cupboard. (William Harrison, 1576–77)

By the late fifteenth century, English pewter and the craftsmen who made it had established an international reputation. An Italian visitor noted that English pewterers made 'vessels as brilliant as if they were of fine silver and they are held in great estimation'. Italian visitors were particularly impressed and many of the descriptions of the trade come from Italian sources. Even such a distinguished metallurgist as Vannoccio Biringuccio writing in his *De La Pirotechnia* of 1540 about tin states: 'the best and most abundant that is found in the provinces of Europe is that

which is mined in England . . . the tin that comes from England, when worked as well as in cakes that show it to be pure, is much more beautiful and better in all works than is that made in Venice'.

By the second half of the sixteenth century, pewter had not only become common in the houses of the rich, but was also being used by the 'inferior farmers' (yeomen) and artificers. William Harrison wrote an interesting account, quoted above, of the social changes that had taken place in his lifetime and in the lifetimes of 'old men yet dwelling in the village where I remain' (Radwinter in Essex). He describes improvements in the quality of household furnishings and a general increase in affluence. A manifestation of this new wealth was the growing use of pewter.

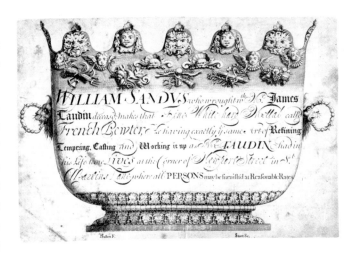

7. On his trade card, the pewterer William Sandys openly measured himself in relation to Taudin, clearly reflecting the extent to which Taudin was seen to set the standard for quality pewter in England at the end of the 17th century. *British Museum.*

In the 1630s there was concern about foreign imports of tin. A royal proclamation dated 19 February 1639 states that no white or cast tin is to be offered for sale until it has been stamped. No persons except the farmers of tin are to ship it on pain of confiscation of vessel and goods, and further penalties in the Star Chamber. The farmers of tin are to employ the pewterers of London to cast the block tin into bars. No pewterer is to cast tin until he has been nominated by the farmers. No merchants are to ship tin. This proclamation repeats a previous one of 22 January 1631 and obviously reflects concern among the London pewterers that their control of the raw material was being threatened.

One of the best known pewterers working in London in the middle of the seventeenth century was the Frenchman Jacques Taudin. There are references to him in the court books of the Pewterers' Company. He first came from France during the period of the Commonwealth as a Protestant refugee, although the Pewterers' Company asserted that it was because of 'rebellion against his king'. He set up in business in the early 1650s and, like so many Huguenot craftsmen, the quality of his wares was considerably better than that of English competitors (fig. 7). French pewter had a very high reputation in the mid-seventeenth century, being prized above all for its lightness, silver colour and hardness.

Taudin introduced what was basically a new type of pewter to London. Customers flooded to buy his wares, much to the chagrin of established London pewterers and the Pewterers' Company. A petition survives from Taudin dated 21 April 1656, addressed 'to His Highness the Lord Protector of ye Commonwealth of England'. In it, he describes how he was violently assaulted in his own house by one James Jacombe, a 'pewterer of London'; and how several men 'fell abattering and spoiling with hammers, or rather a kind of poleaxe, all the pewter they met with there ready wrought (such as themselves acknowledged to be beyond their own skill and much better and better made than they or any of them

could have made it)'. Much of his stock was also carried off. A legal battle then followed, the Pewterers' Company claiming that they had acted in conformity with an Act of Henry VIII 'forbidding strangers born out of the realm to exercize or use the craft of the pewterer'. The conflict went on for some years. The Company particularly resented the fact that Taudin employed 'strangers' – presumably French pewterers – and tried to get him to send the foreigners away. Taudin eventually acquired naturalization through Cromwell's influence and also became a member of the Pewterers' Company. The final word came from King Charles II in 1668, who told the Pewterers' 'that we expect you will look at the said James Taudin as our servant and that he shall not have any occasion given him from you, or any of you, to complain at any time against any hard usage he may receive from you'. Taudin's touch, incorporating the words *ETAIN SONNANT* (ringing pewter), a phrase referring to its quality, beside his initials, can be seen on a platter in the Museum's collection (no. 48).

Like so many other London trades of the second half of the seventeenth century, the pewterers owed a considerable debt to the Huguenot 'strangers', who materially raised the quality of their products. An account of these strangers and their contribution to the London trades, written in 1677, acknowledges 'the silk trade in Spitalfields, the tapestry makers in Hatton Garden, Clerkenwell and elsewhere and Mr. Todin the rare pewterer in St Martin's Lane'. The fact that he is named suggests that he had a considerable reputation among London tradesmen. Samuel Pepys was always aware of new and fashionable tradesmen in London. In March 1668 he was planning a celebration and so, in his own words, 'Thence I to Mrs Turner and did get her to go along with me to the French pewterers, and there did buy some new pewter against tomorrow'. The French pewterer was almost certainly Taudin. He was buried in the parish of St Martin-in-the-Fields on 25 July 1680 and his son, of the same name, carried on his business.

The pewter trade has never in the past been associated with great wealth. Although it has long been known that brewers such as Henry Thraile, the friend of Dr Johnson, or goldsmiths such as Paul de Lamerie and Paul Storr made fortunes from their businesses, it has only very recently been shown, thanks to the research of Dr Helen Clifford and Dr R. Homer in the Public Record Office, London, that some pewterers also became exceedingly wealthy, with vast holdings of shares and property. One of the best documented is the seventeenth-century pewterer John Shorey, 'Company Commander in the White Regiment of Train'd Bands in the City of London'. The Shorey papers at the Public Record Office tell of the rise and growth of a very successful family business. Born at some time in the 1650s, he married in 1681 his first wife Johanna, who bore him ten children, only four of whom survived childhood. In 1693 he acquired the lease of a new building at the Golden Cock on Catteaton Street, at the

corner of Basinghall Street, near Guildhall. By 1695, he was worth over £600. An account of the Shorey home dated 1708 includes all the trappings associated with middle-class wealth – a walnut writing desk, landscape paintings, clocks, barometers, Chinese pots and domestic silver plate worth £127. There were purchases of property in Gloucestershire in 1703, and tenements in Ware, Herts., and Chelmsford, Essex, in 1708 and 1715. He also had investments in land in Essex and Tottenham. By 1716 he could afford a second large house in Tottenham High Cross. He had shares in the South Sea Company worth £3,000 and a majority shareholding in the Temple Mill Brassworks, at Bisham in Berkshire. He nearly ruined this business by speculating in the South Sea Bubble.

Shorey took his son John into partnership in 1708 and the business expanded. A list of 1716 shows that the firm made only flatware, although they also carried a wide range of other wares. This list mentions moulds for chargers, plates, basins, saucers and smaller objects, such as spoons, ladles and forks. The picture from the records is of growth and expansion. By 1720 John Shorey Junior was able, in association with two other partners, to purchase one thousand tons of tin, 'the property of the King and lying in the Tower of London'. The partnership was dissolved because of family quarrels at the end of that year. An idea of how successful the business had become can be gleaned from a document of about 1720, when Shorey's first assets were estimated at £15,976.13s.8d. – two to three million pounds by today's standards. Colonel Shorey died in July 1722, but the business continued under his son John's management until about 1727, when it passed into other hands.

The pewter trade is not one that has encouraged biographies. Fortunately one London pewterer did write an account, which gives some insights into the life of an apprentice in late Stuart London. Sir John Fryer would become not only Master of the Worshipful Company of Pewterers, but also Lord Mayor of London, like Hogarth's good apprentice. He was first apprenticed to a pewterer in Bishopsgate named Harford in 1686. The apprenticeship was to last for seven years and required the payment of £10, which was met by his uncle. Harford's business seems to have been small and rather unsuccessful, and Fryer complains that he found himself doing menial tasks which apprentices in other trades avoided. There was a considerable amount of fetching and carrying of pewter from other shops (fig. 8), which he complained gave him ruptures. He had also to clean the finished wares, service equipment in the shop and turn the wheel. This was usually worked by

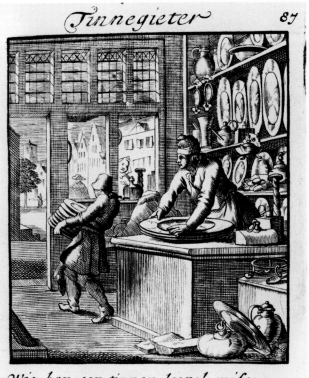

8. This depiction of a pewterer's shop is from a book of engravings, produced by Jan and Kasper Luiken of Amsterdam in 1718, illustrating verses in the Bible that mention various different crafts and materials. *Victoria and Albert Museum.*

a cranked handle, connected by driving bands to a lathe, on which the pewter vessels were turned and finished (fig. 2).

Harford did much of his business with inns and alehouses, to which Fryer had to deliver pewter wares in baskets. He clearly did not think much of his master, who seems to have spent most of his time on licensed premises drinking and ostensibly attracting orders. In Fryer's words: 'and by this Scottish way he supports himself making them pay an extravagant rate for goods'. The temptations of his particular trade proved too much for Mr Harford, who became known as 'Drunken Harry'. After the apprenticeship was finished, Fryer started up on his own, borrowing £300 from his uncle to buy an already existing pewter business. His subsequent career was successful and included such prestigious offices as Sheriff of London in 1715, Justice of the Peace in 1718 and Director of the East India Company in 1719. Examples of pewter by him have survived – all dishes and chargers. These seem to have been made between 1693 and 1709. He also became a Director of the South Sea Company in 1724. One forms the impression of an astute and rather cautious businessman. He avoided the political perils of the age and was rewarded with the title of baronet in 1714 for his support of the Hanoverian cause. He died of the gout on 11 September 1726.

9. From the Middle Ages onwards, traders strove to redefine and defend their rights in relation to changing commercial circumstances. This notice records privileges granted to pewterers in Brandenburg in 1738. *Stadtarchiv, Magdeburg.*

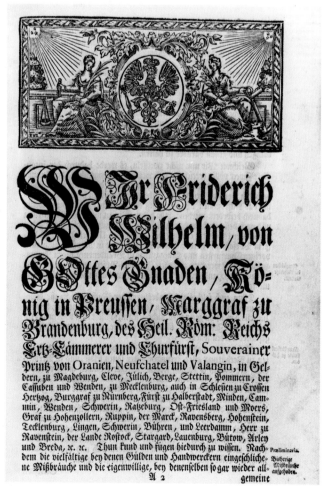

Scotland has always had its own very distinctive pewter wares. In the words of one early authority: 'Scottish pewter is characteristic of the people who made it, strong of line, and entirely devoid of any superfluous ornament'. The craft came under that association known as the Incorporation of Hammermen – literally those who formed their wares by using a hammer. These included such craftsmen as armourers and cutlers. The pewterers of Edinburgh are first recorded as being part of the Incorporation of Hammermen in 1493, and there are references to pewterers in towns like Perth and Dundee from the mid-sixteenth century. The Museum collection includes a number of Scottish measures.

Ireland has had a long tradition of pewter manufacture. There are records of a Dublin priory buying saucers, dishes, plates and chargers of pewter in 1344, and a pewterer named John White from Dublin was made free in London in 1468. Irish pewterers faced competition from England and elsewhere throughout their history, but apparently they flourished in the eighteenth century. Between 1751 and 1775, there were forty-five pewterers working in Ireland. The main centres of production

appear to have been Cork and Dublin, but pewter was also sold in Limerick, Waterford, Kilkenny and Galway. As with their English competitors, Irish pewterers began to see the writing on the wall by the middle of the eighteenth century, for they were complaining in 1753 that 'as a result of the great importation of Rouen, Burgundy and Marseilles earthenware, the trade of pewterers is at a standstill'. By the 1830s, the number of pewterers still working in Ireland was down to four.

Several wares are characteristic to Ireland. However, a curious Irish tradition has added to the difficulties of identifying Irish makers. It was customary for plates and dishes to be displayed with their faces to the wall and, as a result, the backs were highly polished, which, of course, removed all the makers' marks. As one would expect from a country where the art of sociable drinking flourished, tavern pots were made in pewter in large quantities in the nineteenth century. The well known and successful firm of Joseph Austen and Son, of Cork, produced many of these. Some are characterized by a distinctive concave profile, the more commonly found examples having a truncated cone body. The firm appears from directories and contemporary newspaper advertisements to have dealt in a wide range of metal goods in addition to pewter – a feature of their business which enabled them to continue trading when most of their fellow pewterers had fallen by the wayside. Apart from a number of fine chalices, characterized by distinctive domed feet and baluster knops, and mostly dating from the eighteenth century, various types of measure were also produced by Irish pewterers.

DECLINE AND REVIVAL

By the beginning of the eighteenth century, pewterers were facing serious economic problems. Privileges were regularly granted to safeguard their interests, but the tide could not be stemmed (fig. 9). A huge increase in the use of earthenware and porcelain, not only imported from the continent and China but also made in large quantities in England, in areas such as Staffordshire and the Potteries, had a disastrous effect on the pewter trade. The new wares were brightly coloured and came in elegant shapes that the pewterers could not easily imitate without investing in new moulds, which they could not afford to do. By this time, the demand for big garnishes of pewter with the family coat of arms had disappeared almost entirely, in favour of large services of porcelain. Delftware with its attractive coloured decoration was first produced in the seventeenth century, but became increasingly fashionable in the eighteenth century. In the 1760s, creamwares began to be made in large quantities and were extremely popular.

Another factor that affected the pewter trade indirectly was the huge increase in the consumption of beverages such as tea and coffee. Teapots, slop bowls, cups and saucers, sugar bowls and trays were an essential part of the fashionable tea-drinking ritual, and were far more attractive in

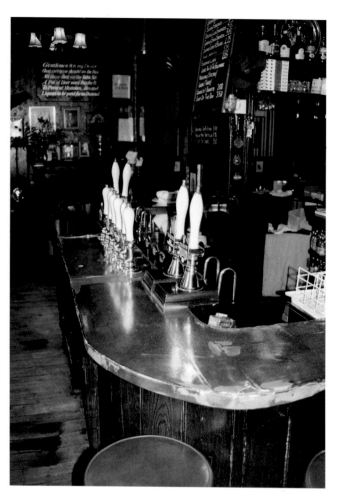

10. The pewter bar in the Grenadier pub, Knightsbridge, dating from about 1800, is the oldest of the three historic pewter bars that survive in London.

pottery and porcelain than in pewter. The price of tin – the essential raw material of the pewterer – also rose after 1780, adding to the woes of a rapidly declining craft. The great pottery magnate Josiah Wedgwood (1730– 1795) was warned against a trip to Cornwall in June 1775, as one of the reasons for the recession in the tin trade was thought by the locals to be the success of his 'Queens Ware'.

Pewterers also faced competition from the trade in tin-plate, which offered cheaply made wares such as pint pots and porringers that had previously been made in pewter. From the 1770s, elegant Neoclassical designs in Sheffield Plate became fashionable, thus forcing pewterers either to develop new designs or to go out of business. The problem was exacerbated in the nineteenth century with the invention and development of Britannia Metal. By the end of the eighteenth century, a few old firms were surviving by making small domestic wares, cheap tankards and tavern pots but the best days were long since gone.

The steady decline of pewter was not helped by an awareness in some quarters of its potential toxicity. People had noticed that stews prepared in pewter vessels did not always taste good, but it was not until 1747 that the Royal Academy of Sciences in Berlin recorded that, left in contact with the metal for long periods of time, vegetal acids such as wine, cider and vinegar could leech out trace elements of lead and arsenic. On the other hand, at least one writer, the eccentric Habbakuk O. Westman, claimed that pewter adds a 'peculiar' and 'etherial' flavour to ale, beer and cider. In *The Spoon*, of 1845, he wrote: 'The phenomenon is due to an electro-galvanic influence, excited by contact of the metallic alloy with the liquids'. Westman noted that this effect had been appreciated in relation to pewter vessels, but that spoons had been neglected. He added: 'When cultivated, [this effect] may lead to incredible results, for it points to sources of human enjoyments which the most enthusiastic could hardly hope for ere the millennium set in'. He went on to develop a theory according to which the taste of foods could be entirely altered by the composition of metals in the spoons with which they were eaten.

During the nineteenth century, the pewter trade was kept alive largely by the need for tankards in pubs and taverns, a number of which reflected this fact in their names – such as the Pewter Platter. In some cases this relationship led to the production of pewter bars. The Grenadier in Wilton Row, SW1, is one of three pubs in London to have preserved its historic bar, covered with sheets of an alloy high in tin and

containing very little copper (fig. 10). It shows considerable signs of wear and may well be contemporary with the building, which dates back to the end of the eighteenth century.

Another reason that the pewter trade had fallen into abeyance was its failure to adapt to new trends; it remained a conservative craft. Towards the end of the nineteenth century, however, it received a new lease of life. The fact that pewter was a traditional material was a cause of interest among revivalists, but perhaps more importantly its softness and malleability were found to be extremely compatible with the *Art Nouveau* movement's interest in sinuous and 'organic' forms. Especially on the continent, *Art Nouveau* gave rise to a wealth of 'art' pewter – but the days of the well laden dresser, groaning with a whole range of highly polished pewter wares had disappeared for ever.

SHIPWRECKS AND MUDLARKS

Pewter dating from before 1600 is very scarce, principally because the trade was so well organized and the demand so constant that damaged or unfashionable wares were simply melted down and recycled. Within the last twenty years, however, a number of important early wares have been recovered both in this country and abroad, from the site of wrecks, from rivers and canals and also from excavated sites. Many have been found by 'mudlarks', using metal detectors to scour river beds at low tide. Some of these early wares were obviously lost very soon after they were made and the anaerobic conditions of river mud have led to their survival in virtually pristine condition.

Important finds include the splendid Gothic octagonal flagon found in the Medway basin near Tonbridge Castle, dating from the second half of the fourteenth century, which has much in common with a rather battered flagon of similar date in the Museum collection (no. 3). It is the best preserved of all its fellows and is likely to have been made in England or the Low Countries. An interesting cruet and a small spice plate with a maker's mark were excavated from a well in the keep of Tong Castle, Shropshire. They were found associated with late fourteenth-century material and are likely to be of English origin. The cruet has a hammer-head thumb-piece and is virtually identical to one in the Museum, which came from a well in Ashby de la Zouch Castle (no. 4).

Many of the finds from the Thames foreshore and from Dutch canals must have been dropped when people were getting in or out of a boat. The Thames was a major thoroughfare for medieval and early modern Londoners, with hundreds of boats plying for trade everyday. Small portable wares such as cups or porringers could easily slip from the pocket when embarking from a swaying jetty. A small sixteenth-century wine taster decorated with a figure of Bacchus, found in recent years at the site of the Vintry, was probably lost on just such an occasion. One curious feature of the finds from the foreshore is the absence of early tankards.

This is surprising given the very large number of ale houses that were on the front.

Numerically the largest number of objects made from a pewter-related alloy to survive are pilgrim badges – the small cast souvenirs of pilgrimages collected from the many important shrines all over Europe (nos. 11a, 11c, 11d). Widespread from the twelfth until the sixteenth century, these badges show a wide variety of designs. It seems to have been the custom to throw them into a river as a thanksgiving for a safe return, hence their being found in large numbers near the sites of old bridges.

Many pewter wares have been found in wrecks in recent years, as a result of the growth of marine archaeology and the development of sophisticated diving techniques. These offer an ideal provenance for artefacts of all kinds, as in many instances the date of the wreck and its nationality are recorded. Significant pewter was found on the *Mary Rose*, which sank off Spithead in 1545. The wares, about twenty-eight in number, include a series of dishes, saucers and plates, porringers, flagons, tankards, spoons and medical instruments, such as a flask and a syringe (fig. 11). The dishes have survived in very good condition and bear owners' marks and coats of arms, as well as makers' marks. One of the most unusual finds from this celebrated wreck was a footed baluster flagon, very much corroded but with a distinctive waisted body and unusual thumb-piece.

Finds from wrecks of the Spanish Armada are of special interest as so much is known about the vessels from which they come. The merchant ship, the *Trinidad Valencera* for example, weighing 1,100 tons, sank off Northern Ireland. One of the most interesting pewter items on board was a broad-rimmed dish bearing the initials *ER* with a crowned Tudor rose, possibly the mark of Edward Roe, master of the Pewterers' Company from 1582 to 1588. It is also stamped with two initials, *IZ*, probably for Juan Zapotta. Zapotta's son Sebastian sailed on the *Trinidad Valencera* and

11. A selection of the pewter items recovered from the *Mary Rose*, which sank off Spithead in 1545. *Mary Rose Trust*.

presumably took his father's plate with him. What an English pewter dish was doing on a vessel of the Spanish invasion fleet has not been explained, although London-made pewter was widely exported throughout the sixteenth century.

A considerable amount of pewter has also been found in wrecks off the Florida Keys, such as that of the 'slaver' *Henrietta Marie*, which sank off Key West in about 1701. The pewter items include a large group of commemorative spoons, presumably trade goods. This is not an isolated case. Pewter vessels seem to have been a regular and important part of the cargo of ships involved in the slave trade. The discovery of a ship's log book from the *Daniel and Henry*, sailing in 1700 from Dartmouth to the Guinea Coast, where the slaves were taken aboard, then to Jamaica where they were sold, confirms that pewter was aboard the vessel in considerable quantity. The log contained the bill of one of the ship's suppliers, which included casks filled with pewter to the value of £245. Tankards of various capacities and basins formed the majority of the wares listed. It is significant that pewter, along with iron bars, from which weapons and tools could be made, should have formed such an important part of what in the early eighteenth century was a very lucrative trade. Mention should also be made of the pewter from Port Royal, Jamaica. The town was destroyed by an earthquake on 7 June 1692, but excavation has brought to light over 150 pieces of pewter, mostly of British origin, from various submerged buildings. A wide range of different vessels is represented with a strong emphasis on hollow wares, such as baluster measures and tankards.

The writer was once shown a large collection of vessels wrapped up in wet newspaper, which had been found two days before in one of the French First World War battlefields by the owner's son using a metal detector. The hoard, which was very large, included several broad-rimmed plates, all with French makers' marks, and a series of late seventeenth-century candlesticks in virtually mint condition. The condition of the items was all the same. Some of the dishes had obviously been stacked together, as corrosion holes went through several in exactly the same place. None of the wares showed any sign of use and the impression was of the contents of a stall or shop window taken and hastily buried, perhaps a long-forgotten act of larceny; or a Huguenot pewterer having to flee at the last moment. It was not possible to find out exactly where the pewter had been discovered, except that it was near a large town in northern France.

HISTORY OF THE V&A COLLECTION
The Museum has been buying pewter since its foundation. Early acquisitions include the Briot dish, bought for £19 in 1855, and the cast relief plates from Nuremberg (nos. 34, 35). It has also received some very generous gifts and bequests.

An exhibition of pewter at Clifford's Inn Hall, London, in 1904, was an important milestone in the history of collecting. It was organized by H. J. L. Massé and included wares from most of the early collectors. It was seen at the time as a major event and, in the words of Antonio de Navarro, 'the most important result has been to bring together collectors, connoisseurs of the art and metal, hitherto scattered and unknown. The combination of their respective specimens, the collection and interchange of their individual information, gleaned in many cases from personal and informal sources, cannot fail to effect a valuable addition to the knowledge of a subject hitherto singularly meagre and conjectural'. Navarro cites the story of a metal dealer he knew who had acquired a large service of pewter from a local family – over two hundred pieces – all marked with the family coat-of-arms. 'What became of it?' Navarro asked. 'I sold it at so much a pound; sent it to Bristol to be melted up for tinning fish-hooks'. It is thanks to pioneers like Massé and Navarro that so much early pewter has been preserved.

A considerable boost to the study and collection of pewter was the establishment in 1918 of the Society of Pewter Collectors. They first met on 9 December 1918 at the London Sketch Club in the Euston Road. The first officers were Antonio de Navarro (President), Howard Cotterell (Vice-President), Lewis Clapperton (Treasurer) and Walter Churcher (Secretary). Cotterell also acted as an additional secretary. Later specialists and collectors owe them a considerable debt.

The large and comprehensive collection of Swiss pewter assembled by Dr Alfonso Gandolfi Hornyold came to the V&A by accident. It was first offered to the British Museum in 1918. The Director, Sir Charles Hercules Read, wrote to his equivalent at the V&A, Sir Cecil Smith, saying: 'I do not think the collection is quite the sort of thing we ought to accept here' and generously nudged the donor towards South Kensington. Dr Gandolfi Hornyold was a lecturer in zoology at the University of Geneva. He came from that old-fashioned tradition of collectors who saw beyond their own interests. In a letter to the V&A, sent in 1918, he wrote: 'I aimed at making as complete a collection as possible of pewter in household use and hope it may be of interest to visitors. Perhaps it may suggest to some the idea of presenting pewter in their possession to the Museum and save interesting specimens from their ultimate fate, the melting pot.' His generous gift was immediately accepted, but it took some seven years before the Museum authorities actually laid hands on it. H. P. Mitchell, writing in 1925, pointed out that the collection of over five hundred pieces included a large proportion of domestic wares, 'apparently of nineteenth-century workmanship, which are of slight artistic interest'. In the event, the Museum accepted about 150 objects; others were sent to the Wellcome Historical Medical Museum.

The polite and formal correspondence dealing with this gift disguises the difficulties that the Museum authorities faced. A less than co-

operative British Consulate in Geneva and a brother described as 'very eccentric who does not reply to letters' form part of the background; other members of the family were unwilling to visit warehouses to examine the material. The collection itself consists mostly of eighteenth and nineteenth-century domestic wares. All the pieces finally accepted were in very good condition and the Museum's collection as a whole is undoubtedly the best collection of Swiss pewter outside Switzerland (nos. 36, 67, 80, 94, 96, 98, 112, 122).

By contrast, the Museum's relations with Colonel Croft Lyons, an early member of the Pewter Society, were very cordial. His collecting interests included ceramics, furniture, textiles, and both English and Continental base metalwork and silver. He had been a generous lender and donor to the Victoria and Albert Museum from as early as 1906. His pewter interests were quite wide and he was acquiring French and Flemish wares in the early part of the century. He was a meticulous collector and very helpfully for later students he had his own personal collector's labels, which he diligently stuck on every piece. These give not only the date on which he bought a particular item, but also where he bought it and for how much. By looking at the labels on a series of French measures, for example, it is possible to trace his buying trips in northern France soon after 1900. He left his whole collection to the Museum in 1925. Sir Eric Maclagan described him in a letter to *The Times*, when the bequest was announced, as a 'constant and generous friend'.

Alfred Yeates left his collection of seventeenth and eighteenth-century English pewter to the Museum in 1944. It proved impossible at first to display all of the objects, for a variety of reasons, including difficulties with the Ministry of Works – 'the Ministry of Works has failed to supply one pane of glass in the course of the last year to light the galleries' – and lack of staff, as everybody available was working on the famous *Britain Can Make It* exhibition, after the Second World War. As a result, it was not until the mid-1950s that the Yeates Bequest was first shown. It includes important early wares, such as the beaker with relief decoration and Prince of Wales' feathers dating from the early seventeenth century (no. 33), and a fine series of late seventeenth-century mugs, tankards and salts (e.g. nos. 66, 75, 116, 166).

The Museum also received in 1938 a selection of pewter objects from the A. Carvick Webster Collection, formed in the 1920s. A photograph taken at the time shows a splendid range of dishes, measures and tankards displayed on the requisite Welsh dresser. The Museum made its selection before the bulk of the collection was left to the Sydney Art Gallery, although the majority of the items of Scottish interest, of which there were many, had already been selected by Glasgow Museum and Art Gallery. Nevertheless, the Museum ended up with some good Scottish measures, a series of fine lidded tankards and some good salts.

1 Medieval Pewter

After the Roman period, pewter appears not to have been used in the West until the early ninth century. The earliest records come from Carolingian France. A document of 812 AD mentions a cruet or small flagon as being made of pewter and there is little doubt that in this early period the material was almost entirely confined to ecclesiastical usage. A few rare exceptions are known. In England it is clear that pewter was being used at an early date for small items, such as jewellery. A hoard found in Cheapside, London, in 1838, contained some cast circular brooches and rings which have been dated to the eleventh century. But in general the early wares are ecclesiastical in character. They include chalices, chrismatories and crucifixes, documentary references to which survive from the twelfth and thirteenth centuries.

At present the earliest datable piece of English domestic pewter is a small saucer or spice plate from around 1290. It was found in a cess-pit in Southampton, which had been filled with debris from a house fire. The saucer is quite deep, with a prominent beaded rim, and has been cast and hammered. The rim is struck with a capital P and the well is scored with numerous knife marks. This suggests that it was used for meat or bread, but could equally well have been used for dried fruits, such as currants, raisins or figs. The letter mark has also been noted on a saucer from Weoley Castle, near Birmingham, and on a fragmentary rim from the River Thames, both of similar date to the Southampton saucer. It has been plausibly argued that the letter is neither an owner's mark nor a maker's touch, but simply the initial for *peautre* (pewter). It is significant that silversmiths were beginning to mark their wares with the leopard's head at around the same time. Where there are owners' marks on pewter wares at this early date, they are almost invariably incised or engraved. The earliest reference to domestic pewter in England comes from a document dated 1307, which lists a range of wares exported by a London merchant Nicholas le Gaunt, including 'pitchers, dishes and salt-cellars of pewter'.

Much of the early evidence for the use of pewter is to be found in documents, as few medieval artefacts survive. After 1300 the evidence from wills and inventories indicates that pewter was becoming increasingly common in the kitchen. Durham Cathedral Priory, for example, was buying pewter pitchers in 1340. There are also some interesting French records of the same period which list large quantities of pewter vessels, many for cooking. They include various kinds of pots and measures, as well as 'écuelles' – presumably porringers. In fourteenth-century France, the domestic use of pewter – as distinct from its ecclesiastical use – became increasingly common not only in the

households of the nobility but also in those of the merchant class. A Normandy merchant, for instance, is recorded as having many pewter platters, salt-cellars, pots and drinking vessels. The variety of wares made from pewter at this date is also illuminating. London wills from the last quarter of the fourteenth century mention lavers, large chargers and candlesticks. By this time, documentary evidence is increasingly supported by the actual survival of pewter objects.

After 1300 plates are commonly mentioned in inventories, as are basins, flagons, salts, candlesticks and platters (the large flat trays on which food was served). It should be remembered that, in the fourteenth century, solid foods such as roast meats were eaten with the fingers, whereas liquid foods like soups and pottages were served in bowls and eaten with a spoon. The earliest surviving pewter spoons date from the end of the thirteenth century.

Other vessels that occur frequently in inventories of the fourteenth century are described as 'pottes'. A craft ordinance of 1348 also mentions them: 'and be it understonde that al maner vessels of peauter as dishes saucers platers chargers pottes square cruettes square chrismatories and other thinges that they made square . . . that they be made of fine peauter . . .' The reference to 'square pottes' almost certainly describes faceted vessels similar to the octagonal flagon in the Museum's collection (no. 3). A better preserved example was found in the River Medway, near Tonbridge Castle, Kent. Both date from the second half of the fourteenth century and are likely to have been made either in France or England. As French was the *lingua franca* of both countries at the time, the French inscription on the handle of the Museum's example – *P: FILLE: H: F DE: MAILEI* – is not an indication of origin. However, a reference to 'Normandy pottes' in 1482 and the fact that a vessel of similar form was excavated in Normandy in the late nineteenth century suggests that the form at least originated in France.

The Museum is fortunate to have a rare early salt (no. 1). Dating from about 1320, it is cast in relief with scenes of the Annunciation and the royal arms of England; the knop is in the form of a hound sejant. Salt as a preservative and as a condiment was a very important feature of medieval cuisine, and used much more than it is today; it is not inappropriate therefore that the vessel containing salt should be elaborately decorated and inscribed. For many years, the present example was thought to be a pyx, because of the religious nature of the inscriptions and scenes that decorate it. However, two very similar objects, in Paris and Berlin, found with the inscription 'when you are at table think first of the poor', indicate that it had a domestic function originally. The lids of similar salts, all inscribed and cast with relief decoration, are preserved in a number of collections and it is therefore clear that by 1400 salts were part of the pewterer's stock in trade.

1

1. Salt

English, about 1320
Height: 6.4 cm. Width: 7.9 cm
4474-1858

TOUCHES AND INSCRIPTIONS: Within a border on the upper section of the body, in Gothic lettering, *AVE MAI: IA GRACIA PLENA DOMINUS TECUM BENEDIT*. On a label between the figures on the upper surface, *AVE*. On four of the side panels and on the right side of the top is a device in wriggle-work, perhaps representing a three-branch candlestick and probably an owner's mark.
PROVENANCE: Purchased for £2.4s.

A number of boxes of hexagonal form, decorated with cast work and standing on feet, are known. Most common are those with hinged lids formed of panels that taper upward towards a central knop. A pyx formerly in the Figdor Collection, Vienna, represents this shape. Despite its religious iconography and its resemblance to a pyx, the V&A example was probably a secular object. Two pewter vessels, one in the Musée du Moyen Age, Thermes de Cluny, Paris, and one in the Kunstgewerbemuseum, Berlin, bear inscriptions – *CUM SIS IN MENSA PRIMO DE PAUPERE PENSA* (When you are at table think first of the poor) – suggesting that they were originally intended for domestic use. Their small size and hinged lids suggest that they were containers for salt.

The knobs used to raise the lids are usually modelled as seated hounds, a feature which is also found on large flagons. The modelling of the animal on the Figdor pyx is virtually identical to that on the Museum example. A close parallel both in shape and decorative treatment is to be found on the box in Paris. As in this case, the flat lid of the Paris example is decorated in relief with a scene of the Annunciation and bears inscriptions. It is also of hexagonal form and may once have had feet. These two pieces seem to be the only recorded survivals of their type. Features such

as the flat lid and hexagonal shape are, however, found on later examples – for instance, a large pyx in a Dutch private collection. The hexagonal lid from a very similar pewter vessel, also decorated with representations of the Annunciation and the Adoration of the Magi, has been excavated from medieval strata at Kalmar in Sweden.

This vessel can be dated on the basis of the two shields of arms which represent the arms of France 'ancient' and the arms of England 'ancient' (to the left, *Azure semé de lis or*, for France; to the right, *Gules 3 leopards passant guardant or*, for England). The arms were in use until 1340 when Edward III claimed the French throne and quartered the arms of France with those of England.

BIBLIOGRAPHY: Massé 1910, p. 161, Berling 1919, pl. 31, Boucaud and Fregnac 1978, pl. 34, Egan 1998, no. 537

2. Box

French, about 1320
Length: 30.8 cm. Width: 17.8 cm. Height: 8.9 cm
222-1894

TOUCHES AND INSCRIPTIONS: None.
PROVENANCE: Purchased from Monsieur G. Duseigneur, Paris.

This rare box, which is of cast and gilded lead/tin alloy mounted on a wood core, was designed as a jewellery casket. As with contemporary pilgrim badges, the cast work is of high quality, which, together with the gilding, probably accounts for the box's survival. The nature of the ornament, especially the eagles, dragons and griffins, which represent authority, suggest that the casket was made for an aristocratic patron. Similar animals and foliage can be found on such contemporary works as the Warwick gittern in the British Museum and in the Ormesby Psalter, in the Bodleian Library, Oxford.

2

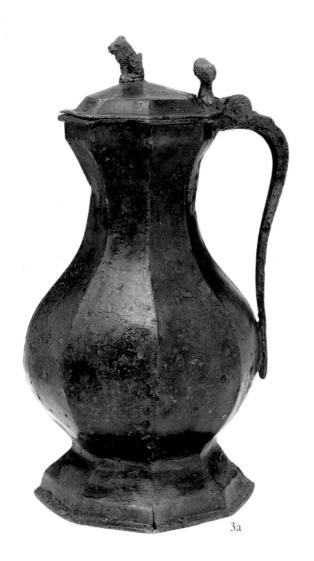

3a

3b

3. Flagon

French or English, second half 14th century
Height: 29 cm. Diameter of body: 15.5 cm
M.74-1914

TOUCHES AND INSCRIPTIONS: Inscribed on the handle, *P:*
FILLE: H: F DE: MAILEI, the name of an owner (?).
PROVENANCE: Fitzhenry Gift.

A series of flagons of this distinctive waisted octagonal
form has been recorded, including two from the castle of
Homburg, Aargau, which was destroyed in 1356, one in the
Rijksmuseum, Amsterdam, one from Bristol and one, the
best preserved example, found in the River Medway, near
Tonbridge Castle, Kent. It has been suggested that they are
examples of what are described in the 1348 ordinances as
'square flagons' and in 1482 as 'Normandy pottes' (see
p. 8). Although in poor condition and with some repairs to
the body, the Museum's flagon has what appears to be the
name of an owner on the strap handle (see illustration,
above right). The finial, although very much corroded, may
have been like that on the Museum's salt (no. 1) – a seated
talbot or hunting dog. Given the close relationship between
England and France during the fourteenth century, it could
have been made in either country.

BIBLIOGRAPHY: *Age of Chivalry* 1987, no. 211

4. Cruet

English, about 1400
Height: 11.8 cm. Width of base: 5.3 cm
Width of rim: 2.6 cm
M.26-1939

TOUCHES AND INSCRIPTIONS: On two of the panels
forming the body of the vessel are inscriptions
arranged vertically, *THOMAS HUNTE* and
HONORIFICABILIUT.
PROVENANCE: Countess of Loudoun Gift. This cruet
was found with a bronze ewer in the filling of a well at
Ashby de la Zouch Castle, Leicestershire. The well had
been filled in preparation for construction of the Great
Tower, known to have been built for Lord Hastings in
1476. The finds were discovered during conservation
work on the castle.

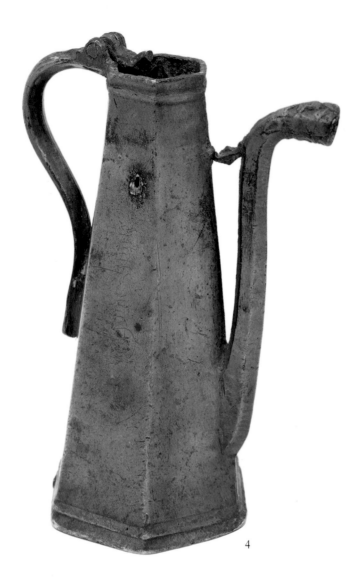

4

This is one of three similar vessels, two of which have been discovered in England. Of the others, one was formerly in the Figdor Collection in Vienna and thought to be French, and so perhaps was acquired in France. It retains an original lid and a quatrefoil plate between spout and body, differing slightly from the Museum's example in the form of handle and spout. The second vessel – the best preserved of the group –- was recovered in 1977 from the well within the keep buildings at Tong Castle, Shropshire, together with some late fourteenth-century material. It is preserved in virtually perfect condition and is very similar in form to the Figdor cruet; it is possibly from the same workshop. The Tong cruet bears a maker's touch and a distinctive 'hammer-head' thumb-piece. It has been pointed out that the Zouch family lived at both Ashby and Tong in medieval times. A number of other faceted cruets are recorded from English and Continental sites of fourteenth-century date. The inscriptions on the vessel are presumably an owner's name, together with an abbreviated version of the medieval tongue-twister 'Honorificabilitudinitatibus', the longest

word known to medieval Latin scholars. In Shakespeare's play *Love's Labour's Lost*, Act V, scene 1, Costard the clown exclaims: 'O they have lived long on the alms-basket of words. I marvel thy master hath not eaten thee for a word; for thou art not so long by the head as honorificabilitudinitatibus; thou art easier swallow'd than a flap-dragon'.

BIBLIOGRAPHY: Berling 1919, pl. 38, Simms 1938, p. 178, 'A Medieval Cruet', *Journal of the Pewter Society*, 1, 3, 1978, Boucaud and Fregnac 1978, pl. 35, *Age of Chivalry* 1987, no. 117

5. Dish

> English or Flemish, about 1400
> Diameter: 37.4 cm. Depth: 4.5 cm
> 200a-1906
>
> TOUCHES AND INSCRIPTIONS: On the upper surface, a roughly incised cross on the rim. On the base, in the centre, a roughly incised *W*; to the left, a cross-staff with pennant set above a *W*; above to the right, *WYN CHEST.*
> PROVENANCE: Purchased with another from Miss A. G. Nicholson, for £8. The owner stated that they had been found at Whitmore Park, near Coventry, Warwickshire, together with two medieval tiles, which were also acquired by the Museum.

This is one of the very few pieces of English medieval pewter to come from a known context. The inscribed cross on the rim suggests that the dish was at one time in ecclesiastical use. The initials, merchant's mark and

5a

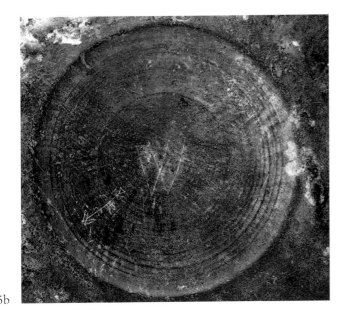

5b

In the bottom of the bowl is set a fourteenth-century French *jetton*, bearing the legend *AVE MARIA GRACIA PLENA*. The design is based on contemporary gold coins, such as the *masse d'or* of Philip IV le Bel (1285–1314). For similar *jettons*, see F. P. Barnard, *The Casting Counter and the Counting Board*, Oxford, 1916, pls. V25, 26.

The use of pewter for sepulchral chalices is recorded in France from the second half of the eleventh century, and may be of much earlier origin. In spite of its condition, this example is of special interest because its date of deposition is recorded. A number of other chalices from medieval times are known from France. The large trumpet-shaped foot with slightly everted sides seems to be characteristic of French work.

BIBLIOGRAPHY: Tardy 1964, p. 640, Boucaud and Fregnac 1978, pl. 21

inscription for Winchester are presumably the device and name of a former owner. Whitmore Park, from which the dish came, is situated a mile north of Coventry. The manor and lands were formerly owned by the Benedictine Priory of St Mary, Coventry, which acquired land to establish a manor and park in 1332.

Professor Francis Wormald expressed a written opinion in January 1961 that the style of the inscription suggested a date early in the fifteenth century. A virtually identical dish, with the same diameter, is preserved in the Historisch Museum, Rotterdam; it was found in the moat of Castle Valckensteyn on the island of Ijsselmonde, Holland. Dishes of similar form are recorded from other sites in the Netherlands, suggesting that the group may be of Flemish origin.

BIBLIOGRAPHY: Blair 1960, pl. 3b, Dubbe 1978, pl. 62, *Keur van tin* 1979, no. 53

6. Sepulchral Chalice

French, about 1450
Height: 15 cm. Diameter of base: 12 cm
Diameter of bowl: 11 cm
72-1904

TOUCHES AND INSCRIPTIONS: None.
PROVENANCE: Fitzhenry Gift. Formerly on loan to the Museum in 1896. A note in the register refers to a label formerly attached to the chalice which read 'Calice en étain trouvé en 1832 a Verdun (Meuse) dans le tombeau d'Etienne Bourgeois abbé de St. Vanne, mort le 24 Mars 1452' (Pewter chalice found in 1832 at Verdun in the tomb of Etienne Bourgeois Abbot of St Vanne, who died 24 March 1452).

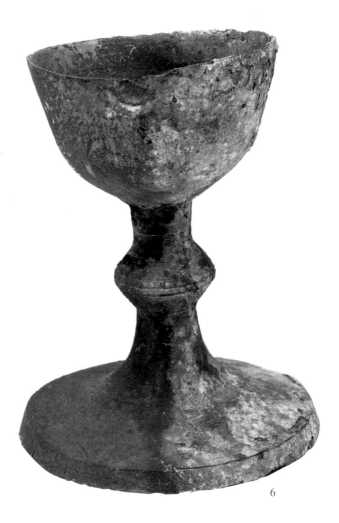

6

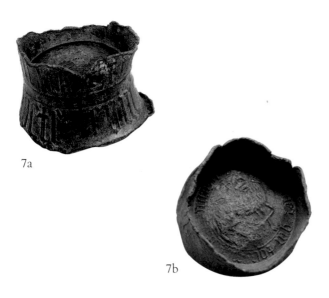

7a

7b

8. Bucket for Holy Water

Flemish (?), about 1500
Height: 12 cm. Diameter: 11.8 cm
M.31-1921

TOUCHES AND INSCRIPTIONS: None.
PROVENANCE: Purchased from Andrew Oliver, for £5.5s.
Said to have been excavated at Whitechapel, London.

Although of English provenance, the form of the vessel
closely resembles a group of brass buckets of similar size
and proportion that were probably made in the Low
Countries. The surface patination seems to indicate that
this piece, if buried, was protected by some form of box or
covering. Vessels of this form in pewter are of exceptional
rarity.

BIBLIOGRAPHY: Blair 1960, no. 54, pl. 2b

7. Fragment from the lower section of a Vessel

English/French, first half 15th century
Height: 3 cm. Diameter: 5.1 cm
M.125-1929

TOUCHES AND INSCRIPTIONS: Lower register, *BEN
DOMINE TECUM*. In the base, a cast plaque of the
agnus dei surrounded by a label, bearing *AGNUS DEI
QUI TOLLIT PECCATA MUNDI*.
PROVENANCE: Caldecott Gift.

The fragment is in the form of a collar of concave section,
set with a plaque cast with the *agnus dei* and an inscription,
the outer surface cast with inscriptions against a raised
cross-hatched ground.

The inscriptions imply ecclesiastical usage, and the
finely cast details can be compared with the work on
contemporary pilgrim badges. The setting of a plaque in
the base of a vessel is commonly found in pewter, especially
on chalices, but the profile of this fragment makes it
unlikely that the original vessel was of chalice form. The
comparatively narrow diameter also seems inappropriate
for an early measure or flagon. Fragments of what appears
to be a spreading foot adhere to the lower edge. The
original object may therefore have been an ecclesiastical
cruet or ewer. No contemporary vessel of similar form and
material seems to have survived, but there are parallels for
the shape in brass and silver, although somewhat later. The
shape would also be consistent with a small beaker.
Although no pewter beakers of this period are recorded,
there are fifteenth-century vessels of this form in silver.

BIBLIOGRAPHY: Dexel 1973, p. 188, no. 210

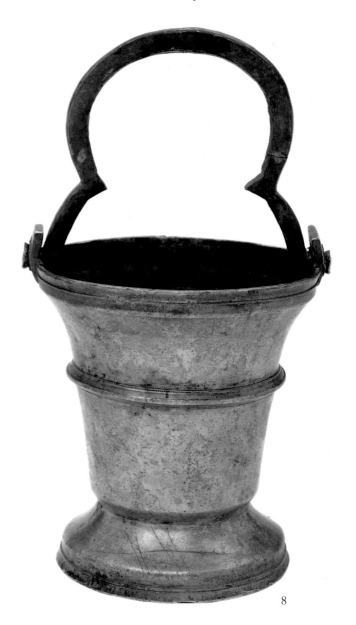

8

9. Spoon with Horned
Headdress Finial (illustrated on p.106)

English, about 1450
Length: 17.2 cm
M.12-1930

TOUCHES AND INSCRIPTIONS: None.
PROVENANCE: Port Bequest.

It is generally accepted that the horned headdress finial is related to the more commonly found maidenhead spoon. The style of the headdress suggests a date in the middle of the fifteenth century, but a survey of surviving examples seems to indicate, from the shape of the bowl, that the type continued in use until the late sixteenth century. Genuine spoons with this finial are of great rarity, but a large number of fakes were made in the late nineteenth century, generally by casting from genuine examples.

10. Spoon with Acorn Knop
(illustrated on p.106)

English, about 1500
Length: 14.6 cm
M.37-1929

TOUCHES AND INSCRIPTIONS: Three pellets within a circle.
PROVENANCE: From the Norman Gask Collection. Found in London Wall.

Acorn-knop spoons are recorded in English wills from the mid-fourteenth century. They remained in use in different forms until the early seventeenth century. It has been suggested that the talismanic powers associated with the acorn, such as the ability to confer immortality, or as a remedy against cholera and fluxes, were responsible for its popularity as a finial on spoons, where it came into direct contact with food.

BIBLIOGRAPHY: Homer 1975, p. 24

BADGES

One of the most popular objects to be made in pewter or in a base lead/tin alloy during the late medieval period was the pilgrim badge. These were first devised in the late twelfth century, in response to the large demand for souvenirs associated with the martyrdom of St Thomas Becket in 1170. Cast in soap-stone moulds, the individual designs show great ingenuity and variety. They were made as hat or cloak badges and usually have a fastening hook cast into the back. Most of the important shrines in Christendom had their own particular image. One of the badges from Canterbury shows the jewelled head reliquary which contained a part of Thomas's skull severed at his murder. In Canterbury Cathedral an altar was set up on the spot where the murder took place. Its chief relic was the sword of one of the four knights who killed him. The sword was accompanied by a scabbard and shield. Westminster Abbey also had a series of badges, including one showing Edward the Confessor.

Badges associated with different political factions were also made from pewter. Most of these date from the fifteenth century and include retainers' badges associated with the contending houses of York and Lancaster in the Wars of the Roses.

11a. Pilgrim Badge

English (Canterbury), about 1380
Height: 4.9 cm
Private collection

TOUCHES AND INSCRIPTIONS: None.

The badge represents the jewelled and mitred head reliquary, at Canterbury, that contained a fragment of the skull of St Thomas Becket.

11b. Retainer's Badge

English, about 1400
Width: 3 cm
Private collection

TOUCHES AND INSCRIPTIONS: None.

11c. Pilgrim Badge

English (Canterbury), about 1400
Height: 8 cm
Private collection

TOUCHES AND INSCRIPTIONS: None.

The badge represents the scabbard and shield that were carried by one of the knights who killed Thomas Becket in

1170, either Richard le Bret or Reginald FitzUrse. The shield is charged with four animal heads with gaping jaws. Contemporary chroniclers stated that the blow which killed Thomas was delivered by Richard le Bret, and that such force was used that his sword broke in two. Le Bret had boars' heads as part of his armorial. Later sources accused Reginald FitzUrse of the murder and the heads on the shield have been interpreted as bears, as borne by the FitzUrse family.

11d. Pilgrim Badge

English (Westminster), about 1400
Diameter: 2 cm
Private collection

TOUCHES AND INSCRIPTIONS: None.

The crowned head probably represents Edward the Confessor.

11e. Retainer's Badge

English, 15th century
Width: 3 cm
Private collection

TOUCHES AND INSCRIPTIONS: None.

The badge represents the red rose of the House of Lancaster.

11f. Brooch

English, first half 14th century
Diameter: 2.5 cm
M.65-1980

TOUCHES AND INSCRIPTIONS: None.
PROVENANCE: Purchased.

Excavated from the River Thames at Vintry in 1979. Ring brooches of this form are common in England from around 1300.

BIBLIOGRAPHY: Callender 1924, vol. LVIII, pp. 60–84, fig. 6, no. 3, London 1940, pl. LXXVII, nos. 5–7, Evans 1970, pls. 8, 14

11g. Retainer's Badge

English, 15th century
Length: 4.4 cm. Width: 2.4 cm
M.64-1980

TOUCHES AND INSCRIPTIONS: None.
PROVENANCE: Purchased from S. Moore.

This badge was excavated from the Thames foreshore at Billingsgate in 1979. According to Brian Spencer, at the Museum of London, this badge was used by the Lancastrian faction.

BIBLIOGRAPHY: Lightbown 1992, no. 32, p. 500

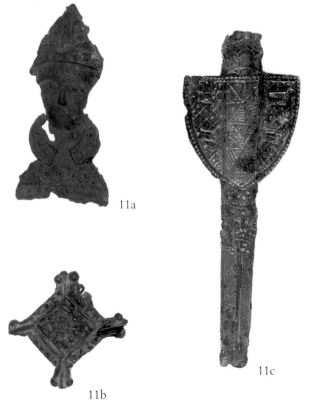

11a

11b

11c

11d

11f

11e

11g

2 Guild Pewter

The advantages to craftsmen engaged in the same trade of working together were fully appreciated in medieval times. The manufacture and distribution of pewter was controlled in Europe by the civic guilds. One of the earliest pewterers' guilds was that of Nuremberg, which was established in 1285. The city was especially celebrated for its metal wares and it is not surprising that some of the earliest guilds controlling the metal trade should have been established there. (The Nuremberg guilds became so powerful that they were abolished in 1348–9.) The pewterers' guild in Paris was also an early foundation, being established before 1300. At their zenith, before 1600, the pewterers' guilds controlled every aspect of the trade, from purchasing the raw materials to maintaining the quality of the metal and managing the apprenticeship. They sometimes had civic responsibilities beyond their craft, such as the upkeep of a local church, and they were often patronized by a saint whose life had in some way been associated with their trade (see plate V on p. 18).

The London pewterers received their first ordinances in 1348. Among other roles, they had a right to search for sub-standard wares nationwide and to fine defaulters, which they exercised until 1702. There are numerous records from the seventeenth century of the searchers being involved in conflict with provincial pewterers, who must have resented the high-handed behaviour of their London colleagues. The power of the pewterers' guilds declined throughout the eighteenth century in the face of competition from the pottery, glass and tin-plate trades. In recent times the Worshipful Company of Pewterers in London has taken a very active role in the craft, sponsoring catalogues and exhibitions of old and new pewter, and generally supporting the industry.

Some of the most interesting and monumental wares made in pewter are the drinking vessels of the craft guilds of Germany. Tankards were widely used for toasts and their decoration often reflects this custom. For example, it was customary to toast the saints and Apostles, and many German examples are engraved with their images or have religious medallions set in the centre of the base. Another popular German toast was the *Minnetrincken* – the toast to absent friends.

From the number and size of these vessels one forms the impression that a German guild dinner was a rather more convivial affair than its English counterpart. The vessels were of various forms, the large standing cup with cover being the most common. These often have a figure on the cover, dressed in the clothing of the craft of the particular guild, such as a miner or a shipwright, and holding a banner decorated with the title of the guild or its coat of arms. A pair of ceremonial banners representing the Ludlow Guild of Hammermen, which included

pewterers, can be seen in the Shropshire County Museum, in Ludlow (plate VIII on p. 25). The miniature versions of such banners are usually of pewter, but embroidered silk was also occasionally used (no. 20). The arms of the town or city in which the guild operated are also found in a prominent position. The names of the various warders or officers of the livery might be engraved on the body or, when this area had been filled, they could be engraved on separate shields that were then attached by rings to the body.

Guild cups are usually of monumental size, as they had to hold sufficient liquid for the entire livery to drink. They also served as centrepieces for the table. Very large tankards were used for drinking ceremonies. These are heavy enough when empty but, once filled, could not possibly be handed round. They were known as *Schliefkanne* – literally, 'a pot that has to be dragged', because they could not be lifted – and would be filled with beer for the livery when an apprentice had served his time and was made 'free' of the Company. In Germany, cups used for special toasts were known as *Wilkomm* cups – 'welcome' cups. They could be simple two-handled cups, passed from hand to hand, or standing cups with covers.

Toasts were often very formal. First, the covered cup would be handed to the master of the guild. The warden would then turn to his neighbour, who would remove the cover and stand aside, theoretically to protect the drinker from attack. The drinker then raised the cup, proposed the toast, drank and wiped the lip with a napkin. The cover was then replaced and passed to the next in line, and so on. The larger the vessel, the more difficult this was to do – especially if a cup and cover, which has no handles, was used and if hot spiced wine was the beverage. The whole toasting process demanded a certain amount of practice and skill if one was to perform the various actions without dropping the cup or cover or forgetting one's lines.

German cups show considerable ingenuity in their design. In addition to the formal cup and cover, or large tankard, guilds often used drinking vessels in shapes peculiar to their individual crafts. A shoemakers' guild might have a cup in the form of a shoe (no. 12), a hatters' guild a cup formed as a hat, a shipwrights' guild, a ship. The variety of designs is considerable. One characteristic of guild pewter is the abundance of names and dates engraved all over it, which makes such pieces of particular interest to the collector.

Colour Plates

IX. Plate, Swiss, about 1660 (cat. no. 36).

X. Tankard, Netherlandish,
late 16th century (cat. no. 64).

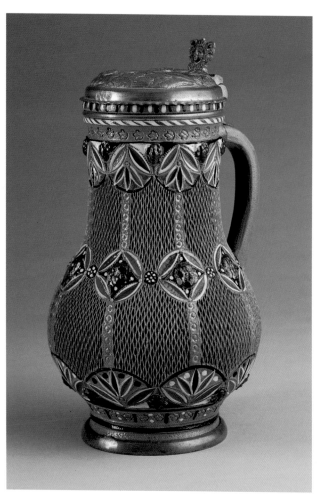

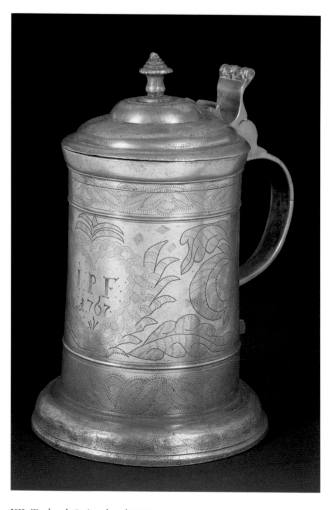

XI. Stoneware tankard, mounted in pewter,
German, about 1675 (cat. no. 71).

XII. Tankard, Swiss, dated 1767
(cat. no. 80).

XIII. Stoneware jug, mounted in pewter,
German, second half of the 16th century
(cat. no. 89).

XIV. From left to right: Two-handled cup,
English, late 17th century (cat. no. 118);
two-handled cup, English, 1697 (cat. no.
117); two-handled silver cup, English,
early 18th century.

XV. Porringer, French, late 18th Century
(cat. no. 125); porringer, French, early 18th
century (cat. no. 126).

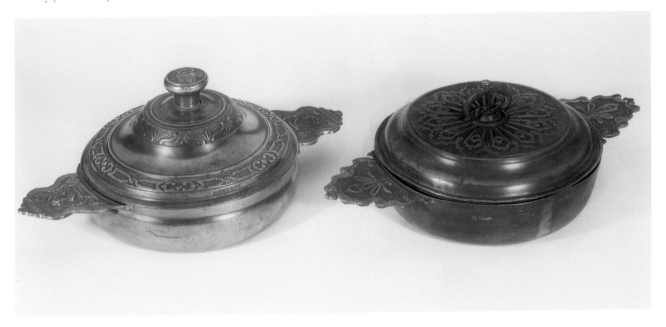

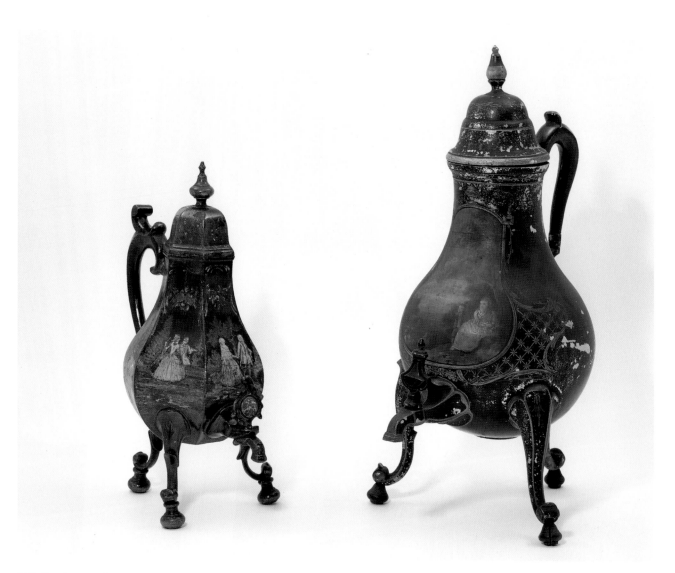

XVI. Two lacquered urns, Dutch, mid-18th century (cat. nos. 146 and 147).

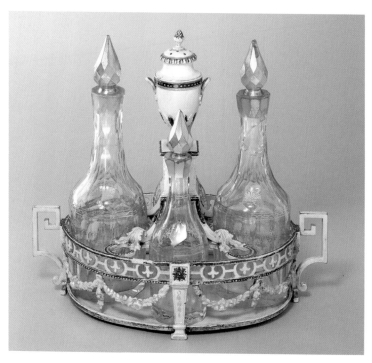

XVII. Cruet stand, Dutch, late 18th century (cat. no. 171).

XVIII. Pewterware for a doll's house, German, 1673 (cat. no. 178).

XIX. Wine pot, Chinese, early 19th century (cat. no. 179); teapot, Chinese, early 19th century (cat. no.180).

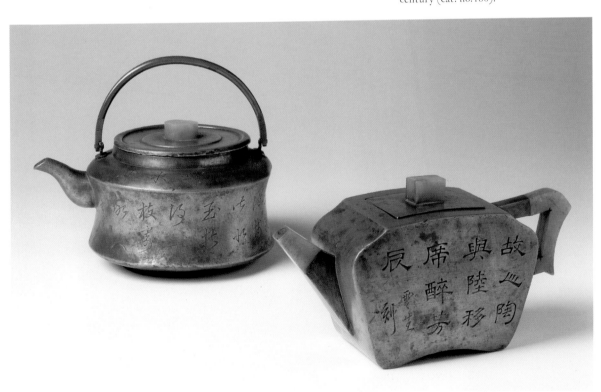

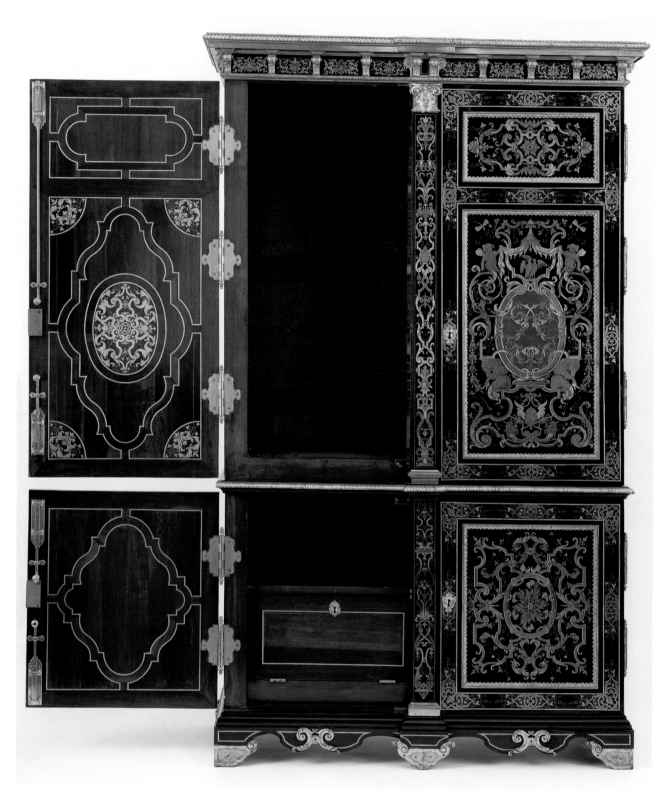

XX. Wardrobe, French, about 1700
(cat. no. 221).

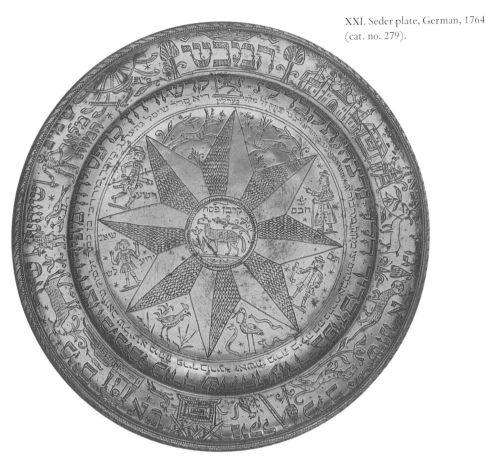

XXI. Seder plate, German, 1764
(cat. no. 279).

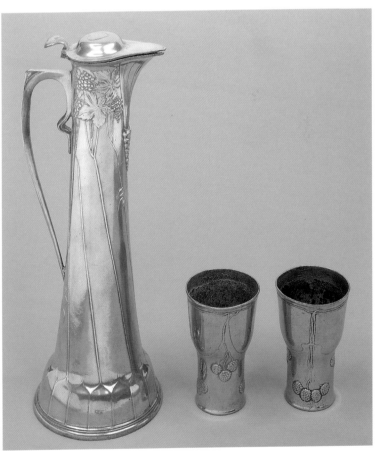

XXII. Claret jug and two goblets, German,
about 1900 (cat. no. 281).

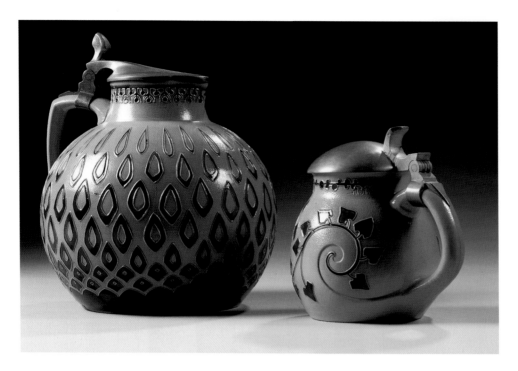

XXIII. Tankards, German, 1903 and 1911
(cat. no. 284).

XXIV. Vase, English, 1997 (cat. no. 293).

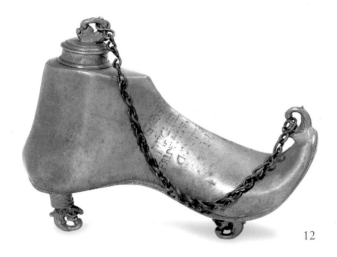

12

12. Cup of a Shoemakers' Guild

German (Nuremberg), about 1550,
inscribed with later dates
Height (including cap): 14 cm
Length: 20 cm. Width: 6.5 cm
1333-1872

TOUCHES AND INSCRIPTIONS: Inscribed on the
upper surface, *GORG KAREL MICHEL
WENDERFRIDERICUS RAY CHRYSTOF SARLE 1670*.
On the base, *JOHANN KAELF ALT.LEISELE 1818*.
PROVENANCE: Purchased from S. Helberg through
Krettinayer, Munich for £1.

Drinking vessels in the form of shoes are known from the
sixteenth century, mostly associated with guilds; the
connection with guilds of shoemakers is obvious. A very
similar vessel from the Figdor Collection, Vienna,
supported on three cast feet, bears the mark of the
Nuremberg pewterer Melchior Koch II, noted as working in
the 1550s. There is a possibility, therefore, that this may
also be a Nuremberg piece. The idea of shoes as drinking
vessels lasted in Holland until this century, a late
manifestation being the cast brass shoes sold as souvenirs.
The names on the upper section are those of guild officers.
The inscription on the base refers to an early nineteenth-
century owner.

BIBLIOGRAPHY: *Edelzinn aus der sammlung Dr. Karl Ruhmann*
1960, pl. 7, cat. no. 11, Hornsby 1983, p. 115, no. 26

13. Tankard of a Butchers' Guild

German (Zittau), about 1560
Height: 51.4 cm. Diameter: 22.9 cm
927-1853

TOUCHES AND INSCRIPTIONS: Maker's touch of Paulus
Weise (c.1535–1591) and town mark for Zittau on
upper face of handle.
PROVENANCE: Purchased for £12.

On the body are two bands of cast ornament, representing
the Sun, Moon and planets (Jupiter, Mercury, Saturn,
Venus and Mars), seven Muses (Terpsichóre, Erato,
Calliope, Euterpe, Clio, Urania and Polyhymnia), seven
Virtues and two Deadly Sins. The handle is cast with a
figure of Lucretia. That the tankard was made for a
butchers' guild is clear from the engraving on the shields:
the escutcheon on the body bears a lion rampant holding an
axe; the other two shields, partly erased, show an ox's head
and a trophy of meat cleavers.

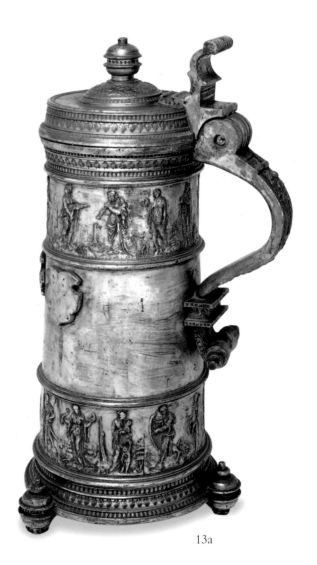

13a

13b

14. Welcome Cup of a Masons' Guild

North German, dated 1609
Height of cup: 39.8 cm
858-1905

TOUCHES AND INSCRIPTIONS: St Michael on shield; three others in bowl (obliterated). Engraved with masons' tools and inscribed *DIESES IST DAS AMPT DER MURLEUT IR WILKUMST, 1609* (This is the loving cup of the Masons' Guild, 1609). The shield is inscribed *Hoch lebe der Maurer* (Prosperity to the Masons).
PROVENANCE: Purchased from J. Connell & Sons.

This is the most common type of guild cup found in the seventeenth century.

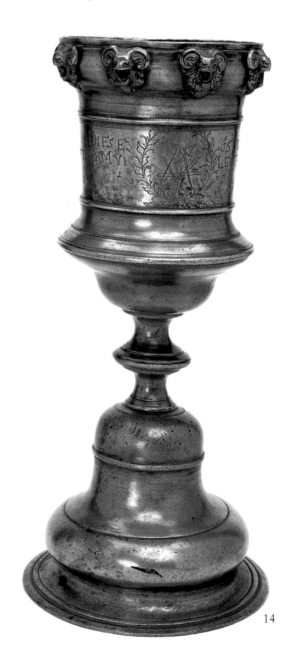

The ornament is based on cast plaquettes by the Nuremberg artist Peter Flötner (d.1546). It was cast from separate moulds, as the seams where the moulds met can still be seen. The surface has distinct traces of silver plating.

A similar tankard by Paul Weise, dated 1562, is in the Stadtmuseum, Zittau. Like this example, the body is decorated with plaques after Peter Flötner and is of similar monumental proportions. Another example is in the Nordböhmisches Gewerbemuseum, Reichenberg.

BIBLIOGRAPHY: Demiani 1904, fig. 4, Hintze 1921, I, no. 1296a, *Fifty Masterpieces of Metalwork* 1951, p. 67, Reinheckel 1983, pl. 13

14

15. Guild Cup and Cover

North German, dated 1652
Height: 37.5 cm. Diameter of cover: 12.1 cm
510-1901

TOUCHES AND INSCRIPTIONS: Maker's touch of Johann
Matthiessen, Hamburg (Hintze 1923, III, no. 795).
Merchant's mark with initial M and another, defaced.
Inscribed, *HINRICH DABELSTHENN HAT DIESEN
HENSEBECHER DER BRUDERSCHAFFT ZUN EHREN
VEREHRET ANNO 1652.*
PROVENANCE: Purchased from C. H. Shoppee, London,
for £16.15s.5d.

The inscription refers to the presentation of the cup to the
guild by Heinrich Dabelsthenn in 1652.

16. Cup and Cover of a Shoemakers' Guild

German, dated 1683
Height: 24.7 cm. Diameter: 11.1 cm
1134-1905

TOUCHES AND INSCRIPTIONS: Inscribed, *GOTT WOLLE
SEINEN SEGEN ZU DIESEN HAND WERCK LEGEN
AD 1683* (May God bestow his blessing on this craft
AD 1683). The cover is surmounted by a shield with a
figure bearing the name *ANDRES TIETRICH.*
PROVENANCE: Purchased from J. A. Cahn, London,
for £9.

The engraved shoe on the upper part of the body suggests
that the cup was created for a shoemakers' guild. The figure
on the cover wears an apron and the shield he holds is
engraved with shoemakers' tools, enclosed in a wreath and
surmounted by a crown.

17. Welcome Cup and Cover of a Wheelwrights' and Axlemakers' Guild

North German, dated 1659
Height with cover: 64.5 cm
381-1854

TOUCHES AND INSCRIPTIONS: Maker's touch of Master D.
S. H. in Lüneburg.
PROVENANCE: Purchased.

The body is inscribed with the names of various officers of
the guild. The figure on the cover would originally have
held a silk banner.

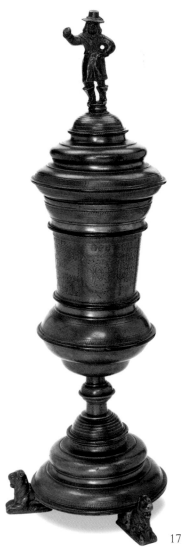

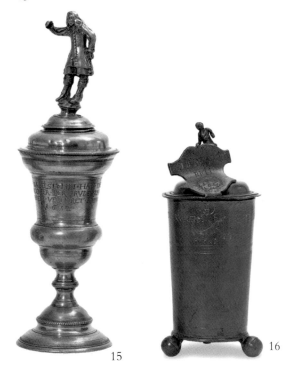

15 16 17

18

18. Guild Tankard of a Masons' and Carpenters' Guild

German (Nuremberg), dated 1695
Height: 66 cm. Diameter at base: 27.9 cm
606-1872

TOUCHES AND INSCRIPTIONS: None.
PROVENANCE: Purchased for £10.

The engraved escutcheon states that the cup once belonged to a United Guild of Masons and Carpenters.

19. Guild Flagon of a Shoemakers' Guild

South German, dated 1704
Height: 50.5 cm
9086-1863

TOUCHES AND INSCRIPTIONS: Maker's touch of Joseph Dor of Bayreuth.
PROVENANCE: Purchased for £4.

The names of various officers, with dates ranging from 1709 to 1776, are inscribed on the body. On the lid is the armorial shield of the guild, engraved with a lion rampant holding a shoe filled with flowers, a spurred riding boot and a lady's shoe.

BIBLIOGRAPHY: Hintze 1927, V, p. 85

19a

19b

20. Welcome Cup and Cover of the Pewterers' Guild of Lübeck

Brass-inlaid pewter, with blue silk banner embroidered with silver gilt
North German, dated 1717
Height with cover: 86 cm
M.136-1930

TOUCHES AND INSCRIPTIONS: A double-headed eagle and a merchant's mark with *33*. Masters of Lübeck: Hinrich von der Hude (Hintze 1923, III, no. 1455), on the cover; Harmen Hülsemann (Hintze 1923, III, no. 1453), on the top; Anton Meyer (Hintze 1923, III, no. 1472), on the base. Inscribed below the lip, *Dis ist der aller Ehrlichen Schardl gieser gesellen Ihren Wilkumst anno 1717 der 24 Junius* (This is the loving cup of the Most Worshipful Company of Pewterers, 24 June 1717); and on the foot, *Trinket und Seidt Lustig Fein doch das Wier alle Einuig Sein* (Drink and be Merry so that we are all friends together). The embroidered silk banner bears the name *PHILIP STICHLER* and the date 1733, describing him as coming from Malmö, Sweden (*AUS MALMO*).
PROVENANCE: Port Bequest.

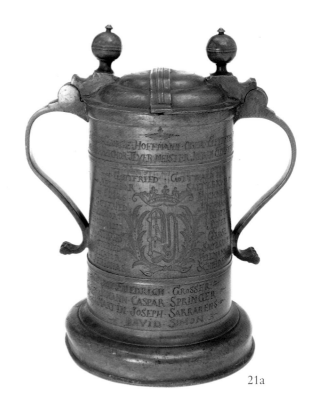

21a

21b

21. Loving Cup of a Bridlemakers' Guild

German (Silesia), dated 1743
Height: 26 cm. Diameter of foot: 16.2 cm
M.337-1940

TOUCHES AND INSCRIPTIONS: Maker's touch for Johann Christian Bothe, Schweidnitz (Hintze 1926, IV, no. 1081). Engraved with the arms of the guild, and the names and dates of various officers.
PROVENANCE: Oppenheimer Gift.

The ingenious pierced strainer fitted inside the lip of the cup indicates that it was designed for drinking spiced wine.

20

3 Pewter for Eating and Drinking

Although pewter was used in a domestic context from at least the thirteenth century, little remains from the Middle Ages, the bulk of the domestic pewter that survives dating from the sixteenth to the eighteenth century. During this 'golden age' – if one can call it that – pewter superseded wood, which was unhygienic and short-lived, before being superseded in turn by porcelain, which was cheaper, finer, more colourful and more practical. It epitomizes that quality of domestic contentment and stability which is celebrated in 'genre' paintings of the period, but which was eventually to be undermined by the Industrial Revolution. All of the most common domestic objects were made in pewter (see frontispiece).

One common type that appears in inventories and is also depicted frequently in still-life paintings of the sixteenth and seventeenth centuries is the trencher. The name derives from the French *tranche*, a slice. In the medieval period food was usually served on square slices of stale bread, cut from a 'four-day-old' loaf. In affluent households, these bread trenchers were placed on a circular or square wooden trencher, often painted, or on one of silver or pewter. Still-life paintings usually show flat circular trenchers, like discs, or square trenchers with a raised rim to retain the juices of meat.

Dishes and large chargers of pewter are mentioned in wills of the last half of the fourteenth century. The Museum has two early dishes dating from around 1400, which were found together with some tiles in Whitmore Park, Coventry (200 and 200a-1906). Like other circular dishes of this date, they have a large flat central boss and a broad rim with a single moulding under the rim to strengthen it.

A vivid contrast is provided by the highly decorated cast dishes made in France and Germany during the sixteenth century. These would have been placed on a buffet in a hall so that the fine detail of their ornament could be admired. Few if any show signs of use, such as knife cuts, and their function seems to have been exactly the same as the larger silver and gold vessels that they imitate. Elaborate ewers and basins would have been used for ceremonial purposes, such as the formal washing of

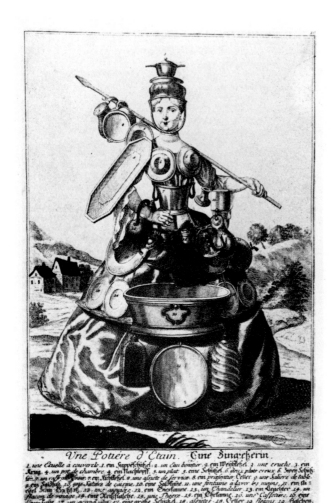

12. Images of craftsmen, composed of their products, were popular visual conceits in the 17th century. Male and female pedlars were both known then, but neither dressed like this! *Une Potière d'Etain*, German engraving, 18th century.

hands at meals. The dishes, however, seem to have been intended primarily for display.

One pewter vessel used for drinking in the fourteenth and fifteenth centuries was the flagon. The earliest to survive date from about 1500 and have a pronounced bulbous body (see plate III). They follow contemporary vessels of similar size in silver and the early forms are Gothic in appearance. The elegant flagons of the sixteenth century also follow contemporary silver forms. One shape that is known in both materials has a globular body and waisted neck, set on a high skirted base and with a prominent domed cover. They are sometimes found with spouts. The shape seems to have originated on the Continent in the fifteenth century and was introduced to England towards its end. These flagons are extremely rare, whether in pewter or silver, and at least two examples owe their survival to the fact that they formed part of the plate of a church.

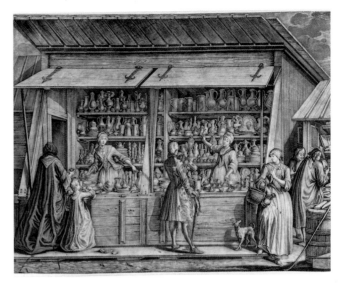

13. Pewter was usually sold in markets, shops and stalls, as seen in this 18th-century German engraving by Christoph Kilian. *Victoria and Albert Museum.*

It has been suggested that what we now describe as flagons were known as 'pottes' in the sixteenth and early seventeenth centuries, and that the word 'flagon' did not acquire its present meaning until later in the seventeenth century. Flagons do not appear to have been common in domestic households at this time; they were, however, used extensively in churches. As we now think of it, the vessel is a tall and straight-sided vessel with a skirted base, and a domed lid with prominent knop and scrolling handle. It became increasingly popular after the accession of James I to the throne; hence the name 'James I' for one of the earliest forms. The pewter shape probably owes its origin to silver prototypes. A somewhat later form, known as the 'Charles I' flagon, is a development, characterized by a spreading two-stage base, a flat bun-shaped lid and a pierced heart and bar thumb-piece (no. 264). It was in use from about 1625 to 1655 and was followed by the well known 'beefeater' flagon, with its distinctive wide flat base resembling a beefeater's hat (no. 265). This style was popular in the 1640s and 1650s. The very wide base, so much a feature, may have been put on to give extra stability, particularly if the pieces were going to be used at sea.

Flagons continued to be made throughout the eighteenth century and into the nineteenth (fig. 13). One well known eighteenth-century type is the 'spire' flagon – a tall slightly tapering vessel, usually decorated with horizontal mouldings, with a domed lid and large scrolling handle. Flagons with spouts are known from the 1580s, but become much more common after 1750. By the eighteenth century it is possible to recognize many local and national types. Scotland developed a distinctive form with a wide tapering body and flat lid (no. 266). This form, which appears to have been introduced in the late seventeenth century, was often used for

church flagons – although it is difficult to tell whether a piece is secular or ecclesiastical, unless there is an inscription. Irish flagons have wide skirted bases, large scrolling handles and prominent domed lids and a small pointed spout (no. 268). Among the many local types, that made by York pewterers in the first half of the eighteenth century has a characteristic 'acorn' profile and a prominent plain spout (no. 109).

Flagons were also used extensively on the continent. In France they usually have a bellied body and waisted upper section, but there are many local variants (no. 106). Another characteristic form has a cylindrical lower body and a waisted upper section, usually with a heart-shaped flat lid. These were made from the seventeenth century until well into the nineteenth. The Museum has a large collection of Swiss flagons, mostly dating from the second half of the eighteenth century. The bodies taper gradually upwards and are usually fitted with a stepped lid, with prominent thumb-piece (no. 112). Many have a characteristic triangular spout with shallow depressions at the front. Again, there are several local types (no. 114). A form popular in the eighteenth century has a long spout linked to the main body of the vessel by a cast bar (no. 94). Spouted flagons are also found in the Low Countries, especially in the seventeenth century, when they are frequently depicted in paintings. They have a 'bellied' form with prominent spout and cover, and seem to derive from Gothic prototypes (no. 95).

Another container for liquids frequently found in pewter is the flask, a form that appears to date from as early as the fifteenth century (plate IV on p. 17). Some very handsome German and Swiss examples have been preserved. Pewter flasks are nearly always based on contemporary pottery forms and are characterized by a wide flat body, sometimes set on a foot, tapering to the neck; they are usually closed with a sophisticated screw cap, which suggests that their contents were precious. Ring mounts are typically fitted to the body of the vessel, one at each side, to which a chain or strap is occasionally still attached. A small portable type is now much rarer, but examples are occasionally retrieved from rivers or from the wrecks of ships. They seem to have been used for spirits or medicines. A number were found in the cabin of the barber-surgeon on the wreck of the *Mary Rose*, 1545, and these have several interesting features. All have left-handed 'screw-threads' for the caps and the body of one flask is divided into two compartments, and has two necks. Small flasks must have been quite common at one time, but as with so many of the smaller pewter wares, most were melted down and recycled into other vessels.

That distinctive drinking vessel, the porringer – essentially a small bowl with one or sometimes two flat handles – was already appearing in inventories in the 1470s. They seem to have been used for liquid foods, such as soups, stews and porridges. Early surviving examples date from around 1500 and already have the characteristic flat flange handle, known as an 'ear', usually of trefoil profile and attached to one side. A number

have been found in datable contexts, at Nonsuch Palace in Surrey, in the 1540s, and on the *Mary Rose* wreck. The examples from the *Mary Rose* have two 'ears'. Porringers continued to be made for use up to 1750 and they are still being made as souvenirs. The simple practicality of their design, coupled with the fact that they were small and portable, ensured their long survival.

In Scotland, there developed a distinctive type of vessel known as a 'quaich', from the Gaelic word *cuach*, meaning a cup. This is formed like a porringer with two small ears, and has a flat base and usually a small ring foot. Silver quaiches and others made of a series of small staves, mounted in silver, are relatively common, but pewter examples are comparatively rare, dating mostly from the eighteenth century or later. They are not usually marked, except for owners' initials. The smaller ones were used for spirits, the larger ones for wine, ale or liquid foods, such as broth or porridge.

Most people associate pewter with tankards, drinking vessels with hinged lids that were used for ale, punch and beer. The tankard was originally a form of pot and references to 'tanggad pots' can be found as early as 1482. The word comes from the French *tanquard*, which was originally used to describe a wooden vessel. Some of the wooden drinking vessels from the *Mary Rose* exhibit many features of the early tankard: tapering bodies, a flat lid and a single handle at the side. The earliest pewter tankards date from the first quarter of the seventeenth century. These have plain tapering bodies, a single scrolling strap handle and a plain simple volute thumb-piece. Such pieces have been compared to a silver example bearing a date-letter for 1638. Thumb-pieces are found on the earliest flagons and cruets, and show a very considerable variety of design. By the middle of the seventeenth century, the lid of a tankard was made with a raised central platform, which became more prominent in the 1690s.

Although most English examples are plain, the body being decorated with simple wriggle-work designs, some continental pieces are cast with complex patterns in relief. The cast strapwork, masks and scrolling foliage on a German tankard by Jacob Koch (no. 30) closely resemble those on earlier ewers and dishes by François Briot (nos. 25, 28). German tankards tend to be more ornate than their British counterparts. The castings are heavier and the thumb-pieces are usually massive, ball thumb-pieces being especially popular. They are often engraved with dedicatory verses and religious scenes. The drinking customs in Germany were more formalized and elaborate than in England and this may account for their more flamboyant appearance.

A feature to be found on English and, later, on American tankards is the extension of the lid, the front of which is sometimes cast with a serrated projection. Continental tankards never adopted this feature, the lids being entirely round. It is likely that, as so often with other object

types, the English flat-lidded pewter tankard was derived from similar examples in silver. This form remained in fashion until about 1710, when it was superseded by tankards with a prominent domed lid, a type first introduced in about 1690. In 1730, again under the influence of contemporary silver, a pewter type was introduced with an elegant waisted body set on a low skirted base. Known as a 'tulip tankard', this was made until the end of the eighteenth century. It is clear that the proliferation of tankards and similar types of vessel occurred as a direct result of the increase in the number of ale-houses and taverns in the seventeenth century.

The tankard also had an influence on the popularity of another type of drinking vessel, the tavern mug, which is basically a tankard without a lid. The earliest examples seem to date from about 1650, and their workmanship and decoration, if any, is generally much less sophisticated; the impression given is of mass-produced wares solidly made for hard usage in ale-houses and taverns. A majority of the surviving examples bear capacity and local verification marks, as the tavern keepers were keen to avoid a reputation for selling short measure. Such pieces often have two substantial horizontal mouldings running around the body and generally taper towards the top; they are also characterized by a large scrolling handle. The bodies are usually quite plain with horizontal mouldings, though a few examples from the early eighteenth century, decorated with fluted bands of ornament clearly taken from contemporary silver vessels, have also survived. Straight-sided mugs became fashionable after about 1750, the bodies cut with a series of narrow mouldings arranged as decorative bands. The elegant waisted tulip form of mug was also fashionable from the 1750s, and is again found in silver. A large number of tavern mugs were made in the first half of the nineteenth century. They are characterized by slightly everted rims and the bodies are mounted on a skirted base.

Tavern mugs often carry details of the tavern or ale-house keeper who owned them, either roughly engraved on the body or, in the case of later examples, on the base. The number of examples incised with phrases such as 'if sold stole' or 'Stop thief!' indicates that theft of these mugs was common. By the end of the eighteenth century, the problem was so great in London that a Bill was put before Parliament in 1796 'to prevent the Secreting, Purloining or Destroying of Pewter Pots, or other vessels, belonging to Persons retailing Malt Liquor'. The Bill tells of publicans losing fifty to seventy pounds a year because of these thefts.

The association between pewter and taverns is aptly reflected in the name of one of the inns in the City of London. The Pewter Pot Inn, in the parish of St Andrew and close to Lime Street, is mentioned in the fifteenth century. It was obviously a house of some size, as coaches set off from there to Braintree in the 1740s, and it was used by carriers plying their trade between London and the principal towns of Essex. Given the

name, it seems ironic that the earliest mention of the inn in the Brewers' Company records should be to the landlord George Sperall, who was fined in about 1420 for not having proper verification stamps on pewter measures. At around the same time, the French poet François Villon (1431–c.1463), described in verse how he and his friends hoodwinked the owner of an inn called the Plat d'Etain into losing a game and therefore having to pay for drinks.

A useful addition to the furnishing of a well appointed middle-class house in the latter part of the seventeenth century was a pewter cistern. This was a large basin that stood in the dining-room and was used to rinse the dishes used at table. Paintings of the sixteenth century show wooden tubs being used for this purpose, with a rather ingenious plate rack, fitted with two handles, in which large numbers of dishes or glasses could be stacked, then plunged up and down in water to rinse them – a primitive but effective form of dish-washer. It was one of these cisterns in pewter that Samuel Pepys, the diarist, acquired on 14 March 1667: 'and thence to the pewterer's to buy a pewter sesterne [*sic*] which I have ever hitherto been without, and so up and down upon several occasions to set matters in order'. The pewterer from whom Pepys bought his cistern was almost certainly 'the French pewterer' from whom he bought other pewter wares – none other than Jacques Taudin.

One of the most common domestic wares was the chamber pot. There must have been many thousands of these in use in the households of the seventeenth and eighteenth centuries. Examples are occasionally found in wrecks, or rivers and canals. They varied very much in size and quality. The records of the London Pewterers' Company reveal that their numerous 'searches' (quality checks) exposed many sub-standard 'pottes' – that is to say, chamber pots – made to a lower standard of alloy. The records reveal four sizes: 'Grand', two quarts, a pint and a half; 'Great', two quarts and a pint; 'Middle', 2 quarts; and 'Small', a quart, a pint and a half. The records also differentiate between what are described as 'chamber pots ordinary' and 'round rim chamber pots'. Surviving examples range from small globular vessels to grander creations, such as the large 'round rim' chamber pot that was found in the wreck of HMS *Association*, the flagship of Sir Cloudsley Shovell, Admiral of the Fleet, which was wrecked off the Isles of Scilly in 1707. This magnificent specimen was very well made with turned mouldings and a stout strap handle with prominent thumb-piece, in fact very like the rare silver chamber pots of the same period.

22

22. Bowl

English or Flemish, early 16th century
Height: 4 cm. Diameter: 18.3 cm
M.37-1945

TOUCHES AND INSCRIPTIONS: Incised into the bowl, a
merchant's mark consisting of a split cross.
PROVENANCE: Yeates Bequest. Found in London.

The central raised section and rim with a single moulding
are found on wares of Flemish origin from about 1400.
Small bowls of similar form are usually dated to the first
half of the sixteenth century and examples have been
recorded from the Low Countries. The form of the
merchant's mark on the base suggests a date early in the
sixteenth century. The former owner described this bowl as
coming from London, and being found in a damaged state,
indicating that it had been excavated. Bowls were certainly
made in England at an early date, as a table of weights for
pewter wares in 1438 mentions 'small bolls [bowls] 13 lbs
per doz.'.

BIBLIOGRAPHY: Yeates 1927, pl. 5

23. Dish

German (Nuremberg), dated 1567
Diameter: 35.6 cm
1511-1855

TOUCHES AND INSCRIPTIONS: On the back of the plate
are the marks of two owners, *W* and *IK*. On a label
beneath the figure of Fame, the name *Sigmund* and the
date *1567*, with the letters *BI* (?).
PROVENANCE: Purchased for £1.4s.

The plate is cast in very low relief with designs showing
figures from Roman history. In the circular medallions on
the rim are Hannibal, Horatius and Marcus Curtius;
between the medallions there is a triumphal procession,

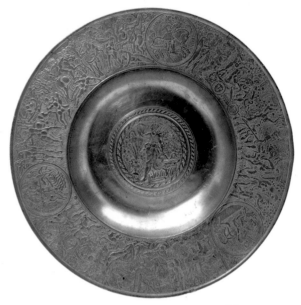

23

Orpheus charming the beasts and a battle scene with
equestrian figures. In the centre is the figure of Fame.

The sources for the designs are as follows: the four
medallions are after Georg Pencz; the battle scene is after
Hans Sebald Beham; the triumphal procession after the
monogrammatist VG and the Orpheus scene after Virgil
Solis. The drawing technique resembles that of some
contemporary German wood-block prints and was later
called the 'wood-cutting' style. Dishes in this form, cast
from etched moulds, were the speciality of Nuremberg
makers in the latter part of the sixteenth century,
particularly the masters Albrecht Preissensin (d.1598) and
Nicholaus Horchaimer (1561–1583). This particular design
has been attributed to Horchaimer.

BIBLIOGRAPHY: Haedeke 1970, pl. 216, Boucaud and Fregnac
1978, pl. 112

24. Dish

German (Nuremberg), dated 1569
Diameter: 36.8 cm
1133-1905

TOUCHES AND INSCRIPTIONS: Nuremberg arms with the
letter *L* and two other shields in a corded border.
Signed *BI*. The initials *FS* are engraved on the back.
PROVENANCE: Purchased for £15.

The central image of the Judgement of Paris is after Hans
Brosamer (working 1535–50). Around it are allegorical
figures representing the Virtues, identified by inscriptions:
*FIDES, CHARITAS, TEMPERANCIA, PACIENCIA, SPES,
COGNICIO, PRUDENCIA, IUSTICIA, MAGNANIMITAS.*

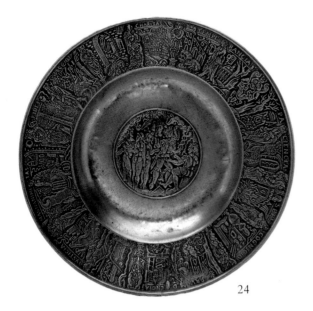

24

1. A figure reclining on a cloud, with a rural landscape. The strapwork border bears the title *AER* (Air).
2. A female figure seated amidst rushes, holding a vessel from which pour water and fishes, with a lake scene and rain clouds in the background; on the border, the title *AQUA* (Water).
3. A female figure seated on a grassy bank, holding flowers, with a vase containing flowers and fruit, set in a wooded landscape; on the border, the title *TERRA* (Earth).
4. An armoured warrior with helmet and sword, holding thunderbolts, in a landscape with burning cities, a furnace and volcanoes; on the border, the title *IGNIS* (Fire); the rim is cast with oval panels separated by strapwork with plants and birds, masks, serpents, fruit, flowers and winged horses; the panels bordered by strapwork represent the Seven Liberal Arts and Minerva, symbolizing Wisdom, as follows:

Like the previous example (no. 23), this dish was cast from an etched mould.

BIBLIOGRAPHY: Haedeke 1970, pl. 216, Boucaud and Fregnac 1978, pl. 112

25. 'Temperantia' Dish

French, about 1585
Diameter: 45 cm. Width of rim: 6.5 cm. Depth: 4.5 cm
2063-1855

TOUCHES AND INSCRIPTIONS: Maker's touch *FB* for François Briot (*c*.1550–*c*.1616), cast in relief on the central boss. Set in the base: a medallion cast in relief with *SCULPEBAT FRANCISCUS BRIOT*, with a portrait bust.
PROVENANCE: Purchased from the Bernal Collection, for £19.

In the form of a circular dish with raised central boss, broad rim and raised convex edge. The surface is decorated with cast designs in relief against a ground of raised dots. In the centre, a circular plaque showing the figure of Temperance holding a wine cup and ewer, seated on a plinth, at the side of which are ears of corn with a sickle, a torch and a pitchfork, with a city and seascape in the background; above her head is the word *TEMPERANTIA*. The edge of the central boss is a convex cast moulding. Surrounding the boss is a broad band of cast ornament, consisting of oval panels separated by demi-figures on plinths set amidst strapwork, fruit and flowers; the panels represent the Four Elements and consist of:

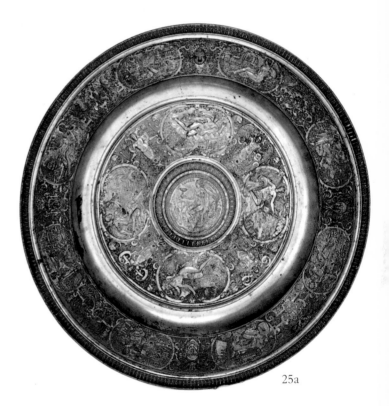

25a

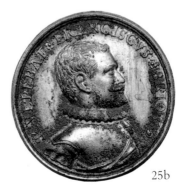

25b

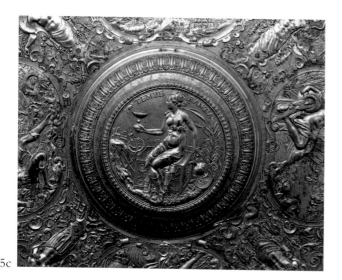

25c

a. A female figure seated in a landscape with a fountain and an alphabet; on the border, the title *GRAMMATIC* (Grammar).

b. A female figure seated in a landscape with key and a book, in the background, a building; on the border, the title *DIALECTICA* (Dialectic).

c. A female figure seated in a landscape, holding a flaming heart, with an open book before her; on the border, *RHETORICA* (Rhetoric).

d. A kneeling female figure, holding a lute with a pipe adjacent; before her, a plinth with music and a vase of flowers; on the border, *MUSICA* (Music).

e. A female figure seated in a landscape, holding a clock and leaning on a board bearing numbers; in front of her, a compass dial and an hour-glass; on the border, *ARITHMETIQUA* (Arithmetic).

f. A female figure seated in a landscape, holding geometrical instruments, including a set-square and dividers; on the border, *GEOMETRIA* (Geometry).

g. A reclining female figure in a landscape, holding a quadrant dial; before her, a table on which are set a planisphere and a globe, with stars above; on the border, *ASTROLOGIA* (Astrology).

h. A kneeling figure of Minerva in a landscape, with an owl and a book before her, holding a shield, a city in the background; on the border, *MINERVA*.

The underside is plain; in the centre is set a medallion showing a portrait bust facing right; inscribed around the edge, *SCULPEBAT FRANCISCUS BRIOT*.

François Briot (c.1550–c.1616) was born at Damblain, in the duchy of Lorraine. In 1580 he is recorded as joining the Corporation of St Eligius in Montbéliard – a craft guild. It is thought that he went to Montbéliard – a Protestant town – to avoid religious persecution, as the region was under the protection of Frederick, Duke of Württemberg, a Huguenot. Briot is known to have engraved medals of the duke in 1585, and in 1586 he was given the title of 'Graveur de Son Excellence'. For debts owing to the duke, an order was made in 1601 to seize his goods, which included 'moulds for making a dish, ewer, vases and salts'. These moulds were still in his possession in 1616, as they were exempted in that year with other necessary pieces of furniture from an enforced sale of his goods. As no mention of Briot is made after this date, he is presumed to have died in about 1616. The family were well known as medallists and coin-die cutters, and members of the family worked for the Paris mint in the early seventeenth century.

BIBLIOGRAPHY: Demiani 1897, p. 12, pl. 1, Haedeke 1970, p. 129, Hayward 1976, p.328, Düsseldorf Kunstmuseum 1981, no. 30

26. Dish

French, about 1580
The central medallion of Limoges enamel, with a scene showing a cherub warrior with sword and shield, by Couly Nouailher (fl. 1580)
Diameter: 44.5 cm
2064-1855

TOUCHES AND INSCRIPTIONS: None.
PROVENANCE: Purchased from the Bernal Collection, for £19.19s.

The dish is cast with scenes from the parable of the Prodigal Son: the son sleeping in the pig-sty, the father greeting the son, the killing of the fatted calf and scenes of

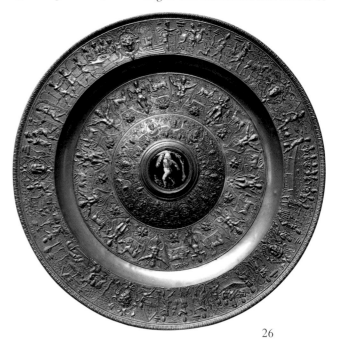

26

feasting. The inner band of decoration consists of half figures of women, with stags and fruit. Between the scenes, lions and human masks alternate within strapwork.

The relief work is of very high quality, against a ground that is entirely matted. It is a curious feature of the design that the heads of the figures from the story of the Prodigal Son were all moulded and applied separately; they are slightly too large for their bodies. Although the dish is not signed by Briot, it clearly belongs to his circle.

The central band has been damaged and a cast patch inserted.

BIBLIOGRAPHY: Boucaud and Fregnac 1978, pl. 107

27. 'Temperantia' Dish

German, dated 1611
Modelled by Caspar Enderlein, after a design by
François Briot
Diameter: 46.2 cm
5477-1859

TOUCHES AND INSCRIPTIONS: Maker's touch of Hans Siegmund Geissen (1652–1682).
PROVENANCE: Purchased from the Soulages Collection, for £8.

Cast in relief with allegorical figures representing Minerva and the Seven Liberal Arts, the Four Elements and, in the centre, a figure of Temperance. Set in the centre of the back of the dish is an inscription *SCULPEBAT CASBAR ENDERLEIN*, with the initials *CE*. To the left of the figure labelled *GEOMETRIA* are the initials *CE* and the date *1611*. The initials *CE* appear again to the left of the central figure representing Temperance.

This is an early seventeenth-century copy by the Nuremberg master Caspar Enderlein of the dish modelled by François Briot (no. 25). It differs from the French original in several respects. The border is wider, the relief figures are larger and less well modelled; the medallion on the reverse is larger than the equivalent on the Briot dish. In general, the cast ornament is much coarser and less detailed.

Several versions of this dish, identified as 'Model II', are known in museums and private collections. It is characterized by the initials and date on the panel representing Geometry, and by the spacing of the letters in the central plaque, as *TEMPER ANTIA*.

Caspar Enderlein (1560–1633) was born in Basle and settled in Nuremberg in 1583. He specialized in the production of pewter, cast with relief decoration from moulds cut in stone. He made two moulds for the Temperantia dish. He is known to have worked with Jacob

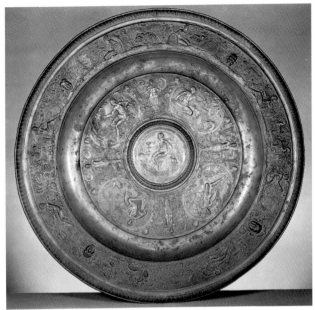
27

Koch II, who is represented in the Museum's collection by a cast plate (no. 35) and a cast tankard (no. 30). The copying of successful designs was not limited to pewter. Briot's patterns were also executed in earthenware (col. pl. VII on p. 19) and silver.

BIBLIOGRAPHY: Haedeke 1970, p. 183

28. Ewer (illustrated overleaf)

French, 17th century
After a design by François Briot
Height: 27.9 cm
4289-1857

TOUCHES AND INSCRIPTIONS: Designer's initials *FB*, beneath a figure.
PROVENANCE: Purchased.

Cast in low relief with strapwork, fruit, masks, winged horses and satyrs; the central horizontal frieze with three oval strapwork panels containing female allegorical figures representing the Cardinal Virtues; the handle cast with a demi-figure and a mask. This ewer represents a well known design by François Briot, of which examples are to be seen in several collections, including the Musée du Louvre, Paris. In the present example, the handle has been distorted and reattached to the body, which also shows signs of soldered repairs. The lack of detail and worn relief decoration are reminiscent of versions of Briot wares that were produced by German pewterers in the seventeenth century; indeed there is every possibility that the ewer is an after-cast.

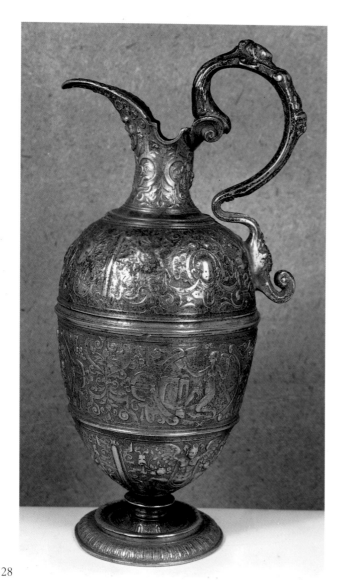

28

A ewer of identical design was produced in earthenware, by a follower of Bernard Palissy. An example can be seen in the Wallace Collection, London (C175).

29. Tankard

French (Strasbourg), about 1650
Height: 18.4 cm
4290-1857

TOUCHES AND INSCRIPTIONS: Maker's touch for Isaac Faust (1628–1669) and town mark of Strasbourg struck on the base.
PROVENANCE: Purchased.

Cast in relief on a punched ground with fruit, foliage, masks, winged cherubs and escutcheons. On the body, oval strapwork panels containing allegorical female figures with labels below: *SOLERTIA* (skill), *NON VI* (non-force) and *PATIENTIA* (patience). The handle (which has been broken and repaired) is cast as a demi-figure on a volute plinth, the thumb-piece as a mask. The design of this tankard appears to be identical to one in the Nordböhmisches Gewerbe Museum, Reichenberg, which has been attributed to François Briot; another example of the same design, marked with the letters *FB* on the base, was sold at Sotheby's in 1982. The figures and masks are also represented with slight differences, especially in the background of the design, on Briot's Mars dish (Bargello, Florence). The figure of Solertia is shown as Europa on the dish; the figure of Patience is shown as Africa; the figure of Non Vi is present, but without the lion and broken sword.

BIBLIOGRAPHY: Demiani 1897, pl. 11, no. 2, Haedeke 1970, p. 311, Düsseldorf Kunstmuseum 1981, pl. 24

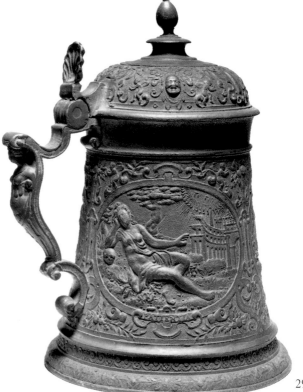

29

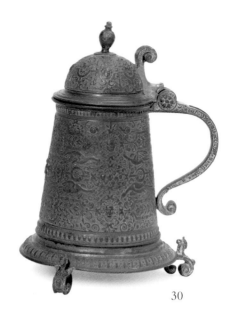

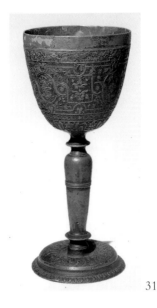

30 31 32

30. Tankard

German (Nuremberg), about 1600
Height: 19.5 cm
220-1853

TOUCHES AND INSCRIPTIONS: Maker's touch of Jacob
Koch II, Master 1583, d.1619 (Hintze 1921, II, no. 152).
PROVENANCE: Purchased.

BIBLIOGRAPHY: Hintze 1921, p. 3

31. Wine Cup

English, 1590–1610
Height: 18.4 cm
417-1905

TOUCHES AND INSCRIPTIONS: Struck on the sides of the
bowl, a leaf within a heart. Inscribed *HW* in wriggle-
work on the underside of the foot.
PROVENANCE: Purchased.

This is one of a group of early seventeenth-century English
pewter wares characterized by the use of cast decoration in
relief. They usually incorporate flowers and strapwork
and the inspiration came almost certainly from Germany.
A number of similarly decorated wares, some with
Nuremberg makers' marks dating from the second half of
the sixteenth century, have been recorded. They include
dishes, beakers, a footed plate and the so-called Granger
candlestick (no. 187). Similar cups are in the collection
of the Worshipful Company of Pewterers (52/211) and
the British Museum (MLA 1980 5-2,1). On the basis of
comparison with contemporary cups in silver, they appear
to have been used for wine.

BIBLIOGRAPHY: Haedeke 1970, p. 222

32. Beaker

English, about 1603
Height: 10.7 cm. Diameter of lip: 8.3 cm
M.253-1928

TOUCHES AND INSCRIPTIONS: None.
PROVENANCE: Purchased from Aalbers Brothers,
Arnhem, Holland.

It has been suggested that this beaker, of unique form,
commemorates the accession of James VI of Scotland to the
English throne in 1603, but the prominence given to the
badge of the Prince of Wales must surely associate it with
Henry, son of James, who was created Prince of Wales in
1610 and died in 1612. Similar badges appear on a beaker
now in the collection of the Pewterers' Company (S3/303),
which can be more closely linked with him. The raised
flange on the body is similar to those found on German
silver *Monatsbecher* and *Satzbecher* (stacking beakers), which
fit one inside another. No pewter examples are known from
England but this might explain the small ring foot. The
relief decoration is a variant of the designs found on other
English pewter drinking vessels of the period.

Within the strapwork are set badges in relief consisting
of the rose and crown, suns in splendour, thistle and
crown, thistles, a crowned fleur-de-lys and Prince of Wales'
feathers. The design appears to have been cast in three
sections, as three prominent seams run vertically down the
body.

BIBLIOGRAPHY: *British Pewterware through the Ages* 1969,
no. 50

33. Beaker

English, early 17th century
Height: 11.7 cm
M.97-1945

TOUCHES AND INSCRIPTIONS: Undecipherable traces inside, on centre of base.
PROVENANCE: Yeates Bequest.

The surface is moulded with bands of ornament, one of which contains the Prince of Wales' feathers, also the crowned Tudor rose and the royal arms of the House of Stuart.

A number of beakers of similar form and decoration have been recorded. These include one from Cheapside, now in the Museum of London (A26941), which has the same horizontal bands of fruit and flowers. Another, found in a well at Hurstbourne Tarrant, Hampshire, is decorated with the Prince of Wales' feathers, flowers and crowns, and is now in a private collection; a comparable well preserved example, similarly decorated but with the letters *HP* (Henry, Prince of Wales), is in the collection of the Worshipful Company of Pewterers. That the rim of the Museum's beaker has been damaged, and the base crushed and folded back beneath the piece, is confirmed by the fact that these other examples still have their original skirted foot in the form of a convex moulding. Other plain beakers of the same form have been recorded and the design seems to have been popular in the early seventeenth century.

The closest parallel to the V&A beaker is an example in the Museum of London (no. 53/303), which is in a better state of preservation. On this beaker the motto *ICH DIEN* is flanked by the initials *H P* for 'Henricus Princeps'. Henry was invested as Prince of Wales in 1610 and died in 1612. The beakers were probably made as souvenirs to commemorate the investiture.

33

BIBLIOGRAPHY: Yeates 1927, p. 101, Cotterell 1929, pl. XVIIa, Worshipful Company of Pewterers 1968, pls. 44, 45, no. 53/303, *British Pewterware through the Ages* 1969, nos. 51, 54, Hornsby 1983, p. 298, no. 1022, Museum of London 1983, pp. 21–22, *Pewter: a Celebration of the Craft* 1989, no. 112

34. Plate

German (Nuremberg), about 1635
Diameter: 19.7 cm
1416-1852

TOUCHES AND INSCRIPTIONS: Maker's touch of Georg Schmauss of Nuremberg (working 1627–39).
PROVENANCE: Purchased for 5s.

The plate is cast in relief with equestrian portraits of members of the royal house of Habsburg, Rudolph I, Albert I, Frederick III, Albert II, Frederick IV, Maximilian I, Charles V, Ferdinand I and Maximilian II, each with an Arabic number below their feet. In the centre is a portrait of Ferdinand II and an engraver's monogram.

This is one of a series of plates cast with patriotic themes, for which Nuremberg pewterers were well known.

35. Plate

German (Nuremberg), about 1620
Modelled by Jacob Koch II (worked 1583–1619); cast by his son, Jacob Koch III (worked 1609–30)
Diameter: 18.1 cm
1417-1852

TOUCHES AND INSCRIPTIONS: Maker's touch of Jacob Koch III (worked 1609–30). On the reverse, an incised owner's inscription *F2 N6*.
PROVENANCE: Purchased for 5s.

Cast in relief with scenes from the Old Testament, the Creation of Eve, the Forbidding of the Tree of Knowledge, the Fall of Man and the Expulsion from the Garden of Eden, with demi-figures and scrolling foliage. In the centre is a medallion depicting a prince with a sceptre and the inscription *DRINCK UND IS GOTS NICHT VOR GIS* (Drink and God is not forgotten).

This plate may well have been used as a paten at some time, as it seems to have been deliberately flattened. The design has clearly been influenced by Catholic doctrine, as the figure of God is represented with a characteristic papal mitre.

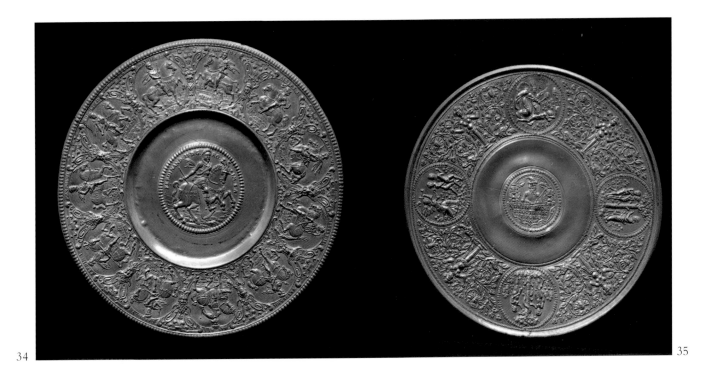

34 35

36. Plate (plate IX)

Swiss (St Gallen), about 1660
Diameter: 21.6 cm
1415-1852

TOUCHES AND INSCRIPTIONS: Maker's touch of Zacharias Taschler (1657–1717) and Joachim Schimmer (1613–1697). The back is incised with an owner's mark, the letter *P*.
PROVENANCE: Purchased for 7s.

The plate, or *Lappenteller*, is cast with the arms of the thirteen cantons that formed the Swiss Confederation until 1798. The central medallion has a design showing three Swiss *Lanzknechte*, with the inscription: *DER ERSTE PVNDT WARD VON GOT ERWELT DO MAN 1308 ZELT.* (The first truce was blessed by God in 1308.)

BIBLIOGRAPHY: Düsseldorf Kunstmuseum 1981, pl. 60

37. Plate

South German, second quarter 17th century
Diameter: 17.9 cm
M.397-1956

TOUCHES AND INSCRIPTIONS: On the back, owner's initials *FIH* are engraved, together with a finely incised inscription (illegible).
PROVENANCE: Hildburgh Bequest.

The plate was cast by Hans Jacob Locher I of Memmingen (Hintze 1928, VI, nos. 388, 395) after a model by Wilhelm Locher. The rim depicts the Twelve Apostles. In the centre, the figure of a female saint stands with an orb and cross. A square halo traditionally indicates that the saintly figure is still alive.

BIBLIOGRAPHY: Boucaud and Fregnac 1978, fig. 124

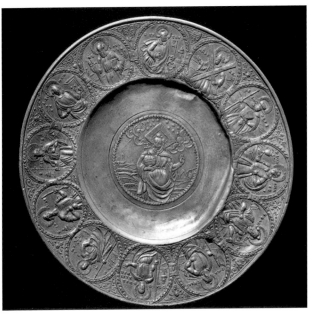

37

38. Plate

South German (Nuremberg), dated 1621
Diameter: 18.1 cm
M.338-1940

TOUCHES AND INSCRIPTIONS: The arms of Nuremberg
and the letter *W*.
PROVENANCE: Oppenheimer Gift.

Decorated with the Creation of Eve and the four seasons.

39. Plate

German (Nuremberg), 1619
Diameter: 17.6 cm
M.121-1915

TOUCHES AND INSCRIPTIONS: The mark of Nuremberg,
the initials *BO* for Paulus Oham the Elder, dated *1619*.
On the back, a collectors's mark is written in ink, *4776
FE JE*.
PROVENANCE: Dingwall Gift.

The scenes represented are the Creation of Eve, the
Forbidding of the Tree of Knowledge, the Expulsion from
the Garden of Eden and the Fall of Man. In the centre, a
medallion with a scene showing the sacrifice of Noah with
the inscription: *NOE GIENG AUS DER ARCH GETROST
OPFERDT 16 GOTT 19* (Noah leaves the Ark . . .). Between
the scenes are vases of flowers.

Paulus Oham was the son of a coppersmith and was
apprenticed to the Nuremberg pewterer Hans Zatger (?)
(1588–93). He died of the plague in 1634.

BIBLIOGRAPHY: Düsseldorf Kunstmuseum 1981, pl. 27

40. Plate

German (Nuremberg), about 1730
Diameter: 19.5 cm
1146-1864

TOUCHES AND INSCRIPTIONS: Maker's touch of Abraham
Mager of Nuremberg.
PROVENANCE: Friedland Gift.

The plate was made by Abraham Mager of Nuremberg
(1701–1741), after a model by Paulus Oham the Younger
(1634–1671). It is cast in relief with images of the Twelve
Apostles, labelled: *S. PETRUS, S. ANDREAS, S. JACOBUS,
S. IOHANNES, S.PHILIPPUS, S. BARTOLOMEUS, S. IUDAS
THADDAE* (St Jude), *S. THOMAS, S. IACOBUS MINIM, S.
SIMONUS, S. MATTHIAS*. In the centre is a medallion
showing Christ with the Holy Banner and four soldiers.

Dishes cast with religious themes were one of the
Nuremberg pewterers' specialities.

BIBLIOGRAPHY: Düsseldorf Kunstmuseum 1981, pl. 36.

41. Plate

North German, dated 1623
Diameter: 19.5 cm
M.645-1926

TOUCHES AND INSCRIPTIONS: Maker's touch of the
Master DS and town marks (unidentified). In the
centre, arms and the date *1623*. The back is incised
with owner's initials, *AG*.
PROVENANCE: Croft Lyons Bequest. As with other wares
from this collection, an inscription on the back gives
details of the acquisition: bought in Stuttgart, 28
August 1907.

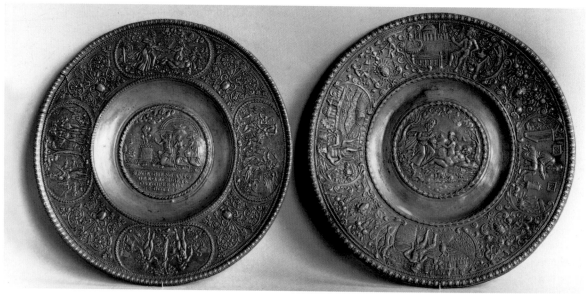

39

38

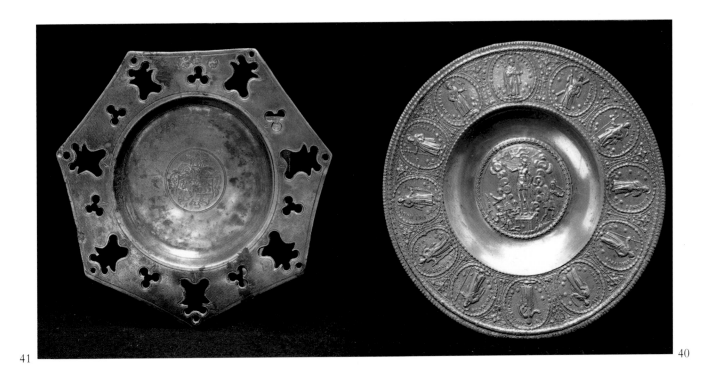

41 40

42. Dish

English, about 1630
Length: 46.4 cm. Width: 37 cm. Height: 4 cm
M.32-1923

TOUCHES AND INSCRIPTIONS: None.
PROVENANCE: Hearn Gift.

In the centre of the dish is a raised circular moulding into which is set a brass boss engraved and enamelled in blue, red and white with the royal arms of England, with the initials *CR* and the Garter. Other English dishes of the period are recorded to have been decorated with similar raised 'perles' or 'prunts', including an example shown in the Clifford's Inn catalogue of 1908 and one in the Hornsby Collection. The technique seems to have come from the Continent and was still being used on Swiss dishes in the mid-eighteenth century. It has been pointed out that the arms appearing on these wares are almost certainly those of Charles I (1625–1649). A boss on a dish from the group in the collection of the church of St Catherine Cree, London, bears the Prince of Wales' feathers and the initials *CP* for 'Carolus Princeps'. These dishes provide additional evidence that the production of enamelled wares, including the well known brass fire-dogs and candlesticks, was confined to London, as they are all likely to be of London origin. The royal arms possibly indicate a royal gift. A noteworthy feature of this dish is the complete absence of knife cuts in the well. The raised moulding that holds the central boss is a separate element, soldered to the base,

rather than raised from the back. Both suggest that it may have been intended for liquid, perhaps in association with a ewer. At table, water would have been poured over the hands into the dish.

The enamelled boss is likely to have been from the workshop of the London braziers Anthony Hatch or Stephen Pilchard, according to Mr Claude Blair.

BIBLIOGRAPHY: Massé 1949, pp. 125–26, Shemmel 1981, Hornsby 1983, pl. 80, Museum of London 1983, p. 13

42

43

44

45

43. Salver

English, about 1645
Diameter: 44.5 cm
M.31-1945

TOUCHES AND INSCRIPTIONS: On the back, the initials *IT*, with three ears of corn surmounted by a crown. On the rim, owner's initials, *MWM*.
PROVENANCE: Gift.

The boss, enamelled on brass, bears the arms and initials of Charles I (1625–1649). As in the case of no. 42, it almost certainly comes from the workshop of Anthony Hatch or Stephen Pilchard.

BIBLIOGRAPHY: *Old Furniture*, July 1937, p. 105, fig. 6, Museum of London 1983, p. 13

44. Dish

Italian, about 1660
Diameter: 55.7 cm
1373-1904

TOUCHES AND INSCRIPTIONS: Struck in the centre of the boss, *GNG* twice with a rayed sun and FN between (unidentified). Incised into the back of the rim, *OI* and *3*, probably owner's marks.
PROVENANCE: Purchased from A. Johnson and Sons, London, for £5.

Italian pewter dating from before the eighteenth century is comparatively rare. This dish was formerly attributed to Venice, although the Venice mark is not struck on the piece. It can be attributed to an Italian pewterer, however, on the basis of the style of mark used and is likely to have been made in one of the northern Italian cities, where most Italian pewter was produced.

This has been described as a venison dish, but the lack of knife cuts on the surface make that seem unlikely. It may have been designed to be used *en suite* with a ewer, hence the reed in the boss. The shape indicates a date in the first half of the seventeenth century, but certain elements of the design, such as the repeating lobes, derive from earlier Gothic forms, as found on Nuremberg dishes. This dish appears to be unique and is almost certainly based upon a silver form.

BIBLIOGRAPHY: Mory 1961, pl. 35, Boucaud and Fregnac 1978, pl. 240, p. 301

45. Rosewater Dish

English, about 1630
Diameter: 40.6 cm
M.32-1945

TOUCHES AND INSCRIPTIONS: On the underside of the rim, part of an illegible mark within a circle. On the upper side of the rim, *WHA* and *IPR*, owner's marks.
PROVENANCE: Yeates Bequest.

This is one of a group of English dishes decorated with raised 'perles'. A similar dish was shown in an exhibition at Clifford's Inn, London, in 1908, when it was described as being from a set of six supplied to Charles I at York during the English Civil War. This cannot be supported by documentary evidence. Another dish, from the Little Collection, with a different boss, seems to belong to the group. The decoration and the incised lines and punched dots on the back are very similar to that on the oval dish (no. 42) and are probably by the same hand.

BIBLIOGRAPHY: Massé 1949, pp. 125–26, Shemmel 1981, Hornsby 1983, pl. 80

46. Bowl

Western European, about 1600
Diameter: 39.2 cm. Width of rim: 5 cm
Diameter: 9.2 cm
M.7-1985

TOUCHES AND INSCRIPTIONS: None.
PROVENANCE: Peal Collection.

This unique bowl from the Peal Collection has been variously attributed to an Anglo-Saxon and to a Scottish workshop, principally on the basis of the ornament incised around the rim. The design appears to be a debased version of Islamic ornament, interlaced strapwork and scrolling palmettes. In a more sophisticated form, such designs are found on the so-called Veneto-Saracenic wares of the sixteenth century. These became relatively common during the sixteenth and seventeenth centuries in the West, and are found on some early seventeenth-century brass dishes from Italy and Germany.

The four indentations around the rim and the ungainly shape suggest that the bowl may have been set in a plinth of either wood or stone for use as a font, the indentations marking the position of retaining clips. The bowl has numerous casting flaws on the underside of the rim.

47. Dish

Italian, about 1630
Diameter: 51.9 cm. Width of rim: 8.1 cm
M.17-1987

TOUCHES AND INSCRIPTIONS: A shield with a device (illegible), surmounted by a vase of flowers (unidentified); struck over the mark *GBS*.
PROVENANCE: Purchased from Brand Inglis, London.

The Doge depicted in the central medallion can be identified as Pasquale Cicogna, who held office from 1585 to 1595 (the heraldic shield, above the central medallion, bears the arms of Cicogna of Venice). Although the ornament incorporates a portrait of a Venetian Doge, the mark does not include the lion of St Mark, nor is the layout of the marks in the form usually found on Venetian pewter wares. There is a possibility, therefore, that this dish was produced in one of the other northern Italian cities noted for pewter. These include Milan, Brescia, Turin and Parma.

46

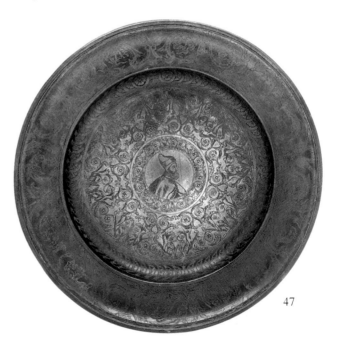

47

Large engraved dishes were especially fashionable in northern Italy during the sixteenth and seventeenth centuries. They were intended for display and would have been accompanied by a matching ewer. In its polished state, this would have resembled silver and been a substitute for the precious metal. The ornament is unusual. Similar scrolls appear on gunstocks of the period 1630–50.

BIBLIOGRAPHY: Nani 1863, p. 88, *Journal of the Walters Art Gallery*, 1949, p. 54, Haedeke 1970, pp. 420–25, Boucaud and Fregnac 1978, p. 301

48

49

48. Platter

English, about 1680
Diameter: 40.6 cm
M.102-1945

TOUCHES AND INSCRIPTIONS: *Iaques Taudin* (Cotterell 1929, no. 4651; London touch plate, no. 344).
PROVENANCE: Yeates Bequest.

The centre is engraved with the crest of an eagle displayed on a ducal coronet.

This plain and simple platter was made by one of the most famous pewterers of the late seventeenth century, Jacques Taudin. It bears his mark, *IAQUES TAUDIN SONNANT 1680*, which bears witness both to his French origins and to the supposed hardness of his pewter, the term 'sonnant' meaning that his wares would ring when struck.

BIBLIOGRAPHY: Yeates 1927, p. 209, fig. 32

49. Charger

English, about 1700
Diameter: 51.6 cm
M.182-1935

TOUCHES AND INSCRIPTIONS: Maker's touch of John Pettit (Cotterell 1929, no. 3638), struck twice on the back of the rim. Four 'hallmarks', struck on the front of the rim. On the opposite side of the rim, *EM*, owner's initials. Engraved on the rim, a coat of arms, *Azure two slaughter-axes in saltire argent handled or, the blades inwards, between two bulls' heads couped argent, armed or; on a chief argent a boar's head couped gules, tusked or between two block brushes vert,* for the Worshipful Company of Butchers.
PROVENANCE: Young Bequest.

John Pettit is described in a document of 1713 as 'a citizen and pewterer of London, but an inhabitant of Cambridge'. The charger was perhaps part of the Butchers' Company plate.

BIBLIOGRAPHY: Cotterell 1929, p. 283

50. Charger

English, 1662
Diameter: 56.9 cm
347-1872

TOUCHES AND INSCRIPTIONS: None.
PROVENANCE: Purchased from A. Wilmshurst,
Chichester, for £12.

Engraved in wriggle-work with the Stuart royal arms, for
Charles II, and inscribed *Vivat Carolus Secundus Beati Pacifici*
(Long Live Charles II of Blessed Peace). On the rim are the
owner's initials *TGA*.

BIBLIOGRAPHY: Weinstein, Hornsby and Homer 1989,
no. 128

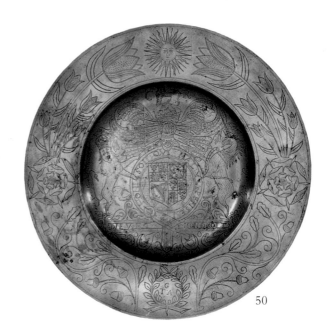
50

51. Broad-Rim Charger

French, about 1660
Diameter: 45.6 cm. Width of rim: 10 cm
Depth: 3.8 cm
M.618-1926

TOUCHES AND INSCRIPTIONS: On the rim an engraved
coat of arms for De la Tour-Garcin of Dauphiné.
PROVENANCE: Croft Lyons Bequest. Inscribed in ink on
the back, *Marseilles 10/9/06 IN francs*.

There is no trace of a maker's touch on this dish. It may
have been removed when the arms were engraved. The
upper surface shows indication of substantial cleaning and
scraping.

51

52. Broad-Rim Dish

French (Lyons), about 1655
Diameter: 45.9 cm. Width of rim: 9.9 cm. Depth: 5 cm
M.541-1926

TOUCHES AND INSCRIPTIONS: *PP* with vase of flowers,
crowned *F* mark for Lyons, struck on the back of the
rim. Engraved on the front of the rim, a coat of arms
stamped within the shield with the initials *GT*.
PROVENANCE: Croft Lyons Bequest. Purchased in
Toulouse.

It has been suggested that this dish is the work of Pierre
Paquin of Bordeaux, working in the first half of the
nineteenth century. The patina and general surface
appearance suggest, however, that the dish is older. Tardy
notes a Lyons maker Pierre Peudefin, working *c.*1638–55,
whose initials would fit the maker's touch.

BIBLIOGRAPHY: Tardy 1964, p. 71, p. 445

52

53

53. Broad-Rim Charger

English, about 1680
Diameter: 55 cm. Width of rim: 12 cm. Depth: 6.3 cm
M.230-1924

TOUCHES AND INSCRIPTIONS: Maker's touch of Richard Gardner (Cotterell 1929, no. 1809a), struck under the rim. On the rim, four hallmarks; stamped on the rim *AAD*, *EAh* and *SR*, owners' initials.
PROVENANCE: Purchased with its pair from Miss Catherine Sheekey, London, for £50.

This is one of a pair. In the Museum's register is a letter dated 20 September 1924 from Howard Cotterell attributing the charger to Richard Gardner. He describes the dishes as 'exceptionally fine examples'. The central well is scored with many knife cuts, indicating that the charger has seen considerable use. The back of the dish is inscribed in ink *Robert Gibson Touch No. 177*.

BIBLIOGRAPHY: Cotterell 1929, p. 213

54

54. Broad-Rim Dish

Dutch, about 1670
Diameter: 38.8 cm
M.884-1926

TOUCHES AND INSCRIPTIONS: Maker's touch *I C* within a crowned rose, struck on the rim. Struck on the back of the rim, a wyvern with *IC* and *1669* (unidentified).
PROVENANCE: Croft Lyons Bequest. Labelled on the base, *no.45*. Purchased at Vitel.

This is a standard broad-rim dish of the 'cardinal's hat' form, found in the Low Countries and elsewhere from the sixteenth century onwards.

BIBLIOGRAPHY: Boucaud and Fregnac 1978, pl. 231, Dubbe 1978, p. 265, pl. 141

55. Basin

French, about 1700
Diameter: 23 cm. Width of rim: 1.9 cm. Height: 6.6 cm
M.531-1926

TOUCHES AND INSCRIPTIONS: Engraved in the centre of the base, a coat of arms beneath a coronet.
PROVENANCE: Croft Lyons Bequest. Collector's label on the base, *No.82 Montpelier 2.10'05 AM frcs*. Purchased in Montpellier.

In shape, this vessel resembles the small brass bowls produced in Nuremberg in the sixteenth and seventeenth

55

57. Plate

French (Lyons), about 1730
Diameter: 33.5 cm. Width of rim: 6.6 cm.
Depth: 2.8 cm
M.1090-1926

TOUCHES AND INSCRIPTIONS: Maker's touch *HUMBERT METRA*, struck on the back of the rim, *DE LION* stamped. On the back, *R*, an owner's identification mark. This maker also used another mark incorporating the words *Etain D'Angleterre*.
PROVENANCE: Croft Lyons Bequest. Purchased in Verona.

BIBLIOGRAPHY: Tardy 1964, p. 442

centuries. It seems to have been used as a food container, because it has knife marks in the base. Pewter basins with vertical sides appear to be unusual, the type with curved sides being much more common.

BIBLIOGRAPHY: Dexel 1973, pls. 304 (for a similar vessel in brass), 467 (for a pewter version of related form)

56. Broad-Rim Plate

French, about 1690
Diameter: 24.3 cm. Width of rim: 54 cm. Depth: 2 cm
M.669-1926

TOUCHES AND INSCRIPTIONS: Maker's touch crowned *PC* (or *RC*?) twice, with other quality mark (illegible), struck on the back of the rim; crowned pewterer's hammer. Engraved on the rim, a coat of arms, *Gules 3 estoiles argent*, for Grimouville, of Normandy.
PROVENANCE: Croft Lyons Bequest. Inscribed in ink on the back, *Lt. Colonel C. Lyons, 13 Hertford Street, Mayfair, Rennes, 15/4/08 MN frcs.*

The chief interest of this plate, which probably comes from a large garnish, lies in the engraved arms.

58. Dish

English, about 1710
Length: 40.6 cm. Width: 29.5 cm. Depth: 4.5 cm
M.35-1945

TOUCHES AND INSCRIPTIONS: Maker's touch *HELLIER PERCHARD* (Cotterell 1929, no. 3611), on the base.
PROVENANCE: Yeates Bequest.

Dishes and bowls with concave apertures are usually thought to have been for use by barbers. The previous owner considered this unlikely in the present case, because of its weight. The shape derives from Continental prototypes, especially from France and Spain, sometimes made of brass. Oval barbers' bowls of similar depth, but without the elaborate undulation found on this example, are known from France in the thirteenth century.

BIBLIOGRAPHY: Yeates 1927, p. 209, Cotterell 1929, pl. XVIIIb, Hornsby 1983, no. 304

59. Salver

Dutch (Amsterdam), about 1730
Length: 29.8 cm. Height: 2.4 cm
M.437-1926

TOUCHES AND INSCRIPTIONS: Three 'hallmarks' below a crowned X, struck on the base (unidentified), probably for an Amsterdam maker.
PROVENANCE: Croft Lyons Bequest. A label gummed to the back, *LT Colonel Croft Lyons No. 89 AMSTERDAM P. GULDEN 26/9/04*. Purchased in Amsterdam.

A virtually identical salver is in the collection of the Colonial Williamsburg Foundation, Virginia. This salver can be attributed to a Dutch pewterer on the basis of the marks, which include two typically Dutch hallmarks. The shape of the salver is very similar to contemporary silver versions.

BIBLIOGRAPHY: Hornsby 1983, no. 351

60. Octagonal Plate

English, about 1755
Height: 1.7 cm. Diameter: 23.5 cm
M.40-1945

TOUCHES AND INSCRIPTIONS: Maker's touch of *GEORGE BACON* of London (Cotterell 1929, no. 180; registered 1746, d.1771). Struck under the rim, *LTP 921*; double crown and *X* mark, on opposite side. On the rim, the arms of Sharpe.
PROVENANCE: Yeates Bequest.

This is a good example of an octagonal plate. The substantial number of octagonal plates inscribed with arms may indicate that they were usually required by wealthier clients. As with no. 61, the moulding at the edge has been roughly soldered to the body and this plate was probably cut from a plain rim dish.

BIBLIOGRAPHY: Yeates 1927, p. 209, fig. 32, Cotterell 1929, pl. LVI, Brett 1981, p. 49, Hornsby 1983, no. 343

61. Octagonal Plate

English, late 18th century
Diameter: 23.5 cm
M.41-1945

TOUCHES AND INSCRIPTIONS: Maker's touch of possibly John Townsend and Thomas Giffen (1777–1801).
PROVENANCE: Yeates Bequest.

BIBLIOGRAPHY: Yeates 1927, p. 209, fig. 22

62. Plate

American (Philadelphia), about 1810
Diameter: 19.8 cm. Width of rim: 2.9 cm
M.14-1969

TOUCHES AND INSCRIPTIONS: Maker's touch of Thomas Danforth III, struck twice on the base. Incised in the base, *I H*, the initials of a former owner.
PROVENANCE: Breckenridge Gift.

This is one of the very few pieces of American pewter in the collection.

BIBLIOGRAPHY: Hornsby 1983, pl. 324

59

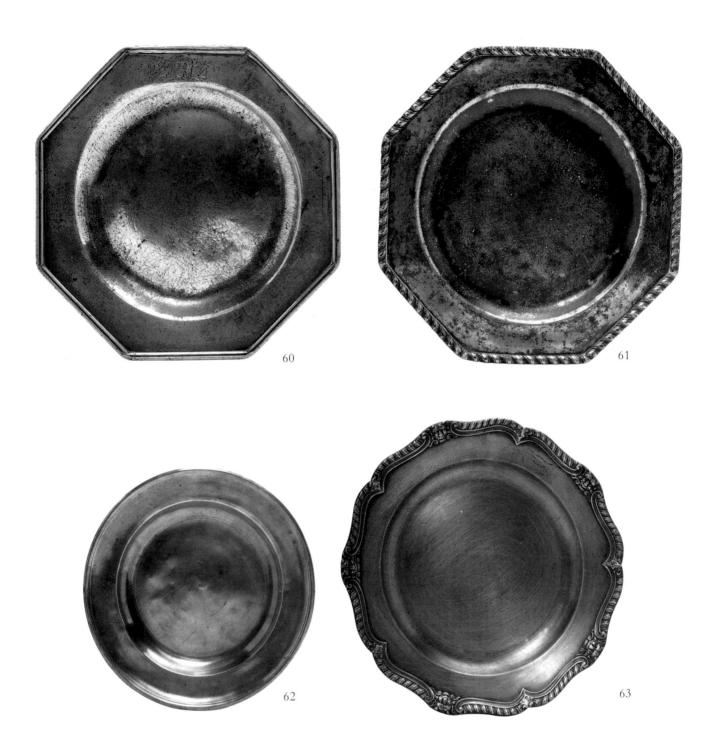

60

61

62

63

63. Plate

English, about 1750
Height: 2.4 cm. Diameter: 24.5 cm
180-1904

TOUCHES AND INSCRIPTIONS: Maker's touch of *GEORGE BACON* (Cotterell 1929, no. 180), struck under the rim; on the opposite side, *"IN THE STRAND"* *LONDON*; crowned *XX*, below.
PROVENANCE: Fitzhenry Gift.

As with other polygonal plates, the decoration at the edge has been applied and was not part of the original casting. This design, incorporating masks in addition to gadrooning, is rather more elaborate than usual and is based on contemporary silver examples.

BIBLIOGRAPHY: *Journal of the Pewter Society*, vol. 5, no.2, Autumn 1985, p. 37

64. Tankard (plate X)

Netherlandish, late 16th century
Clear glass with blue and latticinio stripes, fitted with a pewter lid and thumb-piece
Height: 24.4 cm. Diameter: 8.9 cm
588-1903

TOUCHES AND INSCRIPTIONS: None.
PROVENANCE: Cope Bequest.

65. Tankard

German (Saxon), dated 1646
Height: 20 cm
M.109-1935

TOUCHES AND INSCRIPTIONS: A lion with a column and pilgrim's bottle (unidentified). Engraved on the drum, *MARIA NÆGERIN* and on the lid *MF1646*.
PROVENANCE: Young Bequest.

Tankards decorated with engraved ornament were popular in Germany in the mid-seventeenth century. The present example was probably given as a wedding present.

BIBLIOGRAPHY: Düsseldorf Kunstmuseum 1981, pl. 48, Reinheckel 1983, pl. 26

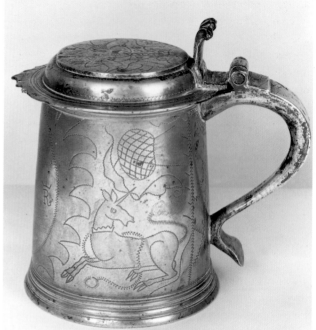

66a

66. Tankard

English, dated 1698
Height: 15.9 cm
M.63-1945

TOUCHES AND INSCRIPTIONS: The initials *TC* and the date *1697*, inside on base. Simulated hallmarks on top of cover; also crowned initials *IB* and *GB*, with the date *1698*.
PROVENANCE: Yeates Bequest.

The body is engraved with a representation of William III and the crowned initials *WR*, flanked by a lion, unicorn, rose and thistle.

This tankard has been the subject of a dispute and an interesting experiment. In March 1955, the *Daily Telegraph* published an article in which a Captain Owen Cunningham claimed to have made the tankard in 1929, in his words, 'when he was apprenticed to a firm turning out reproductions in a little upstairs room opposite the St Martin's Theatre'. Cunningham owned a famous oyster bar in London and was clearly something of a character. He said that he had scratched and hammered at the tankard to get an 'ancient' look. A favourite way of imparting an old look to pewter was to put the piece in a bag full of stones and nails, and shake it up. The corrosion and patination were created, he claimed, by means of 'coatings of nitric and sulphuric acid and a wash with olive oil'.

The Museum's response was to send the tankard and two others to the Government chemist for laboratory tests. The tankards were examined by spectrographic

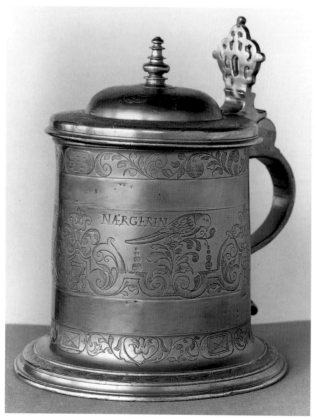

65

analysis, using x-ray diffraction. No significant difference in composition was disclosed between the three tankards and the x-ray diffraction showed that the corrosion products of the disputed tankard closely resembled those on the genuine examples. In the words of their report: 'in our opinion these facts established similarities between the genuine and the disputed tankard which support the view that it is authentic. No evidence to the contrary has been obtained.' The late Dr John Hayward, who was responsible for the pewter collection at the time, pointed out further that the owner had illustrated this tankard in an article of 1927 – so Captain Cunningham would have had to have made it at the age of 14!

In December 1973, Professor K. W. Cross of the Physiology Department at the London Hospital Medical College borrowed the tankard to illustrate a lecture he was giving about the importance of saving premature babies. It is recorded that Isaac Newton was so small, when born, that he could be fitted into a quart pewter tankard; so a perspex replica of the present piece was made, to contain a premature baby and prove the point.

BIBLIOGRAPHY: *Old Furniture*, 1927, p. 207, Hayward 1955, pp. 114–15

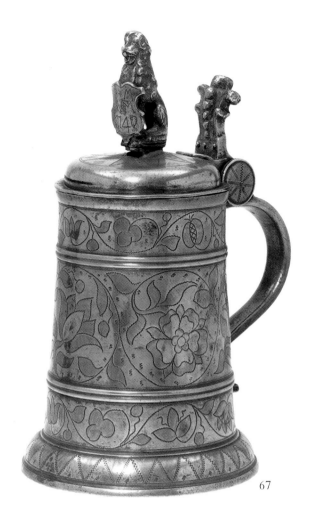

67

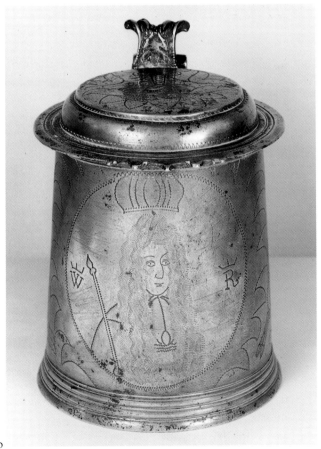

66b

67. Tankard

Swiss, 17th century
Height: 19.1 cm
M.112-1935

TOUCHES AND INSCRIPTIONS: Vevey quality mark on lid.
PROVENANCE: Young Bequest.

The engraved shield, initials and date are later additions.

68. Stave Mug

South German, about 1700
Height: 19 cm
M.170-1930

TOUCHES AND INSCRIPTIONS: Maker's touch of Andreas Haas, Kulmbach, Bavaria (Hintze 1928, VI, nos. 41, 42). Engraved with initials, *MSS*.
PROVENANCE: Port Bequest.

These mugs, also known as *Lichtenhain* tankards, were usually lined with pitch.

BIBLIOGRAPHY: Düsseldorf Kunstmuseum 1981, pl. 70

70

68

69

69. Puzzle Tankard

German, first third 17th century
Height: 19.4 cm
M.165-1939

TOUCHES AND INSCRIPTIONS: Maker's touch for Master
M D F (unidentified).
PROVENANCE: Gurney Bequest.

The base of the tankard is set with a screw to hold a muscat
nut and the contents run through a pipe into the handle,
which is fitted with a mouthpiece.

The body of the tankard is engraved with emblematic
signs of the zodiac.

BIBLIOGRAPHY: Mory 1961, fig. 46, Haedeke 1963,
figs. 291, 307

70. Serpentine Tankard, Mounted in Pewter

German (Saxony), first half 17th century
Height: 12.8 cm
M.6-1940

TOUCHES AND INSCRIPTIONS: None.
PROVENANCE: H. R. H. The Duke of Kent.

BIBLIOGRAPHY: Reinheckel 1983, p. 15

71. Stoneware Tankard, Mounted in Pewter (plate XI)

German (Freiburg), about 1675
Height: 20.8 cm
1937-1855

TOUCHES AND INSCRIPTIONS: Maker's touch of Samuel
Gunther of Freiburg (fl.1659–82).
PROVENANCE: Bernal Collection.

This form is known as a *Birnkrug*. Guild records state that
pewterers used to buy up stoneware pots to mount and sell
in their own shops. In some cases, German stoneware
vessels were imported and mounted with pewter in
England.

BIBLIOGRAPHY: Hintze 1919, p. 244, Horschik 1978, pp.
41–42, Gaimster 1997, cat. no. 148

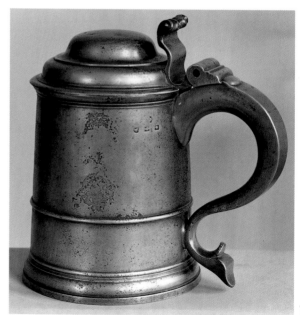

72

72. Tankard

English, about 1720
Height: 15.4 cm. Diameter: 12.5 cm
513-1901

TOUCHES AND INSCRIPTIONS: Maker's touch of William Eddon (Cotterell 1929, no. 1503), struck in the centre of the base. On the upper section of the drum, four hallmarks beneath the *X* mark.
PROVENANCE: Shoppee Collection, London.

William Eddon was a yeoman of the London Pewterers' Company in 1689 and is known to have specialized in tankards, also producing wares for export to America. He was very influential in the trade and his styles seem to have been widely copied.

BIBLIOGRAPHY: Robinson 1979, Hornsby 1983, p. 273, no. 927 (for an American tankard in the Eddon style)

73. Tankard

English, about 1785
Height: 21.9 cm. Diameter of lip: 13.9 cm
Diameter of base: 16.6 cm
512-1901

TOUCHES AND INSCRIPTIONS: Maker's touch of Pitt and Dadley, struck in the centre of the base. On the upper section, an engraved monogram *IAM* below a fouled anchor.
PROVENANCE: Purchased from the Shoppee Collection, London, for £7.10s.9d.

The monogram and cipher may indicate that this tankard was formerly the property of a naval officer.

BIBLIOGRAPHY: Michaelis 1971, fig. 29

74. Tankard

English, about 1680
Height: 18.1 cm
M.71-1938

TOUCHES AND INSCRIPTIONS: Maker's touch *RS* crowned (Robert Seare or Rowland Steward). Stamped under serrated lip, *IA*.
PROVENANCE: Carvick Webster Bequest.

This is one of a series of tankards engraved with royal portraits of William and Mary, with *W* and *M* intertwined before an *R*. Thirteen have been found and eight are by the maker RS, who has been identified as either Robert Seare or Rowland Steward. A plate in the Museum's collection (no. 76) was engraved by the same hand.

75. Tankard

English, about 1690
Height: 12.2 cm. Diameter of base: 11.5 cm
M.61-1945

TOUCHES AND INSCRIPTIONS: Maker's touch of a bird below *AB*, for Adam Banckes III (Cotterell 1929, no. 222a). Under the cover, *DT* engraved in wriggle-work, an owner's mark. On a label under the base, *Shewn Pewter Exhibition Clifford's Inn 1904*.
PROVENANCE: Yeates Bequest.

Adam Banckes (d.1716) worked in Wigan, Lancashire. He came from a long line of pewterers and could trace his family back to an ancestor of the same name who had been a pewterer in the 1470s. Another Banckes was an alderman in the 1540s. The family worked also in Chester, Bewdley and, probably, Ireland.

By the seventeenth century, the small market town of

75 73 74

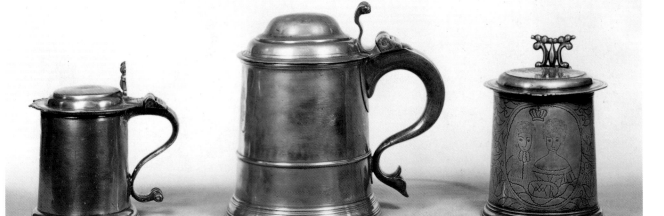

Wigan had become a major centre for the manufacture and distribution of pewter. In 1683 the pewterers were considering a petition that they should be incorporated by royal charter like the Pewterers' Company of London. It begins with the words 'Wigan consisting chiefly of pewterers' and over two hundred pewterers are recorded in the town in the seventeenth century. Surviving records of 'searches' made by the London Pewterers' Company between 1669 and 1683 reveal that Wigan then had eighteen pewterers, exceeding even York, which had sixteen. Other towns of comparable size, such as Kendal, had only two. It has been suggested that the reason for the growth of the industry in Wigan was the availability of fuel, such as wood and coal. The town also had a strong tradition of working in base metal. Braziers, bell-founders, blacksmiths, locksmiths, gunsmiths and clock-makers were all represented. Its geographical position on a line from north to south also meant that it was a convenient centre for distribution.

In 1634, Wigan had fifty-one licensed taverns, which no doubt provided a good living for those pewterers who made tavern pots and tankards. The trade lasted until the 1830s but, as with the industry generally, it had been in decline since the latter part of the eighteenth century, with the competition from the pottery industry.

BIBLIOGRAPHY: *Old Furniture* 1927, p. 20B, Gordon 1980

76. Plate

English, about 1695
Diameter: 22 cm
M.14-1991

TOUCHES AND INSCRIPTIONS: Maker's touch *RS* crowned (Robert Seare or Rowland Steward), stamped on the back.
PROVENANCE: Newsholme Gift. Mr R. H. Newsholme of Withens, Oakworth, West Yorkshire, had noted the similarity to the tankard in the Museum's collection and was keen to reunite them.

The plate is decorated in wriggle-work with flowers and scrolling foliage, surrounding a circular central panel containing portrait busts of William and Mary beneath a crown; below the figures in an oval cartouche is the royal monogram *WMR*.

This small plate is by the same maker as a tankard in the Museum's collection (no. 74). The wriggle-work seems also to be by the same hand, as the design and technique are virtually identical. The maker RS appears to have specialized in wares commemorating William and Mary.

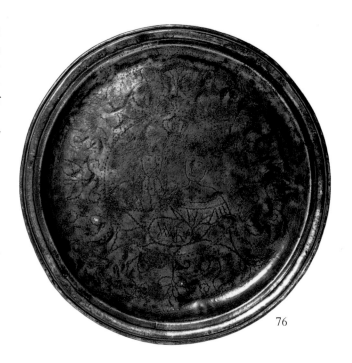

76

BIBLIOGRAPHY: *British Pewterware through the Ages* 1969, no. 108, Hornsby 1983, pl. 52 (possibly engraved by the same hand)

77. Tankard

North German, 1759
Height: 28.3 cm
32-1905

TOUCHES AND INSCRIPTIONS: *LU . . . PRO . . .* , with a crowned monogram (unidentified). Inscribed *ANNA GÖTSCHEN 1759.*
PROVENANCE: Purchased.

78. Tankard

North/central German, dated 1751
Height: 26 cm
M.168-1930

TOUCHES AND INSCRIPTIONS: Angel with initials *CFR*, which are also engraved on the drum. Quality mark.
PROVENANCE: Port Bequest.

The body of the tankard is engraved with the Fall of Man, Christ feasting with sinners and the Baptism of Christ. The two latter scenes are inscribed *JESUS NIEMBT DIE SÜENDER AN UND ISST MIT IHN* (Jesus receives sinners and eats with them) and *DAS IST MEIN LIEBER SOHN AN DEN ICH WOHL GEFALLEN HABE* (This is my beloved Son in whom I am well pleased).

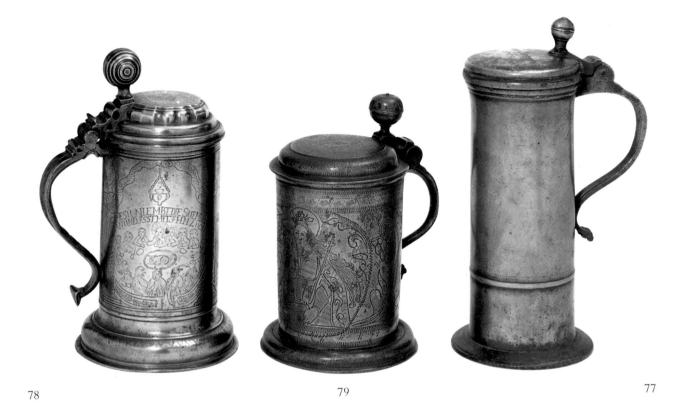

78 79 77

79. Tankard

German, dated 1709
Height: 21 cm
M.108-1935

TOUCHES AND INSCRIPTIONS: None.
PROVENANCE: Young Bequest.

The body of the tankard is engraved with a Virgin and
Child, the lid with the initials *ARCD* and the date *1709*.

80. Tankard (plate XII)

Swiss (Zurich), dated 1767
Height: 20.3 cm
M.34-1926

TOUCHES AND INSCRIPTIONS: *RW*, with Zurich mark and
one other. Inscribed with initials and date *1767*.
PROVENANCE: Gandolfi Hornyold Gift.

81. Beaker and Cover

German (Magdeburg), dated October 1763
Height: 16 cm
M.148-1930

TOUCHES AND INSCRIPTIONS: Engraved by Baron
Friedrich von der Trenck, in prison at Magdeburg.
PROVENANCE: Port Bequest.

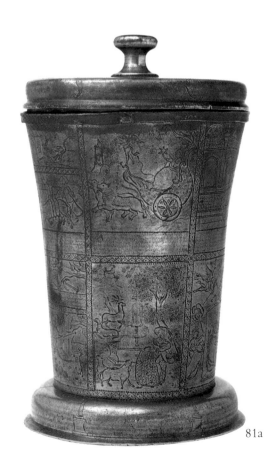

81a

This is one of about ten vessels that were engraved in a similar manner by Friederich, Baron von der Trenck, while he was imprisoned in Fort Etoile, Magdeburg. An account is given in his autobiography *The Life and Surprising Adventures of Frederick Baron Trenck* (fig. 14).

> . . . the daylight I enjoyed induced me to amuse myself by engraving satires, and little drawings with the point of my nail, on the tin cup out of which I drank: and I soon brought this art to so much perfection that my first attempt, though imperfect, was carried to the city. The commandant ordered another such cup to be given me; and in this, I succeeded better than the first; in short, the different majors under whose care I was, requested each a sample of my productions. A year passed away in this occupation with much seeming rapidity; and at length it obtained for me permission to have a light: as I used to write or draw on my cups in emblematic figures, such of the events of my life as I wished to make public, an order was given that all I might engrave should be shown to the governor before they were made public; but this order was neglected; the officers who mounted guard over me making a traffic of my productions, which they sold as high at least as twelve ducats a piece; and since I have

81b

recovered my liberty, their value is become so great that they are considered as curiosities. One of these cups fell by chance into the hand of Augustus Lobkowitz who was then prisoner of war at Magdeburg. At his return to Vienna, he made a present of it to the late Emperor Francis. On it I had engraved the representation of a vineyard with several husbandmen at work, and written underneath:

> *My vineyard flourished by my toil and care*
> *I hop'd, as a reward, the fruits to share:*
> *Says Jezebel, 'that vineyard shall be mine'*
> *Naboth was slain; another drank his wine.*

One of the scenes on the Museum's beaker, showing the baron sitting in a chair, chained to the wall with a chain and collar weighing 68 lbs., refers to an incident when Fort Etoile was under the command of General Borch. 'This cruel man came immediately to my prison, but like a hangman about to take charge of his victim. He was accompanied by locksmiths, carrying a weighty collar, which they put round my neck and a strong chain that was joined to that I had already at my feet; and to these were added two additional ones, so that I was really chained like a savage beast.'

Above the figures are captions: *Mordons la riste, sans reproche, Ecce Homo, Espere, joy.* Above are the arms of Trenck, *a bull affronté with two estoiles,* with the motto *toujours la meme;* to the left, a figure of time with *le prix de la paix;* to the right, a chained figure with a cross with the

14. Frederick Baron Trenck carrying a wounded comrade, from his autobiography *The Life and Surprising Adventures of Frederick Baron Trenck*, Hull, 18th century.

caption *Par ordre*. Above is a scene of a kneeling figure with a heart before a lady. Below in minute script are six lines of verse in German.

The entire surface of the beaker and cover is engraved with scenes and inscriptions, principally in German but also in French. The top of the cover is engraved with a series of subjects, some taken from Aesop's fables, with captions written in minute script below each in German. The central knob is engraved with a hunting dog on a leash. The inside of the cover is engraved in the centre with a circular panel with scrolling foliage containing four coats of arms, with a figure of Cupid in the centre and the motto *Lamitie nous unis* at the top. The arms are as follows and three are captioned:

Cross keys, *de Schritz*; St George's Cross and a bend with de . . . (the caption is incomplete); a bull's head and two estoiles, *Friedrich Baron Trenck*; a branch raguly with an estoile, *de Sebottendorf.*

The beaker can be dated exactly by the following engraved inscription:

Friedrich Freiherr von der Trenck Konigs Carabinier Rittmeister des Odonellitschen Regim und Consilartius esc porte Magnatum in Ungarn hat diesen becher im 10r Jahre seines gefangniltes: mit eine trett nagel verfertigt in Magdeburg 1763 in October zum gedachnis. (Friedrich Baron von der Trenck, member of the King's Carabineers, Rittmeister of O'Donells' Regiment and Consul to the Great Porte in Hungary, in the tenth year of his imprisonment he engraved this beaker with a bent nail finished in Magdeburg in October 1763.)

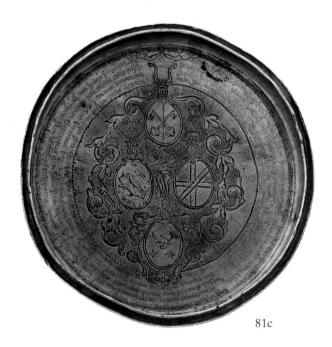

81c

Under the base there is a rhyming verse:

Mon lecteur genereux regarde ce gobblet
Connaissez vous le coeur de la main qui ça fait
Quel support pour mon sort, quel glorieux avantage
Je me voire connu, bien juge parles lages
Demasque l'apparence et voyez faisez bien
ou trouvez vous portrait plus touchant que le mien.

The engraved inscriptions on the base include one in Latin:

Trenckius hunc pictor figuris loquitur cartis pondera nunc prudens: fautor tunc eris lugentis (Here Trenck the artist with careful drawings, now a prudent fellow, tells of weighty matters)

Some of the letters are rendered in capitals. These represent Roman numerals, which can be added together to give the date 1738. The use of similar ciphers is not unknown on buildings. An inscription of similar character appears above the Wybrantzen Gate of Pszcztna castle in Poland, giving the date of construction as 1687. The significance of the date 1738 to Trenck is not clear.

Friedrich Baron Trenck was one of the most distinguished soldiers of fortune of the eighteenth century. Born in 1726 at Königsberg, he had an academic career at the university and was presented to Frederick of Prussia as one of the university's top scholars – hence the fluency of language demonstrated by the inscriptions. He also established a reputation as a duellist. After university, he joined the lifeguards, an elite regiment of the Prussian cavalry. He did not, however, neglect his intellectual studies and counted Voltaire, Maupertius, Jordan, La Meltrie and Pollnitz among his friends. He was appointed an orderly officer on Frederick the Great's own staff. His downfall followed a love affair with the king's sister Princess Amalie. The king had him arrested in 1743 as a spy and confined him in the fortress of Glatz, from which he escaped in 1746. After serving in Russia, he returned to Prussia in 1754 and was confined in the fortress at Magdeburg for nine years, five months and some days. In his own words, 'when I lay in the Bastille of Magdeburg, the mighty Frederick the Great said: "Whilst my name is Frederick, Trenck shall never see day".'

He made several attempts to escape and was chained to the wall, incidents which are recorded on the Museum's beaker. He described the scene as follows: 'When the carriage stopped I was led to my new dungeon. There by the light of several candles, the bandage that covered my eyes was taken off. But good Heaven, what did I perceive! Two locksmiths with their hammers and anvil, and the whole floor covered with chains. They immediately went to work. My feet were fastened with enormous chains to a ring

sunk into the wall at about three foot from the ground so that I could only move two or three steps to each side. They then girt my naked body with a broad iron girdle from which descended a chain fastened at the other extremity to a bar of iron two feet long. At each end of this bar was a handcuff that confined my hands and a collar was added in 1756'. One of the scenes on the body of the beaker depicts Baron von Trenck chained in this way.

At the end of the Seven Years War, Maria Theresa secured Trenck's release. He spent some sixteen years at Aix-la-Chapelle, after marrying the youngest daughter of one of the burgomasters. He not only published a newspaper but also started a wine business, based on Hungarian wines from his own estates. He bought an estate at Zwerbach in 1780 and there wrote his celebrated autobiography. He travelled extensively in Europe visiting France and England in 1774–77, and in 1788 came to Paris. He had been exhibited already as a wax-work, complete with chains, at the Palais Royal and had two plays written about him. He was lionized by Paris society: 'wherever I dined or supped all the friends and relatives of the family were invited that they might have a sight of me; and after meals the company immediately crowded round me with the same view'. He was also presented at the court of Versailles. He then retired to his estates to write, returning to Paris in 1791. He lived safely through the Terror, but was finally denounced as an Austrian spy and sent to the guillotine on 25 July 1794.

BIBLIOGRAPHY: Boucaud and Fregnac 1978, pl. 302

82. Peg Tankard

Norwegian (Bergen), about 1750
Height: 15.8 cm. Diameter of base: 11.5 cm
M.36-1926

TOUCHES AND INSCRIPTIONS: Maker's touch *MPB* with plants and *1736*, struck twice on the top of the handle, for Marcus Pedersson Brandt. On the base, incised *M SA*, an owner's name. On the lid, *M*, an owner's name.
PROVENANCE: Gandolfi Hornyold Gift.

The shape and decoration follow traditional Norwegian forms in silver. The casting is exceptionally heavy, especially the lid. Another tankard by this maker is in the Kunstindustrimuseet, Oslo, and a virtually identical model was for sale on the London art market recently. Peg tankards are a traditional drinking form, the level of the measure being indicated by the pegs set in the side.

BIBLIOGRAPHY: Brett 1981, p. 165, Hornsby 1983, p. 265

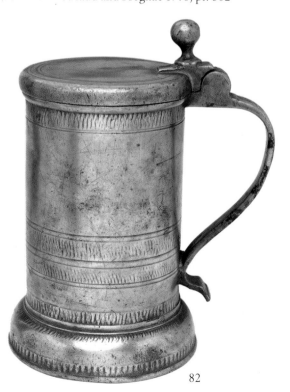

82

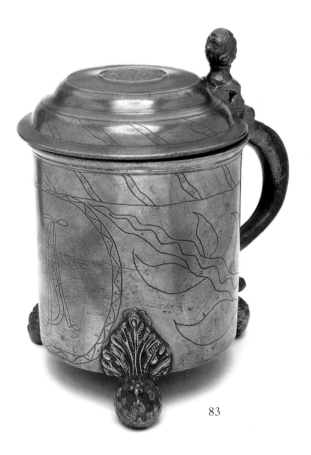

83

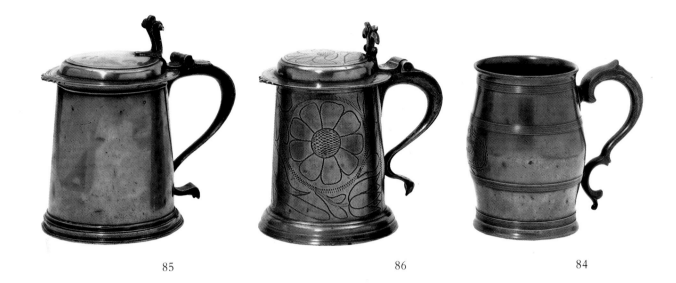

85 86 84

83. Tankard

Swedish (Visby?), about 1795
Height to rim: 14 cm. Diameter of rim: 14 cm
M.115-1935

TOUCHES AND INSCRIPTIONS: *ZB*, with a figure struck twice; the number *12*. Struck on the base, *W* below a low *I*; also *SPBS* in wriggle-work, an owner's initials. In wriggle-work on the body, *JR*, an owner's initials. Set into the lid, a medallion of the arms of Sweden crowned within a wreath, with *I R* with *GUD OCH FOLKET* and *1794*.
PROVENANCE: Young Bequest.

The 'double-head' thumb-piece makes this an unusual piece. Swedish tankards, especially of silver, often have medallions, coins or casts of coins set into them. The medallion on this vessel is dated 1794.

BIBLIOGRAPHY: Brett 1981, p. 164, Hornsby 1983, p. 891

84. Mug

English, about 1800
Height: 15 cm. Diameter: 10 cm
M.124-1935

TOUCHES AND INSCRIPTIONS: Engraved on the body, *SOUTHWARK CHAPEL*, within an open wreath. Near the rim, stamped verification marks; William IV together with the arms of the City of London; the *X* mark stamped twice; George IV with the initial *W*.
PROVENANCE: Young Bequest.

'Hooped' tankards were introduced in the 1750s and were especially fashionable in the 1830s. Common in silver, they are much rarer in pewter. A smaller version of this tankard is in the collection of the Pewterers' Company.

BIBLIOGRAPHY: Worshipful Company of Pewterers 1968, p. 51, 25d Pewterers' Company, Hornsby 1983, no. 986

85. Tankard

English, about 1670
Height: 14 cm. Diameter of base: 13.4 cm
M.167-1930

TOUCHES AND INSCRIPTIONS: Maker's touch *CR*, struck in the centre of the base (for Charles Richardson?). On the lid, a lion rampant within a shield struck three times; on the edge of the cover, stamped *R IB*, an owner's mark.
PROVENANCE: Port Bequest.

BIBLIOGRAPHY: Cotterell 1929, pl. LXX, Hornsby 1983, p. 258

86. Tankard

English (West Country?), about 1685
Height: 13.9 cm. Diameter of base: 13.2 cm
M.115-1930

TOUCHES AND INSCRIPTIONS: Maker's touch *LA* above a fleur-de-lys (unidentified). On the top of the handle, *LP* engraved, an owner's mark.
PROVENANCE: Purchased from J. Seymour Lindsay, for £20.

BIBLIOGRAPHY: Cotterell 1929, p. 138a and b, Hornsby 1983, p. 42, no. 47

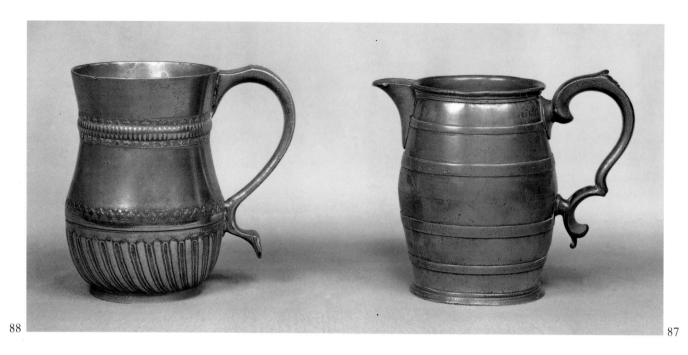

88 87

87. Jug

English, about 1825
Height: 11.8 cm. Diameter of base: 7.7 cm
M.123-1935

TOUCHES AND INSCRIPTIONS: Inside the base, a touch,
probably of Gerardin and Watson (Cotterell 1929, no.
1837, although the present touch contains a *6* in the
centre, rather than a *2*). Below the lip, *RM* with three
simulated hallmarks (Cotterell 1929, no. 8795). On the
body, an engraved monogram *WLW*.
PROVENANCE: Young Bequest.

This jug is probably converted from a tankard. A virtually
identical tankard without the spout is in the Law Collection.
Cotterell notes a similar touch on a piece dated 1826.

BIBLIOGRAPHY: Hornsby 1983, no. 986

88. Mug

English, about 1710
Height: 12.4 cm. Diameter: 8.6 cm
M.59-1945

TOUCHES AND INSCRIPTIONS: Maker's touch of William
Hux (Cotterell 1929, no. 1498), struck in the centre of
the base. Engraved on the thumb-piece, *EI*, an owner's
mark. Struck four times near the rim, a lion rampant
within a shield.
PROVENANCE: Yeates Bequest.

Cotterell noted this as 'a very rare and beautiful mug'. The
shape and possibly the decoration are based closely on
silver prototypes of the late 1680s; a silver mug of similar
design is recorded with London hallmarks for 1688.
Another pewter mug by William Hux, with similar
decoration but of smaller proportions, was included in an
exhibition *British Pewterware through the Ages*, at Reading
Museum in 1969. Hux was admonished in June 1703 by the
Pewterers' Company for making watch-cases of poor-
quality metal. The hallmark of a lion rampant repeated has
been noted on a damaged posset cup of about 1690
recovered from Port Royal. Another example was in the
Mundey Collection.

BIBLIOGRAPHY: Cotterell 1929, pl. LXXIXd, Victoria and
Albert Museum 1960, pl. 19a, Clayton 1971, no. 373

89. Stoneware Jug, Mounted in Pewter (plate XIII)

German, second half 16th century
Height: 23.1 cm
780-1863

TOUCHES AND INSCRIPTIONS: None.
PROVENANCE: Purchased (Weckherlin Collection).

The figure holds in his right hand a stoneware jug of the
Cologne type, with the metal lid held back, and a tall
drinking glass (or 'flute') in his left.

BIBLIOGRAPHY: De Weckerlin 1860, pl. 24, Gaimster 1997,
no. 44

90. Serpentine Flask, Mounted in Pewter

German (Annaberg), about 1655
Height (including cap): 19 cm. Diameter: 10.2 cm
808-1902

TOUCHES AND INSCRIPTIONS: Maker's touch *HEINRICH JOBIN* struck twice and a regional mark, struck on the top of the screw-cap; incised under the cap, *A*, an owner's identification mark.
PROVENANCE: Purchased with another flask (807-1902), for £6. Collector's mark in ink on the mount, *30/5/16*.

Vessels of this form are known as *Schraubflasche*, screw-flasks, and were possibly introduced by Nuremberg pewterers in the seventeenth century. Writing in the sixteenth century, Agricola states that serpentine was obtained from Zöblitz bei Marienberg in Saxony. Most of the serpentine wares mounted in pewter are of Saxon origin. The maker Heinrich Jubin came from a family of pewterers recorded in Annaberg from the early seventeenth century. He seems to have specialized in serpentine wares, as others are recorded in various collections.

BIBLIOGRAPHY: Hintze 1921, I, p. 10, Haedeke 1970, p. 218, pl. 179, Hornsby 1983, p. 254, no. 865

91. Serpentine Flask, Mounted in Pewter

German (Nuremberg), about 1650
Height (including cap): 21.5 cm. Diameter: 10.2 cm
M.447-1926

TOUCHES AND INSCRIPTIONS: Maker's touch *FRANTZ PFISTER*, combined with the town mark of Nuremberg, struck on the cap.
PROVENANCE: Croft Lyons Bequest. On the base, a collector's label, *Lt. Colonel Croft Lyons No. Oxford 25/5/04 AM/- "99"*. Purchased in Oxford.

The serpentine body is almost certainly of Saxon origin, from Zöblitz bei Marienberg (see no. 90). Screw-flasks (*Schraubflasche*) were a Nuremberg speciality and this maker is known to have made other serpentine flasks, one being in the Germanisches Nationalmuseum, Nuremberg.

BIBLIOGRAPHY: Hintze 1921, II, p. 102, no. 291

92. Wine Flask

German (Nuremberg), about 1575
Height: 26.2 cm. Diameter of base: 8.6 cm
462-1873

TOUCHES AND INSCRIPTIONS: Town mark of Nuremberg, struck below the neck. Incised in the base, a cross and *VI*, an owner's identification mark.
PROVENANCE: Purchased from J. H. Goldschmidt, for £2.15s.

90

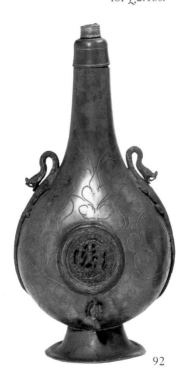

92

91

The body of the flask is incised in wriggle-work with scrolling foliage. In the centre of each face is set a cast openwork medallion, probably depicting Hercules at the Pillars. The cap is a later replacement from another vessel. The original cap was linked to the body by a chain. The gilding was probably applied after the replacement cap had been associated with the vessel, as traces of gilding remain in the turned design on the cap. This suggests that the gilding is comparatively late. The two mounts at the side, cast in the form of dragons, and that set below the medallion were for a chain to carry the vessel.

This form of flask seems to have been a speciality of Nuremberg pewterers. Similar flasks are preserved in German collections; the Kunstmuseum, Düsseldorf has an example bearing Nuremberg marks. The cast medallions are also typical of the later Nuremberg small reliefs.

These vessels have been identified as powder-flasks, an example having been found on the battlefield of Pavia (1525). However, almost all powder-flasks of the period are flat and there seems little doubt that this one was intended for wine.

BIBLIOGRAPHY: Haedeke 1970, p. 202, Düsseldorf Kunstmuseum 1981, p. 23

93. Flask

German, dated 1661
Height: 35.1 cm. Width: 21 cm
M.10-1912

TOUCHES AND INSCRIPTIONS: The date *1661*, engraved in a wreath; with two coats of arms.
PROVENANCE: Purchased.

94. Wine Can

Swiss (Berne), dated 1777
Height (excluding lid): 27.2 cm
Diameter of base: 12.8 cm
M.137-1930

TOUCHES AND INSCRIPTIONS: Maker's touch *LUDWIG RODER*, with crowned *F* quality mark struck twice on the lid. The name of the owner is engraved on the body, *CHRISTI GROSINBACHER 1777*. An angel.
PROVENANCE: Port Bequest.

This is a fine example of a well known type of vessel from Berne. Characteristic are the palmette thumb-piece and hinged spout cap. The practice of representing the end of the strut that joins the body to the spout in the form of a hand is also typical. As with many Swiss pewter wares, there is a marked difference between the quality of the casting and workmanship, and the charmingly naive engraved ornament.

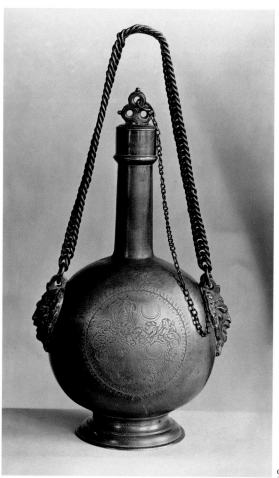

93

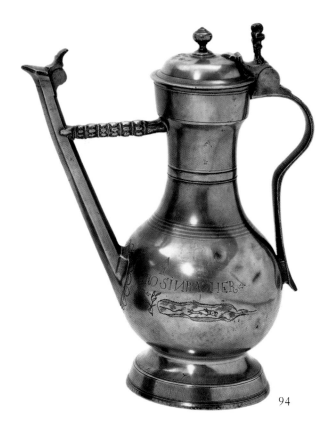

94

96. Wine Can

Swiss (Zurich), dated 1788
Height (excluding cap): 26.5 cm
Width of base: 15.7 cm
M.38-1926

TOUCHES AND INSCRIPTIONS: Maker's touch *ANNA ELISABETH MANZ*, with town mark for Zurich, struck on the cap. Engraved on the body, *HK 1788*, within a floral wreath. Incised under the cap, *IF, HS*, owners' initials.
PROVENANCE: Gandolfi Hornyold Gift.

Flasks of this form (*Prismekanne*) were used for liquids and for liquid foods, such as porridge. The spout has a slight step and a cast dolphin mount for a chain to be attached to the cap, and is found on other flasks by members of the Manz family of pewterers. The body, which is decorated in wriggle-work with flowers and leaves, has been repaired with solder adjacent to the spout.

97. Wine Can

Austrian (Graz), dated 1669
Height: 24.4 cm. Diameter: 19 cm
M.19-1943

TOUCHES AND INSCRIPTIONS: Maker's touch of Master Hans Gugler, Graz (Hintze 1931, VII, no. 842), dated *1669*.
PROVENANCE: Purchased.

The bottle is inscribed, *DIESE FLASCHEN VEREHR ICH MEINEN VIEL GEEHTEN HERNN SCHWAGERN PAULUS ROSTAUSCHER ZU EINEN GLICKSELLIGEN NEUEN IAHR GOTT WOLLE IHM BEI LANG WIR RIGER GESUMHEN DAR BEI GNEDICHGLICH ERHAL* (I present this bottle to my much esteemed brother-in-law M. Paulus Rostaucher for a Happy New Year. May God grant him enduring health and mercifully preserve . . .). Also engraved *HANNS GUGLER* above a cannon, ball and ewer (?) within a laurel wreath, and one the other side, with the name *PAULUS ROSTAUSCHER*.

BIBLIOGRAPHY: Hintze 1931, VII, no. 842

98. Flask

Swiss, dated 1684
Height: 31.8 cm
1332-1872

TOUCHES AND INSCRIPTIONS: None.
PROVENANCE: Purchased.

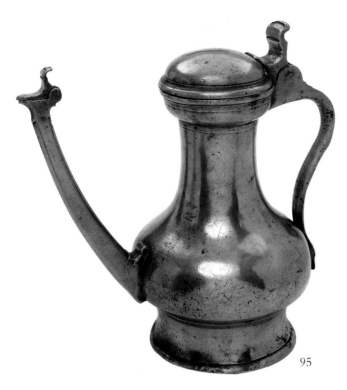

95

95. Wine Flagon

Dutch, about 1690
Height: 20.6 cm. Diameter of base: 12.3 cm
Diameter of body: 15 cm. Length of spout: 16.2 cm
1005-1905

TOUCHES AND INSCRIPTIONS: *B*, within a rose and crown – illegible mark struck on the handle. In the centre of the base, an incised merchant's mark. Around the edge of the base, *GISENENBUSUM*, an owner's name. At the front, an inscription has been polished away.
PROVENANCE: Child Gift. This flagon was purchased from Thrond Ohlson, Øistenso on the Hardanger Fjord, who bought it at the sale of the effects of Preste Jackson of Vikor, who had had it as an heirloom.

This well known type of flagon is popularly known as a 'Jan Steen flagon' after the Dutch painter, as they appear in his work. Flagons with spouts were known in France and Switzerland from the fourteenth century, but this basically Gothic form lasted well into the eighteenth century in Switzerland. The vessel seems to have been used for wine. It is possible that this example is in fact Norwegian, given its provenance, as the style was also popular in Norway in the eighteenth century. However, the form of mark and the name inscribed under the base are Dutch.

BIBLIOGRAPHY: Boucaud 1958, nos. 202, 203, 211, *Keur van tin* 1979, no. 37, Brett 1981, p. 147

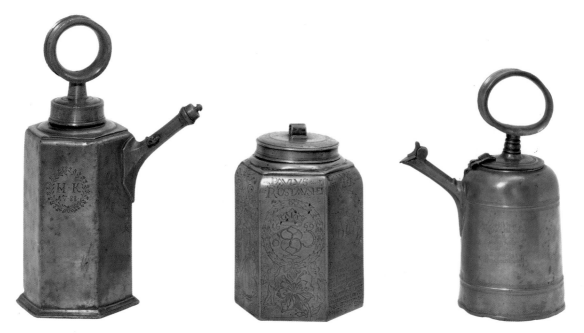

96 98 97

The flask is of a form known as *Glockenkanne*. The centre of the base is cast in relief with a medallion in the form of a vase of flowers. The body has a raised shield, engraved with the owner's initials *CZ*, and is engraved with wriggle-work scrolls and inscriptions:

A 1684 DEN 21 JULI VEREHREN NACHBENANTE MATHEUS PFENDERN ZUE SEINEM HOCHZEITLICHEN EHREN TAG DISE KANNEN

> *DAVID ZORN*
> *MATHEUS BACHS REID*
> *LEONHARDT ADE*
> *JOHANNES KOLLER*
> *JACOB ZORN*
> *MATHEUS RUST*
> *MATHEUS B/D[?]ONOLD*

The inscriptions record the gift of this flask by the seven named donors to Matheus Pfendern on the occasion of his marriage, on 21 July 1684. Two of the donors have the surname Zorn, either brothers or father and son. The vessel has no maker's touch, but has a medallion of unusual design cast into the base.

99. Water Bottle

English, about 1800
Height: 24.3 cm. Diameter of base: 10.6 cm
M.420-1926
TOUCHES AND INSCRIPTIONS: Maker's touch *THOMAS COMPTON* (Cotterell 1929, no. 1063), struck under the base. Incised under the lip, *NH*, owner's initials.
PROVENANCE: Croft Lyons Bequest. On a label under the

base, *Bought of Roe Cambridge V/-.*

A very similar vessel was formerly in the Navarro Collection.

BIBLIOGRAPHY: Cotterell 1929, p. 144e

99

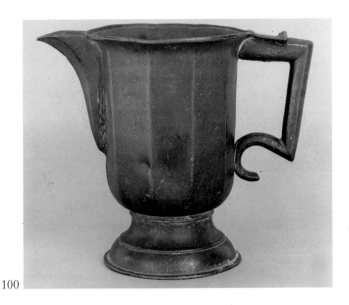

100

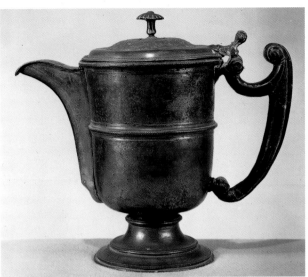

101

100. Ewer

French, about 1600
Height: 19 cm
M.47-1971

TOUCHES AND INSCRIPTIONS: Maker's touch *IM* and a town mark (?), struck under the base. Below the rim on either side of the body, an illegible mark within an oval border.
PROVENANCE: Harris Gift.

This ewer is closely based on contemporary silver prototypes, of similar shape, without the faceted body but with identical handles and large platform thumb-pieces, which were made by Paris goldsmiths in the early years of the seventeenth century. The form is also found in brass and bronze. Surviving examples in pewter, however, are much rarer.

101. Ewer

French (Rodez, Auvergne), about 1700
Height (excluding lid): 19.7 cm.
Diameter of base: 12.2 cm
M.119-1935

TOUCHES AND INSCRIPTIONS: Maker's touch *BUCALENC*, struck on the base. Engraved on the handle, *L M*, owner's initials.
PROVENANCE: Young Bequest.

The Bucalenc family was established in the pewter trade in Rodez before the end of the sixteenth century. This is probably the work of Jean Bucalenc, working a century later.

BIBLIOGRAPHY: Tardy 1964, p. 599, Hornsby 1983, pp. 236, 796, 797

102. Ewer

French (Paris?), about 1700
Height: 24 cm
M.520-1926

TOUCHES AND INSCRIPTIONS: Maker's touch *PANCHETTE* and quality mark *FIN*, struck under the foot. Engraved on the handle, *IP*, an owner's initials.
PROVENANCE: Croft Lyons Bequest. Collector's label, *Lyon 13/9/05 PI Francs.*

This is a classic example of the French *aiguière*, the handle with large shell-shaped upper section, the foot with gadrooned ornament, the helmet-shaped body with two horizontal mouldings. The maker Panchette is not recorded in the list of Parisian makers, but ewers of similar form are known bearing the touches of Parisian pewterers.

103. Ewer

French (Bordeaux), about 1700
Height: 26.7 cm. Diameter of base: 12.6 cm
M.539-1926

TOUCHES AND INSCRIPTIONS: Maker's touch *P. COUSTANS ESTAIN RAFINE*, struck on the base. Engraved on the front, two coats of arms.
PROVENANCE: Croft Lyons Bequest.

A maker P. Coustans is recorded in documents in Bordeaux dated 1685.

BIBLIOGRAPHY: Tardy 1964, p. 249

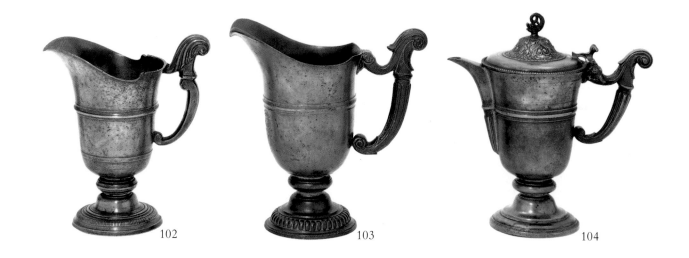

102 103 104

104. Ewer

French (Lyons), about 1690
Height (excluding lid): 21.1 cm
Diameter of foot: 12.1 cm
74-1904

TOUCHES AND INSCRIPTIONS: Crowned *F* quality mark,
struck on the base.
PROVENANCE: Fitzhenry Gift.

Ewers of this form are usually attributed to Lyons. It has
been suggested that variants of the design were produced
in Geneva and examples by Metz makers are also recorded.
As with other ewers of this shape, silver prototypes formed
the basis for the design.

BIBLIOGRAPHY: Tardy 1964, pp. 425, 443, Boucaud and
Fregnac 1978, pl. 355, Hornsby 1983, p. 796

105. Ewer

French (Paris), about 1680
Height: 20.2 cm
M.665-1926

TOUCHES AND INSCRIPTIONS: Struck on the side of the
handle. Incised under the foot, *IVR*, owner's initials.
PROVENANCE: Croft Lyons Bequest. Inscribed on the
base, *LOTER À PARIS 23/4/08 PI FRANCS.*

This is a good example of a French *aiguière*. Helmet-shaped
ewers were based on contemporary silver prototypes.
Certain features, such as the shape of the foot, are found on
pieces bearing the touches of Parisian pewterers. However,
the maker's touch is not of the form normally found. The
handle also differs from that used on Paris-made ewers. It is
possible, therefore, that this object was made in the French
provinces.

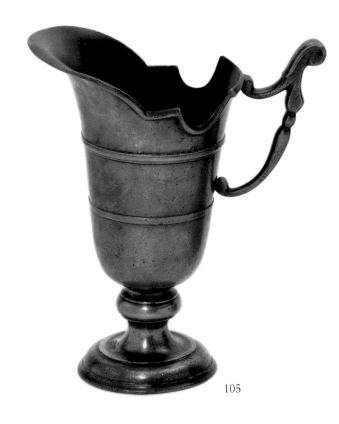

105

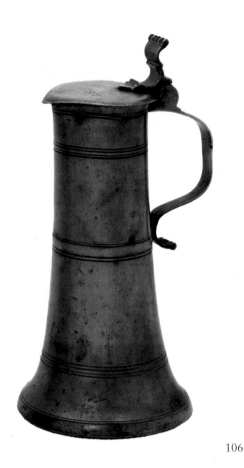

106

106. Flagon

French (Strasbourg), about 1757
Height (excluding lid): 27 cm.
Diameter of base: 15.2 cm
M.554-1926

TOUCHES AND INSCRIPTIONS: Maker's touch *JEAN FREDERIC SCHATS*, with the control mark for Strasbourg, struck on the handle. Engraved on the lid, *ML*, with the date 1757.
PROVENANCE: Croft Lyons Bequest. Inside the lid, a collectors' label, *Lt. Colonel Croft Lyons No. 111 Rue de Seine, Paris 17/10/05. MN frcs.*

This type of flagon was common in Strasbourg. The Schatz family was established in the city by the seventeenth century. J. F. Schatz was born in 1713 and was working until the 1770s.

BIBLIOGRAPHY: Riff 1977, pl. XXb, p. 84

107. Flagon

South German, second half 18th century
Height: 43 cm
962-1905

TOUCHES AND INSCRIPTIONS: *IOH: BA . . .* [Master Johannes Barth?] *F*[ein] *BLOCK Z*[inn], with St Michael and a stag.
PROVENANCE: Said to have come from a convent in the Tyrol.

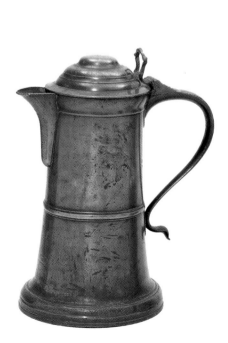

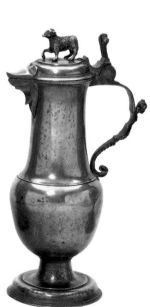

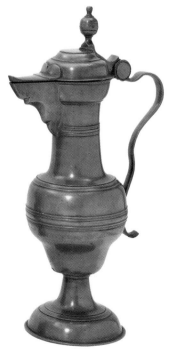

109

108

107

108. Flagon

South German, first half 18th century
Height: 35.5 cm
315-1906

TOUCHES AND INSCRIPTIONS: Illegible maker's touch, . . .
MANN ENG: BLOCK ZINN, with a figure of
St Michael.
PROVENANCE: Purchased.

109. Flagon

English, about 1725
Height (excluding cover): 29 cm
Diameter of base: 20 cm. Diameter of top: 14.3 cm
M.133-1930

TOUCHES AND INSCRIPTIONS: None.
PROVENANCE: Port Bequest.

Engraved with a ship and the inscription *Mary Edwards
Deptford Back Lane.* The only Mary Edwards in the register
of burials in Deptford between 1730 and 1800 is described
as the wife of Loving Edwards, Gentleman. She was buried
in 1733.

110. Beer Jug

English, about 1830
Height: 27.6 cm. Diameter of body: 14.4 cm
725-1904

TOUCHES AND INSCRIPTIONS: Engraved on the body, *J.G.*
PROVENANCE: Purchased from P. L. Isaac, London,
for £3.

According to the vendor, this pewter jug was given by
'Paddy' Green of Evans Supper Rooms, Covent Garden.
Known as 'the father of English music hall', Green
(1801–1874) was an actor at the Old English Opera House,
London, and at Covent Garden. In 1842 he became
chairman and conductor of music at Evans Hall and
acquired the business in 1845. He sold out to a joint-stock
company in 1865 for £30,000. A print of the interior of
Evans Supper Rooms shows similar jugs on the tables, and
this was probably one of the regular vessels used in the
supper rooms.

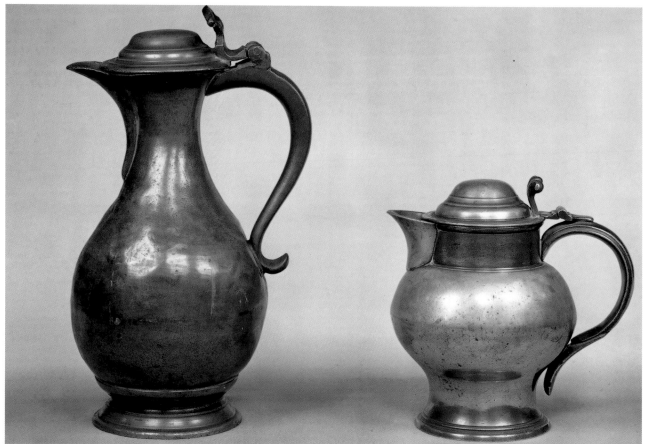

110

111

111. Ale Jug

English, about 1800
Height: 17.4 cm. Diameter of base: 10 cm
M.165-1930

TOUCHES AND INSCRIPTIONS: A beehive within a collar
below crowned *X* and *H* (Cotterell 1929, no. 6133,
unattributed).
PROVENANCE: Port Bequest.

A large number of these pleasingly designed jugs have
survived. They seem to have been used for beer, cider and
perhaps wine. They are sometimes described as Oxford
measures. It is thought that the strainer served to prevent
hops from passing into the tankard.

BIBLIOGRAPHY: Cotterell 1929, pl. XLIIIf, Worshipful
Company of Pewterers 1968, p. 51, no. 26, Hornsby 1983,
no. 786

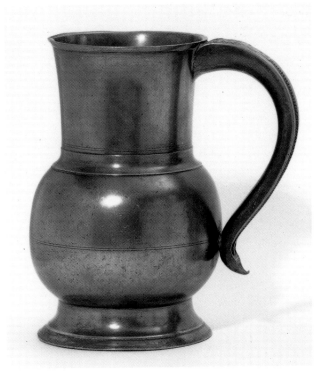

113

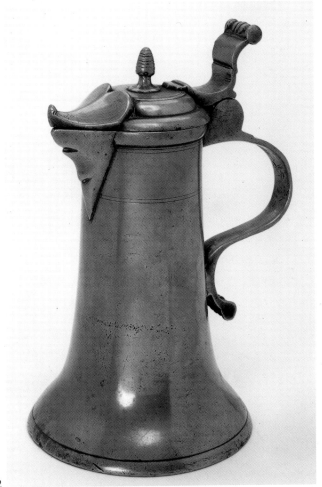

112

112. Spouted Flagon

Swiss (Basle), 18th century
Height: 17.5 cm
M.30-1926

TOUCHES AND INSCRIPTIONS: Maker's touch *ES*, with the
Basle staff (unidentified).
PROVENANCE: Gandolfi-Hornyold Gift.

113. Water Jug

French, about 1800
Height: 18.2 cm
M.663-1926

TOUCHES AND INSCRIPTIONS: None.
PROVENANCE: Croft Lyons Bequest. On the base, in ink,
NANTES 17/4/08 AV FRANCS. Purchased in Nantes.

The body with globular lower section, the handle cast in
relief with formalized acanthus and cable decoration. This
form of jug was very popular in France and was made with
little variation from the mid-eighteenth to the late
nineteenth century.

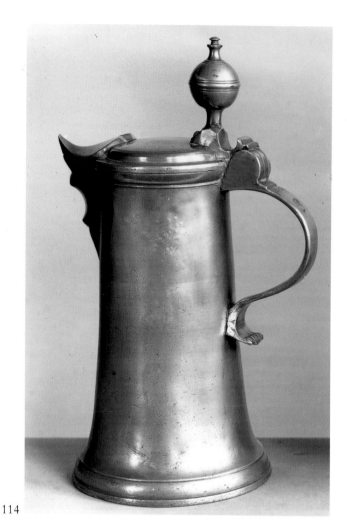

114

114. Spouted Flagon

South German (Württemberg), dated 1758
Height: 28.7 cm
323-1906

TOUCHES AND INSCRIPTIONS: Maker's touch *GMS*,
with a castle (unidentified).
PROVENANCE: Purchased from Ernest Savory, Bristol.

BIBLIOGRAPHY: Aichele 1977, pp. 108–11, pl. 44

115. Vessel

English, second half 17th century
Height: 5.7 cm. Diameter: 8.7 cm
M.141-1930

TOUCHES AND INSCRIPTIONS: None.
PROVENANCE: Port Bequest. Said to have been excavated
in Newgate Market, London.

This is a vessel of unique form. The incurving sides make it
impractical for use as a drinking vessel. The ear seems to
have been attached formerly to a vessel that served another
purpose. The shape of the moulded rim indicates that it
was once fitted with a lid. In its original form this may have
been a small pot.

BIBLIOGRAPHY: Port 1917, p. 200

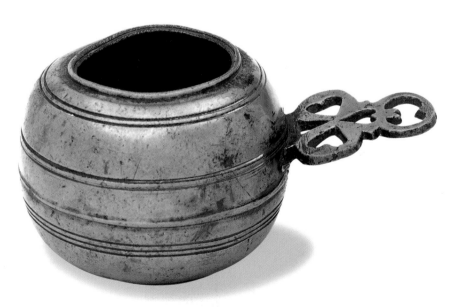

115

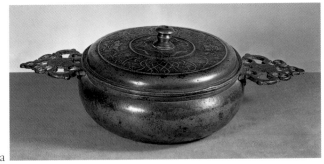

116a

116. Porringer

English, late 17th century
Diameter: 15.2 cm
M.51-1945

TOUCHES AND INSCRIPTIONS: Maker's touch of John Waite of London, on the underside of one of the handles (Cotterell 1929, no. 4903; London touch plate, no. 224).
PROVENANCE: Yeates Bequest. Found in London.

The cover and the inside of the base are decorated with a cast design of flowers, enclosing profile portrait busts of William III and Queen Mary, with their cipher surmounted by a royal crown.

BIBLIOGRAPHY: Yeates 1927, p. 211, fig. 24, Cotterell 1928, pp. 39–41, Michaelis 1958, pp. 59–63

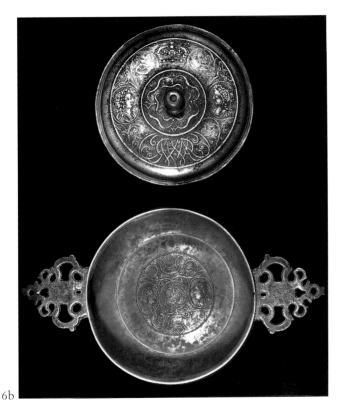

116b

117. Two-Handled Cup (plate XIV)

English, late 17th century
Height: 13.3 cm
M.45-1945

TOUCHES AND INSCRIPTIONS: The letter *F* under a pellet in a heart-shaped shield (unidentified).
PROVENANCE: Yeates Bequest.

BIBLIOGRAPHY: Yeates 1927, p. 107, Cotterell 1929, pl. XXXIIIe

118. Two-Handled Cup (plate XIV)

English, early 18th century
Height: 10.2 cm
M.125-1935

TOUCHES AND INSCRIPTIONS: None.
PROVENANCE: Young Bequest.

This cup demonstrates clearly the widespread tendency at the end of the seventeenth century for pewterers to copy silversmiths' forms, such as the adjacent silver example in the colour plate (Circ. 487-1921), which was made by J. Downes and bears a London hallmark for 1697.

119. Loving Cup or Wassail Bowl

English, about 1730
Height: 15.3 cm. Diameter of base: 11.3 cm
Diameter of lip: 16.8 cm
M.47-1945

TOUCHES AND INSCRIPTIONS: A dealer's mark incised into the base.
PROVENANCE: Yeates Bequest.

Loving cups or wassail bowls were used for toasts at formal functions and feasts, the cup being passed from hand to

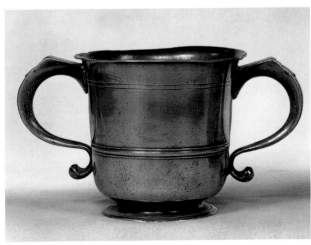

119

hand. The incised band within the bowl is presumably an indication of the level to which the cup should be filled.

BIBLIOGRAPHY: Yeates 1927, fig. 2, Worshipful Company of Pewterers 1968, p. 64, Michaelis 1971, p. 64, Hornsby 1983, p. 295, no. 1008 (for a wassail cup probably from the same workshop)

120. Porringer

English, early 18th century
Diameter: 13.6 cm
M.55-1945

TOUCHES AND INSCRIPTIONS: Maker's touch of John Quick, London, registered 1701 (Cotterell 1929, no. 3807; London touch plate, no. 591). On the upper side of the handle, an owner's initials.
PROVENANCE: Yeates Bequest.

BIBLIOGRAPHY: Cotterell 1929, pl. LX

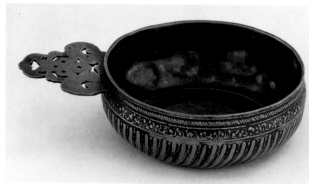

120

121. Bowl

English, about 1700
Height: 7.5 cm. Diameter: 12.2 cm
M.140-1930

TOUCHES AND INSCRIPTIONS: Engraved on the lower section of the bowl, *LINCOLN'S INN 1704*.
PROVENANCE: Port Bequest.

122. Porringer

Swiss, 18th century
Diameter: 14 cm
M.59-1926

TOUCHES AND INSCRIPTIONS: St Michael holding a shield inscribed *EST*. In the exergue, *PIN*.
PROVENANCE: Gandolfi Hornyold Gift.

123. Porringer

German, early 18th century
Max. diameter: 25.4 cm
M.551-1926

TOUCHES AND INSCRIPTIONS: Maker's touch *PHILIPP LUDWIG KRES FEIN ENGLISCH ZIN*, with a figure of St Michael. The centre engraved *MCG*.
PROVENANCE: Croft Lyons Bequest.

The eagles' heads serve as feet for the lid when removed.

124. Porringer

Dutch, late 18th century
Height: 4.5 cm. Diameter: 12.5 cm
M.890-1926

TOUCHES AND INSCRIPTIONS: Maker's touch *BDH* above seeded and crowned rose, struck on the top of one 'ear'.
PROVENANCE: Croft Lyons Bequest. Purchased in The Hague.

The form of the 'ear' bears some resemblance to those found on porringers from Groningen, which also have an elaborated rose print, as on this example.

BIBLIOGRAPHY: Dubbe 1978, p. 285, Brett 1981, p. 159

125. Porringer (plate XV)

French, late 18th century
Max. length: 27.3 cm
M.552-1926

TOUCHES AND INSCRIPTIONS: *DETR . . . 17*, with an eagle displayed, *RAFINE* with *F*, two fleurs-de-lys and *B*.
PROVENANCE: Croft Lyons Bequest.

The knob depicts the head of Emperor Nero.

126. Porringer (plate XV)

French, early 18th century
Max. length: 27.9 cm. Height: 9.5 cm
M.959-1926

TOUCHES AND INSCRIPTIONS: None.
PROVENANCE: Croft Lyons Bequest.

121

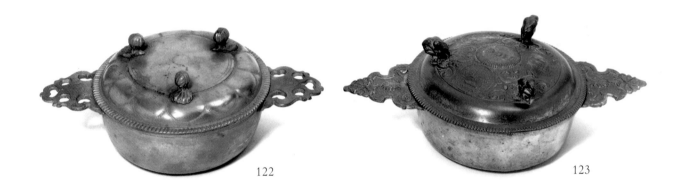

122

123

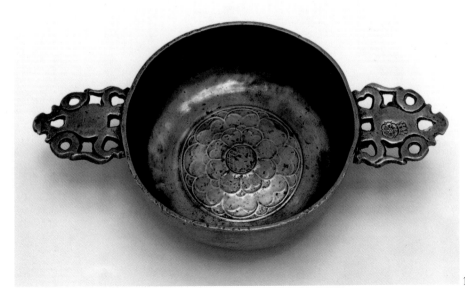

124

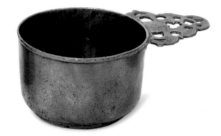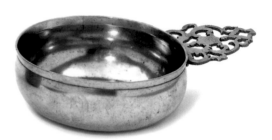

129 128 127

127. Porringer

American (Providence, Rhode Island), about 1795
Diameter: 12.7 cm. Depth: 4.4 cm
M.1068-1926

TOUCHES AND INSCRIPTIONS: Maker's touch *SAMUEL HAMLIN*, struck on the handle.
PROVENANCE: Croft Lyons Bequest.

Samuel Hamlin is recorded from 1746 to 1801 in Providence, Rhode Island. He served as a Lieutenant in the 1st Rhode Island Regiment in 1778 and died insolvent in 1801. Porringers were one of his specialities. This is one of two American pieces in the collection.

BIBLIOGRAPHY: Kerfoo 1942, fig. 161, Laughlin 1971, pl. 336

128. Porringer

English, late 17th century
Diameter: 9.8 cm
M.54-1945

TOUCHES AND INSCRIPTIONS: None.
PROVENANCE: Yeates Bequest.

BIBLIOGRAPHY: Yeates 1927, p. 108, fig. 11

129. Half- Pint Beaker

English, about 1830
Height: 10.1 cm. Diameter of rim: 8.9 cm
M.98-1945

TOUCHES AND INSCRIPTIONS: In the base, the letter *X*. On the upper section of the body, a cross. Incised on the base, *S*, an owner's mark.
PROVENANCE: Yeates Bequest.

The light thin casting and the squat shape indicate a date in the first half of the nineteenth century. The cross may indicate ecclesiastical use, possibly as a beaker chalice, a type that is known to have come to Britain from the Netherlands.

BIBLIOGRAPHY: Michaelis 1971, fig. 25, Hornsby 1983, p. 303, pl. 1038

130. Quaich

Scottish, about 1700
Height: 2.3 cm. Diameter: 6 cm
M.161-1930

TOUCHES AND INSCRIPTIONS: None.
PROVENANCE: Port Bequest.

The name of this traditional Scottish drinking vessel derives from the Gaelic word *cuach*, meaning cup. The shape reproduces the medieval mazer of turned wood, mounted in metal. Quaichs were used not only for spirits, such as brandy and whisky, but also for the various mead beverages favoured in Scotland. These small vessels were usually carried in the pocket. Cotterell noted that pewter quaichs were extremely rare. Dating cannot be precise because of the traditional nature of the wares, but the smaller versions are thought to date from the eighteenth century.

BIBLIOGRAPHY: Finlay 1969, p. 114

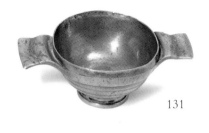

130

132

131

131. Quaich

Scottish, early 19th century
Height: 3.5 cm. Diameter: 6.4 cm
M.53-1945

TOUCHES AND INSCRIPTIONS: None.
PROVENANCE: Yeates Bequest.

The quaich is machine turned.

132. Wine Taster

English, 17th century
Length: 10.5 cm
1379-1904

TOUCHES AND INSCRIPTIONS: The centre is cast with the design of a Tudor rose. The ear is cast with the letters *CR* in relief, probably the maker's touch.

PROVENANCE: Purchased for 1 guinea from a Mr G. F. Lawrence, London, who stated that it had been dug up in the Tottenham Court Road, London.

Although pewter wine tasters must have been very common in the seventeenth century, very few seem to have survived. They usually have cast decoration in the centre. An early example, found appropriately near the site of the Vintry in London, is cast with a figure of Bacchus.

The patination shows that this wine taster has been buried and includes a large area of 'nature's gilding' within the bowl (see p. 16).

133. Wine Taster

French, 18th century
Diameter: 8 cm. Height: 2.3 cm
M.589-1926

TOUCHES AND INSCRIPTIONS: None.
PROVENANCE: Croft Lyons Bequest.

A silver taster in the Museum (M.394-1927) has a handle and flange of virtually identical design. This has been attributed to a provincial maker working before 1789.

BIBLIOGRAPHY: Lightbown 1978, no. 96

133a

133b

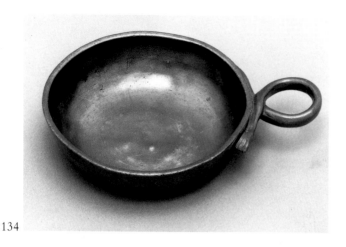

134

134. Wine Taster

French, about 1780
Diameter: 8.7 cm. Height: 2.4 cm
M.516-1926

TOUCHES AND INSCRIPTIONS: None.
PROVENANCE: Croft Lyons Bequest. On the base a
collector's label, *Colonel Croft Lyons No.65 Lyons 1 franc
12/9/03.*

A silver wine taster with a virtually identical handle and
Beaune hallmarks for 1781–87 is recorded in the Musée du
Louvre, Paris.

BIBLIOGRAPHY: Brault and Bottineau 1959, pl. XXI

135. Brandy Bowl

Dutch (Friesland), 18th century or later
Height: 10.5 cm. Diameter of base: 8.7 cm
M.635-1926

TOUCHES AND INSCRIPTIONS: Maker's touch *F VA* above a
rose, struck in the centre of the bowl. On the rim, *AI*,
an owner's initials. On the base, an incised letter *L*, an
owner's mark.
PROVENANCE: Croft Lyons Bequest. In ink under the
base, *Munich 9/9/07 X POSS*, a collector's mark.
Purchased in Munich.

A number of these bowls are recorded and the basic shape
is frequently encountered in Holland. An identical bowl,
also stamped on the side with initials, is in the Hungarian
National Museum (Magyar Nemzeti Múzeum), Budapest;
a bowl of similar design but with a plain foot is in the
collection of the Colonial Williamsburg Foundation,
Virginia, attributed to the London pewterer Charles
Tough. The form of the handles and the decoration of the
foot on the present piece are Dutch and German features,
however. Bowls of this form were almost certainly made in
Friesland up to the end of the nineteenth century.

BIBLIOGRAPHY: Brett 1981, p. 159, Hornsby 1983,
pp. 293, 294

136. Tureen

German, late 18th century
Height (with cover): 29.2 cm. Width: 39.4 cm
317-1906

TOUCHES AND INSCRIPTIONS: Maker's touch *IL*
(unidentified), with a figure of St Michael. Engraved
owner's name (illegible).
PROVENANCE: Purchased.

Tureens were used extensively in Europe during the
eighteenth century. This is a particularly elegant example
in the Neoclassical style. It was almost certainly intended
to hold soup.

BIBLIOGRAPHY: Hornsby 1983, pp. 191, 192

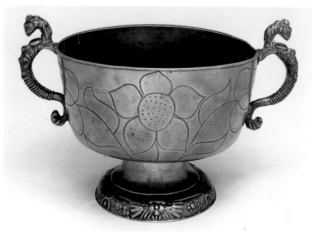

135

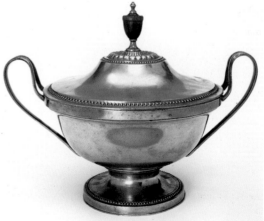

136

SPOONS

While we were at dinner in this miserable hut, on the banks of the River Awatska – the guests of a people with whose existence we had before been scarcely acquainted and at the extremity of the globe – a solitary half-worn pewter spoon, whose shape was familiar to us, attracted our attention and, on examination, we found it stamped on the back with the word 'London'. I cannot pass over this circumstance in silence, out of gratitude for the many pleasant thoughts, anxious hopes and tender remembrances it excited in us.

From the Journal of Captain King, travelling companion of Captain Cook (d.1779).

137a. Spoon

English (?), 15th century
Length: 15.9 cm
M.18-1930

TOUCHES AND INSCRIPTIONS: Maker's touch *IB*, rayed.
PROVENANCE: Port Bequest.

137b. Spoon with Slip Top

English, about 1640
Length: 16.3 cm
M.432-1926

TOUCHES AND INSCRIPTIONS: Maker's touch *IN*, between two pellets within a circle.
PROVENANCE: Croft Lyons Bequest.

BIBLIOGRAPHY: Homer 1975, p. 40

137c. Spoon with Maidenhead Terminal

English, about 1600
Length: 15.6 cm
M.16-1930

TOUCHES AND INSCRIPTIONS: None.
PROVENANCE: Port Bequest.

The knop differs from the usual form of maidenhead spoon in having protruding facial features and raised zig-zag patterns at the base, which may represent hands raised in prayer. The shape of the bowl suggests a date at the end of the sixteenth or in the early seventeenth century.

BIBLIOGRAPHY: Homer 1975, pp. 33, 36, Museum of London 1983, p. 22

137d. Spoon with Lion Sejant Knop

Dutch, first half 16th century
Length 17.1 cm
M.17-1930

TOUCHES AND INSCRIPTIONS: None.
PROVENANCE: Port Bequest.

Spoons with twisted stems are found in the Low Countries in the sixteenth and seventeenth centuries. This form of finial appears to be unique and anticipates the spoons with heraldic knops of the eighteenth and nineteenth centuries. The mark of a crowned hammer was widely used by Dutch spoon makers in the fifteenth and sixteenth centuries. On the shield in relief is a design showing *3 saltires argent*, probably for the city of Amsterdam.

BIBLIOGRAPHY: Keur van tin 1979, p. 22

137e. Spoon with Baluster Knop

English (?), about 1570
Length: 16.2 cm
M.20-1930

TOUCHES AND INSCRIPTIONS: Maker's touch *RN*, with an anchor (?) between.
PROVENANCE: Port Bequest.

Baluster-knop spoons are closely related to the better known seal-top spoons. The top of the stem is stamped with part of a cross plate, possibly an owner's mark. A number of spoons by this unidentified maker have been recorded.

BIBLIOGRAPHY: Homer 1975, p. 29, Museum of London 1983, p. 22

137f. Spoon with Melon Knop

English, about 1550
Length: 16.6 cm
M.2-1962

TOUCHES AND INSCRIPTIONS: None.
PROVENANCE: Trenchard Cox Gift.

This is a comparatively rare type of spoon, which continued in use from about 1500 until the early seventeenth century.

BIBLIOGRAPHY: Homer 1975, p. 37, Museum of London 1983, p. 22

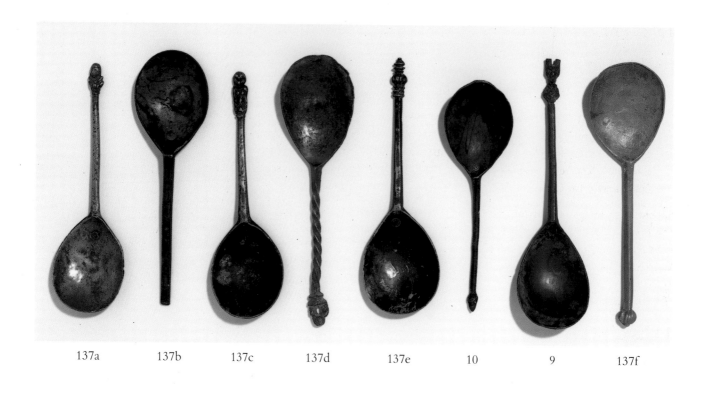

137a 137b 137c 137d 137e 10 9 137f

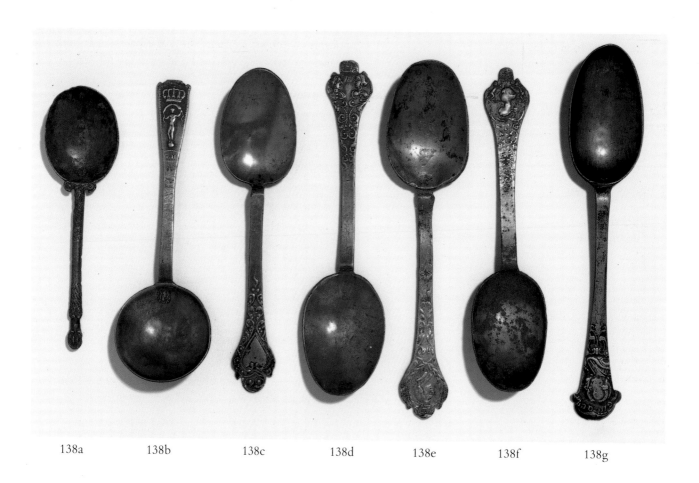

138a 138b 138c 138d 138e 138f 138g

138a. Spoon with Horse-Hoof Knop

German or Dutch, early 17th century
Length 14.5 cm
M.578-1926

TOUCHES AND INSCRIPTIONS: Maker's touch crowned *I*
(inside the bowl).
PROVENANCE: Croft Lyons Bequest. Inscribed in ink on
the back of the bowl, *Paris 28.0*, probably the price.
Purchased in Paris.

Spoons with knops of this form are known in silver from
the first half of the sixteenth century. Surviving pewter
examples seem to date from the seventeenth century. The
knop is cast in unusually fine detail.

BIBLIOGRAPHY: Homer 1975, p. 34, *Keur van tin* 1979, no. 166

138b. Spoon

Dutch, about 1720
Length: 16.9 cm
M.26-1930
TOUCHES AND INSCRIPTIONS: *H.M.SCH ER*, with a
figure, struck in the edge of the bowl. On the front of
the stem, *G.H.* in relief.
PROVENANCE: Port Bequest.

This is a late survival of the round-bowl form of spoon.
The cast design on the stem is almost certainly com-
memorative and represents Fortune.

BIBLIOGRAPHY: *Keur van tin* 1979, nos. 171, 289

138c. Spoon

English, about 1680
Length 18 cm
M.25-1930

TOUCHES AND INSCRIPTIONS: Hallmarks struck on the
back of the stem. Lightly incised in the back of the
stem, *RG R I*, owner's marks.
PROVENANCE: Port Bequest.

A shorter version with similar decoration has been described
as a chocolate spoon.

BIBLIOGRAPHY: Cotterell 1929, pl. LXVII, no. 23, Hornsby
1983, p. 186, no. 599

138d. Spoon

English, late 17th century
Length: 18.7 cm
M.29-1930
TOUCHES AND INSCRIPTIONS: Simulated hallmarks
on back of stem.
PROVENANCE: Port Bequest.

The upper section is cast with busts of William III and
Queen Mary.

Lent to the exhibition, *Parliament and the Glorious
Revolution*, House of Lords, London, July–October 1988.

138e. Spoon

English, about 1690
Length: 19.7 cm
M.28-1930

TOUCHES AND INSCRIPTIONS: Maker's touch *IF* with
hallmarks, struck on the back of the stem
(unidentified).
PROVENANCE: Port Bequest.

A profile bust of King William III surmounted by a crown
forms the upper section. This particular design with the
single portrait bust is less common than the William and
Mary version.

138f. Spoon

English, about 1702
Length: 18.1 cm
M.27-1930

TOUCHES AND INSCRIPTIONS: *E G* in relief, on the stem.
Also *SB* below a profile bust of Queen Anne flanked by
cherubs supporting a crown.
PROVENANCE: Port Bequest.

A number of similarly decorated spoons are recorded, most
with initials on the back of the stem. The use of relief
initials on the front of the stem makes this spoon unusual.
They are presumably those of the maker. Michaelis notes
the same touches on another similar spoon.

BIBLIOGRAPHY: Worshipful Company of Pewterers 1968, p.
86, nos. 810/1–6, Peal 1977, no. 5611A

138g. Spoon

English, about 1761
Length 20.6 cm
M.30-1930

TOUCHES AND INSCRIPTIONS: Maker's touch *VAUGHAN* for John Vaughan of London (Cotterell 1929, no. 4863), struck on the back of the stem.
PROVENANCE: Port Bequest.

This spoon is one of a series made to commemorate the marriage of George III to Queen Charlotte. The upper section is cast in relief with profile busts of George III and Queen Charlotte with rococo scrolls below; above the heads, the initials *G III Q C* are engraved within a scrolling label. The flat stem broadens out to a typical 'wavy-end' Hanoverian pattern, cast in relief with portrait busts of King George III and Queen Charlotte under the initials *GIII* and *Q CH*. Below the busts is a rococo cartouche.

BIBLIOGRAPHY: Worshipful Company of Pewterers 1968, 58/810/17, pp. 85, 86, Homer 1975, p. 45, Hornsby 1983, p. 186, no. 584

139. Marrow Scoop

English, mid-18th century
Length: 22.9 cm
M.562-1926

TOUCHES AND INSCRIPTIONS: Maker's touch *TIMMINS*, with a crown and cinquefoil.
PROVENANCE: Croft Lyons Bequest.

140. Ladle for Punch

English, about 1750
Length: 32.8 cm. Diameter of bowl: 6.3 cm
M.100A-1945

TOUCHES AND INSCRIPTIONS: Engraved with the initials *JA* on the base, probably an owner's mark.
PROVENANCE: Yeates Bequest.

The design is virtually identical to examples in silver of the mid-eighteenth century. A number of punch-bowls with their accompanying ladles are recorded in private collections. The initials are probably those of James Ashley, proprietor of the London Punch House. When given to the Museum, the ladle was accompanied by a bowl inscribed *The London Punch House*. This was a modern reproduction hammered up from an eighteenth-century plate.

BIBLIOGRAPHY: Cotterell 1929, p. 87, pl. XIX

141. Basting Spoon

English, about 1740
Length: 43.8 cm
M.648-1926

TOUCHES AND INSCRIPTIONS: Maker's touch *ID*, cupid, lion rampant with a rose-sprig.
PROVENANCE: Croft Lyons Bequest.

139

140

141

142

142. Basting Spoon

English, about 1840
Length overall: 43 cm. Width of bowl: 7.9 cm
M.144-1935

TOUCHES AND INSCRIPTIONS: Maker's touch *RV* and *Co*
with hallmarks, struck on the back of the stem.
PROVENANCE: Young Bequest.

In spite of early eighteenth-century features, such as the
shape of the handle, the form of the maker's touch suggests
that this spoon is of nineteenth-century date.

143. Mould for Spoon

Cast iron (with modern pewter casting)
English, mid-18th century
Length: 23.2 cm
M.8-1954

TOUCHES AND INSCRIPTIONS: None.
PROVENANCE: Hildburgh Bequest.

The Museum also possesses two bronze moulds for pewter
spoons (M.6-1954, M.7-1954).

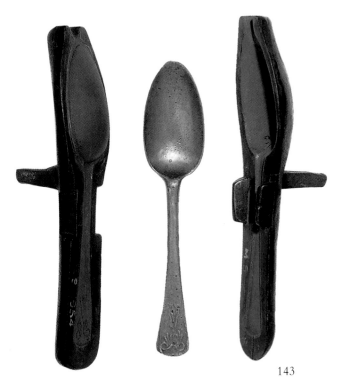

143

TEA AND COFFEE

With the introduction of luxury beverages such as tea,
coffee and chocolate into Europe, it was inevitable that
some of the wares associated with the drinking of them
should be made in pewter. Tea had become a fashionable
drink in Germany and France by 1630, and in Britain by
1650.

Pewter teapots are comparatively rare before the
middle of the eighteenth century and none is known from
before 1700. As is to be expected, their design closely
followed that of silver and porcelain examples. One design,
especially popular in Holland and later in America, had a
high domed top and bulbous body. These are comparatively
small and remained in fashion until the nineteenth century.
A more elegant design, which became fashionable towards
the end of the eighteenth century, had an oval body with a
sharply rising spout, the edges being decorated with bead
work. These were popular in America, although some were
made by English pewterers. They show considerable
Neoclassical influence and similar designs can be found in
contemporary Sheffield plate and silver. More common in
the early nineteenth century are large oval boat-shaped
teapots, usually supported on cast feet. This type is most
often found in Britannia metal.

Pewter tea caddies start to appear in the 1720s. The
forms were vase-shaped, with designs based on Chinese tea-
jars, and nearly all of them have a well made screw top to
keep the precious tea fresh (some silver tea caddies even
had locks, a safeguard against the servants). The majority
of pewter tea caddies, however, were in a distinctive
Neoclassical style, some being decorated with 'bright-cut'
acanthus and swags, again like their counterparts in
Sheffield plate and silver. Cream jugs are also found in
pewter and are virtually identical in form to silver
examples. It is interesting to note that they are often rather
archaic in design; cream jugs made in the 1780s and 1790s
are often based on silver versions of the 1740s and 1750s.

Coffee came to France and Britain in the 1640s and
1650s. However, the majority of coffee pots made in pewter
date from after the 1740s – nearly a century later. A design
with a distinctive writhen body, based on rococo silver pots
of the period, was fashionable in German-speaking lands
throughout the latter half of the eighteenth century and
vase-shaped coffee pots based on Neoclassical designs were
widely used from about 1780 to 1820. Large coffee urns,
usually accompanied by a low stand, were fashionable in the
Low Countries, especially around the 1740s and 1750s. The
designs are based on silver, copper and brass versions. As
these coffee urns were intended for display on a sideboard,
many of them are painted with scenes of figures and
landscapes, in lacquer. Chocolate pots were also made in
pewter. These are smaller than coffee pots and usually have

144

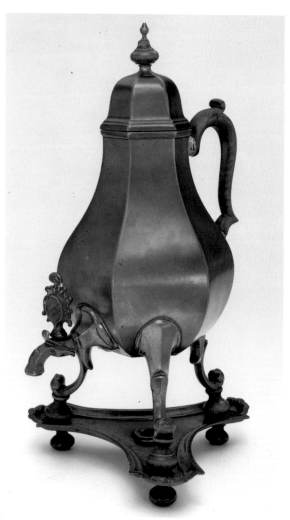

145

a straight handle set at a right-angle to the spout.

The majority of pewter teapots and coffee pots are continental or American, as porcelain and pottery were preferred in Britain. There was, however, a huge production, especially of teapots in Britannia metal.

144. Coffee Pot

German, 18th century
Height: 26 cm
320-1906

TOUCHES AND INSCRIPTIONS: *ENGELS BLOCK ZIEN I G*, with a figure of St Michael.
PROVENANCE: Savory Gift.

145. Urn for Coffee with Stand

Dutch, about 1740
Height with stand: 39.5 cm. Width of body: 15 cm
Height of stand: 3.3 cm. Width of stand: 16.7 cm
M.438-1926

TOUCHES AND INSCRIPTIONS: *HV*, with three hallmarks struck under the base of the urn (crowned *X* mark); also *DB*, possibly for Hendrik van den Broek of Amsterdam. Four hallmarks struck on the base of the stand, including the Amsterdam town mark.
PROVENANCE: Croft Lyons Bequest. On the base a label, *LT COLONEL CROFT LYONS No. The Hague 29/9/04 AM Coulden with stand.* Purchased in The Hague. Collector's label inside the lid, *No. 90.*

A virtually identical urn struck with the marks of Nicholas Kraan of Amsterdam was shown at an exhibition in the Museum Willet-Holthuysen, Amsterdam in 1979. Another, with its original spirit lamp and stand, is in a Dutch private collection. Coffee urns with accompanying stands are known in brass and other base metals from the early part of the eighteenth century in the Low Countries. The hexagonal form seems to have been introduced about 1740–50. As there is a discrepancy between the date of the urn, as suggested by its marks, and the date suggested by its style, it seems possible that there may have been another member of the family with the same initials. The marks on the stand are different from those on the urn. Its condition is also very different. It is likely therefore that the stand has been associated with the urn at a later date. This form frequently appears in silver.

BIBLIOGRAPHY: Dexel 1973, p. 24, Dubbe 1978, p. 292, fig. 177; p. 331, fig. 183, *Keur van tin* 1979, pl. 194

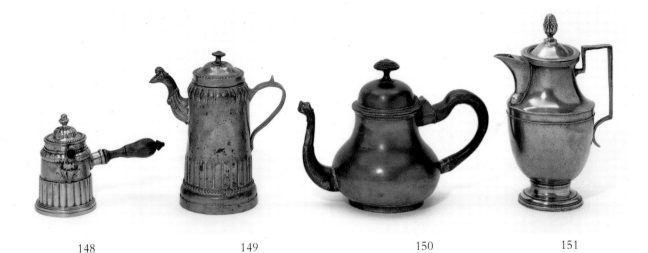

148 149 150 151

146. Lacquered Urn (plate XVI)

Dutch, mid-18th century
Height: 36.8 cm
M.87-1917

TOUCHES AND INSCRIPTIONS: None.
PROVENANCE: Green Gift.

147. Lacquered Urn (plate XVI)

Dutch (Groningen), mid-18th century
Height: 50.2 cm
M.122-1935

TOUCHES AND INSCRIPTIONS: Maker's touch *IAN P DYK*;
an angel with a trumpet and the arms of Groningen.
Stamped with a crowned *X* and *GEHART ENGELS TIN.*
PROVENANCE: Young Bequest.

148. Chocolate Pot

German, late 18th century
Height: 10.8 cm
75-1904

TOUCHES AND INSCRIPTIONS: *FEIN ENGLISCH BLOK
ZIN*, with a figure of St Michael. The initials *BF* are
inscribed on the bottom.
PROVENANCE: Gift.

149. Coffee Pot

German, dated 1774
Height: 17 cm
1211-1903

TOUCHES AND INSCRIPTIONS: Archangel Michael with
inscription and date *I . . . NE . . . FEIN BLOCK ZIN
1774.*
PROVENANCE: Purchased.

150. Teapot

French (?), second half 18th century
Height: 16 cm. Diameter of top: 8.1 cm
M.448-1926

TOUCHES AND INSCRIPTIONS: None.
PROVENANCE: Croft Lyons Bequest. Collector's label,
Neufchateau I francs 29/8/04. Purchased at
Neufchâteau.

This form of teapot was fashionable not only in France, but
also in Holland, Britain and America in the second half of
the eighteenth century. It is closely related to silver versions.
As the vessel is unmarked, its nationality cannot definitely
be established. The provenance suggests a French origin,
however.

A silver prototype of similar form, with the monogram
of Augustus the Strong (1697–1733), is also known.

BIBLIOGRAPHY: Tardy 1964, p. 117, Dexel 1973, pl. 511,
Boucaud and Fregnac 1978, pls. 344, 346, *Keur van tin* 1979,
p. 178, Hornsby 1983, p. 162

151. Coffee Pot

German, 18th or 19th century
Height: 21.6 cm
325-1906

TOUCHES AND INSCRIPTIONS: None.
PROVENANCE: Savory Gift.

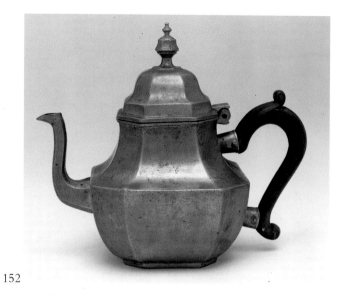

152

152. Teapot

Dutch, about 1805
Height: 17.5 cm. Length: 11.5 cm. Width: 11.5 cm
M.587-1926

TOUCHES AND INSCRIPTIONS: Maker's touch *KOCK* (unidentified).
PROVENANCE: Croft Lyons Bequest. Croft Lyons labels inside, with ink inscription on the lid, *Albi (France) 18/9/06 NY francs 140*. Purchased in France.

Faceted teapots are relatively uncommon in the Low Countries; the shape is based on silver prototypes. This appears to be a revival of a style popular in Germany in the early eighteenth century.

BIBLIOGRAPHY: Waldron 1982, no. 944

153. Half-Pint Tankard

English, about 1840
Britannia metal
Height: 9.3 cm
M.17-1998

TOUCHES AND INSCRIPTIONS: *HPINT*
PROVENANCE: Jerome Bequest.

The tankard was constructed from sheet metal and then engraved.

154. Teapot

English, about 1840
Britannia metal
Height: 21.1 cm
M.15-1998

TOUCHES AND INSCRIPTIONS: None.
PROVENANCE: Jerome Bequest.

The body of the teapot is decorated with wriggle-work, in keeping with the tradition of pewtering. The knob, handle and spout are cast.

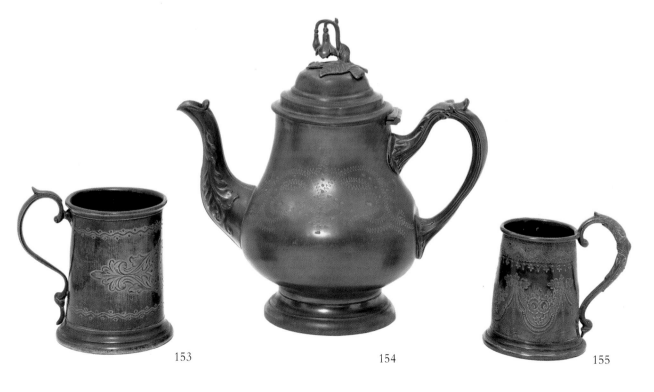

153 154 155

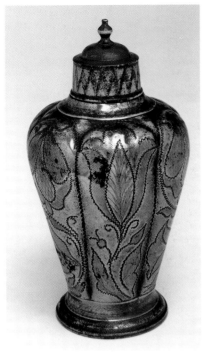

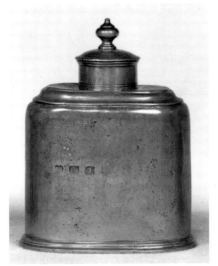

156 157 158

155. Tankard

English, about 1840
Britannia metal
Height: 7.9 cm
M.18-1998

TOUCHES AND INSCRIPTIONS: None.
PROVENANCE: Jerome Bequest.

The raised decoration on the tankard was achieved by stamping.

156. Tea Caddy

Dutch (Zwolle), about 1720
Height: 13 cm. Diameter of body: 7.8 cm
M.162-1930

TOUCHES AND INSCRIPTIONS: *P . . . 17 . .*, with a figure with a trumpet and a palm branch (unidentified), probably a Zwolle pewterer.
PROVENANCE: Port Bequest.

157. Tea Caddy

English, about 1740
Height: 10.8 cm. Length: 11.6 cm. Depth: 6.7 cm
M.129-1935

TOUCHES AND INSCRIPTIONS: Maker's touch of Duncombe of Birmingham, struck on the side of the body. Traces of crowned *X* mark, on the lower section of the opposite side.
PROVENANCE: Young Bequest.

A section of one side appears to have been damaged and has been repaired by letting in a rectangular panel, cut from another vessel. The shape derives from silver versions. A pair of caddies hallmarked for 1728 is noted by Clayton.

BIBLIOGRAPHY: Victoria and Albert Museum 1960, p. 25B, Clayton 1971, p. 406, no. 616

158. Tea Caddy

English, about 1790
Height: 9.4 cm
M.289-1920

TOUCHES AND INSCRIPTIONS: *P 17 . .*, with a figure with a trumpet and a palm branch (unidentified).
PROVENANCE: René de l'Hôpital Gift.

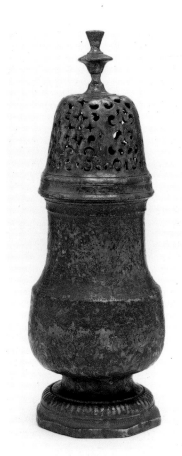

159. Sugar Caster

French, about 1765
Height: 22.5 cm. Width of base: 7.2 cm
Diameter of top: 6.1 cm
M.519-1926

TOUCHES AND INSCRIPTIONS: Marks struck on the inner
edge of the foot with the Lyons control mark, crowned
FF with *Lyons* and the date *1748*; another maker's
touch, crowned fleur de lys *48* and *T* (both marks
partially obscured).
PROVENANCE: Croft Lyons Bequest. Collector's label,
No. 68 Lyons 13.12.05.

Gadrooning on the foot, the pierced work on the cover and
the spool-shaped finial are all characteristic of casters made
in Lyons. The city was famous for its casters during the
eighteenth century. A virtually identical example is in the
Crebir Collection, with the maker's touch *CI*. Another
piece by this maker is dated 1767.

BIBLIOGRAPHY: Tardy 1964, p. 434, Boucaud and Fregnac
1978, pls. 330, 332, Hornsby 1983, pls. 423, 426

159

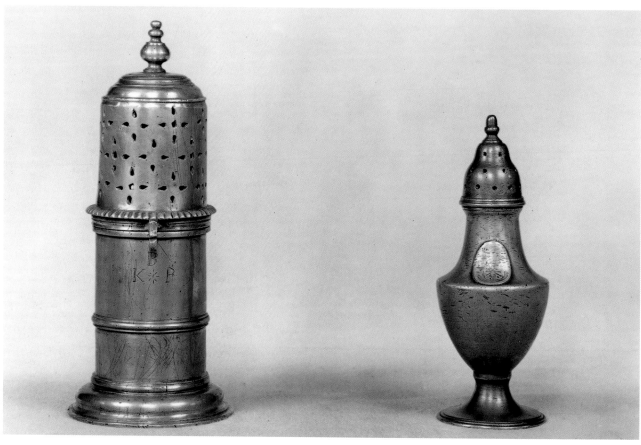

160

161

160. Sugar Caster

English, about 1700
Height: 20.3 cm
M.985-1926

TOUCHES AND INSCRIPTIONS: Engraved with the initials *BKP*.
PROVENANCE: Croft Lyons Bequest.

161. Pepper Pot

English, 18th century
Height: 15.6 cm
M.889-1926

TOUCHES AND INSCRIPTIONS: None.
PROVENANCE: Croft Lyons Bequest.

Engraved with the badge of the 43rd Regiment.

162. Salt

Dutch, about 1640
Height: 11.8 cm. Diameter of base: 10.6 cm
M.634-1926

TOUCHES AND INSCRIPTIONS: Maker's touch *DIRCK JANSZ MESSCHAERT* of Rotterdam (working 1632–83), struck in the centre of the bowl.
PROVENANCE: Purchased in The Hague. In ink on the base, *I/r 30/9/07*. Croft Lyons labels, one numbered *180* on the base.

This is a good example of a Dutch salt of the first half of the seventeenth century, of which a number of examples are known, bearing maker's touches from Amsterdam and Rotterdam. The form is also known in silver.

BIBLIOGRAPHY: Dubbe 1978, pp. 280, 281, pl. 159, *Keur van tin* 1979, p. 291, no. 302

163. Master Salt

English, about 1680
Width of base: 14 cm. Height: 7.3 cm
M.1057-1926

TOUCHES AND INSCRIPTIONS: On the underside of the base, *GLM*, an owner's mark.
PROVENANCE: Croft Lyons Bequest.

Master salts are rare. Only one other of this design is recorded, in the Minchin Collection; there is a variant from the Navarro Collection. The similarities of design and proportion suggest that this is by the same maker. Plain versions are more common and examples are known in private collections; one was recovered from the site of Port Royal, Jamaica, destroyed by an earthquake in 1692. Another example is in the Museum's collection (M.91-1945). Similar cast designs are also found on contemporary candlesticks and the same moulds were probably used for both wares.

BIBLIOGRAPHY: Cotterell 1929, pl. LXII, Boucaud and Fregnac 1978, no. 322, *Journal of the Pewter Society*, 2, no.3, Spring 1980, p. 35

162

163

164. Capstan Salt

English, about 1685
Height: 5.7 cm. Diameter of base: 8.5 cm
M.92-1945

TOUCHES AND INSCRIPTIONS: Stamped under the base, *M.W*, probably an owner's mark.
PROVENANCE: Yeates Bequest.

This is a good example of a well known type of salt. A virtually identical example is in the collection of the Worshipful Company of Pewterers.

BIBLIOGRAPHY: Michaelis 1969, pl. XVII, Worshipful Company of Pewterers 1979, no. 56/609

165. Salt

English, about 1740
Height: 7.9 cm
M.1065-1926

TOUCHES AND INSCRIPTIONS: None.
PROVENANCE: Croft Lyons Bequest.

166. Lower Section from a Bell Salt

English, about 1590
Height: 84 cm. Diameter of base: 8.2 cm
M.89-1945

TOUCHES AND INSCRIPTIONS: The letter *T*, stamped three times into the base; three pellets stamped into the base, probably an assembly mark.
PROVENANCE: Yeates Bequest.

The projecting lip above the bowl indicates that this was the lower section of a three-piece salt, possibly a bell salt. These were in three sections, each fitting over the other. The top is formed as a turned pinnacle. This probably explains the necessity for an assembly mark on the base. The other sections would have been similarly marked to indicate that they belonged together. Multiple salts are well known in silver, but rare in pewter.

In 1596 a Dutch fleet under the command of Jacob Heemsherk and Willem Barentz sailed from Holland to try to find a northern route to China. They travelled as far as Nova Zembla, where they were forced to spend the winter. Included in the fleet's cargo was a large amount of pewter, much of which was removed from the ships and left behind when the fleet set sail for Holland the following year. This hoard was found in the 1870s. It contains a number of interesting candlesticks and salts, preserved in fine condition. The pewter is of special significance on account of the fact that it can be dated to 1596 or shortly before. The lower sections of some of the salts are very similar to the Museum's example. A joint Dutch-Russian expedition has recently visited the site and, using metal detectors, discovered even more pewter.

BIBLIOGRAPHY: *British Pewterware through the Ages* 1969, no. 35, Michaelis 1969, fig. 91 (for the Nova Zembla salts)

167. Capstan Salt

English, about 1685
Height: 6.3 cm. Diameter of base: 8.2 cm
M.93-1945

TOUCHES AND INSCRIPTIONS: Maker's touch *LS*. An owner's initials, *E D*, on the edge of the base.
PROVENANCE: Yeates Bequest.

A good example of a standard form of late seventeenth-century salt; this version differs slightly from the usual shape in having a double concave moulding around the centre of the body.

 165 166 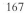 167

168. Salt

English, about 1710
Height: 3.8 cm. Diameter: 6.7 cm
M.94-1945

TOUCHES AND INSCRIPTIONS: Maker's touch *IH*
within a quatrefoil.
PROVENANCE: Yeates Bequest.

This form of salt is also found in silver and seems to have
been introduced at the very end of the seventeenth century.

BIBLIOGRAPHY: Hornsby 1981, pl. 19

169. Trencher salt

English, about 1715
Length: 7.7 cm. Width: 6 cm. Height: 3.1 cm
M.95-1945

TOUCHES AND INSCRIPTIONS: None.
PROVENANCE: Yeates Bequest.

This is a good example of a reasonably common form. The
shape derives from earlier silver prototypes. A virtually
identical example in pewter was in the Cooper Collection.

BIBLIOGRAPHY: Michaelis 1969, fig. 52

170. Salt

German, about 1755
Height: 5.9 cm. Diameter of base: 9.1 cm
M.156-1930

TOUCHES AND INSCRIPTIONS: Angel mark with *CWM*
(for Cristoph Wilhelm Marx?), struck in the base.
PROVENANCE: Port Bequest.

Spiral fluting was extensively used in the middle of the
eighteenth century on wares such as coffee pots and
teapots. Salts in this form are comparatively rare. The
touch may be that of the Nuremberg pewterer C. W. Marx,
or of a member of his family. This attribution is based upon
the similar marks and arrangement of initials used by this
maker.

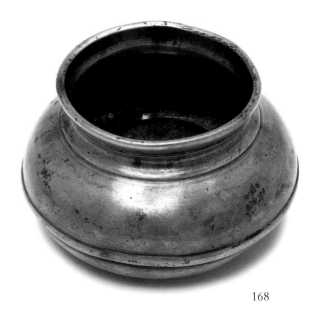

168

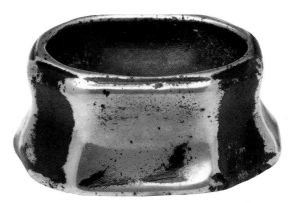

169

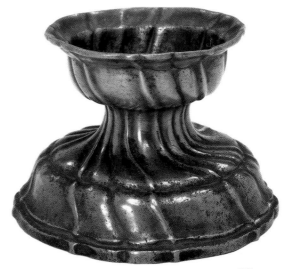

170

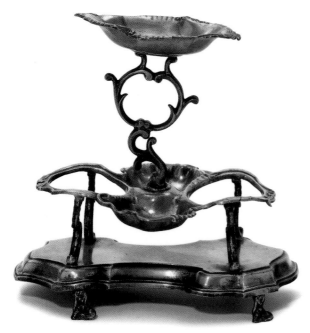

172

171. Cruet Stand (plate XVII)

Dutch, last quarter 18th century
Japanned in white and blue, and gilded
Height: 23.2 cm
60-1898

TOUCHES AND INSCRIPTIONS: None.
PROVENANCE: Purchased from Mrs William Coltart.

172. Cruet Stand or Trembleuse

German, mid-18th century
Height: 21.6 cm
73-1904

TOUCHES AND INSCRIPTIONS: Angel with *FEIN ZIN*.
PROVENANCE: Fitzhenry Gift.

A trembleuse is a stand for serving chocolate or coffee with
sweetmeats. For a contemporary example in silver, see
M. 135-1913.

173

173. Vinaigrette

German, 18th century
Length: 3.2 cm. Diameter: 2.2 cm
M.1084-1926

TOUCHES AND INSCRIPTIONS: None.
PROVENANCE: Croft Lyons Bequest.

The vessel is in the form of a cone with a screw-top and a
smaller container at the base, which also unscrews. The top
is cast in relief with a design showing the device for the
Holy Roman Empire, a double-headed eagle with wings
displayed.

Containers of this form were widely used through the
eighteenth century.

174. Mustard Pot

French, early 18th century
Height: 14 cm
M.515-1926

TOUCHES AND INSCRIPTIONS: A crowned rose.
PROVENANCE: Croft Lyons Bequest. Purchased in Lyons.

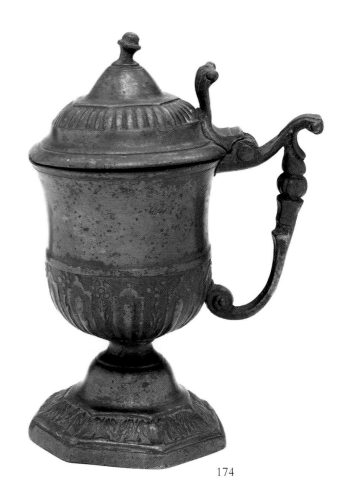

174

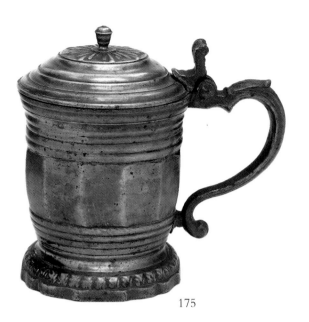

175

175. Mustard Pot

French, about 1748
Diameter of base: 5.9 cm. Height to rim: 6.7 cm
M.521-1926

TOUCHES AND INSCRIPTIONS: Maker's touch *CL* above a wolf (for Loup?), with the date *1748* and the Lyons control mark.
PROVENANCE: Croft Lyons Bequest: Collector's label under the lid, *No. 70 Lyon 13.9.05 AN frs*. Purchased in Lyons.

This is a variation on a type of mustard pot made in Lyons from the beginning of the eighteenth century, the faceted body and serpentine foot being characteristic. It has been suggested that the introduction of a wolf into the maker's touch may signify the surname Loup. No maker of that name is, however, recorded as working in Lyons.

BIBLIOGRAPHY: Tardy 1964, p. 424, Boucaud and Fregnac 1978, pl. 321

176. Spice Box

Central European (South German?), second half 16th century
Height: 9.5 cm. Length: 9 cm
M.293-1910

TOUCHES AND INSCRIPTIONS: None.
PROVENANCE: Purchased.

177. Spice Stand

German, 17th century
Height: 5.1 cm
M.1083-1926

TOUCHES AND INSCRIPTIONS: None.
PROVENANCE: Croft Lyons Bequest.

BIBLIOGRAPHY: Hornsby 1983, pl. 384

178. Pewterware for a Dolls' House

(plate XVIII)

German (Nuremberg), 1673
Diameter of plates: from 2 cm
W.41-1922

PROVENANCE: Transferred from the Science Museum (Education Division) in 1922. Purchased in 1871 from Herr A. Pickert, for £18.

Miniature garnishes of pewter were made to furnish the splendidly ornate miniature houses of the seventeenth and eighteenth centuries. The Museum has a number of houses furnished in this way, of which the present example from Nuremberg is the earliest. It is one of five seventeenth-century Nuremberg dolls' houses; the other four, all larger than the present example, are in the Germanisches Nationalmuseum, Nuremberg.

177

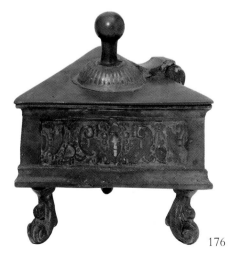

176

Pewter for Eating and Drinking 119

The house contains seventy-two pieces of pewter and gives a very good impression of what a well furnished merchant's house of the period must have looked like. In the parlour there are rows of pewter plates set on shelves. Also made of pewter are various candlesticks, a chandelier, cisterns for washing the dishes and some large porringers and cups. Smaller drinking cups and two ladled bowls are also displayed. All the pewter is very highly polished.

Miniature houses of this kind were originally created to teach young girls how to keep an orderly home. It was only later that they were made as toys. There was no single guild of dolls' house makers – the houses' miniature contents were made by members of the various different trades. Many craftsmen may already have been practised in the production of small-scale pieces which they occasionally made as samples of craftsmanship and design. These well furnished miniature mansions probably represent the ideal rather than the actual but they do give the flavour of a German interior of the period.

Besides furnishings for houses, a variety of other delightful miniatures were made in pewter, although the alloy is often very debased, usually a combination of tin and lead. Most of these toys have been found in recent years by specialists using metal detectors, not only on the Thames foreshore but also in open fields – in fact, in the places where children usually play. The range and variety of pewter toys is very wide: miniature weapons, such as guns, swords and daggers, small jugs and flagons based upon full-size pots in earthenware, puppets and working toys such as birds that waggle their beaks. Miniature items of furniture, such as court cupboards filled with display plate, which can be made up from flat panels, are also found. These anticipate by many centuries the cardboard cut-out kits that are printed with a flat design and can be assembled into a three-dimensional object. There are a few toys from earlier times, but the majority date from the sixteenth to eighteenth centuries.

The name William Hux appears on a number of toy watches. These must have been extremely popular as a large number survive. The earliest examples date from the 1640s, but those by Hux are from the first quarter of the eighteenth century. Some have an ingenious internal strut which gives off a sound exactly like the 'tick' of a watch when wound up with a key. Hux was admonished by the court of the Pewterers' Company in 1714 for making a toy watch-case '5 gr worse than lay' – that is, of a very inferior alloy. He pointed out that 'one Beasly' was making the same kind of watch out of an alloy of even poorer alloy. Although the watches were toys, the court took the view that 'none shall make any sort of pewter watch of any other than fine metal'. As some Hux watches are known to have been made of 'fine metal', he clearly took the court's warning to heart.

Another large producer of pewter toys, including plates and watches, is a maker with the initials IDQ, working in the 1640s. He was almost certainly related to the Quick family of pewterers.

PEWTER IN CHINA

Pewter wares were first produced in China under the Han Dynasty, in the second century BC. Workshops have been noted in Sichuan and various centres in southern China, such as Jiangsu, Hunan and Shantou (Swatow) in Guangdong. As with pewter wares from the West, Chinese wares – especially those of the nineteenth century – were frequently stamped with quality marks, such as *zhen liao* (true alloy) or *jing dian* (pure and verified).

In China pewter was considered a medium suitable for keeping water hot. A book written in the Yuan Dynasty (1279–1368), the *Dongnan Jiwen* (Record of Talks in the South-east), mentions a pewter foot-warmer into which hot water was poured, and that was then placed among bedsheets to keep the feet warm on snowy nights. Another book, the *Yangxian Minghu Xi* (Teapots from Yangxian), written in about 1645, recommends pewter as the ideal material for kettles: 'Pewter is the mother of the five metals. Use it to make tea kettles and it can enhance the water, which sends forth a clear sound when boiled'. Unlike bronze ritual vessels that were buried and have survived in the ground, however, pewter household utensils were discarded when they wore out. Thus most extant Chinese pewter objects in public and private collections today are no earlier than the seventeenth century.

In the late eighteenth century pewter found a new usage. For decades potters in Yixing, a town in south-east China famous for a brown clay known as 'purple sand', had been producing teapots that scholars would then embellish with calligraphy. When calligraphers discovered to their delight that they could exercise their carving knife as easily on pewter as on clay, it became fashionable to encase Yixing stoneware tea or wine pots in pewter, some fitted with a jade handle, spout and knob to avoid scorching (no. 180). The calligraphy on the two ewers in the Museum collection is by the same scholar-official Yunsheng (1805–1856), one in *xingshu* (running script) and one in *kaishu* (regular script).

Pewter teapots and tea caddies were also popular souvenir items for Westerners visiting China during the nineteenth century. They are usually decorated with punched and engraved patterns of flowers and birds. Some products carry the stamp of the manufacturer, a few even in both Chinese and English languages. The marks indicate that whilst the products were sold in retail shops in the port city of Shantou (Swatow), many of the workshops were located in the neighbouring town of Chaoyang.

179. Wine Pot (plate XIX)

Stoneware clad in pewter with jade handle,
spout and knob
Chinese (Yixing ware), early 19th century
Height: 8.5 cm. Length: 16.8 cm
M.163-1930

TOUCHES AND INSCRIPTIONS: Calligraphy by Yunsheng
(signed).
PROVENANCE: Port Bequest.

Pewter-clad stoneware pots of this kind are usually thought
to have been teapots. In the present case, the pot is
inscribed with a verse extolling the virtues of wine, thus
clearly indicating that it was made for this drink. The other
side is engraved with a simple landscape.

BIBLIOGRAPHY: *Etains de Chine* 1994, p. 53

180. Teapot (plate XIX)

Pewter with jade knob and copper handle
Chinese (Yixing ware), early 19th century
Length: 16.8 cm
M.164-1930

TOUCHES AND INSCRIPTIONS: Maker's touch of
Yichanghao. Calligraphy by Yunsheng (signed).
PROVENANCE: Port Bequest.

The decoration of teapots and tea caddies with insightful
verses and images from nature is in keeping with the fact
that tea was anciently revered by the literati in China as a
contemplative drink. The high standard of refinement to
which the art of making tea was taken is reflected in the
words of Zhao Xigu, a member of the imperial family, in
1240: 'the nature of tea leaves is not in harmony with that
of ceramic or bronze jars. They only accord well with
pewter . . .'

BIBLIOGRAPHY: Bronson and Ho Chumei 1988, pp. 9-20,
Etains de Chine 1994, p. 10

181. Tea Caddy

Chinese (Shantou), about 1800
Height: 14.8 cm. Width: 12.7 cm
775-1894

TOUCHES AND INSCRIPTIONS: None.
PROVENANCE: Purchased.

The caddy is punched and engraved with birds and
flowering branches. On some of the containers decorated in
this way the branches and birds are gilded. Many were
made for export to Europe and America.

BIBLIOGRAPHY: *Etains de Chine* 1994, p. 37

182. Pewter Box for a Hairpin

Chinese (Shantou), about 1800
Length of box: 35.5 cm
FE.166-1975

TOUCHES AND INSCRIPTIONS: None.
PROVENANCE: Gift from Bluett & Sons, London.

The lid of the box is decorated with pairs of gourds of
varying shapes, interposed with medallions bearing the
Chinese characters for 'extended years and increasing
longevity'. The rounded end of the box is decorated with a
bat, symbol of happiness. The hairpin itself is decorated
with seed-pearls and gold wire.

Shantou was one of the main centres of pewter
production in China. Its wares were exported to Europe
and America, especially in the nineteenth century. The fact
that hairpins were not worn by western women indicates,
however, that this piece was made for a Chinese client.

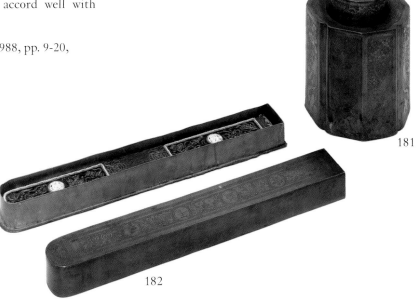

181

182

4 Domestic Pewter

A wide range of other objects, besides those used in connection with eating, were made in pewter – candlesticks, for instance. Examples are known in an ecclesiastical context from the thirteenth century, although surviving examples are extremely rare. A number of fourteenth-century candlesticks in bronze and the brass alloy latten have survived, but only very few in pewter. One was excavated from the Thames foreshore at Queenhithe, City of London. Like its bronze counterparts, it has a round skirted base and a hollow stem with moulded socket.

There is a long tradition of using pewter for vessels and instruments connected with medicine. The fearsome syringes illustrated in early medical texts were almost certainly made from pewter and Salmon's *Art du Potier d'Etain*, Paris, 1788, includes a plate showing how they were manufactured. The large syringe found in the barber-surgeon's cabin on the *Mary Rose* was made of pewter, containing a relatively high percentage of tin, at 97.5%, and was used for treating venereal disease or cleaning wounds. Pewter was also used for specialist feeding bottles, such as those made for invalids and small children. These resemble oil cans and have a long spout and looped handle. A French feeding bottle of this form dating from about 1750 is in the Museum's collection (no. 214). More common are the simple boat-shaped containers with elongated lips known as 'pap boats'. These are very similar to silver versions and were made well into the nineteenth century.

The treatment of chest ailments and more mundane illnesses, like coughs and colds, by inhalation was extremely common in the eighteenth and nineteenth centuries. A special inhaler, rather like a flat-topped tankard with a flexible tube attached to an aperture in the lid, was made for this purpose (no. 216). Most pewter inhalers date from the nineteenth century and follow the same general design. It is rare for their original inhaling tube to survive. The lid also had another hole covered by a perforated plate to allow air to circulate through the vapours of the brew.

Blood-letting was one of the most widely used remedies for a whole range of diseases in the past. Some conditions did certainly benefit from bleeding, such as cerebral haemorrhage and certain types of heart disease, but the practice was also used as a universal panacea. The process was known as 'venesection', the blood being taken from the median-basilic vein in the arm. The recommended quantity of blood to be taken from a patient varied from three or four ounces to as much as twenty ounces in extreme cases. Common sense dictated the importance of knowing how much blood had been taken; this was most easily done by drawing the blood into a vessel which had been gradated. Bleeding bowls are basically porringers that have been marked with gradations – usually a series of

rings incised into the inside walls of the vessel. More sophisticated bleeding bowls have a scale indicating the amount of blood to be taken, stamped on the inside. Most bleeding bowls date from the eighteenth century, but they were still being made, albeit on a smaller scale, until comparatively recently.

From the fifteenth century, many services were offered by itinerant barbers, whose skills ranged from beard cutting to tooth drawing. The poet John Gay (1635–1732) paints an evocative picture of such a traveller:

> *His pole with pewter basins hung,*
> *Black, rotten teeth in order strung,*
> *Ranged cuts, that in the window stood,*
> *Lined with red rags to look like blood,*
> *Did well his three-fold trade explain,*
> *Who shaved, drew teeth, and breathed a vein.*

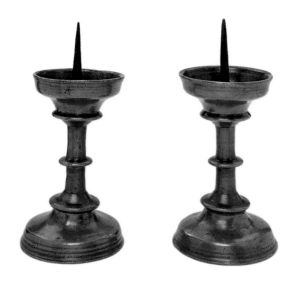

183a

183b

to Flemish brass candlesticks, but were probably made all over Europe. For parallels in brass, in the Museum, see M.19-1919.

BIBLIOGRAPHY: Boucaud and Fregnac 1978, pl. 44, Dubbe 1978, p. 91, pl. 47, Michaelis 1978, fig. 16, Hornsby 1983, p. 318, no. 1078

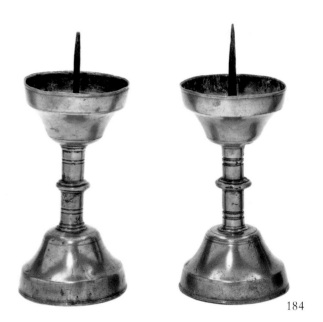

184

184. Pair of Pricket Candlesticks

German, second half 16th century
Height: 31.1 cm
M.450-1926

TOUCHES AND INSCRIPTIONS: None.
PROVENANCE: Croft Lyons Bequest.

This type of candlestick is often found in brass. They are usually described as altar candlesticks, but there is no reason why they should not have been for secular use. The present examples have iron prickets.

BIBLIOGRAPHY: Hornsby 1983, p. 318

185. Candlestick

English, about 1600
Height: 21.6 cm. Diameter of base: 14.6 cm
M.75-1945

TOUCHES AND INSCRIPTIONS: Under the base, maker's touch *T.C.A.*, within indented shields. *G* within an indented shield and *M* over-struck, possibly owner's marks.
PROVENANCE: Yeates Bequest.

This is almost certainly the type described in contem-

183. Pair of Pricket Candlesticks

Flemish, about 1550
Height: 20.1 cm. Diameter of base: 12.8 cm
M.882-1926

TOUCHES AND INSCRIPTIONS: None.
PROVENANCE: Croft Lyons Bequest.

This form is more common in brass and the type seems to have been introduced in the fifteenth century. Because of wear, the profile of the present pieces has been altered slightly, especially in the base. As with brass examples, the stems, bases and pans would have been deeply turned. They are usually described as Flemish because of their similarity

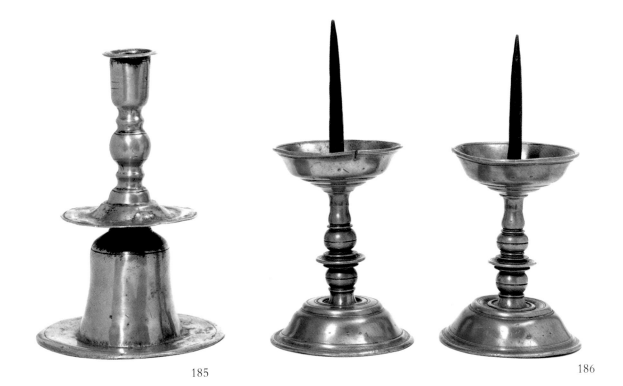

185 186

porary accounts as a 'great bell'. They are of considerable
rarity in pewter, only eight examples being recorded. The
authenticity of this piece has been doubted: it is suggested
that the lower section is from a chalice and that the flat rim
base is a later addition. There seems no trace of a joint,
however, and the wear and corrosion overall is consistent. It
was accepted by Michaelis as genuine and included in his
corpus of base-metal candlesticks. It is one of the two
earliest English socket candlesticks of this form in pewter
to have survived, the other being in private possession.

BIBLIOGRAPHY: *British Pewterware through the Ages* 1969,
no. 34, Michaelis 1978, fig. 86, Worshipful Company of
Pewterers 1979, no. 611, *Pewter: a Celebration of the Craft*
1989, no. 45.

186. Pair of Pricket Candlesticks

German, about 1600
Height (including pricket): 24.1 cm
Diameter of base: 11 cm. Diameter of top: 10.1 cm
M.627-1926, M.627a-1926

TOUCHES AND INSCRIPTIONS: Roughly incised with
the date *1814* on the side of the base.
PROVENANCE: Croft Lyons Bequest. Collector's label
gummed to each base. Inscribed in ink on the base,
Rabb and Knapp Frankfurt 20/9/07 £P AL 0.

This type of candlestick is difficult to date, because the
pricket form continued to be used in Germany until
comparatively late. Certain features, such as the shape of
the foot and deep drip-pan, are characteristic of the
sixteenth century. The form of mouldings on the stem,
however, suggests a later dating. These have been described
as altar candlesticks, but there is no reason why they
should not have been in secular use.

BIBLIOGRAPHY: Michaelis 1978, p. 34, Hornsby 1983, pls.
1078, 1081

187. 'Granger' Candlestick

English, dated 1616
Height: 24.1 cm. Diameter of base: 14 cm
M.210-1925

TOUCHES AND INSCRIPTIONS: None.
PROVENANCE: Purchased from Dr M. Bennath,
Stuttgart, for £15.

The column of the candlestick is cast in relief with
formalized plants and flowers. The base is cast with
strapwork rectangles and roundels incorporating flowers,
plants, the arms of the Pewterers' Company of London, the
date *ANO D 1616* and the name *WILLIAM GRANGER*.

In form, the candlestick has no close parallel in pewter.
There are discrepancies between the design and quality of

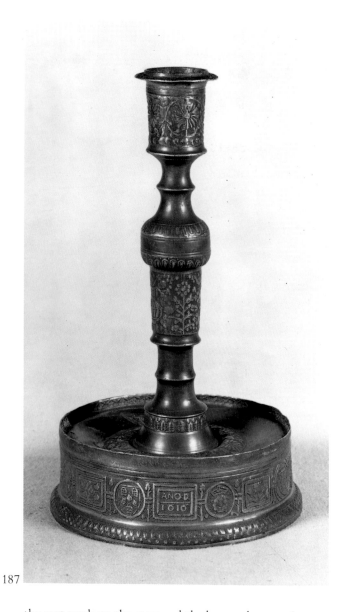

187

surface of the base has been repaired in one area using lead solder, suggesting that it is old. It has been cast in one piece and the underside shows signs of turning. Apart from the repaired surface, the candlestick shows no sign of reworking.

There is further evidence to support the authenticity of the object. A document from 1639, discovered in 1982, was found to be signed by William Granger, using the same spelling as that used on the candlestick – *GRANGER* – thereby underlining a connection between the two. William Granger is recorded as a searcher for the Pewterers' Company in 1610 and Steward in 1620. In 1638, he became upper warden of the Company. It is unlikely that a faker would have chosen such an obscure member of the Company, when better known names, easily accessible from sources such as Welch's *History of the Pewterers' Company*, would have been more prestigious and equally convincing.

Despite its rarity in a pewter context, the form of the candlestick has precedents in other materials. A copper-alloy candlestick in the Lear Collection, dating from the fifteenth century, has a base with a profile of very similar form. The style of the decoration also has some parallels. Similar cast decoration and the same date appear on the well known plate from St Mary's, Great Shefford, Berkshire. It also appears on other early seventeenth-century English wares, including wine cups and beakers in both pewter and silver. A silver-gilt candlestick, now in the Kremlin, Moscow, with London hallmarks for 1619–20 or 1624–25, has the same formalized plants and ornament set within panels formed of narrow raised strapwork.

The significance of the date, 1616, which appears on a series of English pewter wares, has never been satisfactorily explained. Dated English pewter usually commemorates an important royal event, such as the Restoration of Charles II and his marriage to Catherine of Braganza. In 1616 the future Charles I was created Earl of Chester and Prince of Wales, after the death of his brother Henry. It is significant that the decoration of the beakers, wine cups and other wares that are related stylistically to the Granger candlestick incorporate the badge of three ostrich feathers used by the Prince of Wales. The investiture ceremony would have been held in London and all the wares are probably the products of London pewterers. It is possible that they were made as souvenirs to commemorate the event.

BIBLIOGRAPHY: Bailey 1925, p. 245, Oman 1961, p. 41, Michaelis 1969, pp. 39, 40, *Pewter: a Celebration of the Craft* 1989, pp. 92–93, *English Silver Treasures from the Kremlin* 1991, no. 105, Bangs 1995, no. 19

the cast work on the stem and the base – the stem is more finely cast and the detail is clearer. For these reasons, it has been suggested that the base and the stem did not originally belong together. It has also been suggested that the stem may be continental – it was described as such when it was offered for sale by a dealer named A. Fynde in the August 1922 edition of *Connoisseur* magazine, at a price said to be £20. It did not sell, although a number of collectors could have afforded it and should have been interested in acquiring it. There seems little doubt that the authenticity of this candlestick was doubted when it first appeared for sale.

Scientific analysis, however, now confirms that the candlestick is not a composite piece. In November 1997, it was subjected to EDXRF analysis to determine whether base and stem were made from the same alloy. No significant difference was found and the alloy was shown to be a tin, copper and lead alloy, without antimony. The

188. Candlestick

English, about 1670
Height: 19.7 cm. Diameter of base: 14.5 cm
M.76-1945

TOUCHES AND INSCRIPTIONS: On the lip, maker's touch *SB*, over a star within a diamond (Cotterell 1929, no. 5463a, and an indecipherable mark on the side of the stem.
PROVENANCE: Yeates Bequest.

A similar candlestick dated 1670 by the maker CB has been recorded. Bases of this shape are also found on contemporary capstan salts, indicating that a mould could be used for a number of different types of object.

BIBLIOGRAPHY: Yeates 1927, p. 107, Cotterell 1929, pl. XXIIIc, Peal 1949, Hornsby 1983, p. 314

189. Pair of Candlesticks

German, first half 17th century
M.628-1926 Height (excluding pricket): 18.8 cm
Diameter of base: 9.8 cm
M.628a-1926 Height: 19.3 cm
Diameter of base: 9.8 cm
M.628-1926 and M.628a-1926

TOUCHES AND INSCRIPTIONS: None.
PROVENANCE: Croft Lyons Bequest. Collector's labels gummed to the base, *Lt. Colonel Croft Lyons No. 174* and *L MAR 1 PAR*. Inscribed in ink, *KARLSRUHE Y MARKS*.

These are of an unusual design and are presumably German, on account of their provenance. The stem form is possibly based upon turned ivory or turned wooden prototypes.

BIBLIOGRAPHY: Haedeke 1970, pl. 103

190. Candlestick

English, about 1675
Height: 12.5 cm. Width of base: 9.3 cm
M.411-1926

TOUCHES AND INSCRIPTIONS: Maker's touch *LS*, on the upper surface of the sconce. On the edge of the base, *WB* incised in wriggle-work, an owner's mark.
PROVENANCE: Croft Lyons Collection. A label marked *26* is stuck on the base.

A pair of candlesticks of similar form but with more elaborate sconces is in the Minchin Collection.

BIBLIOGRAPHY: Michaelis 1971, pl. XVI, Michaelis 1978, fig. 130, Hornsby 1983, p. 314

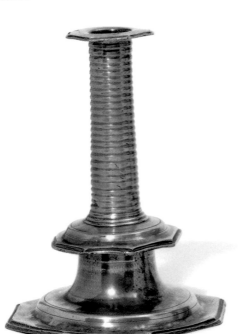

188

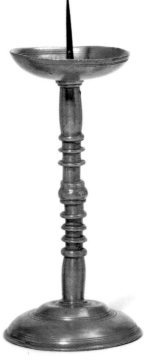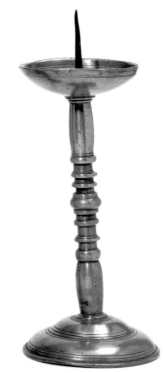

189

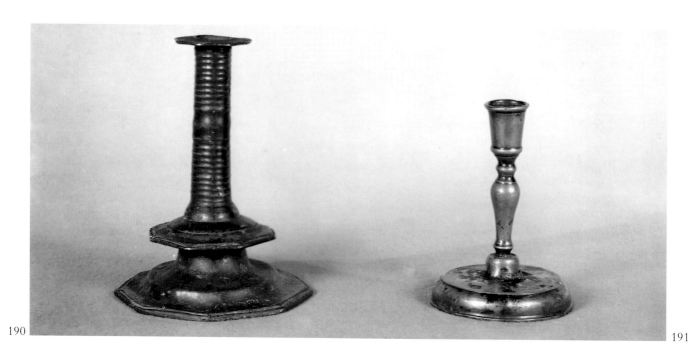

190 191

191. Taperstick

English, dated 1668
Height: 9.7 cm. Diameter of base: 6.7 cm
M.86-1945

TOUCHES AND INSCRIPTIONS: Maker's touch *WD*,
with the date *1668* (Cotterell 1929, no. 558;
London touch plate, no. 107).
PROVENANCE: Yeates Bequest.

This is a rare survival, as tapersticks of seventeenth-century
date are not common in base metal. It could have been made
by any one of three makers with the initials WD: William
Dyer, William Daveson or William Ditch.

BIBLIOGRAPHY: Cotterell 1929, p. 356

192. Candlestick

French, about 1671
Height: 23.3 cm. Width of base: 14.5 cm
Width of top: 4.3 cm
M.143-1930

TOUCHES AND INSCRIPTIONS: Maker's touch of Nicolas
Couvreur of Paris, with the date *1671*, struck under
the base. Roughly engraved on a corner of the base, a
coat of arms. Under the base in ink, *12383 FFM/MN*,
an owner's identification mark.
PROVENANCE: Port Bequest.

This form is known in silver and brass, and was popular in
England as well as France in the 1670s. Nicolas Couvreur
was one of a well known family of pewterers working in

Paris in the seventeenth and eighteenth centuries. Another
member of the family, Jacques-Joseph Couvreur, was
imprisoned in the Bastille in 1724 as a Calvinist.

BIBLIOGRAPHY: Cotterell 1929, p. 89, Clayton 1971, p. 69
(for silver examples), Boucaud and Fregnac 1978, pl. 367

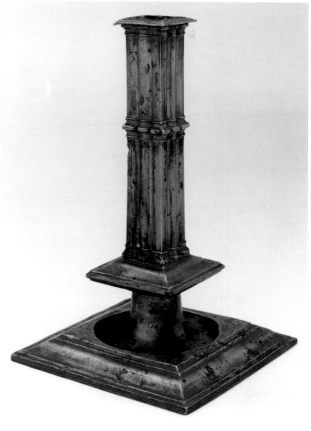

192

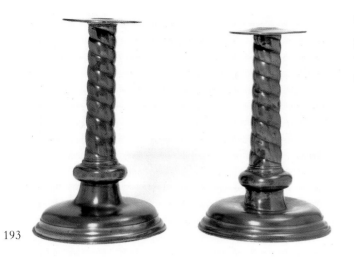

193

193. Pair of Candlesticks

Swedish, Stockholm, about 1680
M.133-1935 Height: 25.3 cm
Diameter of base: 17.3 cm
M.133a-1935 Height: 26.2 cm
Diameter of base: 17.1 cm
M.133-1935, M.133a-1935

TOUCHES AND INSCRIPTIONS: Maker's touch *FIƷLH
FIƷLHSSON* (1675–86), struck on the sconces.
PROVENANCE: Young Bequest.

This type of candlestick was made not only in pewter but also in sheet brass, from the late seventeenth until the nineteenth century. It derives possibly from German prototypes of the first half of the seventeenth century. A similar candlestick is in the Kunstindrimuseet, Oslo.

BIBLIOGRAPHY: Erixon 1972, p. 55, Boucaud and Fregnac 1978, pl. 370, Schiffer 1978, p. 164, Hornsby 1983, p. 320, no. 1081B

194. Candlestick

English, late 17th century
Height: 14.6 cm
M.80-1945

TOUCHES AND INSCRIPTIONS: Undecipherable, beginning with an *H*, on stem.
PROVENANCE: Yeates Bequest.

195. Candlestick

English, about 1820
Height: 21.3 cm. Diameter of base: 10.2 cm
M.367-1921

TOUCHES AND INSCRIPTIONS: None.
PROVENANCE: Bergne Bequest.

The condition of this candlestick (one of a pair) suggests that it has been rarely used. The pattern appears to have been very popular in England and the United States in the period 1800–30. Gadrooned decoration is more often found on the smaller chamber candlesticks.

BIBLIOGRAPHY: Brett 1981, p. 196, Hornsby 1983, p. 330, no. 1126

194 195 196

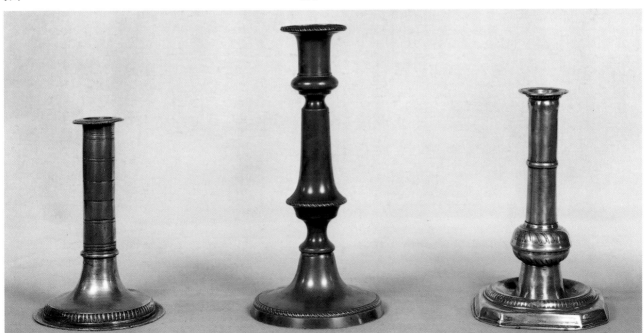

196. Candlestick

English, about 1680
Height: 15.5 cm. Width of base: 10.5 cm
M.77-1945

TOUCHES AND INSCRIPTIONS: Fleur-de-lys within a
diamond-shaped lozenge, on lip.
PROVENANCE: Yeates Bequest.

Michaelis suggested that the introduction of this form of
base was due to Dutch influence. It is commonly found on
brass and pewter candlesticks in the first quarter of the
eighteenth century. A similar candlestick with a plain knop
was in the Cooper Collection. Mr K. Gordon has suggested
that this is the production of a London workshop.

BIBLIOGRAPHY: Michaelis 1978, fig. 119, Gordon 1994, p. 49,
no. 22

197. Taperstick

English, about 1700
Height: 8.2 cm. Diameter of base: 6.1 cm
M.87-1945

TOUCHES AND INSCRIPTIONS: Maker's touch *CH*, struck
in the side of the socket (unidentified).
PROVENANCE: Yeates Bequest.

Tapersticks in pewter appear to be extremely rare. The
date of this one can be established by comparison with
tapersticks of silver and brass. A brass candlestick in the
Victoria and Albert Museum dating from about 1700 is very
close in form.

198. Candlestick

Iberian, perhaps Portuguese, about 1700
Height: 16.5 cm. Diameter of base: 9.9 cm
M.77-1938

TOUCHES AND INSCRIPTIONS: None.
PROVENANCE: Carvick Webster Bequest.

This type of candlestick was produced in Portugal and
Spain from the early seventeenth century until the nine-

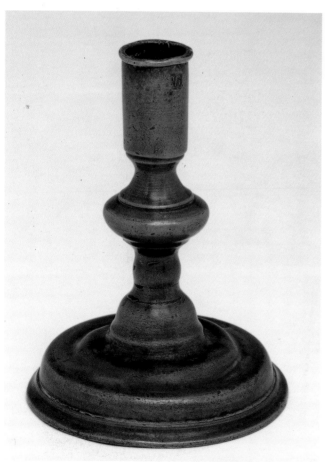

197

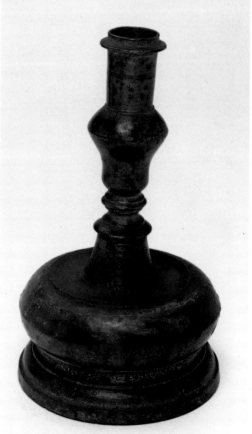

198

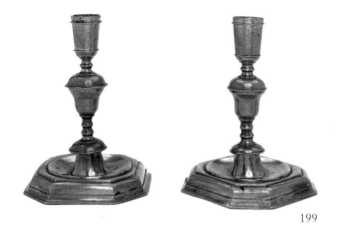

199

199. Pair of Candlesticks

French, early 18th century
Height: 14.6 cm
M.586-1926

TOUCHES AND INSCRIPTIONSS: Maker's touch *IKAV,*
with a pineapple.
PROVENANCE: Croft Lyons Bequest.

This type of candlestick is also found in silver and brass.

200. Pair of Candlesticks

German (Saxony), about 1760
Height: 26.7 cm
M.433-1956

TOUCHES AND INSCRIPTIONS: *JA* monogram, engraved
on front of hats.
PROVENANCE: Hildburgh Bequest.

The figures forming the stems are dressed in the traditional
costume of Saxon miners. Known as *Bergmannsleuchter*
(miners' candlesticks), they were popular in Saxony in the
eighteenth and nineteenth centuries.

BIBLIOGRAPHY: Reinheckel 1983, p. 63

teenth century. The shape of the foot derives from late
Gothic prototypes. Examples in silver are shown in Dutch
paintings of the first half of the seventeenth century. The
type is also very common in Portugal and Brazil. They are
difficult to date precisely because of the continuing use of
traditional styles. However, the patina and shape of the
present piece appear to be consistent with an early date.

BIBLIOGRAPHY: Boucaud and Fregnac 1978, pl. 376,
Michaelis 1978, p. 104, Schiffer 1978, p. 158, Brett 1981,
p. 139, Hornsby 1983, p. 322

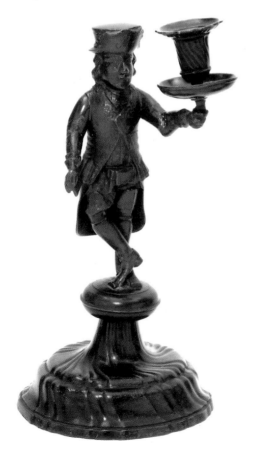
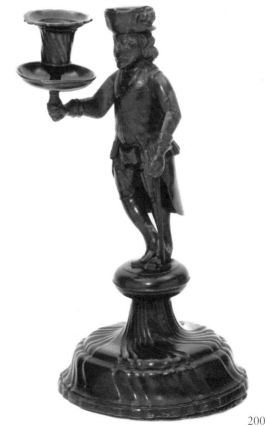

200

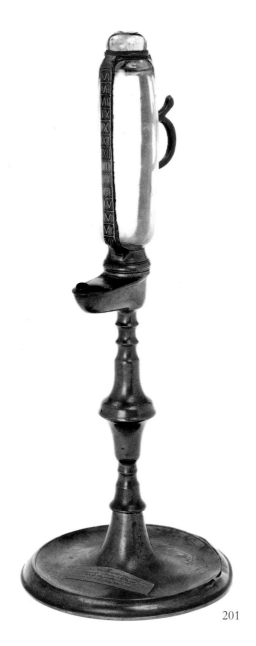

201

202. Container for Scent

German, first half 17th century
Length: 5.1 cm. Diameter: 1.5 cm
M.647-1926

TOUCHES AND INSCRIPTIONS: Illegible mark,
possibly Nuremberg town mark.
PROVENANCE: Croft Lyons Bequest. Purchased in
Würzburg.

The body is constructed from seven separate sections
that screw together. Each forms a hollow compartment,
which contained a sponge soaked in perfume; the finial is
perforated and unscrews, presumably for sprinkling scented
water. Incised on the outside of each container are Roman
numerals. Numbers two and three are missing from the
series, suggesting that there were two additional segments.
Several compartments retain the original scented sponges.

This type of container made from segments was
designed to hold a variety of different scents. Similar
containers of silver are known from the first quarter of the
seventeenth century.

BIBLIOGRAPHY: Clayton 1971, no. 521

202

201. Oil Lamp for Marking the Hours

French, about 1800
Height: 32 cm. Diameter of base: 12.8 cm
590-1883

TOUCHES AND INSCRIPTIONS: None.
PROVENANCE: Purchased for £3.10s. A written label on
the foot gives details in French of the lamp's function.

The graduated scale on the strap holding the glass cylinder
determined the hours as the oil was consumed and the level
fell. Lamps of this form were fashionable in France,
Germany and Austria in the late eighteenth and nineteenth
centuries.

BIBLIOGRAPHY: Wechssler-Kümmel 1963, p. 198, Hornsby
1983, p. 332, no. 1135

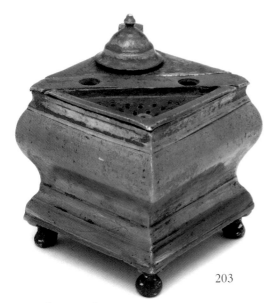

203

203. Inkstand

Dutch, about 1770
Height: 6.4 cm. Width of top: 6.5 cm
Width of base: 6.9 cm
M.449-1926

TOUCHES AND INSCRIPTIONS: *HI* with hallmarks, below a crowned *X* label; *VK* below, with *ENGELS* struck on the base. *HARTTIN*.
PROVENANCE: Croft Lyons Bequest. Collector's label on the base, inscribed *The Hague i gulden 22/9.04.*

This was the standard form of Dutch inkwell in the latter part of the eighteenth century. It usually contained small drawers in the base to hold wafers. The two holes in the diagonal bar were for quills. Sand or pumice was kept in one side of the container (the pierced side); ink was kept in the other. A tobacco box in the Museum's collection (no. 204) is by the same maker.

BIBLIOGRAPHY: Dubbe 1978, pl. 204, *Keur van tin* 1979, no. 207, Brett 1981, p. 155

204. Tobacco Box

Dutch, about 1750
Height: 15.5 cm. Width of base: 13 cm
178-1904

TOUCHES AND INSCRIPTIONS: Maker's touch *HI* with hallmarks beneath a crowned *X ENGEL VK HARTTINN.*
PROVENANCE: Fitzhenry Gift.

The Museum owns an inkwell by the same maker (no. 203).

205. Tobacco Box

Dutch, about 1760
Height (including lid): 15.4 cm. Width: 12.7 cm
179-1904

TOUCHES AND INSCRIPTIONS: Maker's touch *I K H* with an angel (unidentified), struck on the base three times.
PROVENANCE: Fitzhenry Gift.

Tobacco boxes of this form in the rococo style were very popular in Holland.

BIBLIOGRAPHY: *Keur van tin* 1979, no. 209

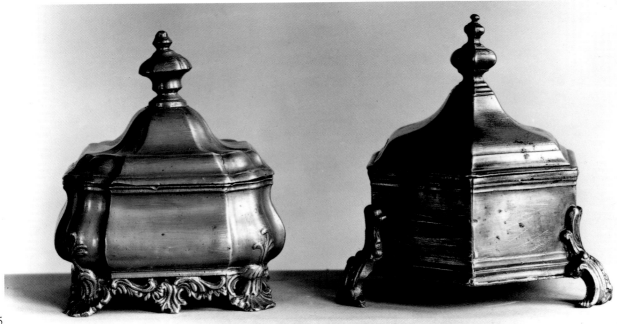

205

204

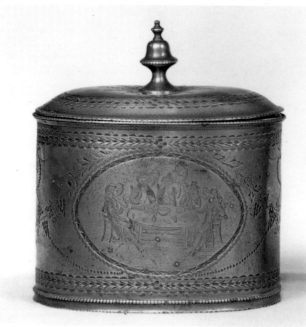

206

206. Tobacco Box

English, about 1770
Height: 10.5 cm. Length: 14.5 cm
M.160-1930

TOUCHES AND INSCRIPTIONS: Richard Pitts (Cotterell 1929, no. 3697), struck in the centre of the base (hallmarks only, not the full mark).
PROVENANCE: Port Bequest.

Although similar in form to a tea caddy, the scenes on the body indicate that this was a container for tobacco.

BIBLIOGRAPHY: Victoria and Albert Museum 1960, no. 25, Hornsby 1983, pl. LXVI

207. Snuff Box

Dutch or German, about 1740
Length: 7.3 cm. Width: 5.7 cm. Height: 2.7 cm
M.1080-1926

TOUCHES AND INSCRIPTIONS: Maker's touch *PJ* above a sun, with a dove (unidentified).
PROVENANCE: Croft Lyons Bequest.

Snuff boxes of this form were made in gilt copper and brass, as well as precious metal.

BIBLIOGRAPHY: Dubbe 1978, p. 378, fig. 544 (for a similar touch by a different Dutch maker)

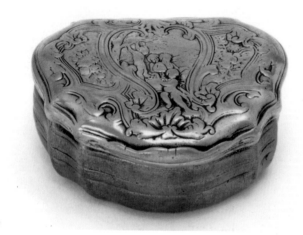

207

208. Patch Box

French, about 1795
Length: 4.4 cm
M.667-1926

TOUCHES AND INSCRIPTIONS: None.
PROVENANCE: Croft Lyons Bequest. On the underside of the lid, inscribed in ink *CAEN 10.4.08 4 Francs*.

The box is cast in relief with a medallion of a general and military trophies. It is one of a series of mass-produced artefacts decorated with patriotic themes, produced in quantity during the Revolutionary Wars.

208

209. Pill Box (?)

French, about 1770
Height: 2.5 cm. Width: 2.5 cm. Diameter: 2.4 cm
M.487-1926

TOUCHES AND INSCRIPTIONS: None.
PROVENANCE: Croft Lyons Bequest.

Inside the box there is a square piece of felt, attached to a string for easy removal.

209

210. Tobacco Box

Dutch (Zwolle), about 1800
Height: 5.8 cm. Diameter: 14.5 cm
M.1000-1926

TOUCHES AND INSCRIPTIONS: Maker's touch *VAN GOUODOM*, with *ENGLISTON*, an angel above the date *1718*.
PROVENANCE: Croft Lyons Bequest. Inscribed in ink on the underside of the lid, *WALPOLE BATH 24/7/13 MN/-* and *831*.

In spite of the date within the mark, this box almost certainly dates from the late eighteenth or early nineteenth century. Tobacco boxes were especially popular in the Low Countries in the late seventeenth and eighteenth centuries. Round jars in both brass and pewter were introduced in the second quarter of the eighteenth century. The Neoclassical form and medallion suggest a date around 1800 for this example. An identical box bearing the arms of Zwolle and the date 1796 is in the Provinciaal Overijssels Museum, Zwolle (no. 744A).

BIBLIOGRAPHY: Dubbe 1978, pl. 186, Hornsby 1983, p. 355, no. 1224

210

211. Snuff Mull

Horn mounted in pewter
Scottish, about 1840
Height: 22.2 cm. Length: 25.4 cm
M.202-1929

TOUCHES AND INSCRIPTIONS: None.
PROVENANCE: Greg Gift.

211

212

Snuff was introduced into Scotland in the first half of the seventeenth century. The earliest mulls were of ivory, horn and wood, and silver. Large table snuff mulls, in which the body is made from the horn of a ram, were introduced comparatively late, most of them dating from the nineteenth century. Many were for use in the officers' messes of the Scottish regiments. The distinctly military character of the finial suggests that this was one of these.

212. Bell

English, about 1800
Height: 9.2 cm. Diameter: 6.6 cm
M.1069-1926

TOUCHES AND INSCRIPTIONS: None.
PROVENANCE: Croft Lyons Bequest.

The bell has been turned at the rim, presumably to alter the pitch.

213. Bleeding Bowl

English, first half 18th century
Height: 4.5 cm. Diameter: 13.4 cm
M.409-1926

TOUCHES AND INSCRIPTIONS: None.
PROVENANCE: Croft Lyons Bequest.

A bleeding bowl in the Wellcome Institute Library, London, is of virtually identical form, although the scale is inscribed differently.

BIBLIOGRAPHY: Hornsby 1983, p. 122, pl. 297

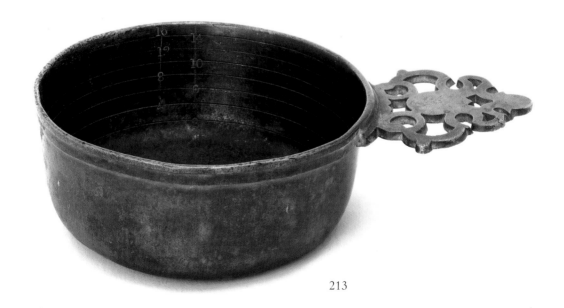

213

214. Feeding Bottle

French, about 1750
Diameter of body: 8.5 cm. Height: 7.5 cm
M.523-1926

TOUCHES AND INSCRIPTIONS: Letter *I* incised into the upper section of one side.
PROVENANCE: Croft Lyons Bequest. Collector's label on the base, *No.72 Lyons 12.9.05 AN Frcs.*

These distinctive feeding bottles for invalids seem to be exclusively French and date probably from the latter part of the eighteenth century or early nineteenth century. This example may be slightly earlier, on the basis of the style of thumb-piece and handle. These are known in France as *canards*.

BIBLIOGRAPHY: Tardy 1964, pp. 137, 709, Boucaud and Fregnac 1978, pl. 393, p. 260, cf. Hornsby 1983, pl. 276

215. Barber's Bowl

French, early 18th century
Diameter: 27.5 cm. Width of rim: 6 cm
Height: 5.8 cm
M.1071-1926

TOUCHES AND INSCRIPTIONS: On the rim, a maker's touch *RID* with a figure, within a scrolling shield, struck twice. Incised into the base and on the rim, *IM*, an owner's initials. Struck four times on the upper side of the rim and once in the centre of the bowl, *DELANDE. 18 BD BNE NOUVELLE*, an owner's mark.
PROVENANCE: Croft Lyons Bequest.

The owner's name Delande was struck on the bowl in the nineteenth century. This is an interesting example of a serviceable vessel being used continually for almost two hundred years. The shape of the touch, although unidentified, is consistent with a date in the early part of the eighteenth century. The small hole in the flange of the bowl may indicate that it belonged to a travelling barber-surgeon who carried it, 'hung on a pole', as described by the poet John Gay (see p. 123), or shown by the *potière d'étain* (fig. 12 on p.54).

BIBLIOGRAPHY: Cotterell 1929, pl. XVIII, Tardy 1964, p. 23

216. Inhaling Mug

English, 19th century
Height: 11.3 cm. Diameter of base: 10.1 cm
M.563-1926

TOUCHES AND INSCRIPTIONS: None.
PROVENANCE: Croft Lyons Bequest. A collector's label inside the mug gives the provenance as Birmingham, acquired 6/12/05.

Inhaling mugs were used to treat respiratory diseases by inhalation.

217. Plaque

German, 17th century
Height: 26 cm. Width: 19 cm
A.1058-1926

TOUCHES AND INSCRIPTIONS: None.
PROVENANCE: Croft Lyons Bequest.

The plaque shows Martin Luther, and is inscribed *D. MARTINUS LUTHERUS* and twice *VERBUM DOMINI MANET IN AETERNUM* (The word of God remains forever).

216

218. Stand

Dutch, about 1730
Height: 12.5 cm. Width: 11.7 cm
M.887-1926

TOUCHES AND INSCRIPTIONS: Maker's touch *PCR* (unidentified).
PROVENANCE: Croft Lyons Bequest.

This type of stand is often found in silver and was common in Holland, particularly in the nineteenth century.

217

218

219

220

219. Badge

English (London), dated 1761
Length: 6.5 cm. Width: 4.6 cm
M.416-1926

TOUCHES AND INSCRIPTIONS: The front is stamped with
initials and numerals. The reverse is stamped *CALEB
FINCH A FREEMAN BOTTOLPH LANE 1761*.
PROVENANCE: Croft Lyons Bequest.

The badge is cast as a heraldic shield with a suspension loop
at the top. The front is cast in relief with the arms of the
City of London, *Argent a cross gules in the first quarter a sword
palewise hilt to the base gule*s. Badges of this form were worn
by licensed porters in the City of London.

BIBLIOGRAPHY: Hornsby 1983, p. 360, no. 1246

220. Mantel Ornament

English, about 1840
Height: 8.4 cm. Length: 10.5 cm
M.8-1917

TOUCHES AND INSCRIPTIONS: None.
PROVENANCE: Hildburgh Bequest.

An identical model, but with a cast base in which to stand
the ornament, is in an English private collection.

BIBLIOGRAPHY: *Journal of the Pewter Society*, vol. 8, Spring
1991, p. 27

221. Wardrobe (plate XX)

French, about 1700
Made by André-Charles Boulle
Height: 203.2 cm. Width: 162.6 cm. Depth: 50.8 cm
1026-1882

PROVENANCE: Jones Collection: 'Acquired from a house
in Carlton House Terrace, for a moderate sum'.

The Museum's collection of fine furniture includes a
number of pieces from France and Germany that are
lavishly decorated with pewter inlay. The present wardrobe
or armoire is of oak, veneered with ebony, with marquetry
of engraved pewter, brass and clear tortoiseshell, laid over a
dyed leather ground. It is decorated with the cipher of
Louis XIV and was probably made for the Grand Dauphin
(of 1711) by one of the leading cabinet makers associated
with André-Charles Boulle (possibly Jean Berain).

For a relatively short period in the eighteenth century,
pewter was used as an inlay for grand fine-quality furniture.
It flourished in this context because it is relatively
malleable and easy to engrave. It also provides a colour
contrast with the other inlaid materials, possibly imitating
silver. Cabinet makers acquired their material from a
wholesaler in sheet form.

5 Measures

Whereas many of the domestic wares used at table in the fourteenth century were of wood, copper, brass or earthenware, in the cellar pewter was used for pots and measures. These are among the most common pewter vessels and have been in production in various different sizes from the fourteenth century to the present century. Their function was to determine quantities of liquid for commercial purposes, like pint and half-pint glasses in pubs today. They were used to bring wine or ale from the large barrels which were cradled up in the cellar to the smaller drinking vessels used in hall and at table. An idea of the size of the barrels used in wine cellars can be formed by looking at the gigantic cradles still remaining in royal palaces such as Hampton Court. Some vast barrels still survive, such as the famous 'Grosse Fass' from the castle in Heidelberg in Germany, which held 221,726 litres of wine. It is nine metres long and eight metres high and by tradition was supervised by a diminutive cellar-man named Perkeo, who once drank the entire contents.

The earliest form of measure in England is the baluster measure. These were used both in the home and in taverns, principally for wine.

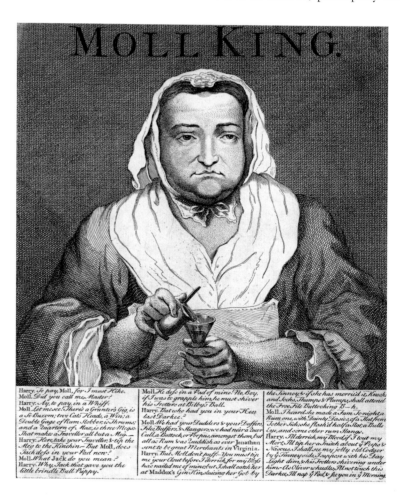

15. Moll King, the owner of a notorious brothel in Covent Garden from 1720 to 1745, fills her glass with gin from a pewter measure. *British Museum.*

The early baluster measures have a distinctive squat, waisted profile, a flat lid and a simple strap handle with a prominent thumb-piece. The suggestion has been made that the distinctive shape derives from prototypes in leather and pottery. The earliest surviving examples date from the latter part of the fifteenth century.

Bread and ale were the staple foods of people in the medieval period, and their sale and quality were regulated from an early date by acts known as 'assizes'. The earliest assize dates from about 1266 and was primarily concerned with the quality and selling price of ale in relation to the price of grain, but it did also stipulate that the measures were to be 'sealed with the iron seal of our Lord the King'. No measure was to be used unless it was agreeable to the king's standard measure.

Inspectors, known as ale-conners, were appointed and it was clearly one of the really good late medieval jobs. One test for quality required the conner to pour ale on to a bench and then to sit in the puddle for a specified period in leather breeches. If he stuck to the bench, then the ale had too much sugar in it and was bad. With a large number of establishments to sample, the temptations were obvious and it is surprising to learn that the ale-conner's role lasted well into the eighteenth century.

Fraud was a concern from an early date. In a period when food and drink were very precious and fraud was comparatively easy, it was most important that the capacity of certain vessels, especially measures, should be accurately determined and indicated. Various attempts were made by different authorities to establish set measures for ales, wines and spirits. The ideal measure would be accurate and would have its capacity clearly marked on it.

In London, a precept by the Lord Mayor dated 1423 ordered that ale sold retail should only be sold in pewter pots, sealed with a capacity mark. An early example is the well known *HR* mark which appears on measures from the first half of the sixteenth century onwards. The Museum's collection includes an early measure bearing this mark (no. 222). It was excavated in Parliament Street, Westminster, in 1903 and has the rather long waisted profile of measures dating from the first half of the sixteenth century.

Many different measures have been used in the wine and beer trades over the centuries. Because pewter measures are difficult to date and evaluate, they provide a rich field of research for specialists. There are many local variants, ranging from the Scottish tappit-hen and Irish noggin, to the Channel Islands group – each with its own characteristics and, in many cases, capacity. The Scots, for example, were still using a measure equivalent to three Old English Ale pints, first introduced in 1425, up to the introduction of the Imperial Standard in 1826.

The pewter measures of Scotland differ both in capacity and design from all others and, even after the introduction of the Imperial Standard,

the traditional capacities continued to be used in some areas. Before the Act of Union in 1707, Scottish standard measures consisted of the gill, mutchkin, chopin, and pint (4 gills = 1 mutchkin; 2 mutchkins = 1 chopin; 2 chopins = 1 pint). It should be remembered that some of the measures were much larger than their English counterparts. One Scottish pint, for example, is the equivalent of an English quart and a pint; a Scots gallon is equivalent to three English gallons.

The Scottish pint measure is also known as a tappit-hen. Its waisted upper section is similar to early Normandy flagons and is probably based on a French prototype. A Scottish dictionary derives the name from the knob on the lid, which is supposed to resemble a crested hen. The chopin has the same shape as a tappit-hen, but is of a smaller capacity. Mutchkins are usually of tappit-hen form, but are very occasionally of a more distinctive bellied form, with a waisted base and no lid. The smaller measures, such as the gill, half-gill and quarter gill are basically miniature forms of baluster measure. They are often found with domed lids. A thistle-shaped measure is also found in the smaller capacities, but these are comparatively rare in pewter.

Typical of Irish manufacture are the well known haystack measures (the shape resembles an Irish haystack), made in various sizes up to a gallon, usually by Cork pewterers, and a distinctive small slightly bellied beaker form of measure usually made in sets of four. The small Irish measures come in different capacities, such as the half-pint, gill, half-gill and quarter noggin. Another form associated with Ireland is the small duck and hen measure, formed like an egg cup. Many of these were made in Cork.

Measures of capacity have a long history. The gallon is first mentioned in about 1266 and the pint as a measure of ale was definitely established by 1474, when a record instructs Coventry innkeepers to sell a pot of three pints of 'the best ale within him' for one penny. Measures, like other hollow wares (such as tankards and jugs), are usually stamped with marks indicating that their capacity has been checked by an appointed inspector.

Early verification stamps of capacity have yet to be properly understood. One of the best known and most controversial is the *HR* mark, which is found on a number of early English baluster measures and tavern pots. Some specialists believe that it stands for a new measure of liquid capacity introduced in 1497, during the reign of Henry VII. Another has suggested that the letters stand for 'household rex', the king's household, and that measures so marked were part of the furnishings of the royal household. In a lengthy correspondence on this subject in the Museum's files between Harold Cotterell and the collector Alfred Yeates, Cotterell was suggesting as early as 1933 that it had something to do with Henry VII. A recently discovered document, dating from 1517, in the reign of Henry VIII, mentions the 'settying the kyngyes lettyr H upon a potte that holdy the but VII pyntes of the kynges

standard pynte; whyche potte ys occupied for a galon. Wyche potte agreethe no wise with seighte nor measure'. This seems to refer to the *HR* mark or something similar. At present, none of the wares stamped with the mark can be ascribed definitely to Henry VII's or Henry VIII's reign and many are clearly much later.

Another English capacity mark is a crowned *C*, presumably for Charles II, usually found on late seventeenth-century pots. During the reign of William III, in 1700, an act was passed establishing the Ale Standard. This required all quarts and pints to be measured and verified, then marked with a *WR* and a crown. As this act was not repealed until 1824, a large number of eighteenth and early nineteenth-century pots and measures are stamped with a mark dating from 1700.

Most pub habitués are familiar with the 'poacher's pint'. This is a pint pot holding rather more than a pint and many a novice barman has been inveigled into providing that extra mouthful by filling it to the brim. In 1634 a complaint was made that 'many victualers and others that lett out their beere to tapster at 14s, 15s and 16s the barrell whereby those tapsters by their juggs, blackpotts, canns and bottles and other deceiptful measures doe much deceive and defraud the subject, they having but a bare wine pint of beer for a penny'. To stop such fraudulent practice, the Act of William III dated 1700 stated that liquors were to be sold 'by the full ale quart or pint or in proportion thereto in a vessel made of wood, earth glass horn, leather, pewter, or of some other good and wholesome metal, made, sized and equalled into the Exchequer standard and signed, stamped or marked to be of the content of the said ale quart or ale pint'. Those responsible for setting the standards for the different sizes of measures for ale and beer noted in one of their assizes: 'and for that ale and beer are not in themselves perfect liquors, but being filled into a small measure the Yeast and froth thereof will ascend by working very speedily, requiring a time in settling thereof again, there is also used and to be allowed within this realm, sundry measures of lesser contents for Brewers, In-holders and Victuallers, selling their ale and beer by retail unto subjects; the which are named and called hooped quarts and pint measures, Thurdendels and half Thurdendels being a small quantity somewhat bigger than the aforesaid standard, in respect of the working and ascending of the Yeast and Froth as aforesaid'.

An additional problem for authorities trying to prevent fraud was the use of false punches to verify capacity. A London broadside of 1730 issued by the Lord Mayor mentions 'pewterers and others who do presume to Mark or Seal unlawful Weights and Measures in their own workshops with instruments in imitation of the Stamps appointed by this Court for marking or sealing the same'. In order to prevent this practice it was 'ordered that this City's Arms shall for the future be added to the Mark or Seal used for sealing the same'.

In 1824, Parliament passed 'an Act for ascertaining and establishing

uniformity of Weights and Measures'. The first section described the desired result of all the committees and commissions that had worked to frame the act: 'the removal of the weights and measures some larger, and some less, which are still in use in various places . . . and the true measure of the present standards is not verily known, which is the Cause of great Confusion and manifest Frauds!' Its importance for liquid measurements was that it repealed all previous acts, from the thirteenth century onwards, which related to weights and measures. From 1 May 1825 the standard measure for capacity for liquids and dry goods became the Imperial Standard Gallon. This contained 10 lbs. *avoirdupois* of distilled water weighed in air at 62° Fahrenheit. Measures made after 1824 were 'imperial' or 'post-imperial'; those made before were 'pre-imperial'. It is thus possible broadly to determine the date of a measure or similar container for liquids by establishing a vessel's capacity. With the introduction of the Imperial Standard in 1825, verification marks became more sophisticated. In addition to the usual crowned royal cipher, local coats of arms, the initials of inspectors and numbers are all found stamped with varying degrees of accuracy.

If the question of capacity in Great Britain seems complicated, the system used in France until the end of the eighteenth century was, in the words of the chief authority on the subject, utterly chaotic. Each district had its own standards and some had a large number of different standards within the same district. This may account for an extraordinary pewter measure in the Museum's collection, acquired in Arles and dating from the 1690s, which has thirty-four verification stamps on the lid (no. 241).

The great French statesman Talleyrand (1754–1838) made proposals for standardizing measures in 1790, and suggested a sensible collaboration between the French Academy and the British Royal Society to produce a model for all weights and measures. From these beginnings the metric system was introduced, as a result of the work of Lagrange, Laplace, Borda, Monge, Condorcet and Lalande, who presented a report to the French Academy on 19 March 1791. It is an essential feature of the metric system that the unit of length defines both weight and capacity. The principal measures of capacity are the kilogram and the litre. A litre was defined as the volume of water under standard atmospheric pressure which weighed a kilogram. After the introduction of the metric system, most French pewter measures conformed to a recognizable standard capacity.

222. Baluster Wine Measure

English, second half 16th century
Height: 19.1 cm. Diameter of base: 9.2 cm
Capacity: 1⅔ pints
M.314-1923

TOUCHES AND INSCRIPTIONS: Two prancing stags, with a
letter *F* between and three pellets struck below the
rim. Struck on the opposite edge, *HR* below a crown. A
'house mark' consisting of a bishop with mitre and the
letters *NE*, struck on the upper section of the body and
five times on the lid. Stamped in the edge of the base,
IC, an owner's mark. Designs roughly incised into the
lid, including *GR*, possibly an owner's mark.
PROVENANCE: Bouverie Gift. Formerly on loan to the
Museum. Said to have been excavated in Parliament
Street, Westminster in 1903, from a depth of 18 feet.

This well known vessel is one of a group of English baluster
wine measures dating from the second half of the sixteenth
century. It has been suggested that the shape derives from
pottery forms of the fourteenth and fifteenth centuries.
Within recent years several similar measures have been
excavated from London sites. One in the London Museum
(no. 80.227) came from the Thames foreshore at Three
Cranes Wharf. This has a medallion set in the base and is
stamped with various marks including the *HR* verification
mark. The house mark is likely to be a punning reference to
the name of a tavern such as the Mitre or Bishop's Head.
The maker's touch was first revealed when the vessel was
cleaned in 1960.

This measure incorporates a number of features usually
considered to be indicators of an early date. They include
the shape of the vessel, the attachment of the handle
directly on to the body, the cast medallion set into the
base, and the ball and wedge thumb-piece. In spite of its
condition, it is an important early English baluster
measure. A baluster measure of similar proportions,
probably slightly later in date, was exacavated from the
Thames foreshore in 1998. It has house marks on the lid,
but no verification mark. It also has a cast medallion set
into the base.

BIBLIOGRAPHY: Victoria and Albert Museum 1960, no. 13,
British Pewterware through the Ages 1969, no. 22, Haedeke
1970, p. 446, pl. 438, Woolmer 1975, p. 27, Woolmer 1977,
p. 5, Worshipful Company of Pewterers 1979, p. 52, no.
54/401, Homer and Shemmel 1983, pls. 8, 9, Hornsby 1983,
p. 240, no. 811

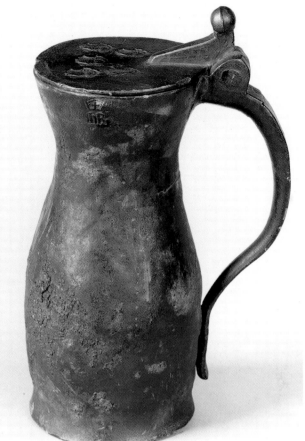

222a

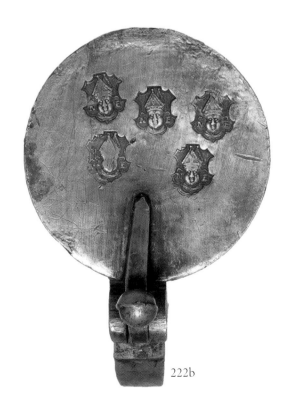

222b

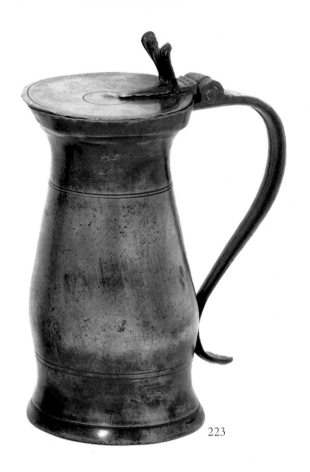

223

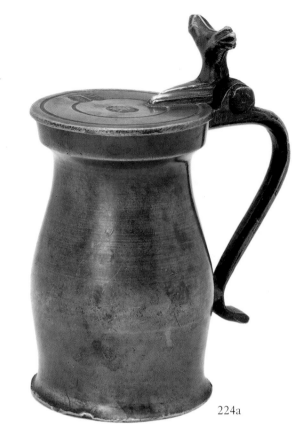

224a

223. Baluster Measure

English, about 1720
Height: 18.4 cm. Diameter of base: 10.7 cm
Capacity: 1⅝ pints
M.598-1926

TOUCHES AND INSCRIPTIONS: Letters within an oval,
perhaps *RB*, struck on the lid.
PROVENANCE: Croft Lyons Bequest. Inside the lid a
label, *Given me 19/2/06 by C. J. Praetorius who got it in
village of Llanfacreth Angelsay [sic].*

This type of baluster measure, with its spray of plume
thumb-piece, is usually associated with the north of
England.

BIBLIOGRAPHY: Hornsby 1983, pl. 815

224. Wine Measure

English, about 1740
Height: 10.2 cm. Diameter: 5 cm
Capacity: ⅓ pint
M.691-1926

TOUCHES AND INSCRIPTIONS: Maker's touch *AH* on a
globe (for A. Hincham), and a crowned *WR* verification
mark struck on the lid.
PROVENANCE: Croft Lyons Bequest.

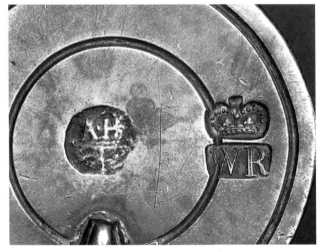

224b

This is one of the most commonly found forms of English
baluster wine measure. The crowned *WR* verification mark,
introduced at the end of the seventeenth century, was used
until 1826.

BIBLIOGRAPHY: Cotterell 1929, no. 2329, Worshipful
Company of Pewterers 1968, p. 60, no. 28, Hornsby 1983,
p. 241, no. 814

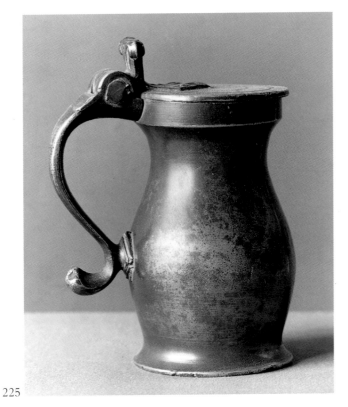

225

226

225. Baluster Measure

English, about 1780
Height: 8.3 cm. Diameter of base: 5.1 cm
Capacity: ⅓ pint
M.692-1926
TOUCHES AND INSCRIPTIONS: None.
PROVENANCE: Croft Lyons Bequest. On the base a collector's label, *437*.

This is a well preserved example of a type of English measure common during the period 1780–1820.

BIBLIOGRAPHY: Cotterell 1929, pl. XLVId, Hornsby 1983, no. 816

226. Beaker Measure

English, about 1835
Height: 9 cm. Diameter: 8 cm
Capacity: ½ pint
M.1081-1926

TOUCHES AND INSCRIPTIONS: Indecipherable maker's touch inside base. *1/2* capacity mark on the upper section of the body; verification stamp of Essex stamped on upper section of the body. On the body, the monogram *ILB*. On the base, *J.BAXTER GRAPES 130 HOLBORN*.
PROVENANCE: Croft Lyons Bequest.

The initials are presumably those of the J. Baxter whose name is engraved on the base. Beakers were especially popular in the first half of the nineteenth century. A very similar vessel with the touch of Francis Gerradin was in the Law Collection.

BIBLIOGRAPHY: Hornsby 1983, p. 303, pl. 1038

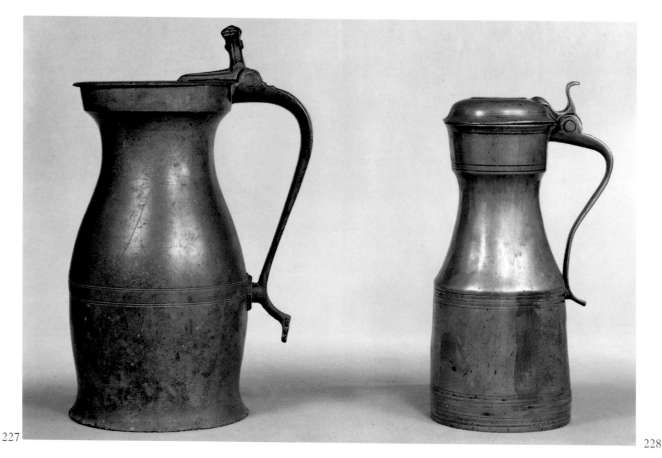

227 228

227. Baluster Measure with Lid

English, about 1716
Height (excluding lid): 28.5 cm.
Diameter of rim: 13.8 cm. Diameter of base: 16.3 cm
Capacity: 6½ pints
711-1904

TOUCHES AND INSCRIPTIONS: Maker's touch *JOHN HOME*, with hallmarks, struck under the lid (Cotterell 1929, no. 2393); *TM* with *1716* (Cotterell 1929, no. 5800), struck on the rim.
PROVENANCE: Purchased from Mr W. H.Crofts, London, for £5.

Cotterell notes that in 1754 John Home was given consent 'to strike Mr Warden Smith's touch', hence the appearance of the letters *SS* in the hallmarks. There is a considerable discrepancy between the condition of the lid and that of the body. There is also a discrepancy between the dated mark *1716* on the body and that of the maker John Home, who is recorded as working in the latter part of the eighteenth century. It is likely, therefore, that the lid is either from another vessel or a later replacement.

BIBLIOGRAPHY: Cotterell 1929, p. 52, Victoria and Albert Museum 1960, p. 14, Worshipful Company of Pewterers 1979, no. 404

228. Tappit-Hen Measure

Scottish, about 1760
Height: 27.5 cm. Diameter of base: 12.4 cm
715-1904

TOUCHES AND INSCRIPTIONS: Incised in the lid, *IM* (twice), owner's initials.
PROVENANCE: Purchased from Mr G. F. Lawrence, London. Sold at Glendinings & Co., 25 April 1904, lot 99, for £3.10s.10d.

The term 'tappit-hen' is said to derive from the terminals resembling crested hens to be found on some of these vessels. The shape derives from late medieval continental forms, especially from France, and was probably introduced to Scotland in the sixteenth century.

BIBLIOGRAPHY: Wood 1904, pl. XXIV, Victoria and Albert Museum 1960, pl. 14, Worshipful Company of Pewterers 1968, no. 355, Hornsby 1983, pl. 752

229. Tappit-Hen Measure

Scottish, about 1700
Height (excluding cover): 24.2 cm
Diameter of base: 12.7 cm. Diameter of rim: 9.7 cm
Capacity: 3 pints
716-1904

TOUCHES AND INSCRIPTIONS: On the upper section of the
body, *IH IS* in wriggle-work, an owner's initials.
PROVENANCE: Purchased from Mr G. F. Lawrence,
London. Sold at Glendinings & Co., 25 April 1904, lot
100, for £4.9s.3d.

According to some specialists, the type of tappit-hen with
a finial is later than the flat-lidded type.

BIBLIOGRAPHY: Wood 1904, pl. XXIV, Cotterell 1929, pl.
XLVIIIe

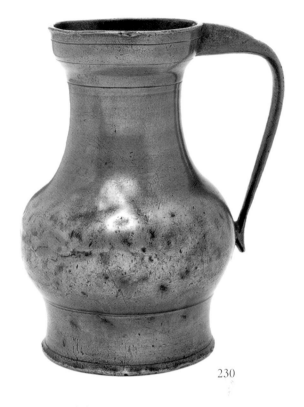
230

230. Mutchkin Measure

Scottish (Aberdeenshire?), about 1700
Height: 16.5 cm. Diameter of base: 9.2 cm
Diameter of rim: 8.5 cm
Capacity 1½ pints
M.59-1938
TOUCHES AND INSCRIPTIONS: Stamped on the thumb-
piece, *WS AG*, an owner's identification marks.
PROVENANCE: Carvick Webster Bequest.

Cotterell described this type of measure, known as a
mutchkin, as 'extremely rare'. It has been suggested that
this form was made in Aberdeen.

BIBLIOGRAPHY: Wood 1904, pl. XXIII, Cotterell 1929,
pl. XLVIIIb, Hornsby 1983, pl. 751

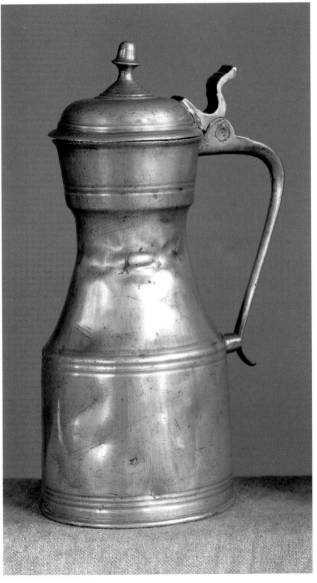
229

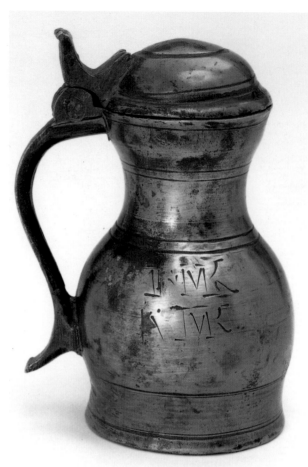

231

231. Measure

Scottish, about 1710
Height (excluding lid): 7.9 cm
Diameter of base: 5.2 cm
Capacity: ½ pint
M.57-1938

TOUCHES AND INSCRIPTIONS: Incised on the body, *I MK*, *A MK*, the initials of previous owners. On the base, incised dealer's marks *£MA £AE DAY*.
PROVENANCE: Carvick Webster Bequest.

Cotterell describes 'pot-bellied' measures of this type as 'extremely rare'.

BIBLIOGRAPHY: Cotterell 1929, pl. XLVIIIc

232. Baluster Measure

Scottish, about 1820
Height: 9.6 cm. Diameter of base: 6.1 cm
Capacity: ⅜ pint
M.61-1938

TOUCHES AND INSCRIPTIONS: A castle (?) within a circle, stamped on the cover. Initials *IG* and *1½*, stamped adjacent to the mark. Initial *R* incised into the base, an owner's mark.
PROVENANCE: Carvick Webster Bequest. On the base, inscribed in ink, *4 Webster*.

The mark is probably the castle mark used by Edinburgh pewterers.

BIBLIOGRAPHY: Wood 1904, pl. XXVI, Cotterell 1929, pl. XLIXc, Worshipful Company of Pewterers 1968, p. 63, pl. 33, Hornsby 1983, p. 243, pl. 819

233. Baluster Measure

Scottish, about 1800
Height: 10.9 cm. Diameter of base: 7 cm
Diameter of rim: 6.7 cm
Capacity: ½ pint
M.63-1938

TOUCHES AND INSCRIPTIONS: Maker's touch *DG* (unidentified). Stamped in the base, *IMPERIAL HALF PINT*. Incised into the base, *PG* and *D*, owner's marks.
PROVENANCE: Carvick Webster Bequest.

This shape is usually associated with Aberdeen. Features such as the raised hinge-plate and lack of a lid are found on a number of characteristically Scottish measures.

BIBLIOGRAPHY: Wood 1904, pl. XXIII, Cotterell 1929, pl. XLIXe, Hornsby 1983, p. 226, pl. 754

234. Measure

Scottish, about 1825
Height (excluding lid): 8.5 cm
Diameter of base: 5.5 cm
Capacity: ¼ pint
M.185-1938

TOUCHES AND INSCRIPTIONS: On the rim, *GILL* and the verification mark for Edinburgh. Under the lid, in relief, *KINNIBURGH & SONS EDINBURGH*. Incised in the base, *HM*, for an owner.
PROVENANCE: Carvick Webster Bequest.

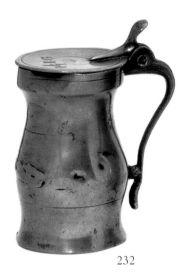

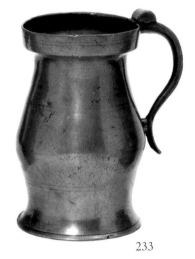

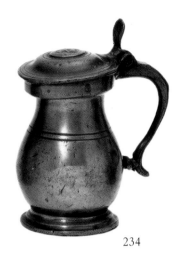

232 233 234

In spite of its poor condition, this measure is of interest because of the maker's name on the lid. Kinniburgh and Sons were the descendants of earlier pewterers of that name. The firm is recorded at 112 West Bow, Edinburgh, around 1823. There are traces of an inscription ...*IA*, for *IMPERIAL*.

BIBLIOGRAPHY: Wood 1904, pl. XXVI, Cotterell 1929, p. 250

235. Noggin Measure

Irish (Cork), 1828–33
Height: 9.2 cm
Capacity: ¼ pint
M.54-1938

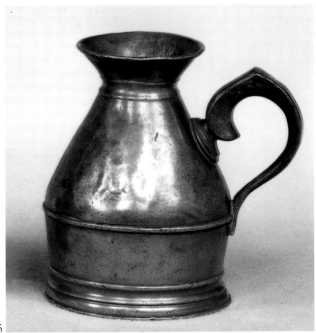

235

TOUCHES AND INSCRIPTIONS: On the base, a crown surmounted by a lion and surrounded by an inscription, *Austen & Son, Cork Imperial*; below this, the address *94 North Main Street*. On front of body, *1 noggin, Austen, Cork*. On outside of rim, *C. R. W. 835, VR* crowned etc. On the inside of the rim, a crowned harp with *VR 869*, a crown and another obliterated mark.
PROVENANCE: Carvick Webster Bequest.

236. Measure

English, second half 18th century
Height: 16.8 cm
Capacity: 1½ pints
M.62-1938

TOUCHES AND INSCRIPTIONS: None.
PROVENANCE: Carvick Webster Bequest.

237. Measure

Channel Islands (Guernsey), about 1720
Diameter of base: 11 cm. Diameter of rim: 7.7 cm
Height (excluding lid): 20.4 cm
Capacity: 1⅞
M.142-1930

TOUCHES AND INSCRIPTIONS: Maker's touch *TC* with three devices (Cotterell 1929, no. 5530), perhaps for Thomas Couch, struck twice on the lid. Stamped on the lid, *PBH*. Label with London letter *N* reversed.
PROVENANCE: Port Bequest.

This measure has the classic Guernsey form, with a bulbous body and strongly everted foot, and falls within the Type I category established by Woolmer and Arkwright. They pointed out that the *TC* touch might be that of Thomas Couch of Tywardreath, a Cornish pewterer recorded in

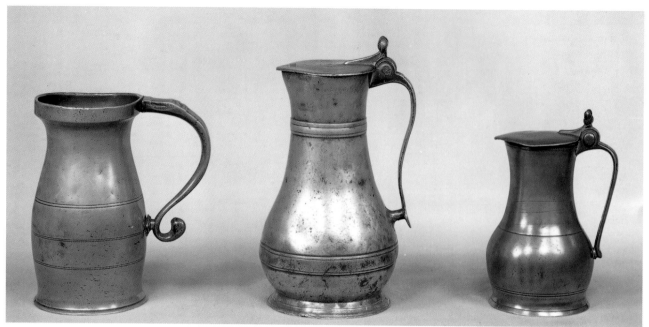

236 237a 238

1717. The use of a beaded border for the touch and the reversed *N* in the London label suggest a provincial pewterer. Measures of this form are of considerable rarity, only four being known.

BIBLIOGRAPHY: Victoria and Albert Museum 1960, pl. 15B, Worshipful Company of Pewterers 1979, p. 58, no. 412/3, Hornsby 1983, pl. 755

238. Measure with Lid

Channel Islands (Jersey), about 1780
Height: 16.5 cm. Diameter of base: 8.9 cm
Capacity: 1 pint
M.423-1926

TOUCHES AND INSCRIPTIONS: Verification mark *GR* with crown, struck near the rim.
PROVENANCE: Croft-Lyons Bequest. Collector's label on the base, *Lt. Colonel Croft-Lyons No. HHN/- Set of three 10/6/02.*

The verification mark is Woolmer and Arkwright's seal B, in use 1754–1901. This flagon has characteristics which suggest that it should be included in Type 4, as proposed by the above authors. The combination and arrangements of the horizontal lines incised on the body suggest a date in the last quarter of the eighteenth century.

BIBLIOGRAPHY: Victoria and Albert Museum 1960, pl. 15c

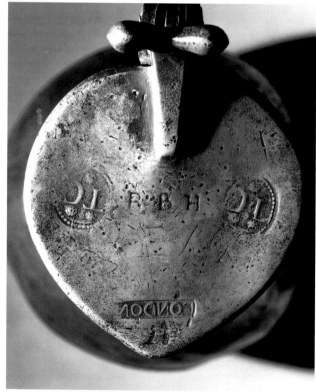

237b

239. Baluster Measure with Lid

Channel Islands (Jersey), about 1740
Height (excluding lid): 24.5 cm
Diameter of base: 13.4 cm
Capacity: 3⅔ pints
M.396-1926

TOUCHES AND INSCRIPTIONS: Maker's touch *JOHN DE ST CROIX* (Cotterell 1929, no. 1360), struck inside the lid. Incised into the strap handle, *MLH*, the initials of an owner.
PROVENANCE: Croft Lyons Bequest. Inside the lid, a label inscribed *Lt. Col. Lyons, 3 Hertford St. Mayfair.*

Jean de Sainte-Croix was the most important Jersey pewterer working in the eighteenth century. He was apprenticed in 1722 to Hellier Perchard and registered his mark in London on 18 June 1730. He apparently worked both in London and Jersey, and is last recorded in a document of 1765. This flagon falls within Group 2 of the classification by Woolmer and Arkwright. The hinge pin is cast with the *D5* and cross device found on Jersey measures. For another measure by the same maker in the Museum (M.397A-1926).

It is quite possible that at least some 'Channel Islands' pewter was made in London, or France.

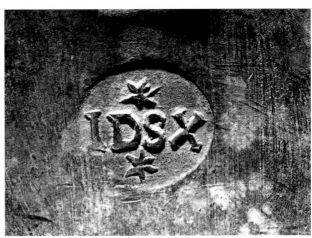

239b

240. Wine Measure

French (Paris), about 1660
Height (excluding lid): 15.5 cm
Diameter of base: 9.5 cm
Capacity 1⅓ pints
M.538-1926

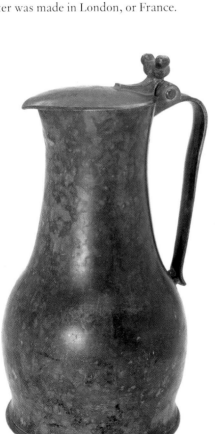

239a

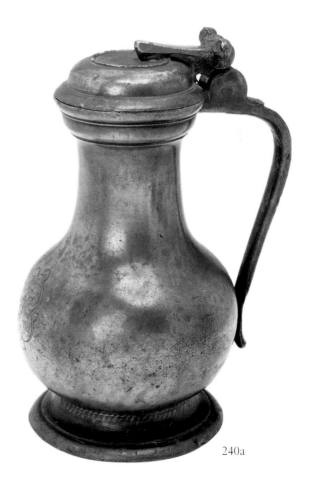

240a

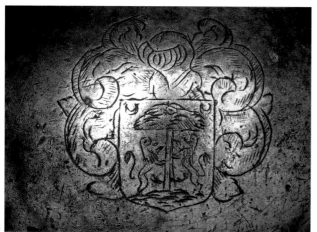

240b

have been made in Arles, although it lacks the Arles verification mark. The stamps include initials, devices and two coats of arms, demonstrating the complexity of the verification system.

BIBLIOGRAPHY: Boucaud 1958, p. 49, Tardy 1964, p. 745, Hornsby 1983, p. 221

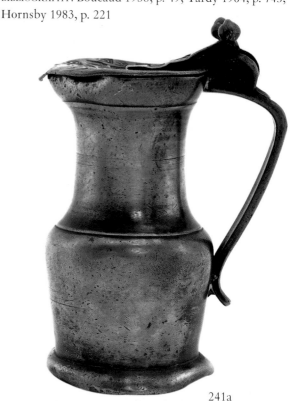

TOUCHES AND INSCRIPTIONS: Maker's touch *NICHOLAS RACHARD* (?), with a date *1643*, struck on the base and upper section of the handle. At the front, an engraved coat of arms.
PROVENANCE: Croft Lyons Bequest. On the lid, a collector's label, *Lt. Colonel Croft Lyons No. 89 Carcassonne 4.11.05 T frcs No.233*. Purchased in Carcassonne.

This is a fine solidly made early measure. The large thumb-piece seems out of proportion, but similar ones are recorded on some Toulouse measures. In shape, this measure also has many features of Toulouse examples. Tardy lists a Nicolas Rachard as working in the rue Saint-Antoine, Paris, in 1669, possibly the maker of this piece. The date within the mark is that when the marking of pewter in Paris was regulated.

BIBLIOGRAPHY: Boucaud 1958, fig. 71, Tardy 1964, pp. 42, 68

241. Measure

French, about 1690
Height (excluding lid): 16 cm
Diameter of base: 8.7 cm
Capacity: 1 pint
M.601-1926

TOUCHES AND INSCRIPTIONS: Thirty-four verification marks stamped in the lid. Engraved on the handle, *EF IR*, for previous owners.
PROVENANCE: Croft Lyons Bequest. Inscribed in ink under the lid, *ARLES 12.9.06 AN/Frs*. Purchased in Arles.

This vessel has had considerable use and is remarkable for the large number of verification marks it bears, clearly indicating that it was used for some considerable time. The twin-bud thumb-piece is of the type associated with Provence and, given its provenance, this measure could well

241a

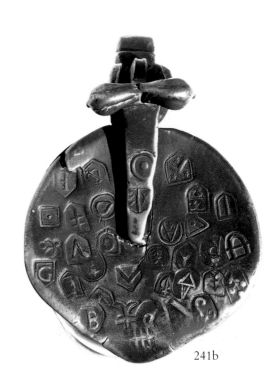

241b

242. Measure

French, late 17th century
Height: 27.1 cm. Diameter of base: 15.7 cm
Capacity: 4 pints
M.661-1926

TOUCHES AND INSCRIPTIONS: Cast plug with fleur-de-lys and stars set into the base. On the lid, a roughly incised star design and an illegible name *ME . . .*, probably that of an owner.
PROVENANCE: Croft Lyons Bequest. On the base in ink, *Lt. Col. Lyons 3 Hertford St. Mayfair Paris 23.4.08 HN Francs*. Purchased in Paris.

The very broad convex mouldings and narrow moulding on the lid make this measure an unusual piece. The latter feature is said to be characteristic of measures from Angers and Bordeaux.

BIBLIOGRAPHY: Boucaud 1958, fig. 70

243. Measure for Oil

French, about 1720
Height: 19.5 cm. Diameter of base: 9.7 cm
Capacity: 1 pint

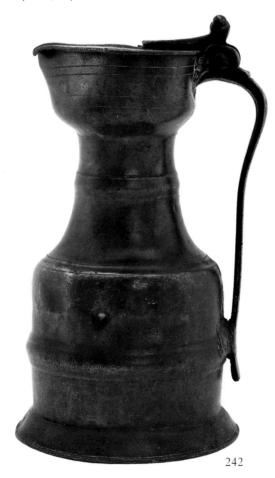

242

TOUCHES AND INSCRIPTIONS: Incised line on body (part of an unfinished inscription). Monogram roughly incised under the base, perhaps *MN*.
PROVENANCE: Croft Lyons Bequest. Collector's label under the lid, *No. 96 DIETREIN TOULOUSE 7/11/05 AN FRCS*. Purchased in Toulouse.

This form of vessel is characteristic of southern France and was produced with variations until the nineteenth century. The earlier types appear to be those with straight spouts. A number are recorded bearing the marks of Toulouse pewterers. Given its provenance, this vessel is also likely to have been made in Toulouse.

BIBLIOGRAPHY: Boucaud and Fregnac 1978, pl. 316, Brett 1981, p. 77, Hornsby 1983, p. 246

244. Measure for Oil

French, 19th century
Height: 20 cm. Diameter of base: 9.1 cm
Capacity: 1 pint
M.662-1926

TOUCHES AND INSCRIPTIONS: Town mark, possibly Rouen, struck in the centre of the base, with *1699*.
PROVENANCE: Croft Lyons Bequest. Inscribed in ink on the base, *Paris 23/4/08 AM francs. Col. Lyons 5 Hertford Street Mayfair*. Purchased in Paris.

In spite of the seventeenth-century date incorporated into the mark, this is very probably a later piece, as the surface is preserved in almost perfect condition and there are no signs of any wear. Vessels of this form continued to be made in the eighteenth and nineteenth centuries. The mark is badly struck, but may be that of Rouen.

BIBLIOGRAPHY: Brett 1981, p. 76, Hornsby 1983, pl. 834

245. Measure

French, about 1720
Height: 17.3 cm. Diameter of base: 10.1 cm
Capacity: 1 pint
M.565-1926

TOUCHES AND INSCRIPTIONS: *BEA* partly illegible, struck in the centre of the base, probably for Beaune.
PROVENANCE: Croft Lyons Bequest. Collector's label, *No.55 I frcs 1/10/05 Dijon*. Purchased in Dijon.

Vessels of this form were produced from the end of the seventeenth century until the middle of the eighteenth century and are thought to have been inspired by silver prototypes. The basic form, however, is late medieval.

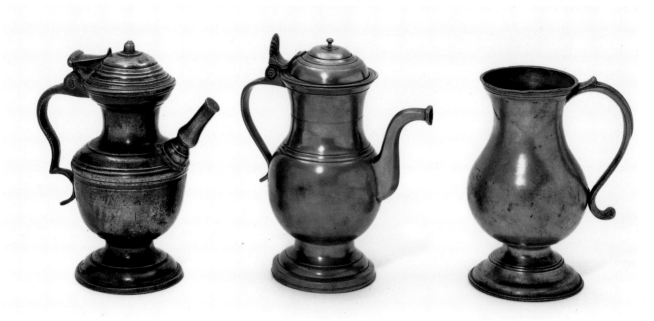

243 244 245

Many have a vestigial spout and round base. The Beaune mark usually incorporates a date and a crowned letter *C*.

BIBLIOGRAPHY: Tardy 1964, p. 203, Boucaud and Fregnac 1978, pl. 358, Hornsby 1983, pl. 795

246. Measure

French, about 1800
Height: 22 cm. Diameter of base: 11.7 cm
Capacity: 2⅓ pints
M.527-1926

TOUCHES AND INSCRIPTIONS: Maker's touch *GSG*, cast in relief on the base (unidentified).
PROVENANCE: Croft Lyons Bequest. Collector's label gummed to the base, *Lt. Colonel Croft Lyons No. 77 Avignon 26.9.05 AN Frcs.* Purchased in Avignon.

This is a well known type of ewer, thought to have been used for water. Similar vessels with a characteristic beaded handle are known from the first quarter of the eighteenth century in France. It is also found in those areas of Switzerland that are under French influence. This type of measure is usually attributed to Parisian pewterers.

BIBLIOGRAPHY: Tardy 1964, p. 76

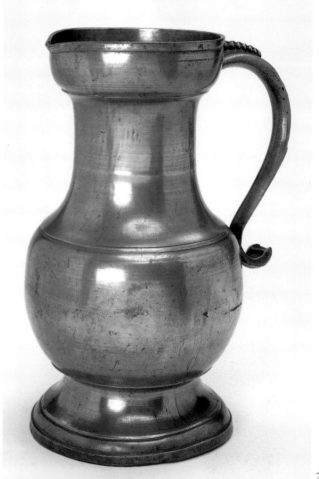

246

247a. Wine Measure

French (Toulouse), about 1800
Height (excluding lid): 22.1 cm
Diameter of base: 12.5 cm
Capacity: 2¾ pints
M.550-1926

TOUCHES AND INSCRIPTIONS: On the base, town mark of
Toulouse, with *1709*.
PROVENANCE: Croft Lyons Bequest. Under the lid, *Lt.*
Colonel Croft Lyons No. 102 Toulouse 7/10/05 M1 frcs the
six. Purchased in Toulouse.

This measure (one of a set) is of the classic Toulouse form,
with bulbous body and cap-shaped lid, and was acquired in
the city with five other similar measures (see no. 247b–f).

BIBLIOGRAPHY: Boucaud 1958, fig. 71

247b. Measure

French, about 1800
Height (excluding lid): 17.6 cm
Diameter of base: 10.7 cm
Capacity: 1¾ pints
M.550A-1926

TOUCHES AND INSCRIPTIONS: *TOL* with *1709*, for
Toulouse. Stamped on the lid, *I N*, the initials of a former
owner, with a formalized flower between the letters.
PROVENANCE: Croft Lyons Bequest. Gummed to the
underside of the lid, a collector's label, *Lt. Colonel Croft*
Lyons No. 103 Toulouse &.10.03 MI frcs the 6. One of
half a dozen measures purchased in Toulouse.

This is a classic example of a Toulouse measure, in its shape
and decoration. As with many measures from this area, the
wedge turns up slightly at the end. The date *1709* indicates
when the pewterers of Languedoc first adopted the mark.

BIBLIOGRAPHY: Boucaud 1958, fig. 71, Tardy 1964, p. 680

247c. Wine Measure

French (Toulouse), about 1800
Height (excluding lid): 15 cm
Diameter of base: 8.4 cm
Capacity: ¾ pint
M.550B-1926

TOUCHES AND INSCRIPTIONS: Maker's touch *PCB* with a
cross (unidentified), struck under the base. On the lid,
I C with a stylized flower, an owner's identification
mark.
PROVENANCE: Croft Lyons Bequest. Collector's label
under the lid, *Lt.Colonel Croft Lyons, Toulouse 7/10/05*
M1 the 6. Purchased in Toulouse.

BIBLIOGRAPHY: Boucaud 1958, fig. 71

247d. Wine Measure

French (Toulouse), about 1800
Height (excluding lid): 14 cm
Diameter of base: 8.5 cm
Capacity: ¾ pint
M.550C-1926

TOUCHES AND INSCRIPTIONS: Struck on the lid, a flower
with initials *I N*. On the base, the town mark of
Toulouse, with the date *1709*.
PROVENANCE: Croft Lyons Bequest. Under the lid, a
collector's label, *Lt. Colonel Croft Lyons No. 106 Toulouse*
7/10/05 Mi frcs the 6. Purchased in Toulouse.

Compare with no. 248f, which is almost certainly by the
same maker; although the initials on the lid are different.

BIBLIOGRAPHY: Boucaud 1958, p. 13, fig. 71

247 a–f

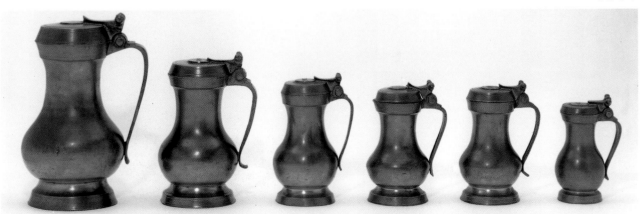

247e. Wine Measure

French (Toulouse), about 1800
Height (excluding lid): 13.9 cm
Diameter of base: 8.7 cm
Capacity: ¾ pint
M.550D-1926

TOUCHES AND INSCRIPTIONS: A cross with illegible initials. Struck on the rim, *PFO*. On the base, town mark of Toulouse, with the date *1709*.
PROVENANCE: Croft Lyons Bequest. Collector's label under the lid, *Lt. Colonel Croft Lyons No. 105 Toulouse 7/10/05 Mi the 6 frs*. Purchased in Toulouse.

The cross mark is recorded on other wares from Toulouse, including measures.

BIBLIOGRAPHY: Boucaud 1958, p. 66, nos. 156, 157, fig. 71, Tardy 1964, pp. 684, 953, no. 684

247f. Wine Measure

French (Toulouse), about 1800
Height (excluding lid): 12.1 cm
Diameter of base: 6.4 cm
Capacity: ⅔ pint
M.550E-1926

TOUCHES AND INSCRIPTIONS: Struck on the lid, a flower with the initials of an owner, *IC*. On the base, the town mark of Toulouse, with the date *1709*.
PROVENANCE: Croft Lyons Bequest. Under the lid, a collector's label, *Lt. Colonel Croft Lyons No. 107 TOULOUSE 7/10/05 Mi frcs for the six*. Purchased in Toulouse.

The rose mark is adjacent to the owner's initials on the lid and may be an identification mark, rather than that of the maker.

BIBLIOGRAPHY: Boucaud 1958, pl. 13, fig. 71

248. Measure

French (Lille), about 1885
Height: 18.2 cm. Diameter of base: 9.9 cm
Capacity: 1¾ pints
M.32-1926

TOUCHES AND INSCRIPTIONS: Maker's touch *AL* in a rose and crown, struck twice on the base; also on the base, *ALBERT. PLACE DES PATINIERS. 7. LILLE*. On the lid, *G N*, an owner's mark.
PROVENANCE: Gandolfi Hornyold Gift.

Straight-sided measures of this form were used in northern France and Belgium during the nineteenth century. Unlike most other examples, the capacity has not been engraved on the body nor has the measure been verified. The makers Albert and Mulie are noted by Tardy as working in Lille in 1860. Albert worked at 7 place des Patiniers from 1885.

BIBLIOGRAPHY: Tardy 1964, p. 404, Brett 1981, p. 151, Hornsby 1983, nos. 805-807

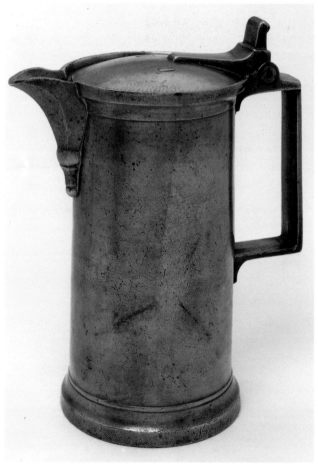

248

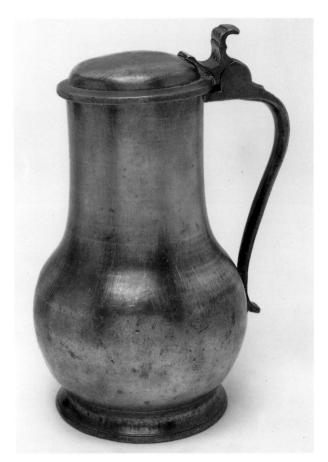

249

249. Measure

Dutch, about 1700
Height: 23.1 cm. Diameter of base: 11.2 cm
Diameter of body: 15 cm
Capacity: 3 pints
M.442-1926

TOUCHES AND INSCRIPTIONS: Maker's touch *WVW*
within a rose and crown (unidentified, but perhaps a
Leiden pewterer), stamped on the handle. On the lid,
GWEB in wriggle-work, an owner's mark.
PROVENANCE: Croft Lyons Bequest. Acquired in The
Hague.

This form of flagon was common in the Low Countries
towards the end of the seventeenth century. An example is
in the Stedelijk Museum 'De Lakenhal', Leiden, struck
with the marks of an unidentified Leiden pewterer; and
another bearing the marks of Coenraad Timmers of
Rotterdam, about 1750, is in the Historisch Museum,
Rotterdam. The form changed very little in the eighteenth
century. This type of flagon is usually known as a
Rembrandtkan, because examples often appear in Rembrandt's
paintings.

BIBLIOGRAPHY: Boucaud and Fregnac 1978, no. 199, Dubbe
1978, pl. 108, *Keur van tin* 1979, nos. 134, 252

250. Measure

German (Cologne), 18th century
Height: 13 cm
Capacity: ⅓ pint
1199-1903

TOUCHES AND INSCRIPTIONS: *G, W, H.*
PROVENANCE: Purchased from Messrs Raab and Knapp,
Frankfurt am Main.

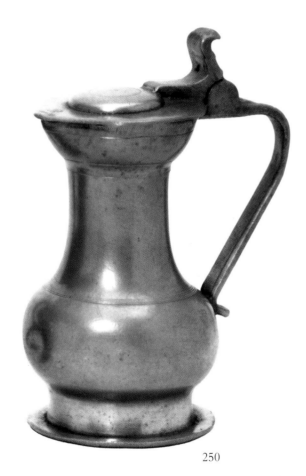

250

251. Measure

Swiss (Basle), about 1720
Height (excluding lid): 19 cm
Diameter of base: 10.3 cm
Capacity: 1⅓ pints
M.31-1926

TOUCHES AND INSCRIPTIONS: Maker's touch *IW*, for
Joseph Wick, struck on the handle.
PROVENANCE: Gandolfi Hornyold Gift.

A very similar measure by a member of the Wick family is
in the Schweizerisches Landesmuseum, Zurich (LM.21557).
The shape and form of mark are typical of Basle.

251b

252. Measure

Swedish (Kalmar?), about 1822
Height: 16.3 cm. Diameter of base: 13.3 cm
Capacity: 2 pints
284-1906

TOUCHES AND INSCRIPTIONS: *PI P*, three crowns within a
shield, with *MS*, lion and device, struck inside the base.
On the lid, three crowns and *R* with the date *1822* (the
crowns are part of the arms of Sweden). On the body,
MED, for an owner.
PROVENANCE: Purchased from Mr G. Jorck, London.

The distinctive shape and horizontal hoops of this measure
are derived from wooden vessels, popular in Scandinavia
until comparatively late. The tapered shape is also found in
copper and brass. The moulded spout and cover form are
found on flagons from German-speaking lands from the
seventeenth century.

BIBLIOGRAPHY: Dexel 1973, nos. 889, 890, Brett 1981, p. 165,
p. 207, Hornsby 1983, no. 148

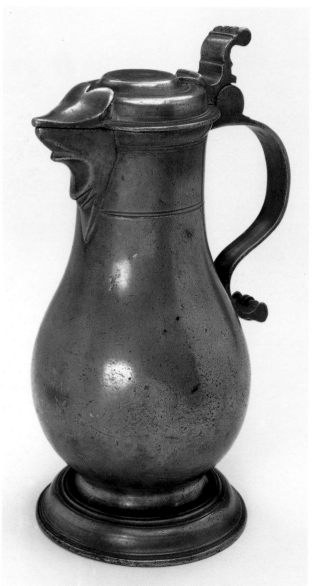

251a

252

253. Half-Pint Baluster Measure

English, about 1680
Height (excluding lid): 11.1 cm
Diameter of base: 6 cm
M.65-1938

TOUCHES AND INSCRIPTIONS: Maker's touch *SB*, with a bell struck on the base (unidentified). On the lid, two hallmarks *S C*; incised under the lid *WW*, owner's initials.
PROVENANCE: Carvick Webster Bequest.

The mark is possibly a pun on the maker's surname S. Bell.

BIBLIOGRAPHY: Cotterell 1929, pl. XLVIa, Worshipful Company of Pewterers 1968, p. 60, no. 27

253

6 Ecclesiastical Pewter

Although tin-alloy artefacts survive from the ancient world, an unbroken history of working pewter cannot be traced further back than the early Middle Ages. While it seems unlikely that tin mining and the tin trade ceased with the demise of the Roman Empire, there is little to suggest that the working of pewter became a continuous tradition until the Carolingian revival of the ninth century. Indeed, the fact that all the early medieval references to pewter are ecclesiastical suggests that the revival of the pewter trade may have been directly stimulated by the liturgical reforms of the Carolingian kings. Whether this is so or not, it remains a fact that from the early Middle Ages until the end of the thirteenth century, the few pewter objects that survive and all the mentions of pewter arise within an ecclesiastical context.

This close association of pewter with the Church is supported by the fact that the earliest references to pewter are concerned with the legitimacy of using the material in the making of sacramental vessels, primarily the chalice and paten. During the ninth century, theologians attempted to unify ecclesiastical practices throughout Latin Christendom (partly with a view to facilitating political control) and the procedure and significance of the Mass were systematically clarified for the first time. The question of which materials were most appropriate for sacramental use was addressed as part of these reforms. However, as the ideal solution – gold or silver – contradicted what was practically possible or affordable in the vast majority of individual cases, the issue continued to arise throughout the Middle Ages, inviting a range of practical and ideological compromises.

The earliest known mention of ecclesiastical pewter was at the Council of Reims in 803 (or 813), which allowed churches to use pewter patens and chalices (preferably with gilded interiors) on account of poverty. This concession was confirmed at the Council of Tribur in 895. The use of horn was forbidden by Pope Adrian II in 867 because it 'contained blood' (although it is known to have been used in twelfth-century France) and again in Aelfric's letter to Wulfstan, Bishop of Worcester, in 1006. This letter, which also rejected the use of wood because of its porosity, recommended the use of fusible materials, namely gold, silver, glass and tin. The Councils of Rouen and Winchester, in 1074 and 1076 respectively, banned the use of wood but allowed pewter. Bronze and copper were also disallowed because they oxidized, inducing nausea, although gilt-copper chalices were used throughout the Middle Ages.

The progressive refinement of the materials deemed worthy for sacramental use meant that by the end of the twelfth century most chalices and patens were made of silver or pewter. It seems likely that, in

England, the nationwide requisition of church plate in 1194, enforced to raise the ransom for Richard I, further increased the demand for ecclesiastical pewter. It is particularly pertinent therefore that not only does the first named British pewterer date from this period but that his name, typically reflecting his occupation, was 'Alexander le calicer', the chalice-maker. Between 1190 and 1348 thirteen individuals named 'le calicer' (including one woman) are recorded in London; ten of them lived in the parish of St Martin's, Ludgate, and two in the neighbouring parish of St Bride's, Fleet Street. The fact that two of these individuals are also referred to as 'peutrer' and 'peautrer' confirms that they were pewterers. Henry le calicer is recorded in parish records (in 1306) and in his own will (in 1312) as 'le calicer', but is referred to in deeds drawn up by his widow Agnes la calicer and his son Thomas le peutrer in 1324 and 1329, as 'le calicer' and 'le peutrer' interchangeably. One Nicholas le peautrer, who married Elena the daughter of Henry and Agnes is referred to as Calcere and Calyser in 1329, 1332 and 1338.

The gradual replacement of the name 'le calicer' by 'le peutrer' at the beginning of the fourteenth century coincides with the production of the earliest surviving pieces of domestic pewter. This suggests that, prior to that time, some pewterers at least were specifically involved in the production of ecclesiastical wares and therefore that the demand must have been large enough to sustain a livelihood. Some of the demand can be explained by the fact that, besides the regular production of chalices and patens for use in the liturgy, there was also a demand for sepulchral vessels – objects to be buried with a bishop, abbot or priest. Although this practice is known from archaeological finds to have existed in the early Middle Ages, the first actual mention occurs in the 1229 constitutions of William of Blois, Bishop of Worcester, who recommended that each church should have two chalices, one of silver for the Mass and one of pewter, unconsecrated, for burial with clerics. Buried chalices were usually placed at the side of the body or were clasped over the deceased person's chest (fig. 16); occasionally they are found upright, with some evidence that they once contained wine. While silver vessels are also known to have been buried in this way, the majority of examples from the thirteenth century are of pewter. Eight of the nine chalices buried in the chapter house of Lincoln cathedral in the thirteenth century and discovered in 1955, are of pewter. It is tempting to think that they were made by the 'calicer' mentioned in Lincoln records for 1281.

The employment of pewter as a 'cheap substitute' for silver led some ecclesiastics to question the propriety of using pewter as a sacramental material; they considered it inappropriate to economize on the glorification of God. This view was presented at the Council of Westminster in 1175, which instructed bishops to consecrate vessels of silver or gold but not of pewter. The widespread acceptance of unconsecrated pewter chalices for use in the administration of the

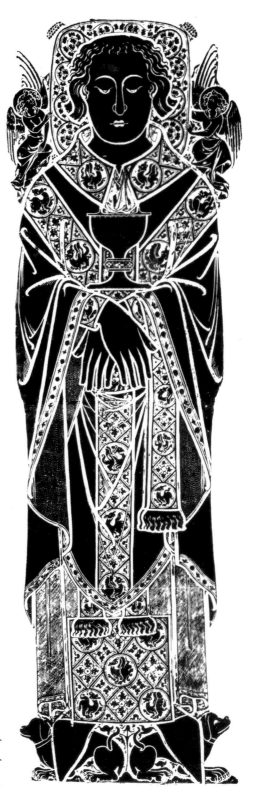

16. The memorial brass of Sir Simon of Wensley, Yorkshire, who became a priest before his death in about 1375, represents the traditional position of a sepulchral chalice buried with a cleric (rubbing: E.5989-1911). *Victoria and Albert Museum.*

sacraments to the sick (as permitted, for example, by Walter de Cantelupe, Bishop of Worcester, in 1240) may have stemmed from this ruling. But the opposite point of view – that pewter should be used precisely because it is humble and does not divert funds that could be better spent on other causes – was also expressed. The Cistercian order, founded in reaction to the ceremonial extravagance of the Cluniacs at the end of the eleventh century, preferred pewter to gold and silver for this reason. Perhaps the most archetypally medieval point of view, setting out to prove the foregone conclusion that the meaning of all things is Christ, was expressed by William Durandus, Bishop of Mende, in his *Rationale Divinorum Officiorum* (The Meaning of the Divine Offices) of around 1285. In the *Rationale's* section on church ornaments, Durandus places tin between silver and lead and gives it meaning by comparing it to the dual nature of Christ as man and God:

A golden Chalice signifieth the treasures of wisdom that be hid in Christ. A silver Chalice denoteth purity from sin. A Chalice of tin [pewter] denoteth the similitude of sin and punishment. For tin is as it were half way between silver and lead: and the Humanity of Christ, albeit it were not of lead, that is, sinful, yet was it like to sinful flesh. And therefore not silver: and although impassible for His own sin, passible He was for ours: since He thus took our infirmities and bare our sicknesses.

The ecclesiastical use of pewter peaked in the thirteenth and fourteenth centuries. Because it was relatively cheap and easy to work – small castings could be made over an open fire at the road-side – it was particularly well suited to the production of pilgrim badges and tokens. Pilgrimages to Rome and the Holy Land had been undertaken for centuries, but they became particularly popular from the eleventh century onwards, when the Crusades gave them an additional missionary significance. For most people in Britain, however, the idea of going on a pilgrimage did not become a reality until the end of the twelfth century when the canonization of Thomas Becket transformed Canterbury into a focal point for the cult of relics. Indeed, the records of Canterbury Cathedral include a reference to an 'ampoller', a craftsman who specialized in the production of the small lead and pewter flasks (ampullae) which contained holy water and were carried by pilgrims. Pilgrim badges were also produced in vast numbers throughout the Middle Ages and were given to pilgrims as souvenirs. Some of them were pierced or had hooks with a view to being sewn on to garments.

Another object of this type was the pilgrim token. The exact purpose of tokens is unclear. They may have been given to poor pilgrims by the Church, as charitable donations on feast days (such as the Feast of the Boy Bishop) or possibly even for attendance at communion, to be exchanged for food or accommodation *en route*. Pewter communion, or 'housel', tokens, stamped with Christian signs or parish names and issued as

certificates of a communicant's worthiness to receive communion, were in use in England in 1534. In Scotland, where they were especially common, pewter communion tokens were eventually replaced by printed cards bearing the names of the communicants. As these were issued at the beginning of the service and collected at the communion rail, elders were able to tell who had and who had not communicated. Worn tokens were either restamped or buried in hallowed ground – in the churchyard or beneath a revered part of the church, such as the pulpit. In some parts of Scotland, metal communion tokens are still used. In 1561, a system of tokens was introduced in the Protestant Church in France, on Calvin's recommendation.

In countries that remained Catholic after the Renaissance, most of the types of religious object that had developed in the Middle Ages continued to be used. The Museum has good examples of pyxes (for carrying the sacrament to the sick), ciboria (for storing the consecrated host) and chrismatories (containing the oils for baptism, confirmation and ordination). Pewter monstrances, reliquaries and censers were also produced. Pewter cruet sets (used to contain the communion wine and water) are particularly common and it may be significant that it was a cruet that the twelfth-century goldsmith Theophilus chose to illustrate his description of pewter working in his manual *De Diversis Artibus* (On Diverse Arts). Besides the cast plaques that often surmount holy water stoups and a number of domestic crucifixes, figurative work is relatively scarce. The twelfth-century figure of the crucified Christ, found at Ludgvan in Cornwall and now on loan to the British Museum, is a unique survival for its date.

In some areas in Britain, up to seventy per cent of churches owned a pewter chalice. However, by the time of the surveys of church possessions in the middle of the sixteenth century, silver had largely replaced pewter and comparatively few mentions of the material occur in inventories. The comprehensive requisition of liturgical and devotional silver by the Crown led to a revival of the use of pewter in the later sixteenth century and the ecclesiastical canons (decrees) of 1602–1603 expressly stated that communion wine was 'to be brought to the Communion table in a clean and sweet standing pot or stoup of pewter – if not of purer metal' ('coque ex stano, si non ex metallo praestantiore').

In England, as in other Protestant countries, changes in religious attitudes were reflected in the types of object that were produced for the Church. The rationalization and simplification of the communion service resulted in the suppression of all objects, such as monstrances and reliquaries, that were perceived to be cultish. At the same time, sacraments which had been ritually reserved for the celebrating priest since the thirteenth century, were returned to the laity and this led to the increase in the sizes of patens and chalices, soberly renamed 'communion cups'. The large quantity of wine consumed led to the introduction of

flagons from which to refill the cups, and alms dishes reflect the new concern for the material and social welfare of the community. Pairs of altar candlesticks were also common.

Throughout its history, ecclesiastical pewter was subject to the same stylistic and technical developments as civil and domestic pewter. Particularly in a Protestant context, where the taking of communion was to some extent deliberately domesticated, the two fields were occasionally so close that for some objects, the same design could be produced for a domestic or ecclesiastical object; the moulds used for the stems of chalices, for instance, were sometimes used for secular candlesticks (M.75-1945). Many objects that were originally made for the home were adapted for use in the Church and vice versa; in many such cases, it is only an inscription – if there is one – that enables one to distinguish a secular flagon from a communion flagon. Occasionally there were objections to this 'laxity'. In 1683, bishops visiting Moreton in Essex demanded that 'the pewter tankard be changed for a ffaire fflagon'; at Oakley Magna in the same year they demanded that 'the pewter tankard that is for the use of the Communion . . . be changed for a fflagon'.

Church plate continued to be made in pewter in the eighteenth century, but with the development of cheap silver-plating techniques it fell out of fashion. With rare exceptions, such as the pewter baptismal ewer and basin designed by the studio of Engelbert Kayser in Cologne and made by J. P. Kayser Sohn of Krefeld (no. 282), it did not benefit from the revival of interest in pewter that took place at the beginning of the twentieth century.

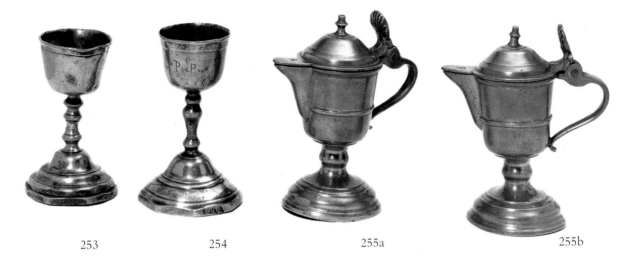

253 254 255a 255b

253. Chalice

French, 18th century
Height: 9.2 cm
M.1079-1926

TOUCHES AND INSCRIPTIONS: None.
PROVENANCE: Croft Lyons Bequest.

254. Chalice

French, 18th century
Height: 10.1 cm
M.152-1930

TOUCHES AND INSCRIPTIONS: Engraved *LPP*.
PROVENANCE: Port Bequest.

Small chalices were used by priests when visiting the sick.

255. Cruet Set

Flemish, early 18th century
Height: 11.1 cm
M.548-1926 and M548a-1926

TOUCHES AND INSCRIPTIONS: A crowned rose with *1716* (?). Stamped with a *V* and *A* (*vinum* and *aqua*).
PROVENANCE: Croft Lyons Bequest.

256. Crucifix

Spanish, 18th century
Height: 18.8 cm. Width: 12.2 cm
M.454-1926

TOUCHES AND INSCRIPTIONS: None.
PROVENANCE: Croft Lyons Bequest. A label at the back records that the cross was purchased in Amsterdam, *26/9/04*.

The rough workmanship indicates that this is one of the mass-produced crucifixes made for domestic use. The design shows the Instruments of the Passion within a narrow frame.

256

257. Holy-Water Stoup

German or Swiss, 18th century (?)
Height: 19.6 cm
M.63-1926

TOUCHES AND INSCRIPTIONS: On the lid, within a
roundel *IHS* with a cross.
PROVENANCE: Gandolfi Hornyold Gift. At the back of
the stoup, a dealer's label inscribed *6485 112a.*

A very similar stoup is in the Kunstgewerbe Museum,
Cologne. According to the donor this stoup is Swiss.

BIBLIOGRAPHY: Hornsby 1983, p. 102, no. 220

258. Holy-Water Stoup

French, 19th century
Height: 24.2 cm
M.633-1926

TOUCHES AND INSCRIPTIONS: Maker's touch *I FAR*,
struck on the lid (unidentified).
PROVENANCE: Croft Lyons Bequest. Collector's label
gummed to the lid and inscribed in ink, *NAMUR
29/8/07 T francs.* Purchased in Namur.

Preserved in good condition, this stoup is of interest
because of its provenance and because it is marked.

BIBLIOGRAPHY: Hornsby 1983, p. 102, no. 220

259. Chalice

Dutch (Leeuwarden), about 1700
Height: 22.2 cm. Diameter of foot: 13.6 cm
M.426-1924

TOUCHES AND INSCRIPTIONS: Maker's touch *HL* with
crowned rose (unidentified), struck inside the base.
Engraved on the foot, a Maltese cross.
PROVENANCE: Purchased from Mr S. W. Wolsey,
London, for £6.10s.

The touch is that of an unidentified maker from Leeu-
warden.

BIBLIOGRAPHY: Dubbe 1978, p. 362, fig. 451, Hornsby 1983,
p. 88, no. 166

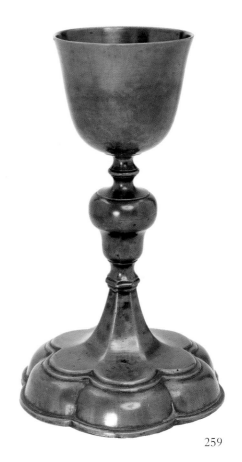

257 258 259

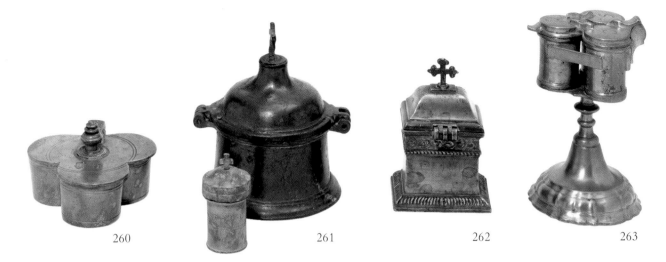

260 261 262 263

260. Chrismatory

German (Karlstadt), about 1600
Height: 3.2 cm. Width: 9.1 cm
M.632-1926

TOUCHES AND INSCRIPTIONS: Maker's touch *NW,* for
Nicolaus Winder, and town mark of Karlstadt, struck
on the lid. Inside the lid, engraved *c I s* (one letter for
each of the different types of oil); in the centre roughly
incised *A,* a collector's mark. On the base, *A,* an
owner's mark. On the side of one container, *A,* an
owner's mark.
PROVENANCE: Croft Lyons Bequest. Gummed to the
inside of the lid, *LT Colonel Croft-Lyons No. 178 350.* In
ink on the base, *Wurzburg 17/9/07 Y marks.*

These boxes were used to contain the holy oils. The casting
is unusually heavy for such a small vessel.

BIBLIOGRAPHY: Hintze 1927, V, no. 1358

261. Pyx

French (Toulouse), 17th century
Height: 12.7 cm
M.535-1926

TOUCHES AND INSCRIPTIONS: *TOL* with a crown,
F, FIN DM, with the cross of Toulouse.
PROVENANCE: Croft Lyons Bequest.

262. Pyx

French, early 18th century
Height: 9.8 cm
M.580-1926

TOUCHES AND INSCRIPTIONS: Maker's touch a ship,
ANLP with an apple and a crown (unidentified).
PROVENANCE: Croft Lyons Bequest.

263. Chrismatory

German, mid-18th century
Height: 13.3 cm
966-1905

TOUCHES AND INSCRIPTIONS: None.
PROVENANCE: Purchased.

Chrismatories are vessels for the holy oils. This ensemble is
inscribed *S C I,* for *sacrum chrisma, oleum catechumenorum* and
oleum infirmorum. It is said to have come from a monastery in
the Tyrol.

264. Flagon with Lid

English, dated 1639
Height (excluding lid): 27.8 cm
Diameter of base: 15.3 cm
511-1901

TOUCHES AND INSCRIPTIONS: Maker's touch *IE* with a unicorn (unidentified), struck on the handle. Engraved on the body, *WILLYAM HUNT AFTER DAWSON CHURCH WARDANES OF FOSDICK ANON DOMI 1639* (William Hunt, Arthur Dawson, Churchwardens of Fosdyke Anno Domini 1639).
PROVENANCE: Purchased from C. H. Shoppee, London, for £12.11s.5d.

In spite of its condition and altered lip, this flagon is of special interest because of the inscription and date. Fosdyke is a town in Lincolnshire, near the Wash.

BIBLIOGRAPHY: Worshipful Company of Pewterers 1968, no. 14, Brett 1981, p. 55, Hornsby 1983, p. 197, no. 647

265. Flagon with Lid

English, about 1650
Height (including lid): 22.3 cm
Diameter of base: 17.4 cm
M.67-1945

TOUCHES AND INSCRIPTIONS: Maker's touch *FS* with a star, struck in the centre of the base. Four hallmarks including the maker's touch, struck on the lid (Cotterell 1929, no. 5921).
PROVENANCE: Yeates Bequest.

This is a good example of the well known 'beefeater' flagon; the name originating in the shape of the lid, which is said to resemble the hats worn by the 'beefeaters' at H.M. Tower of London.

BIBLIOGRAPHY: Yeates 1927, p. 108, pl. II, Cotterell 1929, pl. XXXVIIa, Worshipful Company of Pewterers 1968, p. 39, no. 15, Brett 1981, p. 56

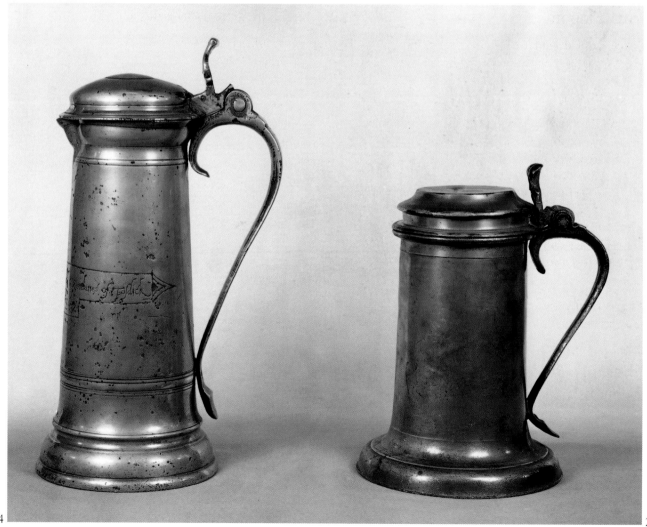

264

265

266

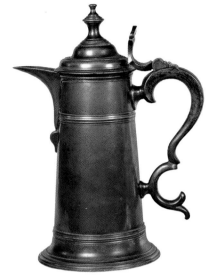

267

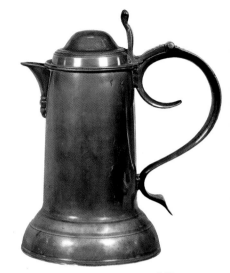

268

266. Flagon

Scottish, dated 1702
Height: 28.5 cm. Diameter of base: 17.9 cm
Diameter of rim: 12.8 cm
M.134-1930

TOUCHES AND INSCRIPTIONS: Engraved on the upper
section of the body, *HAEC LAGENA EMPTA FUIT A*
CONSISTORIO CELLAE MADOCI IN USUM CCENAE
DOMINICAE 1702 (This was bought by the Kirk
Session of Kilmadock for use in celebrating the Lord's
Supper).
PROVENANCE: Port Bequest. On the base, a label of the
Scottish Exhibition, Palace of History, Glasgow, 1911,
Chas. G. J. Port, 1 West Mansion, Worthing.

This is a classic example of the Scottish flagon, whose form
changed little throughout the eighteenth century. Full
inscriptions in Latin appear to be unusual on Scottish
flagons.

BIBLIOGRAPHY: Wood 1904, pls. XII, XIII, XVI, Cotterell
1929, pl. XXXIXa, Hornsby 1983, p. 207, pl. 680

267. Communion Flagon

English, dated 1677
Height: 33 cm
781-1896

TOUCHES AND INSCRIPTIONS: The date *1677*, scratched
on the under side.
PROVENANCE: Purchased from Mr J. Newman.

This flagon and a communion cup (no. 271) came from
Midhurst church, West Sussex.

268. Flagon

Irish, first quarter 18th century
Height: 31.1 cm
M.56a-1933
TOUCHES AND INSCRIPTIONS: Stamped *BC* crowned.
PROVENANCE: Campbell Bequest.

BIBLIOGRAPHY: Cotterell 1929, pl. XLIIa

269. Communion Cup

English, second half 17th century
Height: 18.4 cm
M.71-1945
TOUCHES AND INSCRIPTIONS: None.
PROVENANCE: Yeates Bequest.

BIBLIOGRAPHY: Yeates 1927, p. 102

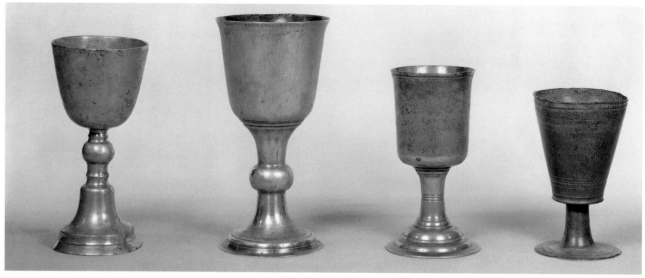

269 270 271 272

270. Communion Cup

English, last quarter 17th century
Height: 20.3 cm
M.72-1945

TOUCHES AND INSCRIPTIONS: None.
PROVENANCE: Yeates Bequest.

This cup and its related paten (M.74-1945) are from Goosnargh church, Goosnargh, near Preston, Lancashire.

BIBLIOGRAPHY: Yeates 1927, p. 102, pl. XXIX

271. Communion Cup

English, dated 1670
Height: 17.3 cm
781a-1896

TOUCHES AND INSCRIPTIONS: The date *1670*, scratched on the under side.
PROVENANCE: Purchased from Mr J. Newman.

This cup and the communion flagon (no. 267) came from Midhurst church, West Sussex.

272. Cup

English, dated 1617
Height: 14 cm
M.15-1932

TOUCHES AND INSCRIPTIONS: *IB, 16 . . .*
PROVENANCE: Croft Lyons Bequest.

The cup was dredged from the River Severn, near Berkeley,

Gloucestershire. It has often been described as a communion cup, but may initially have been for secular use.

273. Beaker

Dutch, about 1710
Height: 17.2 cm. Diameter of lip: 10.3 cm
Diameter of base: 8.2 cm
M.147-1930

TOUCHES AND INSCRIPTIONS: Maker's touch *PP* above a seeded rose, struck in the centre of the base. Incised into the base, *EXEI*, a cross and the letter *A*, the identification and purchase marks of previous owners.
PROVENANCE: Port Bequest.

The surface is engraved in wriggle-work with scenes from the life of Christ, the title of each scene being engraved as follows:
1. The Annunciation (*DE BOOTSCHAP MARIA*)
2. Christ born at Bethlehem (*DE GEBOORTE CRISTIS TOT BETTELEM*)
3. The visit of the Three Kings (*DE 3 CONINGE*)
4. The Flight into Egypt (*DE VLUCHT NA EGUPTEN*)
5. Judas receives thirty pieces of silver and betrays Christ with a kiss (*JUDAS ONTFANGET DE 30 PENNINGE EN VERRAET CRISTIS MET EEN KUS*)
6. The denial of Peter (*PEETERIS VERLOGGENT CRISTIS*)
7. Judas hangs himself (*IUDAS VERHANGT SYN SELVER*)
8. The Passion of Christ (*DE PASSIE CRISTIS*)
9. The women come to the tomb (*DE VROWE KUME HET GRAF*)
10. The Resurrection of Christ (*CRISTIS VERSCHIN OT SYN RESTELLEN*)

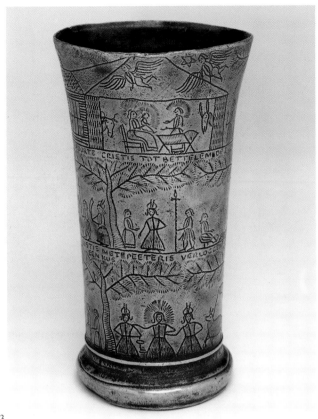

273

11. The Lamb of God (*HET LAM GODT*)

The beaker is by the same maker as M.15-1913, although the engraved work on the body is by a different hand. A beaker of similar form with similar scenes, dated 1711, is in the N. H. Gemeente, Akersloot. Beakers of this form and decoration were used for Holy Communion.

BIBLIOGRAPHY: Dubbe 1978, p. 283, pl. 164

274. Chalice

Flemish, 18th century
Height: 18.1 cm
M.629-1926

TOUCHES AND INSCRIPTIONS: A crowned rose.
PROVENANCE: Croft Lyons Bequest.

275. Large Ciborium

South German (Regensburg?), 18th century
Height: 28.9 cm
958-1905

TOUCHES AND INSCRIPTIONS: *P* . . . with crossed keys, and two others (obliterated).
PROVENANCE: Purchased from Mr J. Cahn.

276. Chalice

English, about 1655
Height: 16.6 cm. Diameter of base 9.9 cm
M.70-1945

TOUCHES AND INSCRIPTIONS: Maker's touch dove with olive branch; and initials *CF* (Cotterell 1929, no. 5575A). This maker has been identified as Charles Flood, working about 1631–55.
PROVENANCE: Yeates Bequest.

This chalice can be compared with datable silver examples, for instance an English chalice with London hallmarks for 1650–51 (M.44-1925), although the form of the knop suggests that this pewter vessel is slightly later.

BIBLIOGRAPHY: Yeates 1927, p. 102, Cotterell 1929, pl. XXIXa, Peal 1977, no. 557A

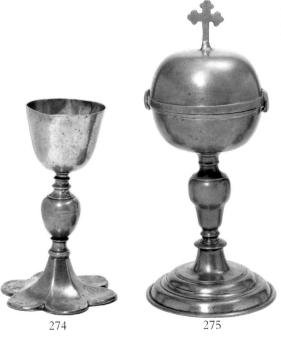

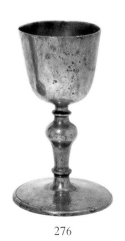

274 275 276

277

277. Alms Dish

Scottish, about 1740
Diameter: 30 cm. Depth: 4.9 cm
714-1904

TOUCHES AND INSCRIPTIONS: Maker's touch *JOHN SMITH* of Edinburgh (Cotterell 1929, no. 4364). Rose and crown, struck on the base. On the rim, stamped *AS IK*, owner's marks. Incised at the edge of the base, *Alms dish Aberdeen.*
PROVENANCE: Purchased from Mr G. F. Lawrence, London, for £3.3s. Sold at Glendining & Co., 25 April 1904, lot 91.

There is no reason to doubt the information incised in the base of this basin, suggesting that it was used as an alms dish in Aberdeen. Deep basins were especially popular in Scottish churches. This example is probably the dish noted by Ingleby Wood as being in the church of St Matthew, Meldrum, Aberdeenshire, as the marks and measurements are the same.

BIBLIOGRAPHY: Wood 1904, pp. 171, 205, pls. XVIII, XX, Cotterell 1929, pp. 85, 308

278. Figure of a Dove

English, 18th century (?)
Length: 28.5 cm. Depth: 8.3 cm
Height (including perch): 26.5 cm
M.561-1926

TOUCHES AND INSCRIPTIONS: None.
PROVENANCE: Croft Lyons Bequest.

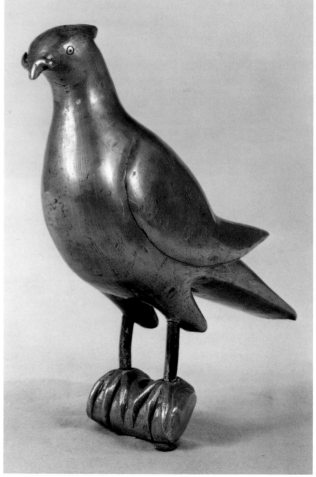

278

The figure has been cast solid in a two-piece sand mould. It is said to have come from a church in Surrey where it was attached to the cover of a font, presumably through the threaded hole in the perch.

279. Seder Plate (plate XXI)

German (Berlin), dated 1764
Diameter: 39.4 cm
M. 151-1935

TOUCHES AND INSCRIPTIONS: St Michael and the letters
LI; St Michael on a coroneted shield with the name
GOTTLIEB I0 . . .
PROVENANCE: Young Bequest.

The plate is decorated with a star, the centre of which is
decorated with the Passover lamb and the Hebrew for
'Passover sacrifice'. In between the points of the star are
two stags and the four sons whose characters have to be
considered when explaining the symbolism of *Pesach*. These
sons are the wise son, representing learned disputation; the
wicked son; the simple son and the young son. At the
bottom, a stork is eating eels. The images on the rim
illustrate a traditional Aramaic song 'a kid for two *zuzim*'.

An inscription tells that the plate was made by Leib
bar Yitzak of Berlin for Mordecai ben Salman of Friedberg
(in Hessen) and his wife Bella of Marburg. It would have
been placed in front of the celebrant on the first two nights
of the Feast of the Passover.

BIBLIOGRAPHY: Cotterell 1928, Keen 1991, no. 42

280. Purim Plate

German, dated 1771
Diameter: 24.9 cm
M.127-1913

TOUCHES AND INSCRIPTIONS: Lamb and flag, and coat of
arms. The back is inscribed *S H V D.*
PROVENANCE: Given by Mr A. Cohen.

This plate of silvered pewter was used by Jews for
conveying presents at the Feast of Purim. It is engraved
with scenes from the Book of Esther. At the top, Haman is
shown riding a horse on which Mordecai sits (each figure
identified by an adjacent engraving *Blessed be Mordecai, cursed
be Haman*). In the bottom half, Haman, his wife and his ten
sons are shown hanging from the gallows intended for
Mordecai, Esther and the Persian Jews. On the rim of the
plate is inscribed in Hebrew *FOR PURIM*, in a heart-
shaped shield supported by two lions, with the date in
Arabic numerals 1771, and the corresponding Hebrew date
5531 AM. The first line of the inscription is in Hebrew and
reads: 'sending portions/presents one to another and gifts
to the poor' (Esther 9, 22). The second line is in Yiddish:
'this plate, used for sending Purim presents, belongs to
Leib of Gallbach and his wife Pessele Auerbach, residing at
Rome'. Then follow the names: Ahasuerus, Esther.

BIBLIOGRAPHY: Keyser and Schoenberger 1955, pp. 142–43,
nos. 151–52, pl. lxxvi, Keen 1991, no. 40

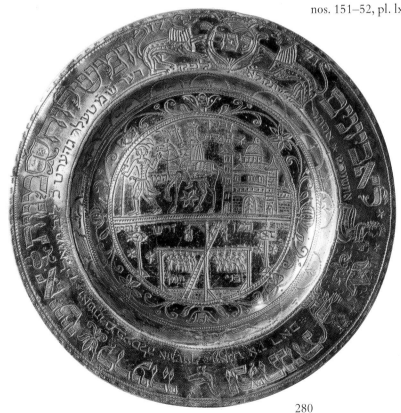

280

7 Art Nouveau *and Twentieth-century Pewter*

We should scarcely expect to find in these days of art revivals and competition any field practically unoccupied. Yet, though the venerable craft of the pewterer can hardly be called extinct, it is from an art standpoint distinctly moribund.

Thus began a lecture delivered at the Society of Arts by J. Starkie Gardner on the evening of 8 May 1894. The lecture consisted of a brief survey of the European history of the pewterer's craft, illustrated with lantern slides and examples from the collections of the Victoria and Albert Museum. It provoked considerable interest, as the account of the ensuing discussion readily indicates, and it marks the beginning of a renewed interest in pewter as a medium with a distinctive style and character all of its own.

Ten years later, almost to the day (17 May 1904), another lecture, 'Pewter and the Revival of its Use', was delivered in the same room by Arthur Lasenby Liberty, the famous retailer of Regent Street. He too began by acknowledging that the status of the industry had sunk perilously low, specifically quoting Starkie Gardner's opening paragraph. Like Starkie Gardner, Liberty conceded that the decline was largely as a result of competition from the pottery and glass industries.

Another cause alluded to by Starkie Gardner was the identification of pewter with Britannia metal. An alloy of fifty parts tin to three or four of antimony and one of copper, this had been developed in Sheffield by Hancock and Jessop, in 1770. Always the poor relation of the Sheffield trades, the Britannia metal manufacturers saw little to lose by subscribing to the Elkington patents, which made electroplating a commercial viability, when they were registered at the Patent Office in March 1840. Along with nickel silver (a form of brass alloy), Britannia metal became one of the standard base metals of this new industry, the bulk of which offered a cheap, imitative and expendable version of models made in sterling silver.

It was against this background that Liberty started to import pewter from Germany in 1899 for sale in his Regent Street shop. His principal suppliers were J. P. Kayser Sohn of Krefeld-Bockum (founded 1885), Walter Scherf's Osiris-Metallwarenfabrik für Kleinkunst of Nuremberg (founded 1899), the Orivit-Metallwarenfabrik in Cologne (founded 1894) and Ludwig Lichtinger Werkstätte of Munich. These companies had quickly established themselves as manufacturers of 'art pewter', following a French initiative some ten years earlier, which had started a revival of interest in the material, as capable of being an artistic medium in its own right. Shortly afterwards, in 1901, Liberty began to manufacture a range of pewter, which his company issued under the

brand name 'Tudric'. It is thought that the name owes its origins partly to the Welsh ancestry of Liberty's partner and managing director, John Llewellyn; a sentimental and unilluminating explanation for the most important and innovative range of pewter produced in Britain this century.

The introduction of the Tudric range was documented in Liberty's lecture. Manufacture was undertaken by W. H. Haseler of Birmingham, a firm of manufacturing goldsmiths and jewellers. In May 1901, Haseler had formed a partnership with Liberty's to manufacture the 'Cymric' range of silver and jewellery, which Liberty had launched in 1899 – it was partly the success of this that prompted the introduction of the Tudric range in pewter. Haseler's had no previous experience of pewter smithing and began by undertaking a series of trials to determine the most appropriate alloy; the one finally chosen was a composition of 90% tin, 8% copper and 2% antimony. Unlike the silverware and jewellery, manufacture of the Tudric range was from the start organized on batch production lines. Profit margins were pared to the minimum, for each product had to be priced to appeal to a market, less affluent than that supplied by the Cymric range, against stiff opposition from the German factories in particular. Objects were either machine stamped or, more frequently, cast using iron moulds. It is a credit to Haseler's technical expertise that his firm mastered the complexities of pewter casting quickly and efficiently, for the surfaces of Tudric ware are uniformly free of the trapped air bubbles that can so easily occur in inexperienced hands.

The designs for the Tudric range, as with the Cymric range, were supplied by the Silver Studio, which had offices in Brook Green, Hammersmith. Founded in 1880 by Arthur Silver, it flourished as an independent design studio until the retirement of Rex Silver, the son of the founder, in 1963. It played an important and influential role in formulating Liberty's house style, being responsible not only for supplying the majority of the metalwork designs, but over the years contributing some of the most graceful and innovative textile designs ever produced on Liberty's behalf. Attributing individual designs to particular designers has been hampered by the company's policy of keeping their identity anonymous. Liberty always retained the right to modify designs to make them more commercially viable if this was thought necessary, but the real reason was promotional. He was primarily concerned with fostering a brand image, under the umbrella of his own name, rather than to promote the individual designer or manufacturer, with whom the majority of his customers would not have been so familiar.

Nonetheless, research over the years, primarily by staff at the Victoria and Albert Museum, has identified the principal contributors. From the Silver Studio they included Rex Silver, the studio head after 1896; his brother Harry Silver; Harry Napper, a celebrated watercolourist, who was in charge between 1893 and 1895; John Illingworth Kay and, most

prominently of all, Archibald Knox (1864-1933), a gifted designer from the Isle of Man, who started working at the Silver Studio in 1898. His association with Liberty's, through the Studio, was to last until 1912, during which time he supplied nearly 5,000 designs, although not all were put into production.

Knox was responsible for introducing linear patterns based on Celtic scrollwork. In part, his work can be judged in the context of the Celtic revival, a style rooted in nineteenth-century antiquarian studies of ancient Celtic art in Britain and Ireland. As a boy, Knox had joined the local archaeological society in Douglas and during his studies at the Douglas School of Art, between 1878 and 1884, he became increasingly interested in the interlaced ornament found on Manx crosses. He was awarded a prize medal in historic ornament for his specialist study of Celtic design. In Knox's hands, however, the Celtic element was never simply a revivalist exercise, but a point of departure for a richly developed stylistic language with an indisputable modernity and character all of its own. A comparison of Knox's metalwork designs with those of the Dublin architect William A. Scott or the Dublin silversmiths Edmond Johnson Ltd, who worked within a literal Celtic revival framework, makes this immediately apparent.

Knox's designs owe rather more to the immediate precedents offered by the British Arts and Crafts movement, and the work of C. R. Ashbee and his Guild of Handicraft in particular. The designs shared expanses of plain metal, concentrated fluid ornament and monochrome enamel work. Ashbee was to complain later that Liberty's straightforwardly plagiarized his ideas and principles, but in this he was wrong. Liberty metalwork was altogether richer, more assured and self-confident than the work of the Guild of Handicraft. Knox and his colleagues, his fellow designers at the Silver Studio and the Liberty management, who gave their undoubted support, had moved the Arts and Crafts stylistic principles one stage further forward and, in so doing, had created a distinctive British version of *Art Nouveau*.

Liberty himself firmly denied this in his famous lecture of 1904. From the perspective of nearly a century later, however, his denial must be read with a degree of caution. The success of the German manufacturers, both in their domestic and overseas markets, was due to the fact that pewter was peculiarly appropriate for the fluid form and line of the emerging international *Art Nouveau* style. Liberty's initiative in starting the Tudric range was in direct response to this, and both its success and final eclipse can be explained by the fact that it fell within the parameters of *Art Nouveau*.

An understanding of the British hostility to *Art Nouveau* helps to place the British version of the style in context. Liberty himself advocated it actively until the movement came into full bloom at the Paris 1900 exhibition. Thereafter, the British mood became distinctly reserved.

The distinguished orientalist Sir George Birdwood, who chaired Liberty's lecture, referred to it in his summation, feeling compelled to pontificate on contemporary European developments: 'In France, the contortionists of *l'art nouveau* have reached the basest artistic degradation in the studied pruriency of the nude decorative bronzettes with which the shop windows of all Europe have been crowded during the past three or four years.' Clearly the work of Auguste Ledru (1860–1902), Jules Desbois (1851–1935) and Madrassi (1848–1919), with its frank sexuality and potent symbolism, was altogether too florid for English taste. By comparison, British *Art Nouveau* was a more abstract, tightly disciplined, self-conscious affair.

Knox ceased to be associated with the Silver Studio, and thus with Liberty's, in 1912. His career continued as a teacher, first at the Kingston School of Art and subsequently on the Isle of Man, at the Douglas High School and the Douglas High School for Girls. By then his career as a designer had virtually terminated. After his departure, fewer new designs were issued, although the range continued in production until the late 1930s (fig.17). Between the World Wars, what new production there was took an overtly historicist turn. There was little of the verve and originality which had characterized the range when Knox was associated with it. Nor within England was there any alternative to rival Tudric pewter. Production finally ceased in 1939, at the outbreak of war, when Haseler's turned over all but four of their iron moulds to the British Government.

Some of the most exciting developments in pewter during the inter-war period took place in France. Christian Fjeringstad (1891–1968), a Danish silversmith who had settled in Paris after serving in the French Foreign Legion during the First World War, is widely regarded as being among the leaders of French modern pewter production. His designs used a carefully modulated geometry and surfaces often have a softly planished appearance. Production was undertaken by the silversmithing and electroplating firm of Christofle, in their factory on the outskirts of Paris. Jean Desprès (1889–1980), another silversmith, also produced several very distinguished modernistic designs in pewter. His war experience had been in helping to design aircraft engines for the Aviation Militaire and, like Fernand Léger, he initially discovered and developed his particular brand of the machine aesthetic through military service. Other distinguished French pewter designers and makers of the period include Pierre-Amédée Plasait (b.1910), Jean Perey (1905–1981), Maurice Daurat

17. The enduring popularity of the *Art Nouveau* designs which dominated the early Tudric range is confirmed by the late date of this catalogue. Liberty's continued to manufacture and sell the early Tudric designs long after they had ceased to be fashionable. The vase in the lower right-hand corner of the page (no. 47) can loosely be described as 'Adam revival' and is a later addition to the range. It is not by Knox, who refused to provide any designs in a period style. Page from a Liberty catalogue, published by Liberty & Co. Ltd, London, 1926.

(1880–1969), and the husband and wife team of Alice (1872–1951) and Eugène Chanal (1872–1925).

In Britain there has been a modest revival in modern pewter design since the Second World War. It should come as no surprise that there is a consistent link with silversmithing, as there had been in France and at Liberty's. Gerald Benney CBE (b.1930) has enjoyed a distinguished career as a silversmith since the early 1950s. During the course of his career, apart from picking up four Royal Warrants, he has acted as a design consultant to manufacturing companies. In 1957, shortly after he graduated from the Royal College of Art, in London, he was retained in this capacity by Viners, the Sheffield manufacturer of silver, electroplate and stainless steel wares. One of his first designs for them was a pewter Martini jug with six accompanying beakers, which had a pleasing geometric simplicity (no. 289). The only decorative concession was a partly striated surface, which Benney was to develop into his own distinctive trademark. Many years later, in 1982, he was asked to design a tea and coffee service for the Malaysian company, Royal Selangor (no. 290). A near-contemporary of Benney's, Keith Tyssen (b.1934), who is also a graduate of the Royal College of Art and a successful silversmith, now produces a range of quietly understated but very elegant modernistic pewter (no. 291).

Younger people have begun to explore the metal's potential. It is perhaps no coincidence that two of the most recent acquisitions made by the Museum are by graduates of the 3D Silversmithing and Metalwork course at the Camberwell College of Art, London, in the last fifteen years. The interdisciplinary nature of the course has encouraged students to be more adventurous with a range of metals, including pewter. Eleanor Kearney (b.1966) graduated in 1993 and since then has established her own company, Eleanor Kearney Pewter Design. She has developed a range of pewter tableware that enjoys success both in Britain and abroad. The teapot and milk jug illustrated here (no. 292) are based on an idea formed from a series of sketches of a Moorish castle in Peracense, Spain. Toby Russell (b.1963) graduated from Camberwell in 1986 and has begun to achieve international recognition as a silversmith and pewterer. He has developed and refined folding and soldering techniques to make large sculptural vessels, in forms with a remarkable fluidity (no. 293). The results take us a step further away from the regular orthodoxy of mid-century modernism. Both these young designers provide encouraging indications for the future of British pewter.

281. Claret Jug and two Goblets

(plate XXII)

Possibly designed by Frederich Adler (1878–1942)
Made by Walter Scherf & Co.
German (Nuremberg), about 1900
Height of jug: 34.3 cm. Height of goblets: 11.4 cm
Circ.941-943-1967

TOUCHES AND INSCRIPTIONS: On the jug, *Osiris 500*.
On the goblets, *Osiris 504*.
PROVENANCE: Battersby Gift.

Frederich Adler studied at the Munich Kunstgewerbeschule between 1894 and 1898, where he obtained a thorough grounding in the applied arts. As early as 1897, his work began to be published in such prestigious publications as *Kunst und Handwerk* and *Deutsche Kunst und Dekoration*. He began producing designs for pewter in 1899, supplying the Nuremberg firms of Orion and Walter Scherf & Co. (under the trade marks Isis and Osiris) and, in Munich, Reinemann and Lichtinger. Until 1902, his pewter designs had a distinctly vegetal and plant-inspired element, which identified Adler as one of the major contributors to the German *Jugendstil* or *Art Nouveau* style.

BIBLIOGRAPHY: Liberty's, *Yule Tide Gifts*, 1900, p. 70, no. 8

282. Baptismal Ewer and Basin

Designer unknown
Made by J. P. Kayser Sohn
Germany (Krefeld-Bockum), about 1900
Height of ewer: 27 cm. Diameter of basin: 35.6 cm
894-1900

TOUCHES AND INSCRIPTIONS: On the ewer,
36/KAYSERZINN/4327.
PROVENANCE: Purchased from the Paris 1900 Exhibition,
for £2.12s.6d.

The basin is decorated with a dove at the centre and the symbols of the four Evangelists around the rim, inscribed *MATTHEUS*, *MARKUS*, *LUKAS* and *JOHANNES*. The ewer is decorated with four angel's faces, apple branches and a serpent signifying the Garden of Eden.

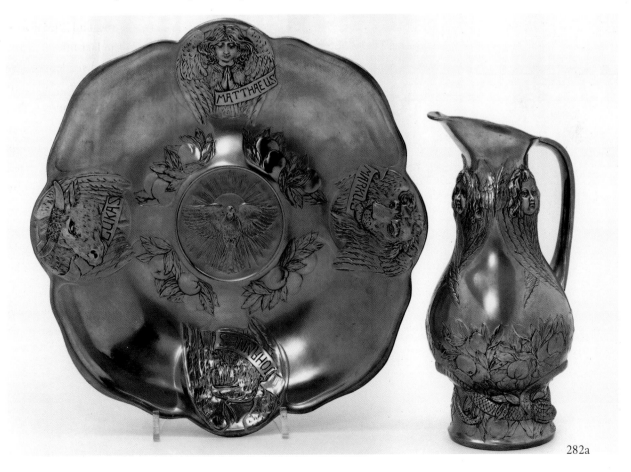

282a

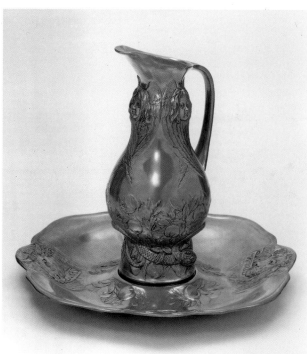

282b

283. Glass Bowl with Pewter Mounts

Glass made in the Lötz-Witwe workshops,
Klostermühle, Bohemia
The pewter mounts probably German
(designer unknown), about 1900
Height: 22 cm
Circ.953-1967

TOUCHES AND INSCRIPTIONS: None.
PROVENANCE: Battersby Gift.

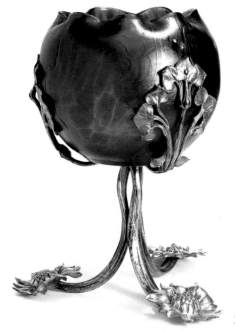

283

The Lötz glassworks became famous for lustred glassware in the latter part of the nineteenth century. It was founded in 1836 by Johann Eisenstein and acquired in the early 1840s by Johann Lötz (1778–1848). After his death, the firm continued under the direction of his widow and, from 1879 until about 1900, his nephew Max Ritter von Spaum (d.1909). Under von Spaum's supervision, the glassworks moved into the production of artistic glass in imitation of hardstones. There followed a range of lustred glass, imitating the glass produced in the workshops of the American, Louis Comfort Tiffany, who had acquired a patent for the production of lustred glassware in 1881.

The earlier provenance of the Museum's bowl remains unknown, but it is possible that it was originally imported in the early 1900s by Liberty & Co. for sale in their Regent Street store.

284. Two Tankards (plate XXIII)

Salt-glazed stoneware with pewter lids
Designed by Richard Riemerschmid (1868–1957), 1902
Made by Reinhold Merkelbach
German (Hör-Grenzhausen, Westerwald),
1903 and 1911
C.32-1990 Height: 22.2 cm. Width: 20.2 cm
C.33-1990 Height: 14 cm. Width: 15 cm
C.32-1990, 33-1990

TOUCHES AND INSCRIPTIONS: Impressed on the underside, *1769S*.
PROVENANCE: Purchased.

Richard Riemerschmid's designs for ceramics helped to stimulate a revival of the Westerwald stoneware industry. They soon received critical acclaim and, as a result, began to be issued in series. The pewter lid of the larger of the two vessels illustrated here was designed, and possibly made, by Riemerschmid himself. The lid of the smaller tankard is a standard Merkelbach production.

Riemerschmid's reputation as one of the major German designers of the Jugendstil period and of the Modern Movement after the First World War lay in his particular skill in reviving vernacular forms and techniques, and successfully adapting them to modern production methods. He began his career as a painter, but quickly became one of Munich's most proficient designers across a very broad range, from architecture, fabric design, ceramics, glassware and silver; but he is remembered most particularly as an extremely talented furniture designer.

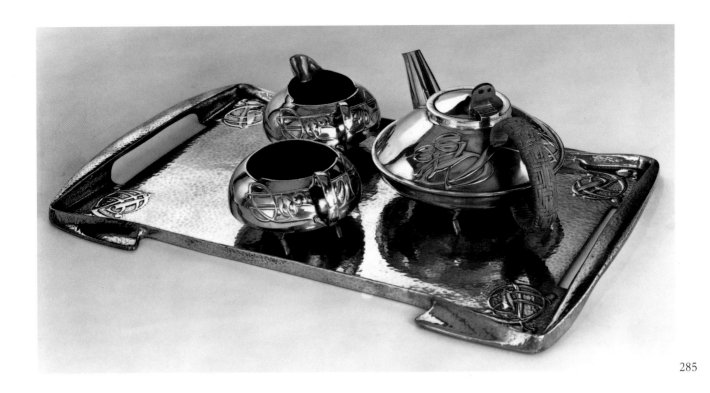

285. Tea Service

Designed by Archibald Knox
Made by W. H. Haseler, Birmingham
London, 1903 (design registered)
Length of tray: 49.2 cm. Length of teapot: 24.1 cm.
Width of milk jug and sugar bowl: 11.4 cm
Circ.915-1967, 916-1967, 917-1967, 918-1967

TOUCHES AND INSCRIPTIONS: Tray, *H*, *Made in England*, *TUDRIC*, *0376*, a crossed-plant mark and *Solkets*. Teapot and sugar bowl, *6*, *Made in England*, *TUDRIC PEWTER*, *0231*, *1¾ pints*. Milk jug, *H*, *Made in England*, *TUDRIC PEWTER*, *0231*.
PROVENANCE: Battersby Gift.

The vessels are embossed with stylized, interlaced honesty motifs.

BIBLIOGRAPHY: *Mannin*, no. 7, 1916

286. Glass Beaker in a Pewter Holder

Designed by Archibald Knox
Made by W. H. Haseler, Birmingham; the glass probably made by James Powell & Sons, Whitefriars, London
London, 1903
Height of beaker: 13.75 cm. Width of holder: 10.5 cm
Circ.751-1969, 751a-1969

TOUCHES AND INSCRIPTIONS: *English Pewter/Rd 460340/0534/7* (design registered in 1905).
PROVENANCE: Purchased from P. Myers.

The pewter holder is decorated with a pierced design of stylized tendrils, leaves and berries.

BIBLIOGRAPHY: Liberty's catalogue, no. 119, 1900, p. 75, no. 3, *Liberty's 1875–1975* 1975, p. 74, no. D179, *The Silver Studio* 1987

286

287

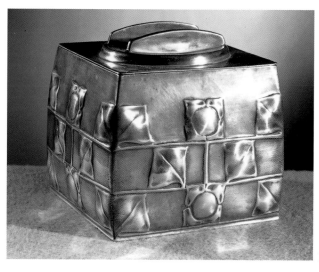

288

BIBLIOGRAPHY: *Journal of the Society of Arts*, LII, 1904, p. 639, fig. 18, Liberty's catalogue, no. 107, 1905–1906, p. 79, no. 3, *Mannin*, 1916, *Apollo*, LXXVII, 1963, p. 110, fig. 4, *Liberty's 1875–1975* 1975, p. 74, no. D177

287. Hot-Water Jug

Designed by Archibald Knox
Made by W. H. Haseler, Birmingham
England, 1904
Height: 20.5 cm
Circ.238-1970

TOUCHES AND INSCRIPTIONS: *Rd.427010/TUDRIC/0307.*

PROVENANCE: Purchased from Mr A. Tilbrook.

The jug has a cane-covered handle.

BIBLIOGRAPHY: Liberty's catalogue, no. 97, 1904, p. 29, no. 2, *Mannin*, 1916, *Liberty's 1875–1975* 1975, p. 76, no. D189

288. Biscuit Box

Designed by Archibald Knox, about 1903
Made by W. H. Haseler, Birmingham
Width: 12 cm
Circ.934-1967, 934a-1967

TOUCHES AND INSCRIPTIONS: *English Pewter/0194/Made in England.*
PROVENANCE: Battersby Gift.

In 1924, this box was copied (with slight alterations to the lid) in aluminium by the box manufacturer N. C. Joseph for the biscuit manufacturers Carr & Co. of Carlisle (M.J. Franklin Collection, M.83-1983).

289. Martini Jug and six Tankards

Designed by Gerald Benney CBE, RDI (b.1930), 1958
Made by Viners Ltd, Sheffield, 1959
Height of jug: 25.8 cm. Height of tankards: 15.1 cm
Circ.27-1959, 28-1959, 29-1959, 30-1959, 31-1959, 32-1959, 33-1959

TOUCHES AND INSCRIPTIONS: Stamped on bottom of all pieces, *English Pewter made by VINERS of Sheffield. Designed by Gerald Benney* [facsimile signature] *Made in England.*
PROVENANCE: Given by Viners Ltd, Sheffield.

Viners was one of the first British firms to introduce modern pewter designs after the Second World War. In 1957, they appointed Gerald Benney as a consultant designer, a new departure for the company, and this Martini set was amongst the first of his designs to be put into production. Pewter was considered particularly suitable for an experimental line, since it was cheaper than either silver or stainless steel.

BIBLIOGRAPHY: Hogben 1983, pp. 206–207

290. Tea Service

Designed by Gerald Benney CBE, RDI (b.1930), 1992
Made by Royal Selangor, Kuala Lumpur, Malaysia, 1996
Height of teapot: 18.5 cm. Height of sugar bowl: 9.2 cm. Height of jug: 7 cm. Diameter of tray: 25.9 cm
M.1-4-1998

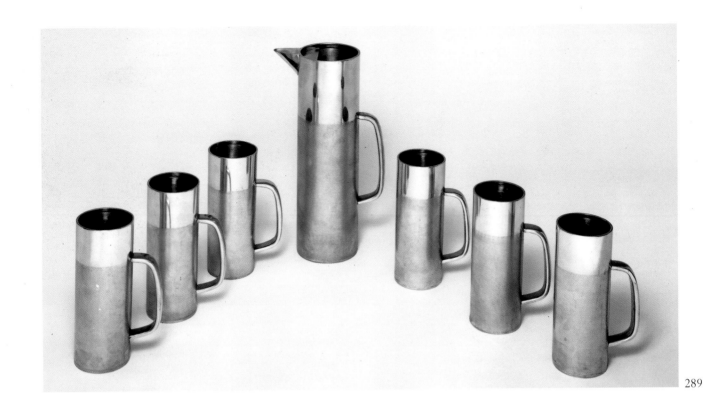

289

TOUCHES AND INSCRIPTIONS: Maker's touch *Royal Selangor*. Tray also marked *MCMXCVI* (1996) and *AGB*.
PROVENANCE: Given by Royal Selangor.

The teapot handle is of steamed wood and the tray of smoked glass. Royal Selangor is one of the largest and most successful pewter manufacturing companies in the world today. While the majority of their range follows historicist styles, they have also used Gerald Benney's skills as an industrial designer to produce a new range of tea and coffee services in a thoroughly sophisticated, modern idiom.

291

291. Bowl

Designed by Keith Tyssen (b.1934)
Made in a limited edition (no. 234) in the workshops of Keith Tyssen, Sheffield, 1990
Diameter: 31 cm
M.10-1998

TOUCHES AND INSCRIPTIONS: Maker's touch Keith Tyssen [facsimile signature], *SHEFFIELD PEWTER 234*.
PROVENANCE: Purchased.

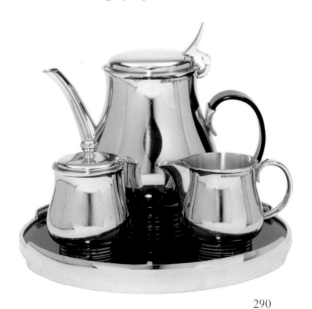

290

Keith Tyssen studied at the Sheffield College of Art and the

Royal College of Art, London. In 1963, he set up his silversmithing workshop in Sheffield and has since undertaken many prestigious commissions, both private and institutional. In 1960, he joined the teaching staff of the Sheffield College of Art, becoming eventually the head of the Department of Silversmithing and Jewellery. He is a Liveryman of the Goldsmiths' Company, London and a Fellow of the Royal Society of Arts. Since his retirement, eight years ago, he has designed and manufactured in his own workshops a range of pewter that is essentially functional. Several designs within this range use a double-skin method of construction, based on two flat discs, spun and soldered round the rim, to achieve a high degree of thermal insulation, while at the same time, making them pleasurable to handle.

292. Teapot and Milk Jug

Designed by Eleanor Kearney (b.1966), 1995
Made in the workshops of Eleanor Kearney, London (spun in Sheffield), 1998
Length of teapot: 34 cm. Maximum height: 15.7 cm
Height of jug: 10.6 cm
M.12-1998

TOUCHES AND INSCRIPTIONS: None.
PROVENANCE: Purchased.

The pieces are of spun and polished pewter, with handle and lids of polished oak. Having graduated with an English degree from University College, London, Eleanor Kearney embarked in 1990 on the 3D Silversmithing and Metalwork course at the Camberwell College of Arts, where she became particularly interested in the potential of pewter.

In 1993, she graduated with a first-class Honours degree and, since then, has established her own design and production company for a range of pewter, which is sold within Britain and abroad. Her work has also been extensively covered in the national and international press.

293. Vase (plate XXIV)

Designed by Toby Russell (b.1963)
Made in the workshop of Toby Russell, London, 1997
Height: 31 cm. Diameter at top: 26 cm
M.9-1998

TOUCHES AND INSCRIPTIONS: Maker's touch *TR*, with hand holding a crescent moon.
PROVENANCE: Purchased.

The piece is made from pewter polished and fabricated from sheet. Toby Russell trained at Camberwell College of Art between 1982 and 1986. Since graduating, he has had his own workshop, where he works mainly in pewter and silver. He has already collected a formidable selection of awards and exhibition appearances, and has enjoyed considerable exposure in the media. In 1997, he was commissioned by the Silver Trust to produce a silver bowl for their collection, for the use of the Prime Minister at 10 Downing Street. His main concern in recent years has been to discover novel ways of manipulating the metal, preferably without relying on traditional techniques. The resulting curved, highly polished surfaces, give an ever-changing and interesting series of fractured reflections, developing a firmly post-modernist idiom.

BIBLIOGRAPHY: Jenks 1998, p. 12

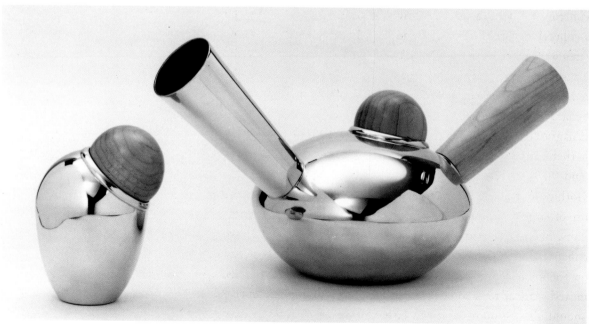

292

8. Fakes

Antique pewter was not collected seriously until the late nineteenth century, with the exception of spectacular wares such as the Briot dishes (no. 25) and *Edelzinn*, but it is a remarkable feature of pewter collecting in its early days that interesting pieces were quickly faked. By the 1920s, sophisticated workshops were in operation, supplying wealthy collectors with both entirely new and old but repaired and redecorated wares. In a letter to the collector Alfred Yeates in the Museum files, written in the early 1930s, Howard Cotterell rages against the fakers, who, in his opinion, were seriously undermining the whole study of the subject.

Like the fakers of 'antique' silver in the same period, the more sophisticated craftsmen were making their own punches – copying the 'touches' of well known makers but also of the comparatively obscure. A mark plate used by the faker Richard Neate, working in the 1920s, has survived and is revealing for the number and variety of touches that it bears – including one of his own *NR*, with his initials switched to stand for 'Naughty Richard'. Neate used to aggrandize original pieces by faking engraving in contemporary style. Among his specialities were large 'Restoration' chargers of the 1660s, decorated with royalist emblems and mottoes in wriggle-work. The Museum received an example as part of the Alfred Yeates Bequest (no. 294). Ironically, the original plate is also a 'fake' in that it has seventeenth-century pseudo-hallmarks to make it look more like silver. Had Yeates known that the engraving on his charger was modern, he might have taken consolation from the fact that another was acquired from Neate by no less a collector than Sir William Burrell of Glasgow.

The controversy over a late seventeenth-century tankard in the Museum's collection is told elsewhere (no. 66). It reveals not only how antique wares were made in the 1920s, but also the location of one of the London workshops where much faking was done. The early collectors, like Antonio de Navarro, were wealthy and keen to buy rare items. These were grist to Richard Neate's mill. Rare salts, unusual tankards, rare Irish and Scottish measures, candlesticks of unusual form or size – the Museum has an example that is almost three feet high – all of these were being faked in the 1920s and 1930s, and some continue to deceive.

The Gothic revival in Germany also started a fashion for the manufacture of large guild tankards, ornate dishes and vaguely medieval-looking wares, like *nefs*. These were not made as fakes but as decorative wares to enhance a neo-Gothic interior, and illustrated catalogues of the period show these odd-looking items arranged on shelves in serried ranks. After a hundred years of wear some of the tankards can be quite deceptive today. It should also be noted that old-fashioned firms working in base

metal continued to produce traditional wares in an old style – some from old moulds – until well into the 1920s and 1930s. A glance at their catalogues reveals beer jugs, tankards, candlesticks and even bleeding bowls, many of which would be dated on the basis of their form to the late eighteenth and nineteenth centuries.

Pewter is comparatively easy to repair and some of the rare hollow wares have new lids, thumb-pieces and handles, carefully distressed and patinated to imitate the originals. Given the colour and patination that old pewter acquires, it is often possible to patch and repair a piece almost invisibly.

294. Dish

English, dated 1664
By Richard Neate, about 1920
Diameter: 54 cm
M.28-1945

TOUCHES AND INSCRIPTIONS: Faked maker's touch of a windmill between the initials *WH* (Cotterell 1929, no. 5694, also known on pieces dated 1655 and 1677).
PROVENANCE: Yeates Bequest.

The plate was made in the seventeenth century, but the engraving is modern. The centre is engraved with the arms of Charles II, the rim with portraits of Charles and his Queen, Catherine of Braganza, the arms of the Butchers' Company and the motto *LOVE NEVER DIES WHERE VERTUE LIES*. The initials of owners Thomas and Margaret Cox are also engraved.

On the left-hand side are original pseudo-hallmarks that were included in the seventeenth century to make the plate look like silver.

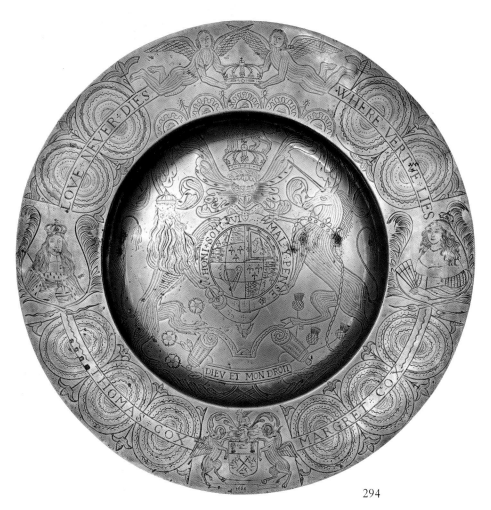

294

295. Guild Tankard

German, late 19th century
Height: 49 cm
M.7-1940

TOUCHES AND INSCRIPTIONS: Faked maker's touch of
Max Weggang, Augsburg.
PROVENANCE: Goltze Gift.

The tankard is sumounted by a griffin with a shield; the
shield is dated 1655 and may have been taken from an
original piece. The inscription purports to record the
commissioning of the vessel in 1657 by officers of a guild of
millers. The shape and type of decoration are in keeping
with this date, but many signs indicate that the vessel is a
fake.

Copies of large Augsburg and Nuremburg guild
tankards were very popular in Germany in the late
nineteenth and early twentieth centuries. Many were made
by the firm of August Weggang in Ohringen, which issued
an illustrated catalogue in 1902. The lack of wear and
patination, and the form and style of the engraving declare
this example to be nineteenth-century work. The pseudo-
mark is cast into the handle, as are the dents and scratches,
and even the 'punched' decoration.

BIBLIOGRAPHY: *Zinn, Kunst und Fälschung*, 1981, p. 6

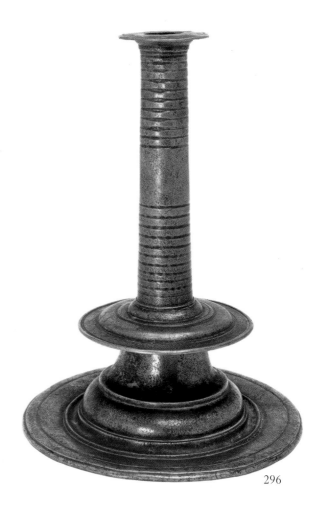

296

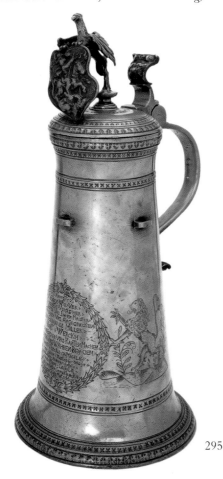

295

296. Candlestick

English, 20th century, in the style of 1675
Height: 23 cm. Diameter of base: 16.7 cm
M.84-1945

TOUCHES AND INSCRIPTIONS: Faked maker's touch *CR*.
PROVENANCE: Yeates Bequest.

This candlestick is a twentieth-century forgery. The
surface has been deliberately splashed with acid, giving it
an unconvincing mottled appearance and also leaving
white deposits in some of the mouldings. The mark is
insubstantial and based upon Cotterell 1929, no. 5878.
Writing to the collector Alfred Yeates in 1933, Howard
Cotterell complained: 'Anything rare is being copied by
these fiends – Jacobean candlesticks and salts, broad-
rimmed armorial dishes, quaint bowls, cups and what-not .
. .'

BIBLIOGRAPHY: Cotterell 1929, p. 375

Bibliography

The Age of Chivalry, exhibition catalogue, Royal Academy of Arts, London, 1987

Aichele, F., *Zinn*, Munich, 1977

Art Nouveau in Munich, exhibition catalogue, Philadelphia Museum of Art, 1988

Bailey, C. T. P., 'A Historic Pewter Candlestick', *The Burlington Magazine*, November 1925

Bangs, C., *The Lear Collection – a study of copper alloy socket candlesticks, AD 200–1700*, London, 1995

Benker, G., *Alte Bestecke*, Munich, 1978

Berling, K., *Altes Zinn*, Berlin, 1919

Bidault, P., *Etains Réligieux*, Paris, 1971

Boucaud, P. and Fregnac, C., *Les Etains*, Fribourg, 1978

Boucaud, *Les Pichets d'Etain*, Paris, 1958

Brault, S. and Bottineau, Y., *L'Orfèvrerie française du XVIIIe siècle*, Paris, 1959

Brett, V., *Pewter*, Oxford, 1981

British Pewterware through the Ages, exhibition catalogue, Reading Museum, 1969

Bronson, B. and Ho Chumei, 'Chinese Pewter Teapots and Tea Wares', *Field Museum of Natural History Bulletin*, 59, 3, 1988

Brownsword, R. and Homer, R., 'The marks on medieval pewter flatware', *Journal of the Pewter Society*, 6, no. 3, Spring 1988

Brownsword, R. and Pitt, E. E. H., 'An analytical study of pewterware from the Mary Rose', *Journal of the Pewter Society*, 7, no. 4, Autumn 1990

Burford, E. J., *Wits, Wenches and Wantons*, London, 1986

Callender, J. G., 'Fourteenth century brooches and ornaments in the National Museum of Antiquities, Edinburgh', *Proceedings of the Society of Antiquaries of Scotland*, LVIII, 1924

Clayton, M., *The Collector's Dictionary of Gold and Silver of Great Britain and North America*, Woodbridge, 1971

Clifford, H., 'Colonel Shorey, citizen and pewterer of London', *Journal of the Pewter Society*, 7, no. 4, Autumn 1990

Connor, R., *The Weights and Measures of England*, Science Museum, London, 1987

Cotterell, H., 'Jewish Passover Plates', *The Connoisseur*, April 1928

Cotterell, H., 'Further Notes on Commemorative Porringers', *Antiques*, July 1928

Cotterell, H., *Old Pewter*, London, 1929

Demiani, H., *François Briot, Casper Enderlein und das Edelzinn*, Leipzig, 1897

Demiani, H., *Sächsisches Edelzinn*, 1904

Dexel, W., *Das Hausgerät Mitteleuropas*, Brunswick, 1973

Dubbe, B., *Tin en Tinnegieters in Nederland*, De Tijdstroom Lochem BV, 1978

Düsseldorf, *Kataloge des Kunstmuseum Düsseldorf Zinn*, Düsseldorf, 1981

Edelzinn aus der Sammlung Dr. Karl Ruhmann, exhibition catalogue, Tiroler Landesmuseum, Innsbruck, 1960

Egan, G., *Playthings from the Past*, London, 1996

Egan, G., *The Medieval Household, Medieval Finds from Excavations in London*, no. 6, Museum of London, HMSO, 1998

English Silver Treasures from the Kremlin, exhibition catalogue, Sotheby's London, January 1991

Erixon, S., *Gammal Mässing*, Uppsala, 1972

Etains de Chine, Collection Eva et Henry Maertens de Noordhout, exhibition catalogue, Musée Royal de Mariemont, 1994

Evans, J., *A History of Jewellery*, London, 1970

Fifty Masterpieces of Metalwork, Victoria and Albert Museum, HMSO, London, 1951

Finlay, I., *Scottish Gold and Silver Work*, London, 1969

Gaimster, D., *German Stoneware: 1200–1700*, British Museum, London, 1997

Gordon, K., 'List of Wigan Pewterers', *Journal of the Pewter Society*, 2, no.3, Spring 1980

Gordon, K., *The Candlestick Maker's Bawle*, Congleton, 1994

Gotelipe-Miller, S., 'The Port Royal pewter collection', *Journal of the Pewter Society*, 6, no. 2,

Autumn 1987

Haedeke, H.-U., *Zinn*, Brunswick, 1963

Haedeke, H.-U., *Metalwork*, London, 1970

Hals, A.-S., *Norsk Tinn Fra Laugsliden*, Oslo, 1976

Hatcher, J. and Barker, T., *A History of British Pewter*, London, 1974

Hayward, J. F., 'A Disputed Pewter Tankard', *The Connoisseur*, October 1955

Hayward, J. F., *Virtuoso Goldsmiths, and the Triumph of Mannerism*, London, 1976

Hintze, E., *Schlesien Vorzeit in Bild und Schrift*, 1919

Hintze, E., *Nürnberger Zinn*, Leipzig, 1921

Hintze, E., *Die Deutsche Zinngiesser und ihre Marken*, Leipzig, I (1921), II (1921), III (1923), IV (1926), V (1927), VI (1928), VII (1931)

Hogben, C. ed., *British Art and Design 1900-1960*, Victoria and Albert Museum, London, 1983

Homer, R., *Five Centuries of Base Metal Spoons*, London, 1975

Homer, R., 'John Shorey senior and junior', *Journal of the Pewter Society*, 8, no. 2, Autumn 1991

Homer, R., 'Thurdendels and Hooped Quarts', *Journal of the Pewter Society*, 10, no. 3, Spring 1996

Homer, R. and Hall, D., *Provincial Pewterers*, London, 1985

Homer, R. and Shemmel, S., *Pewter – a Handbook of Selected Tudor and Stuart Pieces*, Museum of London, 1983

Hornsby, P., *Pewter, Copper and Brass*, London, 1981

Hornsby, P., *Pewter of the Western World: 1600-1850*, Schiffer Publications (USA), 1983

Hornsby, P., 'Wriggle-work Plates', *Journal of the Pewter Society*, 6, no. 4, Autumn 1988

Hornsby, P., 'James I Flagons', *Journal of the Pewter Society*, 10, no. 4, Autumn 1996

Horschik, J., *Steinzeug 15. bis 19. Jahrhundert, von Bürgel bis Muskau*, Dresden, 1978

Horschik, J., 'Creussener Steinzeug', *Keramos*, 139–40, 3-282, 1993

Jenks, C., *The Architecture of the Jumping Universe*, London, 1998

Journal of the Pewter Society, 1918–98

Keen, M., *Jewish Ritual Art in the Victoria and Albert Museum*, HMSO, 1991

Kerfoo, J. B., *American Pewter*, New York, 1942

Keur van tin, exhibition catalogue, Museum Willet-Holthuysen, Amsterdam; Provincial Museum Sterckshof, Antwerp; Museum Boymans-van Beuningen, Rotterdam, 1979

Keyser, S. and Schoenberger, G., *Jewish Ceremonial Art*, Philadelphia, Jewish Publication Society, 1955

Laughlin, L., *Pewter in America: its Makers and their Marks*, Barre, Massachusetts, 1971

Liberty's, *Yule Tide Gifts*, London, 1900

Liberty's 1875–1975, exhibition catalogue, Victoria and Albert Museum, London, 1975

Lightbown, R. W., *French Silver*, HMSO, 1978

Lightbown, R., *Mediaeval European Jewellery*, Victoria and Albert Museum, London, 1992

London Museum Medieval Catalogue, 1940, new edition, Ipswich, 1993

McInnes, A., ' New light on an old problem: the crowned hR verification seal', *Journal of the Pewter Society*, 8, no. 1, Spring 1991

Mannin, Manx Language Society, Douglas, Isle of Man, 1913–18

Massé, H. J. L., *Pewter Plate*, London, 1910

Massé, H. J. L., *Chats on Old Pewter*, London, 1949

Michaelis, R. F., *Antique Pewter of the British Isles*, London, 1955; New York, 1971

Michaelis, R. F., 'Royal Portraits and Pewter Porringers', *Antiques*, January 1958

Michaelis, R. F., *British Pewter*, London, 1969

Michaelis, R. F., *Old Domestic Base-Metal Candlesticks*, Woodbridge, 1978

Morton, R. S., *Collecting Pewter*, Antique Dealer and Collectors' Guide, 1997

Mory, L., *Schönes Zinn*, Munich, 1961

Moulson, D., 'Sir John Fryer,

Index

Picture credits

Unless otherwise stated images
are © The Board of Trustees of
The Victoria and Albert Museum.

© Copyright The British Museum
(figs 7 & 15); Historisches Museum
des Kantons Thurgau, Schloss
Frauenfeld (plate IV); Mary Rose
Trust (fig. 11); Mendelschen
Stiftung, Nuremberg (plate I); © The
Trustees of the National Museums of
Scotland 1998 (fig. 6); The Royal
College of Music, London (fig. 5);
Sammlung Dr. Karl Ruhmann,
Wildon (frontispiece); Shropshire
County Museum Service
(plate VIII); Staatliche Graphische
Sammlung, München (plate III);
Stadtarchiv, Magdeburg (fig. 9);
Reproduced by permission of the
Trustees of the Wallace Collection
(plate VI).